close READING

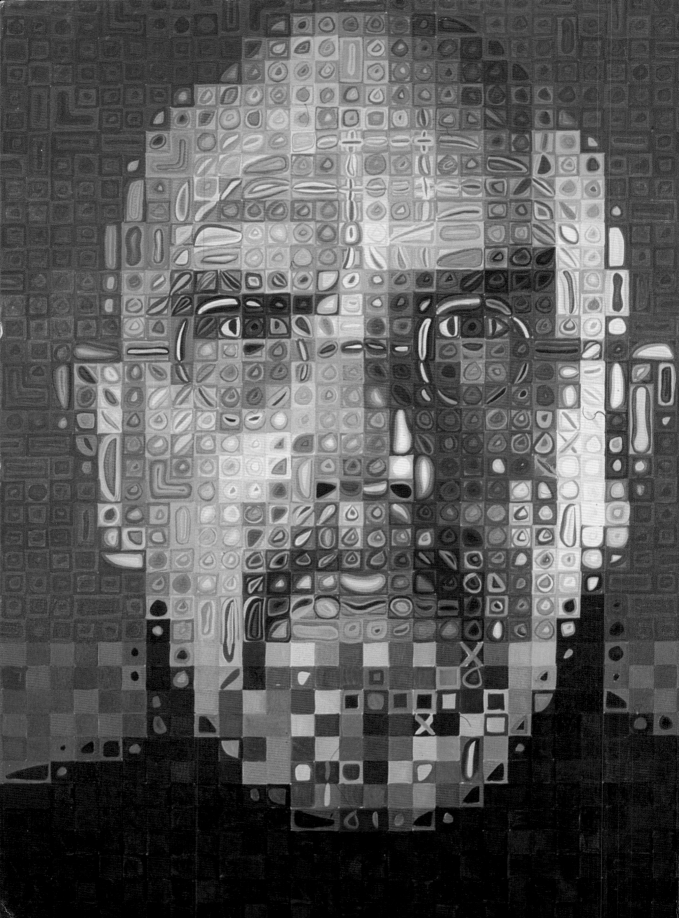

close READING

Chuck Close and the Art of the Self-Portrait

MARTIN FRIEDMAN

HARRY N. ABRAMS, INC., PUBLISHERS

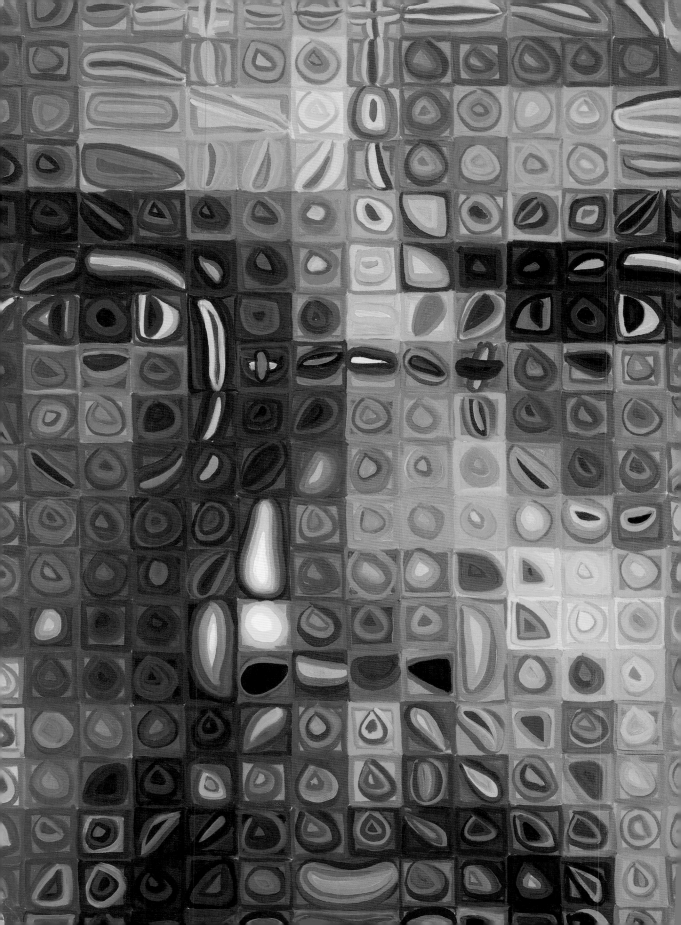

For Mickey

EDITOR: Deborah Aaronson
PICTURE RESEARCH: Céline Moulard
DESIGNER: Brankica Kovrlija
PRODUCTION MANAGER: Maria Pia Gramaglia

LIBRARY OF CONGRESS CATALOGING-IN-PUBLICATION DATA

Friedman, Martin
 Close reading : Chuck Close and the artist portrait / Martin Friedman.
 p. cm.
 Includes bibliographical references and index.
 ISBN 0-8109-5920-8 (alk. paper)
 1. Close, Chuck, 1940– 2. Self-portraits. 3. Artists—United States—Portraits.
 4. Artists—United States—Biography. I. Title.

 N6537.C54F75 2005
 759.13—dc22

 2005008913

Printed in Singapore

10 9 8 7 6 5 4 3 2 1

Harry N. Abrams, Inc.
100 Fifth Avenue
New York, N.Y. 10011
www.abramsbooks.com

Abrams is a subsidiary of

LA MARTINIÈRE

N.B.: Unless otherwise indicated, all works of art are by Chuck Close.

Page 2: Work in progress for *Self-Portrait*, 2004–05

Page 4: *Self-Portrait* (detail), 2004–05

CONTENTS

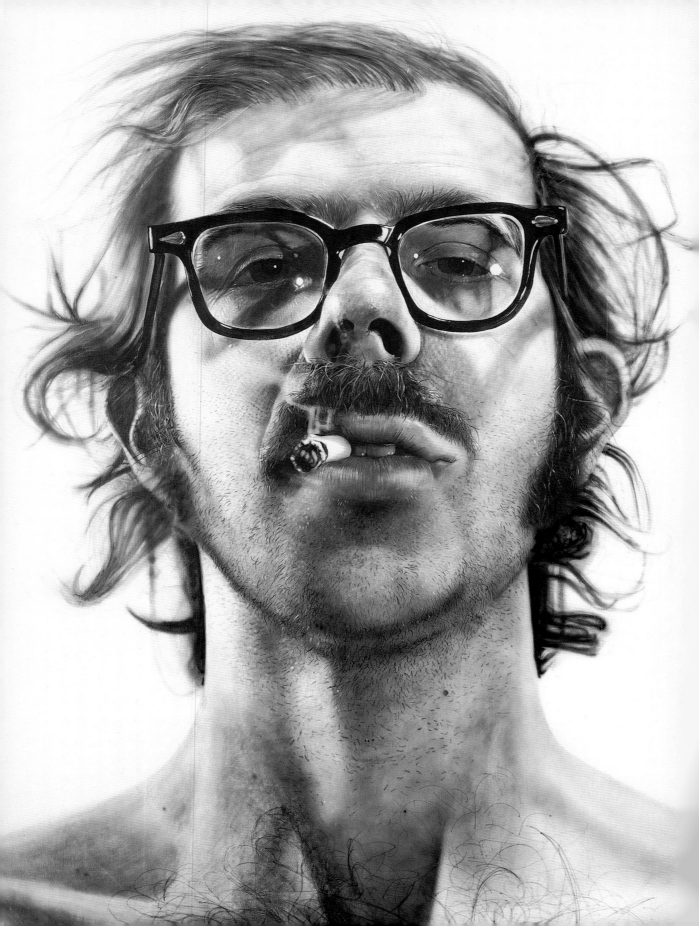

Introduction

The first Chuck Close painting I ever saw was the 1968 *Big Self-Portrait* in his studio at 27 Greene Street in SoHo, where I was taken by Robert Israel, a young artist friend of Close's and mine, who had watched its development on the easel during successive visits. So impressed was Israel with the completed work that he invited me to see it with him. We walked up three flights of steep stairs, and there, at the far end of the narrow loft, was a huge black-and-white portrait of an unshaven, bare-shouldered young man. Standing next to it, greeting me apprehensively, was its towering, slightly glowering, six-foot-three painter, no less formidable-looking than his scraggly-locked image on the canvas. Steeped as I was then in the prevailing mystiques of Abstract Expressionism, Minimalism, and Pop, I was far from ready for what was before me: a painting that not only seemed to break the rules for what then passed as modernism, but one that was defiantly descriptive in its photographic detail. What confronted me was not just a head, but a giant headscape, nine feet high. Parts were in sharp focus, especially the eyes and the mouth, while others such as the tip of the cigarette, the tip of the nose, and the outline of the hair were slightly blurred. It was as though a plane of sharp-edged realism were sandwiched between two slightly out-of-focus ones. Not sure what to say on this first encounter with Close's vast creation, I, of course, said the wrong thing. Had he already finished painting the neck? I wondered aloud. I still remember the look he gave me, something between dismay and contempt. And I remember Israel's discomfort at my efforts to make amends by changing the subject to something like, What were Close's thoughts about the future of realism in contemporary art? That, too, drew a chilly response. How could I have known, then, that so seemingly academic an approach would, in the hands of this fervent young painter, soon become a vividly modernist one?

Whatever may have been going through his mind during those first few minutes, Close decided to give me the benefit of the doubt. Lightening up a bit, he patiently explained what his work was all about. The painting, I learned, was based on a photograph he had made of himself. By overlaying it with a horizontal-vertical grid, sign-painter fashion, he had painstakingly transferred the data gleaned from it, area by area, to the canvas. What became increasingly apparent as he spoke, and as I gazed at the portrait, was that Close was not only a technical wizard, but an artist with an highly idiosyncratic approach to picture-making. By the time Israel and I had left the

(opposite) *Big Self-Portrait,* 1967–68. Acrylic on canvas, 107 ½ x 83 ½". Collection of Walker Art Center, Minneapolis; Art Center Acquisition Fund, 1969

studio, the portrait had so imprinted itself on my consciousness that, early the next day, I phoned Close to tell him I would like it for the Walker Art Center and asked the price. The number he quoted was absurdly low: $1,300. Was he sure about this? He was. Could it be sent on approval to the Walker Art Center, which was, I apologized, how things were done there. Yes, he grudgingly supposed, it could.

Once the painting was shipped to Minneapolis and installed on the Walker's pristine white walls for review by the museum's acquisition committee, I could study it further, without the artist looking menacingly over my shoulder. I saw that, for all its obsessive descriptiveness, subtle but insistent distortions of reality were going on. The slight asymmetry of the artist's face, negligible in real life, had taken on a kind of lopsidedness in its magnification. The nose that I found myself looking up into was wackily off-center. The modeling of the head and neck (yes, the neck) seemed a little arbitrary in some areas. Later, as I got to know the *Big Self-Portrait* better, I would understand that those slight modifications were early evidence of Close's constant pursuit of the abstract forms inherent in even the most photographically descriptive imagery.

Fast forward to the happy ending. Because the Walker's acquisition committee was used to hearing from me about the virtues of pure abstraction, so large and seemingly revisionist a work as this painting took a few of them aback. Hard-core realism was probably the last thing they had expected to vote on, but they responded nobly, if with some amusement, to my pitch—and the price was right, too. To this day, if I happen to be in the audience during a public occasion when he is being honored, Close never fails to mention the price the museum paid for his first self-portrait and, to his delight, my face never fails to turn bright red. On the other hand, as I keep reminding myself—and him, at times—this was, after all, the first painting he had ever sold.

Although Chuck Close has painted himself far more often than any of his other subjects, the overwhelming majority of his sitters have been fellow artists, several of whose visages he has used more than once. While my initial objective in writing this book was to explore the evolution over more than three decades of his self-portraits— from insistently neutral renditions to increasingly expressionistic ones—the more I saw of them, the clearer it became that they should be considered within the larger context of all his work, especially his artist portraits, to which they are so closely related in style and technique. Not only did ideas about form, color, and scale in the self-

portraits find their way into his depictions of his artist friends, the reverse was often true: many stylistic ideas and techniques that first saw the light in his paintings of his fellow artists subsequently surfaced in the self-portraits.

It was the single-head format of his *Big Self-Portrait* that set the template for all his subsequent imagery. Most immediately influenced by that black-and-white, acrylic-on-canvas portrait were the late 1960s and early 1970s paintings of his artist friends Nancy Graves, Joe Zucker, Robert Israel, Richard Serra, and Keith Hollingworth. Conversely, the color-dot paintings he began of himself in the mid-1980s exemplify the reverse flow of influence. As early as 1973, he had made a black-and-white self-portrait consisting of sprayed ink dots afloat in grid squares and had also produced dot paintings in oils portraying other subjects. Not until 1986 did he use this technique in painting his own face.

Yet, if Close's paintings of himself and his portraits of other artists are stylistically of a piece, how they differ in other ways, especially in their expressive content, is another story. With such questions in mind, I decided to broaden the scope of my exploration of his imagery so that, in addition to my focus on self-portraiture, it would also deal with his portrayals of a number of his artist subjects.

Soon apparent in this wider approach was that Close, by painting his fellow artists, was implicitly stressing both the importance of their friendship to him and his high regard for their work. The catholicity of his choices of artist subjects is amazing: he has always been open to any and all possibilities. What has always intrigued me is the fact that many of Close's subjects are also known for their self-portraiture. Some continuously so, such as Cindy Sherman, Lucas Samaras, and Francesco Clemente; some intermittently, like William Wegman, Kiki Smith, and Alex Katz; still others sporadically but no less seriously, like Jasper Johns and Richard Artschwager. With this in mind, I asked a number of Close's fellow self-portraitists to talk with me not only about his representations of them, but also about their own highly individualistic approaches to this genre. We also talked about what a Close painting, for all its studied neutrality, might reveal about the psychology of its subject, as well as that of the artist who made it.

(following pages) Chuck Close in his Greene Street studio with *Nancy* (1968), *Keith* (unfinished), *Joe* (1969), and *Robert* (1969-70), 1970

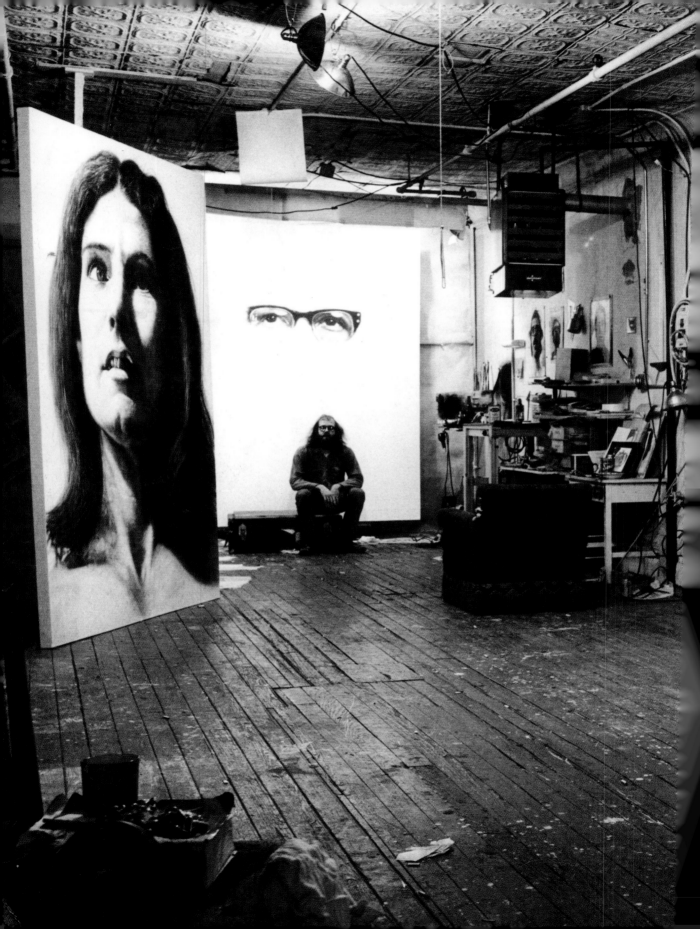

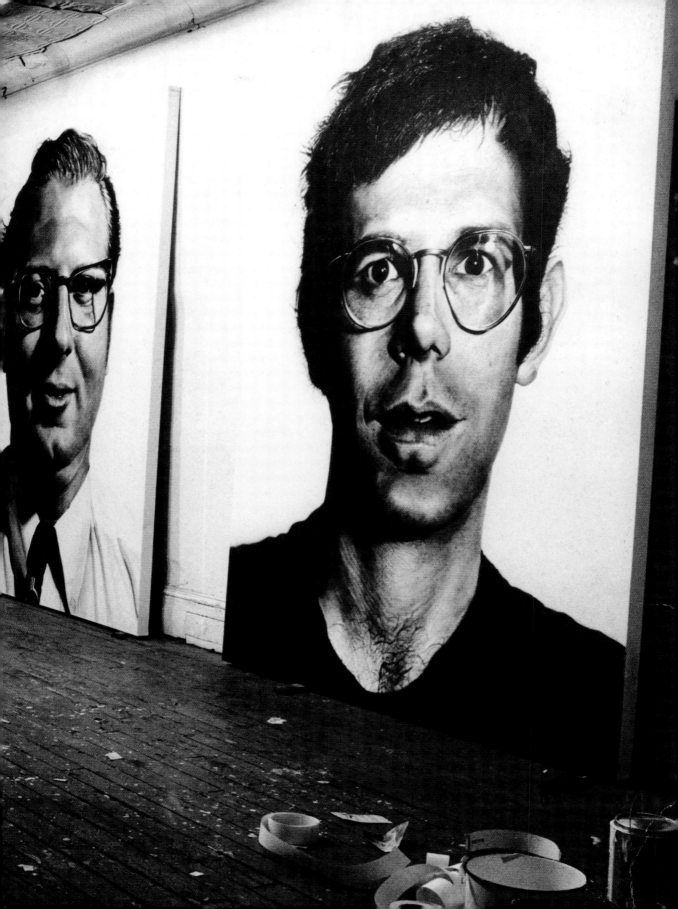

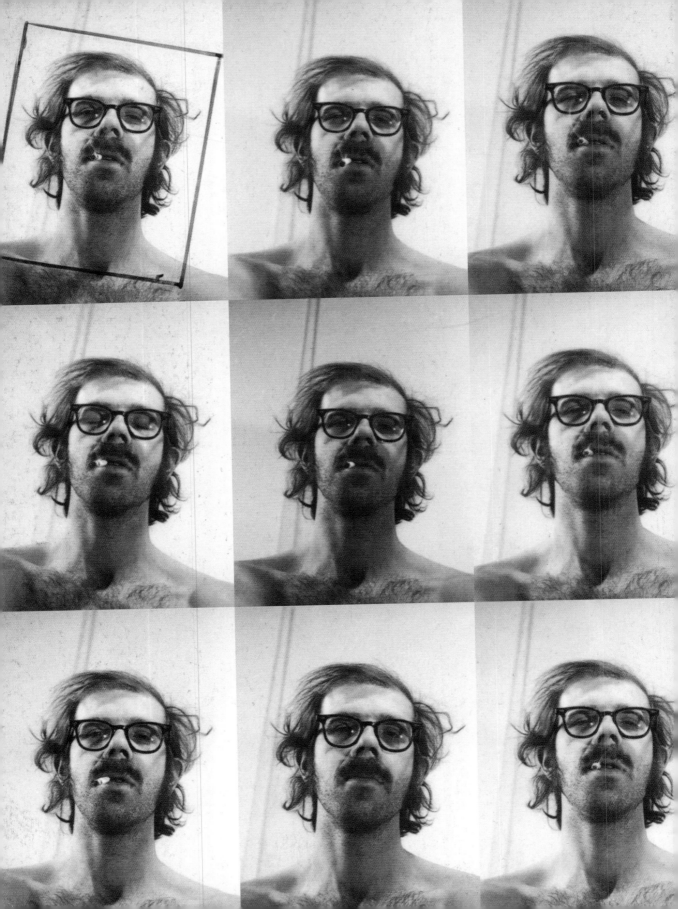

PORTRAIT OF THE PORTRAITIST

The Day of Infamy

"It took me decades to admit that I was making portraits. It's very hard, when you're inoculated with the modernist virus." —CHUCK CLOSE

On December 7, 1988, the forty-seventh anniversary of the catastrophic Japanese attack on Pearl Harbor, Chuck Close experienced what he sardonically calls his own "day that shall live in infamy," when he underwent a traumatic event that would indelibly change the course of his life and force him to confront his mortality. While attending a Gracie Mansion ceremony at which then-mayor Ed Koch and other dignitaries were honoring a group of recipients for their achievements in the arts, Close, one of the presenters on the dais, was gripped by intense pains in his back, chest, and both arms. Although he had had previous episodes—some, earlier that day, in fact—so severe was this new onslaught that he urgently requested that his presentation be moved ahead so that he could leave the ceremony and walk across York Avenue to Doctors Hospital (now Beth Israel Medical Center). Even with a New York City police officer at his side, he barely made it to the emergency room. His wife, Leslie, was waiting for an elevator in their apartment building when she heard the phone ring. "As soon as I got to the hospital," she remembers, "he had some kind of episode—chest pains. He said he couldn't move—he couldn't feel anything. The nurses were kind of dismissing it, thinking it might be the result of whatever they had given him intravenously. By the end of that night he was paralyzed." The seizure went on for about twenty minutes, until he finally lapsed into a calm state. By then, he was almost totally paralyzed from the shoulders down. He could barely move his head and neck; breathing was almost impossible because only the upper part of his lungs was working, the lower having filled with fluid. After extensive tests, his seizure was diagnosed as the result of an occluded spinal artery, a rare phenomenon. He remembers being terrified but, at the same time, preternaturally calm throughout all of this. "For about eight weeks I was unable to move any part of my body below the shoulders. I was on my back. I began getting some movement in my arms and they would slowly move up, involuntarily—I had no strength in my biceps—and they would push against my throat. It was like Dr. Strangelove. I couldn't control them. The nurses would have to pull my arms back down to my sides." He had suddenly become, in his words, an "incomplete" quadriplegic.

(page 14) *Self-Portrait* contact sheet, 1967. Gelatin-silver print, 10 x 8"

Earlier that morning, Close had been walking about the city on various missions. After a visit to the Robert Miller Gallery, then at Fifty-seventh Street and Madison Avenue, where he looked at some Robert Mapplethorpe photographs as a possible anniversary gift for Leslie, he continued on to the National Public Radio bureau on Forty-seventh Street for an interview about the future of the politically imperiled National Endowment for the Arts. Then, he headed uptown to Gracie Mansion, at East End Avenue and Eighty-eighth Street, where he was to present the award.

"When I look back on it," he says, pondering the sudden onslaught of his illness, "there were a few signs earlier about what might happen that I just didn't read." The fact is, he had experienced the first of those fateful harbingers, the severe pains in his chest and sternum, in 1978, when the Closes were living on Prince Street in SoHo. "At the time, I thought I was having a heart attack. It was frightening, but I didn't want to awaken Leslie to watch me die." The doctors he consulted decided that his condition was not a heart attack, but some other affliction they were unable to diagnose. With no health insurance or money for doctor's fees and on the advice of his friend the painter Jack Beal, Close flew to Chicago to consult a specialist, a collector of Beal's work, who had agreed to see him at no charge. After examining him thoroughly, the doctor determined that his affliction was myasthenia gravis, a disease, according to *Merriam-Webster's Medical Desk Dictionary,* "characterized by progressive weakness and exhaustibility of voluntary muscles...." Wrong guess, as things turned out.

Back in New York, Close underwent further tests at University Hospital, associated with NYU Medical Center, a pattern that would continue for the next few years as his symptoms recurred. "I'd go there, they'd put an electrocardiogram on me, show me there was nothing wrong with my heart, then send me home. Or they'd give me some digitalis or nitroglycerin tablets to put under my tongue." In the fall of 1986, while working in Kyoto with an eminent Japanese printer on his first color woodblock—its subject was Leslie Close—a violent seizure landed him in a Japanese hospital, where little English was spoken and where he tried to describe his pain to concerned but uncomprehending doctors. Released from the hospital and fortified with nitroglycerin tablets, he flew back to New York and underwent still more tests, but again with no conclusive results. Thinking about all this, he observed, "The electrocardiogram reads the heart, not the spine—but it was my spinal artery that was closing down. Still, it was a strokelike situation. Each time the artery would close down I would have tremendous pain. Then, it would reopen and I'd be fine." But the

last time it happened, the day of the Gracie Mansion awards, "it just closed and didn't reopen." After a few days at Doctors Hospital, he was transferred to University Hospital. He spent a month in intensive care, to keep his lungs functioning, and another in critical care, and was then moved next door to the center's renowned Rusk Institute of Rehabilitation Medicine, where he would undergo intensive therapy until July 4 of the following year. These were dismaying, uncertain days for Close, Leslie, and their young daughters, Georgia and Maggie, then aged fifteen and four.

At the time of this cataclysmic, life-altering event, Close was already a well-established figure in the art world. In 1980 a large retrospective of his work was organized by the Walker Art Center and circulated to museums across the country. He had long since arrived at his distinctive theme, the epic-scale portrait, which instantly identified his work. His paintings were not so much portraits as portraits of portraits, based on highly detailed photographs of frontally posed sitters gazing stoically into his camera lens. When they began appearing in galleries and exhibitions in the late 1960s, some critics, and even some fellow artists, dismissed them as curious anachronisms, as much for Close's singular preoccupation with the near-forgotten art of portraiture as for their obsessive realism. Outside the corporate boardroom or salon, the painted portrait has long been a marginal phenomenon. Painters critically esteemed for their work in this genre, realistic or otherwise, were relatively few then—and still are. Close radically helped change that perception by the force and unmistakable contemporary edge of his painting; of its present-day exemplars, he is surely among the most inventive and profound. Since the advent of his giant heads in the late 1960s, some eighty models—some of them members of his family, but most his artist friends—have sat for the photographs from which the portraits derive. It was not so long ago that Close airily referred to these photographs as "mug shots," but that raffish characterization has now given way to the loftier term "photo-maquette." From the visual information distilled in those photographs has ensued not only a daunting progression of large-scale paintings, but richly inventive works in other media.

Beginnings

Born in 1940 in Monroe, Washington, Charles Thomas Close was the much doted upon only child of Leslie Durwood Close, a plumber, sheet-metal worker, all-around

handyman, and part-time inventor, and Mildred Emma Close, a piano teacher. The same year, the family moved to Everett, a small town near Seattle, and in 1945 to Tacoma, where Close's father had secured a civil service job with the Army Air Corps. Even in elementary school, young Charles was well on his way to being viewed by his classmates as something of an oddball; he wanted to be part of the group, but it was no easy fit. Shorter than his peers (hard to imagine, considering his present height), awkward at sports, he often found himself doing things on his own. "I wasn't athletic. I couldn't run," he recalls, ruefully remembering his young self. "My eyes didn't converge quickly enough to catch a ball, let alone hit it." All of this added to his sense of isolation. With the encouragement of his parents, though, he found ways to bring the world to his door. His ever-resourceful father built him a puppet theater, and his mother, an expert seamstress, made him an impresario costume, complete with top hat and cape. Soon, Charles was presenting puppet shows and performing magic acts in the family's backyard, events to which his previously indifferent schoolmates soon flocked. At least for the moment, an appreciative audience was under his spell. "I had found new ways to bring everyone to me, and to be in charge of things. It was one thing that distinguished me from everyone else at school. Another was that I could draw, and they couldn't. I could make drawings that would get the other kids to go, 'Ooh!'

"In Tacoma, we lived in a housing project next to the Air Force base [McCord Field], so it was probably subsidized housing. I remember rationing and blackouts. My first-grade teacher made a kind of map of the project, because virtually everyone at the school lived there. She wanted each of us to make a drawing of the house that we lived in. The area was like Levittown—tiny little houses that were relatively new but incredibly modest. I made a drawing of my house in perfect perspective. I don't know how I was able to do this, but I did it. The teacher had no idea how to draw in perspective, but would draw in isometric projection, in totally parallel lines that didn't meet in the distance. She wanted all our houses, including mine, to look like hers. But she didn't know diddly-squat about drawing! And I remember my sense of outrage—it's as palpable today as it was in 1946—of knowing something about art and being forced by a grown-up, a Philistine, to do something so wrong. I argued with her, but she prevailed and forced me to draw my house the way all the other kids did theirs.

"When I was about five, my parents asked me what I wanted for Christmas. I said all I wanted was an easel. So my father made one for me. He made all my toys, my bicycles—everything. He made me a jeep, too—because the war was on—that I

Close dressed as a magician, c. 1946

pedaled around the neighborhood. He made it from scratch. About the same time, I was leafing through a Sears Roebuck catalogue, and there, before my wondering eyes, appeared a 'Genuine Weber's Oil Color Set' in a wooden case. We were of very modest financial means, so I rarely asked for toys or anything else, but I wanted that paint set so much. I started saving money and asking my father and mother if there were things that I could do around the house to earn fifty cents, here or there. They finally realized what it was I was saving for, and how badly I wanted it, so they sent off the order for the paint box to Sears. I can still, to this day, smell the cheap linseed oil in the tubes of paint. They were big fat tubes, not little skinny ones. I knew, even then, that the little skinny tubes were for dilettantes. I would sit in my room at night, unscrew the caps of the tubes, and just smell the paint. The paint set came with a little palette—a little white palette.

"About the time that I was given it, my father would drive to work, with a stop for breakfast at a diner, where he would always order bacon and eggs. He ate like this every day of his life, which is probably why he died of a stroke or heart disease." It was in that unlikely setting, Close says, that his father, eager to nurture his young son's burgeoning talent, found an unusual means of doing so. "He had met a woman there who lived in a rundown house across the highway from the diner who said she had studied painting at the Art Students League in New York. So he got me private art lessons with her." Young Charles, eight when he began studying with his unconventional teacher, continued his lessons with her for some two and a half years. She doubtless discerned his considerable artistic gifts early on—among them, a precocious ability to draw whatever was before him—and went about fostering them systematically. "She was very academic in her approach to teaching art," he remembers. "For instance, she taught me how many heads high a figure should be." He learned not only to draw and paint landscapes and still lifes, but every now and then, "she would bring in a few other women who lived in the house to pose seminude or nude for me."

Word soon got around the neighborhood about Close's weekly art lessons at the house across from the diner. "Listen, if you were my age then and getting a chance to paint nude models, wouldn't you go every week? I was the envy of all the kids at school." Oblivious, at first, to whatever else might be going on in his teacher's house, he eventually concluded that the models she so considerately provided were probably in the same line of dubious work as she. "Men were constantly knocking at the door, but if they showed up during my lessons, she would tell them to come back

Close with his mother (above) and father (opposite), Everett, Washington, c. 1943

later." As we spoke, Close reflected, with amused nostalgia and mild incredulity, on his unorthodox introduction to the rudiments of drawing and painting. "It's kind of amazing that my father would have sent me to a house of ill repute for art lessons. Later, I sometimes wondered whether he might have been a customer."

In 1952 Close's father, a frail man with a history of illness that included rheumatic fever and heart disease, died at the age of forty-eight—ominously, the same age his son would be when he had his seizure in 1988. Close remembers him as "a charming, charismatic man who would have been good at politics." Soon after his death, Mildred Close and her young son moved back to Everett to live in a house next door to his grandparents. She found a job in a department store in the town and later a civil service position with the Air Force. His grandmother Blanche Wagner, to whom Charles was devoted, looked after him while his mother was at work.

Both in junior and senior high school, his achievements were not in academic areas but in his art classes. "In junior high school, I won the 'Keep Washington Green' poster contest for the state of Washington, with a painting I did of a bunny rabbit. I got fifty dollars and a big certificate for it, and it was in the newspaper." Little art instruction was offered until high school, and what was available there were mainly crafts activities, "like wood-burning pictures of Lassie on plywood." But Close plunged into it wholeheartedly, "because I could wood-burn as well as anybody else there." Illustrations in the glossy magazines were his major inspiration. "Early on, it was the *Saturday Evening Post, Collier's,* and *Look,* the ones that had paintings on their covers. I would pore over their covers with a magnifying glass, trying to decode how those paintings were made, how those artists would lay down their brushstrokes. I didn't know from 'high art.' I only knew what illustrators did. I was not a Norman Rockwell fan, although I did like him. But there were others—I've forgotten their names now—who I thought were great illustrators." His early certitude about what art should be soon underwent some erosion in an unexpected way. "In 1951, when I was eleven years old, my mother first took me to the Seattle Art Museum, where I saw my first Jackson Pollock," he vividly recalls. "I was outraged. I was flipped out. 'Who does this guy think he is? What is this shit? This isn't anything!' But I couldn't tear myself away and just kept looking at it. It was a modest-sized, three-by-five, allover drip painting, with gravel, black tar, and aluminum paint, as well as many colors." For all his youthful outrage, the confrontation with the Pollock was fateful: "Within a matter of days, I was secretly dripping paint over all my old paintings, my still lifes and landscapes."

Though the art room at South Junior High School in Everett served as a refuge, life outside was more complicated. Because of undiagnosed dyslexia, Charles was having a hard time keeping up with his schoolmates in history and geography. But, ever the ingenious manipulator in difficult situations, he soon learned the advantages of taking on "extra-credit" projects, such as making elaborate maps, charts, and other visual aids for the topics being studied. It was an easy, enjoyable way of getting by and attracting a little favorable attention along the way from teachers and fellow students. He also immersed himself wholeheartedly in such extracurricular activities as making illustrations for the yearbook and designing and building sets for the school's theatrical productions.

Notwithstanding his memorable exposure to the Pollock and its transforming effects on his ideas about painting, Close still wanted to be a commercial artist. Mindful of his family's limited means, financial security was an issue. "I thought that I would probably starve to death if I were a regular artist, but if I were a commercial artist, I would make enough money to buy a Thunderbird!" Such were his concerns when he enrolled at Everett Junior College (now Everett Community College) in 1958, with the goal of preparing himself for a career in commercial art. He also went there, he says, because, given the dearth of academic subjects in his high school transcript, he couldn't get into the University of Washington. "I was so learning-disabled that I couldn't take algebra, geometry, physics, or chemistry courses in high school. When I took the University of Washington 'grade prediction' test, it said that the only field in which I might get a D average was nursing, but I would fail in everything else. On that basis I could not get into the university or any other four-year school." Everett Junior College, however, was glad to have him as a student, and he signed up for classes in painting, drawing, design, and photography. "I blossomed there. I made up all my high school deficiencies," he says, convinced that he could not have chosen a better or more nurturing place at that stage of his young life. "I'm a product of open enrollment. The junior college system had a place for every taxpayer's son or daughter, no matter what.

"One of my earliest memories soon after I enrolled was of receiving some large charts from the Museum of Modern Art that explained rhythm, movement, pattern, whatever, and they had images, mostly culled from the museum's collection. That's where I saw my first Mirós and Mondrians, so I became a nonobjective painter almost immediately. I painted my own Rothkos and de Koonings. I had no idea

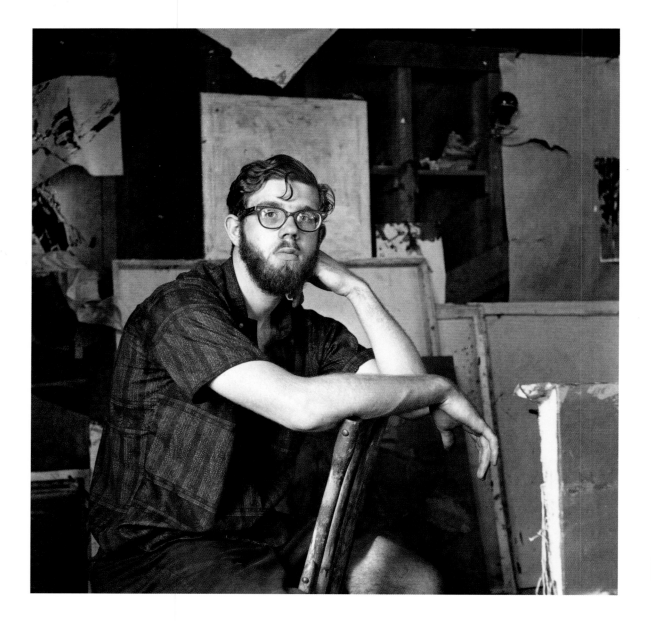

Close at Yale Summer School of Music and Art, Norfolk, Connecticut, summer 1961

what a real de Kooning looked like, or what color it was. I think that's one reason I made so much black-and-white work in my youth. You couldn't tell much from those little black-and-white photos in the art magazines. I didn't know what the surfaces of those paintings were or how thick the paint was." It was about then that Close discovered the vanguard magazine *It Is*, which had just begun publication and whose pages featured illustrations of paintings by prominent New York artists. "There were only about five or six issues in all, but some had large color reproductions of Hofmanns and Rothkos. 'Oh!' I thought, 'So this is what this stuff is supposed to look like!'" By now, he had undergone a sea change in his career objectives. So obsessed was he with painting that commercial art was no longer an option. Nothing was more important to him than painting while he was at the junior college. "I remember hiding at night on top of the lockers in the studios until the cleaning people had gone through," he says. "After they turned off the lights, locked the doors, and left, I would crawl down, go back into one of the painting rooms, turn on the lights, and paint all night."

After two years at Everett, he amassed enough credits to transfer to the University of Washington in Seattle—no hotbed of modernism, as he soon found out. Rather, its artistic scope was limited and local. Some of his fellow students, he recalls, could "draw like angels, with greater facility than mine, but most of them were content to display that facility and probably never went anywhere with it. I was a notch below that kind of extreme virtuosity." The Northwest's long-reigning and most venerated artistic figures were Mark Tobey and Morris Graves, whose mystical imagery alluded to the art of the Orient and to nature's inner worlds. "People didn't look to New York or Europe for artistic ideas. I knew no one then who had ever been to Europe. Everything was influenced by Asian and Native American forms, which at that time I was totally uninterested in. I wanted to be connected with whatever this thing was that went from the Lascaux caves to the Impressionists to the artists who fled the Nazis and had come to New York. Instead, I was interested in the colorful, visible New York School painters, which virtually no one there really knew anything about, except for my one great painting teacher, Alden Mason, who is still one of my best friends." In 1961 Close received a scholarship to Yale's Summer School of Music and Art in Norfolk, Connecticut, a defining experience in his decision to become an artist. Among the school's visiting critics were the painters Philip Guston and Elmer Bischoff and the photographer Walker Evans. On his way to

Norfolk, Close went to New York for the first time, enthusiastically visiting museums and galleries and having the exhilarating experience of seeing paintings he had known only from black-and-white reproductions.

While still a student at the University of Washington, Close started submitting works to local exhibitions. One was a cut-apart and heavily overpainted American flag in the shape of a giant mushroom cloud that he titled *Betsy Ross Revisited* (c. 1961)— a heartfelt expression of his "ban the bomb" feelings and his dismay at America's disastrous Cold War policy. Though his entry received third prize in the Forty-seventh Annual Exhibition of Northwest Artists at the Seattle Art Museum in 1961, it was banished from the galleries by the museum's indignant ex-officio director, Richard E. Fuller. Its capacity to make trouble was in no way diminished, however, because it reappeared soon after in a regional exhibition in the little town of Puyallup, near Tacoma, this time to the outrage of the local American Legion, whose members, according to Close, "literally chopped the gallery door down" in their fury. Despite such notorious distractions, he pursued his academic and artistic goals with such single-mindedness that he graduated magna cum laude from the University of Washington in 1962. That year, he was also accepted for admission by the graduate school at Yale's School of Art and Architecture. Even though the introductory summer at Yale's Norfolk campus had brought him into contact with other talented and motivated young artists, including the painters Brice Marden, David Novros, and Vija Celmins, it barely hinted at what two years of graduate work at Yale would do for him. That experience, as he describes it, was a headlong immersion in the ethos of late 1960s modernism.

Though New York was some eighty miles from New Haven, the discussions and debates that raged among the fledgling artists in the graduate school were fraught with awareness of what was going on in the big city. The atmosphere at Yale was as competitive as it was exhilarating, to the point where conversations about current ideas in painting and sculpture often ended up as shouting matches. Students mercilessly critiqued each other's work and ideas, but were also supportive of one another. It was as much a tightly knit community as a creative hothouse. Not surprising, then, that among Close's earliest models in New York were some of his fellow alumni: Richard Serra, Nancy Graves, Kent Floeter, and Janet Fish. As involved as he was in his studio courses, Close more than managed to cope with his academic studies. When he graduated with an MFA degree from Yale in 1964, he did so with highest honors.

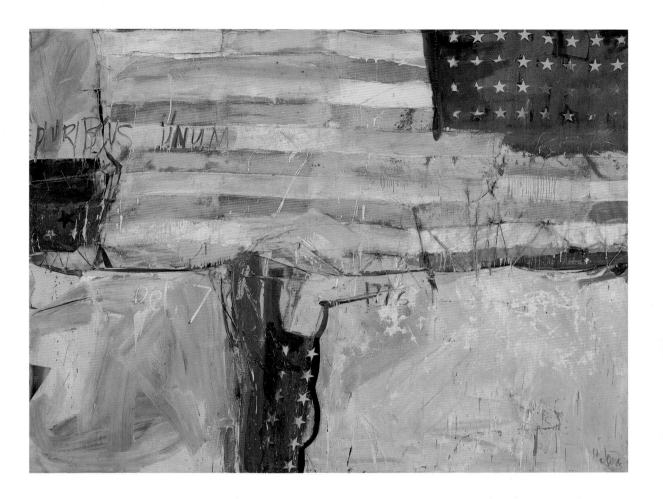

Betsy Ross Revisited, c. 1961. Mixed media on canvas, 86 x 111". Private collection

Close at Yale University School of Art and Architecture, New Haven, Connecticut, 1963

This is probably a good point to raise the question of how Close, who, with such severe learning disabilities since childhood, managed not just to get through but to excel in all his junior college and university courses. Not until he attended a lecture on learning disabilities at his daughter Georgia's elementary school in the early 1980s did he grasp that his own difficulties with reading, memory, and processing information might have to do with dyslexia. "When I was growing up in the northwest," he said, "who knew about such things?" For someone who had to live with the effects of dyslexia, which included an inability to remember many things he had just read and heard, that he did so well scholastically was near miraculous. As is apparent in the ways he goes about making art, whether a painting, drawing, or an editioned multiple composed of fragments of dried paper pulp, he is a problem-solver who devises the requisite processes and techniques. Early on, as he explains, "I developed techniques that enabled me to retain information." In some instances, these involved the use of sensory deprivation, and in others, the use of mnemonics, a method of helping him memorize words and sentences. To prepare for a test, for example, he would sit in a tub of hot water as a means of relaxation, then prop the textbook on a board across the edges of the tub. To heighten his concentration, he would turn off all lights except one focused on the book, then read each line aloud over and over. "The idea," he said, "was to hear it, to have it in my ear, and to retain what I heard long enough to use it the next day."

His other technique, mnemonics, was to come up with a phrase to describe a particular image. For a biology project, he said, "I would look at a slide of plankton under a microscope and, to remember the word 'plankton,' would conjure up a description of what the word looked like in order to spell it out. For example, the first letters of each word in the phrase 'pigs leaping across next' are the first four letters of the word 'plankton.'"

A brief digression and fast forward on the subject of reading, which is important to talk about in Close's case because reading an image (a photograph) is central to his work. He maintains that reading books is still an arduous process for him. "It's very slow, and I have a difficult time with it," he says. Leslie Close has her own views about her husband's reading abilities, and though she agrees that he certainly has difficulties, this has not stopped him. "He reads constantly. He reads everything written about art. He's monomaniacal in that way. I think he overstates his disability. He's going to be very mad at me when he reads this, but his disability certainly hasn't kept him from

reading and retaining every ounce of what he has read." She concedes that he has difficulty remembering faces, but points out that he has never forgotten a painting. "Things in two dimensions are more memorable to him than things in three," and she suggests that he might remember a photograph of a face more than the face itself.

By the time Close got to Yale, he had developed enough reading strategies so that he could cope with assignments in his academic classes—not just cope, but deal with them inventively. For a term paper on the relationship of late-eighteenth-century American furniture to architecture of that era, assigned by his art history professor Jules Prown, he combined images reproduced from photographs with diagrams that he had made as acetate overlays to illuminate stylistic connections between a breakfront and a house of the period. Prown was so impressed with these visual analogies that he kept the paper and later contributed it to the Manuscripts and Archives Department at Yale's Sterling Library. For a project on the history of printmaking, assigned by another eminent art historian, Egbert Havercamp-Begemann, Close had to determine how the seventeenth-century Dutch artist Hercules Seghers made his etchings. Though the works look like aquatints, that medium had not yet been invented. Close took the empirical route in solving the mystery by making a few etchings that emulated not only Seghers's landscape themes but also their visual qualities. Like Seghers's images, they looked like aquatints but were not. He reasoned that Seghers must have used an unconventional process to achieve so agitated a surface, one with so much "tooth." To approximate his subject's faux-aquatint quality, Close says, he flooded an etching plate with acid, allowing it to "froth and bite the metal like crazy" until it was sufficiently pitted to produce the desired texture, when a print was pulled from it. Given how fragile the copper plate was after so arduous a treatment, only a few prints could be made from it. But, as Close was well aware, Seghers, too, had produced only a few images of a given theme. Therefore, he surmised, wasn't it probable that the early graphics master had also tinkered with his copper plates a bit, even at the cost of being able to make only a few images from each? That proposition, supported by the tangible evidence Close had put forth, apparently gained Havercamp-Begemann's favorable attention. And, for his diligent student, the process of going through such an exercise was far more gratifying and useful as a learning experience than a routine immersion in art history.

When I asked Close how he had managed to continue using, at Yale, the special-project approach that had been his modus operandi throughout junior and senior

high school, his response was that he had carefully researched how each class was taught and who taught it, well before signing up for it. As for the reactions of his professors to his novel ways of meeting assignments, he had these words: "If they were real human beings, they would let me do these things." There was little question in their minds about his seriousness and interest in the course work, and many were not only intrigued, but overwhelmed, by the originality of thought behind his idiosyncratic submissions.

Upon graduation from Yale, Close received a Fulbright Grant to study abroad. He enrolled at the Akademie der Bildenden Künste in Vienna ("the same school where Hitler went," he deadpans). He picked Vienna less for its artistic stature, he says, than for its location. According to his Fulbright application, he wanted to go there to pursue his studies of the paintings of Gustav Klimt and Egon Schiele. Bernard Chaet, who administered Yale's summer program at Norfolk and whose recommendation helped get Close into its graduate school, suggested that listing the names of these two illustrious sons of Austria on his application might help his cause with the Fulbright jury. "I had no obsession with either of those artists," Close now avers. "I just wanted to be in a city in central Europe that would be a good base for travel, and that I could easily get back to, so I could pick up my monthly grant payments." Not that there wasn't a great deal about Vienna to engage his interests. Once settled there, he would often visit the Kunsthistorisches Museum, among whose treasures were Dürer's *Virgin and Child with Pear* and Vermeer's *Artist's Studio*. So taken was he with encountering such marvels in the original that, he says, "Very soon, Klimt and Schiele became far less interesting to me than Vermeer." His travels outside Austria were constant, wide-ranging, and full of heady discoveries. "I would walk into museums like the Prado and see paintings by Velázquez and Breughel that I had known only from out-of-focus slides. And when I came across Caravaggio for the first time in Rome, it was as though I had just stumbled in from the darkness. It all just blew my mind."

As his Fulbright year neared an end, it dawned on Close that he would soon need some sort of job back home. As he and Kent Floeter, a companion on some of his travels, were basking on some pleasant beach, they would periodically bestir themselves, he recalls, long enough to ask one another, "Oh my God, what if we get off the boat with no job?" then sink back into the sand. Something had to be done. Because Yale had an excellent record for placing its art school graduates, the logical step was to contact the school. Once more, his guardian angel Chaet was at the

Close leaving New York for Vienna, 1964

ready. It was at his recommendation that in 1965 Close was hired, long-distance and sight unseen, by the University of Massachusetts at Amherst to teach drawing and painting. It was the nearest Close could get to New York, where he really wanted to be. But there were compensations in being at Amherst, he soon found, because it was there that he met his future wife, Leslie Rose, at that time a student in his drawing class. Relatively secure in his new job, he began working in his studio toward an artistic identity that would clearly be his own.

From frequent forays into New York, he had an excellent sense of what was going on among the city's young artists. Several of his Yale friends were already active there, and, if somewhat isolated in Amherst, he was open to many of the new stylistic impulses. All the while, he found himself agonizing about how to reconcile his interests in both figuration and abstraction. At first, he thought the answer lay in de Kooning's example and accordingly was in the master's thrall, but even as he was making energetic use of Abstract Expressionism's "slash and splash language," it was with less and less conviction. For all of abstraction's powerful allure, it was impossible for him to abandon descriptive form. At the time of this soul-searching, he was painting heavily patterned, quasi-figurative pictures (the revenge of the spirit of the abandoned Klimt?) and candidly admits to being in a state of confusion about where all this might be taking him.

Even at this nascent stage of his career, Close sensed that the answer to his dilemma of finding a strongly personal approach to form lay less in forsaking realism than in using it in assertively modernist ways. More and more, he felt that the issue was how to reveal the abstract forms inherent in realism. At this point, he had an epiphany: He would use photography as an intermediary step in making his paintings. He had already begun to use photographic images, his own and those of others, as a way to generate forms that he could paint from. This was only one of several approaches he was pursuing, and what issued forth from his studio then gave little indication of what would subsequently be his signature theme, the megaportrait. As his notorious 1967 solo exhibition at the University of Massachusetts Student Union revealed, he was a driven virtuoso who, unwilling to limit himself to a single subject, style, or technique, industriously pursued multiple thematic and formal approaches. Among the paintings he exhibited were female and male nudes, including one of Bob Dylan based on illustrations appropriated from magazine and record covers, and a three-dimensional rendition of a bathroom with an image of himself

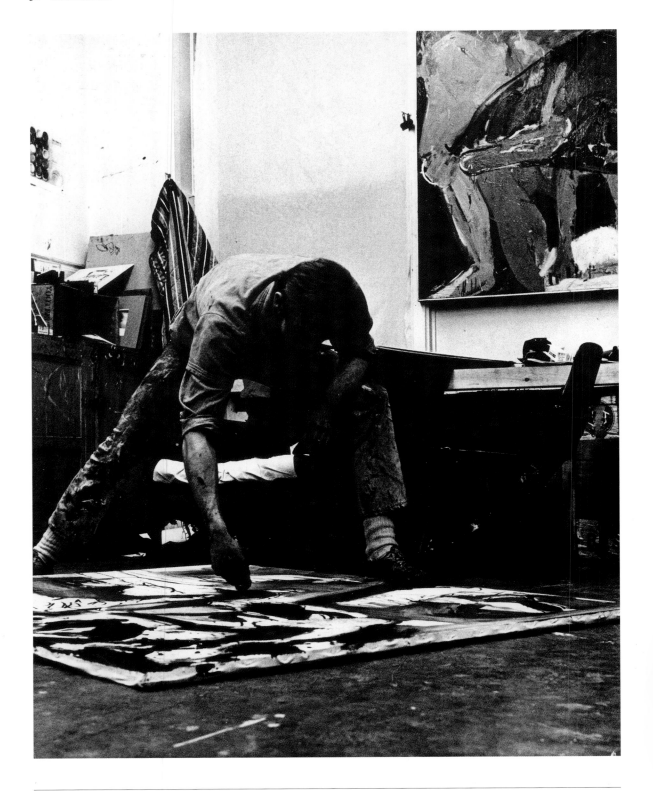

Close in his studio at Yale University, 1963–64

Seated Figure with Arms Raised, 1962. Oil on canvas, 8 x 5". Note: This painting was destroyed.

lurking at the back. One of his objectives in showing these, he claims, half seriously, was to get himself fired. He was right in his prediction of the fallout. So distasteful and provocative did the administration find the exhibition that it was raided at night by campus police who forcibly deinstalled its offending images and, for double measure, closed it to the public. (Shades of the notorious mushroom-cloud flag painting dustup back in Seattle.) It was subsequently shown in a private gallery in Amherst, where it continued to generate controversy, much of it in the form of student and art faculty condemnation of the administration's precipitous action in closing it. A coda to the whole affair was the lawsuit that Close, joined by such stalwarts as the ACLU and the American Association of University Professors, filed against the University of Massachusetts. They won the case, but lost on the appeal.

SoHo Immersion

In 1967, at the conclusion of that eventful academic year, Close and Leslie departed Amherst for New York, Leslie leaving in late spring, Close following after teaching summer school. They married December 24 of that year. Though Abstract Expressionism's fires had long since abated, still very much in the air were Minimalism and Pop, its successors but polar opposites, philosophically and aesthetically. Minimalism, with its primal geometric forms, remained the period's theology of "extreme" abstraction. Banished from its temple were any evidences of the artist's "hand," such subjectivity being regarded as hopelessly anachronistic. Stylistically, Pop was as incorrigibly descriptive as Minimalism was unconditionally abstract. In its latter-day variation on vernacular American realism, ordinary objects and events took on both iconic and ironic significance. But however much younger artists like Close respected Pop, it was too rooted in the ethos of the 1960s for them to add much to it. Aspiring to something of their own, they had no more interest in being second-generation Popsters than in being junior Minimalists. Still, the influences of both movements were impossible to ignore. Asked about Pop's effects on his own imagery in the 1960s, Close observes cryptically, "There are no short answers to that question," but adds that he took what he needed from it. "If you go back to 'proto-Pop,' Johns probably had the most influence on me." What appealed to him about Johns's painting was the apparently objective way its forms were represented: how a subject

was rendered was more important than the subject itself. "He got away from standard ideas about composition by accepting a simple form like a target as a subject. Then he put it in the middle of the page, so that composition wasn't even an issue."

Those early reactions to Johns's paintings foreshadowed qualities that soon characterized Close's own work, such as simple format and, outwardly at least, a sense of implacable neutrality. Indeed, the archetypal Close head, centered in the canvas, its facial expression impassive, can be seen as a figurative variation on the enigmatic Johns target. As to Pop's other effects on him, its rehabilitation of figuration from its long banishment under abstraction was undoubtedly the most important. Under such Pop masters as Claes Oldenburg, who invested everyday objects with peculiarly human attributes, realism had resurfaced, if in highly unlikely incarnations. Oldenburg, Close adds, was important to him as a "someone who made it okay to have a 'good hand.'" He had the kind of facility usually associated with commercial art and illustration, but he used it to create descriptive images of such originality "that he opened the door so wide that other people could walk through, too. He made it safer for the rest of us."

If Pop provided Close's generation with a passport to a new realm of realism, even more compelling were the attractions of Minimalism, with its irreducible geometry. Even though he committed himself to descriptive imagery early in his career, the allure of Minimalist painting and sculpture has never diminished for him. Even today he talks about it as "the old-time religion." While there may be "no overt content there," he avers, "that work is a very emotional thing for me, and I'm absolutely moved by it. Experiencing the harsh quality of a Judd stack piece is like being in church. The empty space of those Jo Baer paintings and the elegant logic of a Sol LeWitt construction are right up there, too. That work functions on a very personal, emotional level for me, but it's not something I could do myself." Very likely not, but the style has left quite an imprint on the way he goes about making his own work. There are allusions to its reductive vocabulary and adamant neutrality in his monoform heads.

Critical as Minimalist purity was in Close's early development, he was also susceptible to other impulses, among them a pair of currents related in some ways, but stark opposites in another: Conceptual art, an antiexpressionistic, rather intellectualized attitude toward form-building, and Process art, an approach in which the actual process of making an object determined its ultimate form. Aspects of both

currents are perceptible in the ways that Close began translating data gleaned from a photograph and realized on canvas. The Conceptualists held that form could be generated by means of impersonal systems, as opposed to reliance on fugitive emotion. There is an echo of that spirit in Close's early efforts to insulate his work from the slightest contamination of expressionistic excess. In fact, the series of steps he devised for himself in making a painting would have gladdened the heart of even the most hard-shelled Conceptualist. The first was to limit the potentially contaminating presence of the model by photographing him or her during a session that, at most, might run only a few hours. The next was to enlist the model's cooperation by having him or her assume as neutral an expression as possible before the camera, then leave—but, of course, amid profuse thanks. Not for Close the endless hours of communing with a live body in his studio. Far better instead to have a surrogate on hand—one in the form of a photograph—that he could work from at his own pace and convenience. The last step, dutifully following his system, was to selectively extract the information from the photograph and, by means of a horizontal-vertical line grid, translate it to the canvas, square by square.

The effects of Process art, with its emphasis on evidence of the artist's journey, are still to be found in a Close portrait. In fact, even more so these days, when his brushing is so open, free, and individualistic. We sense it in the brush marks that fill the grid squares. Each is different from the ones adjacent to it. As his longtime friend the composer Philip Glass so perceptively put it when we talked about their respective approaches to creating form during those beginning years, he and Close were early believers in the power of process. "The process of making a work," Glass said, "became its focus," and when that happened, "the process allowed for the form and content to become one."

Though Close describes himself as a child of the 1960s, his art is very much in the spirit of the next decade. "What made the seventies so interesting," he remarks, "is how undefined and uncertain they were. People didn't much like that decade because it was a time of flux. They loved the sixties, when what was going on was very clear. Then, you knew what was 'high art,' and what wasn't. The sixties were a real crucible for change, and anyone who lived through them knows what those influences were. There were the antiwar movement and the assassinations of the Kennedys and Martin Luther King. In art, the recent past and the work of our previous heroes were all up for reassessment. But the seventies were almost like the

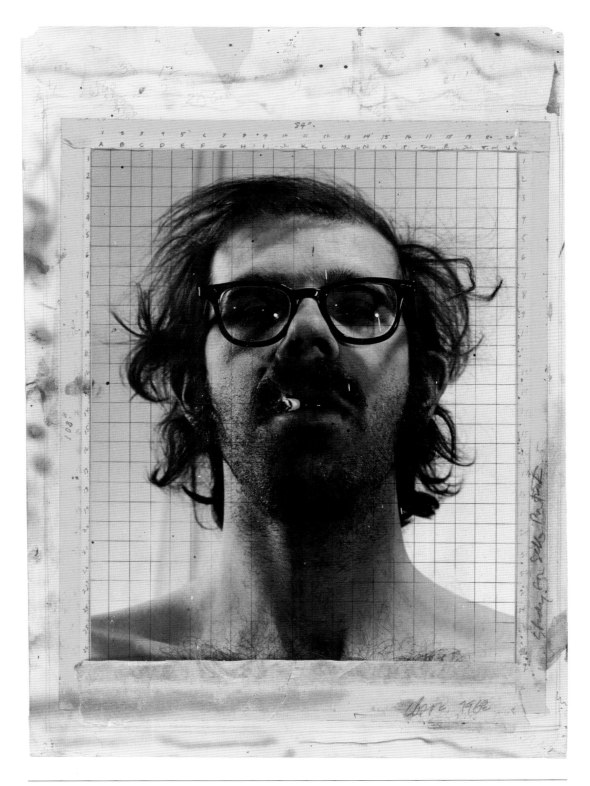

Study for *Self-Portrait*, 1968. Photograph, pen and ink, pencil, masking tape, acrylic, wash, and blue plastic strips on cardboard, 18 ⅝ x 13 ⅜". Collection of The Museum of Modern Art, New York; gift of Norman Dubrow

nineties, a confusing, pluralistic era in which nothing predominated. It drove crit-
ics, collectors, and curators crazy that there was no focus—but it was a great time to
be an artist because you could pursue whatever you wanted to pursue without its
being dictated by the art world."

What Close had chosen to pursue, then—painting photographically descriptive
renditions of giant heads—was so far off the modernist path that some critics and
even some fellow artists considered him misguided and calculatedly revisionist. As
far as he was concerned, though, he was doing exactly what he had to do. Painting
giant heads from photographic data was his way of dealing with the supposedly
irreconcilable polarities of description and abstraction within a single work. By
"neutralizing" perceived reality, by insisting that his sitters assume expressions of
nonexpression, as it were, he sought to bypass the pitfalls of depicting a transitory
reality by opting for a more generalized one. The idea was that the forms inherent
within that deliberately stilled version could be treated dispassionately in his quest
for the abstract truths that presumably underlay them. That may have been his
intention, but, fortunately for his art, such armored neutrality was not easy to
achieve. Much of his painting's force, even then, is attributable to the tensions
between that desire for absolute objectivity and the expressive impulses, not so eas-
ily controlled, that find their way into his work and energize it.

In his new job at New York's School of Visual Arts, Close taught courses in draw-
ing, painting, and design to photography students. Leslie, pursuing her own artistic
interests, took sculpture classes at Hunter College. Even though Close's teaching
income was marginal, he was now able to devote himself to painting. Soon, his mon-
umental heads of family members and artist friends caught the eye of the prescient
young art dealer Klaus Kertess, who had in 1966 established the Bykert Gallery,
where he showed works by a number of exceptionally innovative, primarily abstract
artists of Close's generation, among them Brice Marden, Dorothea Rockburne, and
David Novros. When Kertess first saw Close's paintings in his studio, he describes
himself as having been "stunned by the work." He sat in front of the paintings for a
long time, not knowing what to make of them. On one level, they looked like vastly
enlarged passport photos, but on another, more somberly, they could have been
"giant death heads." In fact, the more he looked at these unflinchingly factual rendi-
tions, the more Kertess wondered if Close might be haunted by thoughts about "the
mortality of the flesh." But he found them compelling enough to invite Close to join

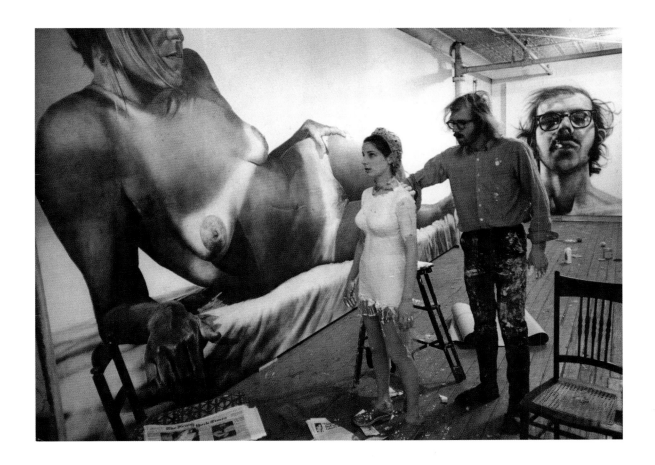

Plaster of Leslie made by Close in his studio, 1968

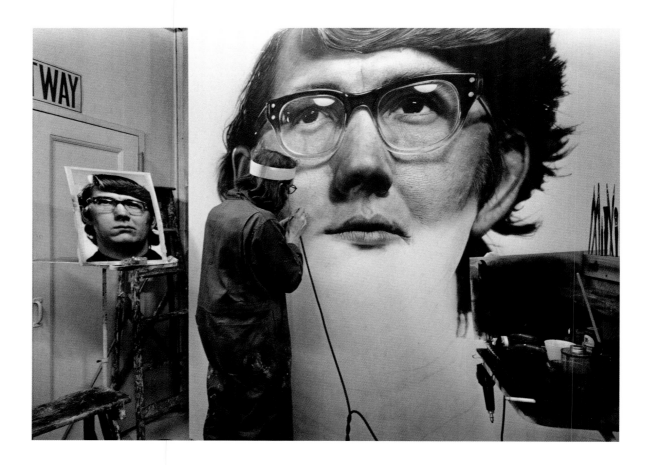

Close in his studio, New York, 1970

the gallery and in 1969 included him in a group show there, whose other participants were the sculptors Lynda Benglis, David Paul, and Richard Van Buren.

Close's first solo exhibition at Bykert the following year included paintings of Nancy Graves, Joe Zucker, and Robert Israel, as well as a twelve-minute, 16-millimeter color film made for the show with the assistance of the filmmaker Richard Landry. Titled *Slow Pan for Bob*, it was a minutely detailed exploration of Israel's impassive face, beginning at the top of his head and slowly, in twenty passes from one side to the other, systematically recording it in its entirety. The film was shot in Close's studio and carefully planned and calibrated in his typically systematic fashion. Israel's face was framed behind a large, matlike open rectangle whose proportions approximated those of a grid-covered canvas. The camera covered exactly the same left to right distance each time.

As I looked at a videocassette of the film recently, I was struck by how the camera's line-by-line movement was analogous to the reading process. I found myself thinking about Close's strenuous efforts as a young man to deal with his dyslexia by concentrating intently on reading one line at a time. Like reading, *Slow Pan for Bob* was a cumulative process of gathering information—in this instance, one with some startling results. At times, as the film progressed, it was impossible to identify which part of Israel's face was in view. Vastly enlarged strands of his dark hair resembled coils of wire. Minute bristles on his beardless countenance looked like tree stumps in a desiccated forest. His pores in this facial landscape were oddly shaped craters. In its unrelenting clinical examination of its subject, the project had an unsettling dermatological aspect. There was also a detached, all-accepting Warholian quality about it, a passive acceptance of what the camera revealed. Parts of the facial fragments were in sharp focus, while others were hazy and unidentifiable. All these qualities, including the revelation of complex abstraction within the surface of reality and the juxtaposition of sharp-edged and blurred shapes would, of course, continue to fascinate Close and be at the heart of his singular approach to painting and photography. In many ways, the film was an early statement of belief, a credo to which he has adhered with remarkable fidelity.

Close was happy to show with Bykert, given its focus on new stylistic currents and commitment to artists who worked primarily in abstract modes. He felt more comfortable in that setting than he would have in a gallery devoted to entirely realistic work. In fact, being automatically linked by critics and curators with other painters

who were using photography for their images had by then become a sore point for him. Close felt no philosophical connection to the emerging mode of Photo-Realism, from which he sought to distance himself. In the early 1970s, much to his dismay, his hyper-realistic heads were often critically grouped with the urban vista paintings of Ralph Goings, Richard Estes, and other exemplars of Photo-Realist style, with which they had only photography-inspired sources and techniques in common. Right from the beginning, by concentrating on a single subject, the human head, Close had pursued another course. In their cool embrace of everyday reality, the Photo-Realists were the sober-minded offspring of Pop. But unlike their putative begetters, for whom reality was merely a point of departure and whose forms were there to be manipulated at will, they accepted and faithfully reproduced in paint all that their cameras saw. They found inspiration in familiar urban surroundings and recorded what they saw with unblinking fidelity. Near-surreal renditions of city streets, deserted except for rows of parked cars whose chromium grilles and windows reflected bright sunlight, were characteristic themes. Though a figure or two might appear in the distance of one these vistas, these paintings were less about human presence than meditations on urban emptiness.

It was at this nascent stage in his career that a few critics, prominent among them Cindy Nemser, perceived something more than another aspect of the Photo-Realist ethos in Close's painting. One of the first writers to make Close's works known to a wider public, Nemser was also the first to refer to him in print as "Chuck Close." How that came about is a minisaga. Though he had been "Chuck" to all his friends since high school, for his professional name he had reverted to the more formal "Charles" soon after moving to New York. Then, quite by accident, he explains, "Chuck" came back into the picture. "I had just done an interview with Cindy for *Artforum* that was still untitled when she turned in her manuscript. It just had 'CC' on it for me, and 'CN' for her. I had hired one of my students to take photographs of the paintings and, as soon as the prints had dried, to put them in an envelope and take them over to *Artforum*, because there was very little time to get them into the issue. Because he knew me as 'Chuck,' as all my friends did by then, he wrote on the outside of the envelope, 'For the interview with Chuck Close.' It was published in the January 1970 issue as 'An Interview with Chuck Close.'"

Anxious as he was to avoid being grouped with the Photo-Realists, Close was and continues to be as dependent on photography for his painting as any of those artists

have been. The relationship of photography to painting, always a complex issue in his work, is even more so these days, now that he is making daguerreotype images of many of his sitters. "A photograph is finished from the start," he rationalizes, while "a painting is unfinished until it's done, because its vocabulary happens as a result of work that is done over time." Since he began his giant heads in the late 1960s, the photograph has been a means to an end for him, the starting point from which the painting would proceed. Because painting directly from the model was never an option, there was no way that he could even begin a painting without such a photograph at hand. Now, a theory (admittedly, an oblique one) about Close's preference for the photographic image might be considered—that it concerns his oft-expressed chagrin at frequently being unable to remember the face of a particular person, especially if he has not seen him or her recently. His inability to retain three-dimensional images, it has been suggested, could be an extension of his earlier problems with dyslexia. If this were so, one way to indelibly "fix" a face that he wanted to paint would be to have it before him in two-dimensional form. To pursue this Psychology 101 speculation a bit further, the next step would be to transmute that version of it into a painting, not a standard life-size rendition of the subject's face but an unforgettable, monumental one.

While numerous painters since the late nineteenth century, Degas and Manet among them, had used photography as a research tool, many of their generation and successive ones looked upon it as painting's insidious enemy. Such suspicion persisted well into the late twentieth century, especially among artists deeply committed to abstraction, for whom painting and photography remained irreconcilable. No wonder then that Close's emergence as a painter who so openly embraced photographic means, especially during the abstraction-dominated late 1960s, was perceived by some as an irritating anomaly. Who was this brash character, so self-convinced, so out of touch with everything else going on, and so challenging of purist orthodoxy? As an artist whose sensibilities had been largely shaped by Minimalist form, he understood early in the game that employing such blatantly descriptive means would be seen as anachronistic, if not a touch perverse.

Today, Close blithely rationalizes that in using photography as a springboard for his work, he does no less than acknowledge its seminal role in the march of modernism. While its arrival and popularity undoubtedly hastened the demise of academic painting, he goes on expansively, not all was doom and gloom, because artists

were freer to pursue new directions. Its advent, he instructively points out, in a well-rehearsed account of photography's effects on painting, was a Trojan horse phenomenon. "At first, it was embraced by artists, but then it began to eat into their livelihoods—especially the portrait painters. It could do the job faster than they could and was soon seen by them as undermining." But, he adds, the bright side was that it ultimately forced painters to explore entirely new possibilities. "If you think about it much, painting suddenly became everything that photography couldn't be. Photographs were in black and white, so paintings became more about color. Photographs were about static images, so the painters' reaction was to portray movement—flickering Impressionist stuff and later Futurism—ideas that photography couldn't deal with then."

In a one-man reprise of this multidecade evolutionary process, Close has not just allowed, but relied on, photography to take his painting into drastic new directions. There is nothing new about that kind of reliance, he notes, since only a generation earlier, the Pop artists had already made photographs integral to their work. "They began looking at them as something to use, rather than as a threat. Whether it was Rauschenberg taking images out of a newspaper or Warhol photo-silk-screening them, photography was once again a fertile source of images. It began to creep back into painting as something to work from." For these artists, he continues, the photograph was a point of departure for invention. "It was one step removed from what the object had been originally." That step, though, represented a new kind of reality: the way that an object was reproduced on canvas became as significant as the object itself. Warhol's memorable images of Jackie Kennedy as she appeared immediately before and after the assassination of her husband evoked the indelible newspaper and television images they derived from. Rauschenberg combined within a single painting iconic images casually lifted from art books, periodicals, and newspapers: in one such example, the 1961 canvas *Trace*, he juxtaposed a silk-screened reproduction of a seventeenth-century Rubens nude with forms evocative of NASA's latest outer-space wonders. "There was a distancing in this kind of work, an arm's-length way of keeping yourself from being totally involved emotionally in whatever you were drawing."

Even as Close was settling into his Greene Street space, some unresolved aspects of the Amherst experience began surfacing in unanticipated ways. Along with the arduously arrived-at idea of using photographic imagery as a starting point for painting, he added another dimension, so to speak: size. Even the most descriptive forms, he

reasoned, when greatly magnified and seen from up close, will lose their associative qualities and function as indeterminate abstract forms. It was at this stage in his rationalizing process that a seed, planted in Amherst, had an unanticipated flowering in New York. He had inveigled a young woman who worked in the dean's office there to pose nude for some photographs, all in the interest of art. What resulted from that session was not a group of studies of the unclad model but a series of topographical views of her body, each successive shot made from the same distance but a few feet to the side of the previous one. It was as though the camera had been mounted on a track parallel to her reclining form. Close's next move was to combine the contiguous components into a whole: a collaged photographic image of his accommodating muse. Once that was accomplished, his next concern was how to translate that visual information into a painting. His first idea was to select certain parts of the nude and make a group of shaped-canvas paintings, with each body part represented in actual flesh tones. The plan was to install these eccentrically contoured figurative components on a large field, possibly a wall, much in the way surviving fragments of a damaged fresco or a relief sculpture might be shown. After painting a few of these oddly contoured canvases, however, Close abandoned this approach, a basic reason being, he says, that the Amherst nude photograph was in black and white, not color. Another probable reason was that he wanted to deal with his grande odalisque subject not in fragmentary fashion but as a whole.

That's what happened a few months after the Closes's move to New York in 1967, when he decided to make some large paintings based on the composite photograph. He had not quite given up on using color, but this time, he says, he was thinking about rendering his subjects in monochrome, not flesh tones. "It was going to be all blues or purples, or blues and greens, or something like that, but then I very quickly realized that wasn't going to work, so I removed everything from the canvas and painted it in black and white." Working in this epic scale—the painting is nearly ten feet high and just over twenty-one feet long—he scrupulously transferred the details of the collaged photographs to canvas, employing an arsenal of techniques that included airbrushing, rubbing some areas with cloth, and scraping others with a razor blade, to achieve the desired tones and textures. He had taught himself the rudiments of airbrush technique while at Amherst, but to learn more about it, he signed up for a class at the School of Visual Arts. Shortly after walking into the first session though, he concluded that what was being taught there was less basic methodology than something like

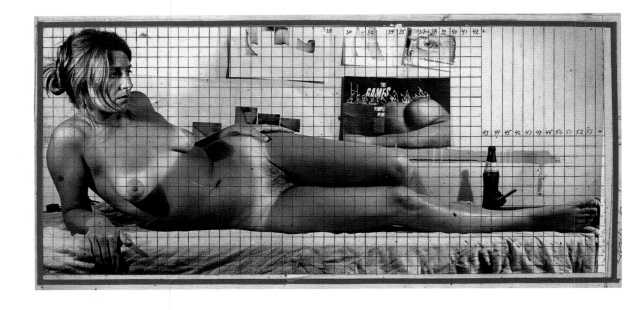

Maquette for the *Big Nude*, 1964. Photograph scored with ink, masking tape, and red tape mounted on cardboard, 6½ x 14″

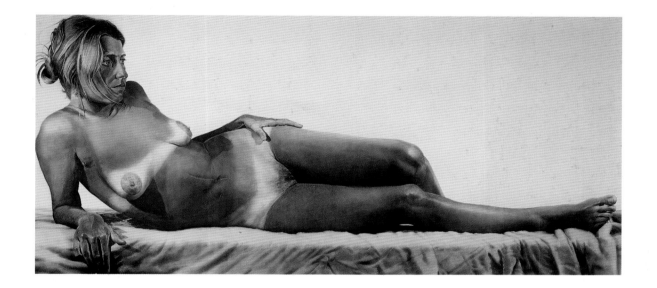

Big Nude, 1967. Oil on canvas, 117 x 253". Collection of Jon and Mary Shirley

"homage to the airbrush." He wanted nothing to do with those slick commercial tech-niques, he says, "any more than I wanted my paintings to be an homage to the bristle brush, so I got out of there and learned it on my own. I used the simplest, most prim-itive, least sophisticated machines I could find, because I hate complicated technology, where things can always go wrong."

Because Close's loft was so narrow, he found it difficult to step back far enough to judge the progress of his giant reclining lady. (In fact, in photographing the fin-ished painting, he found himself in a situation not unlike that he encountered at Amherst while photographing his model. He was obliged to make successive shots from several vantage points in order to arrive at a continuous image.) Working on such an immense canvas at such close range must have been a disorienting, if not dizzying, experience, as even the most recognizable forms can at times dissolve into a sea of amorphous ones. From near distance, the *Big Nude* is a figurescape of curv-ing, swelling forms rendered in various degrees of gray, the lightest being the untanned skin areas demarcated by the model's absent bikini. But back away slowly, and everything coheres into an unremittingly realistic image of a slightly bored naked woman. This billboard-scale grisaille is no idealized vision of the female body, and if her recumbent pose alludes to those of Titian's or Velázquez's god-desses, it is about all she has in common with them. Close perceives his working-class Venus empathetically, "as a real person whose body, with its scars and stretch marks, shows all the wear and tear of life." Even though the *Big Nude* is a one-of-a-kind painting in his production, it presaged the unflinching realism that would characterize the steady progression of large portraits that soon followed.

The Chosen Ones: Close's Models

It is an art world truism that being painted by Chuck Close is a kind of anointment. He chooses his artist subjects as much for his regard for their work as for their appear-ances. Not only established figures such as Johns and Rauschenberg but young artists new to the scene are often asked by him to sit for Polaroid photographs that might lead to a painting. As to how he selects his subjects, he says, "I try to pick people who matter to me but who also project compelling images." Though at an early stage of his career, he had thoughts about focusing on "anonymous subjects, like 'everyman' or

'everywoman,'" he gave up that idea quickly, "because I soon found I didn't like to paint anyone who was truly unknown to me." Even for those Close invites to sit for a photograph, there can be disappointment. The attrition rate can be high. No matter how well the Polaroid studio session might have gone, some of the results will end up, figuratively, on the cutting room floor. Though he always makes the ground rules clear to his models—if he doesn't find what he needs in the photograph for painting, then that's the end of it—he admits, "That can be a problem for the people I didn't choose to paint, especially, if they assume there is an unwritten contract that a painting would follow." There have been times when he has photographed someone he particularly wanted to paint but found the results unusable, "because I never got an image I wanted to work with." And then, there have been paintings begun but ultimately abandoned, "because things didn't work out as they should have."

Close was mildly taken aback when I observed that most of the artists who have sat for him have been associated with descriptive modes. True, he has painted such stalwarts of abstraction as Serra, Rockburne, and John Chamberlain, but for the most part, he seems to have gravitated to artists identified with figuration. Responding to my comment, he conceded this may have been the case, but it was by no means intentional. When I asked if their use of descriptive subject matter was a factor he could more easily relate to, it was clear that I had crossed the line. Not at all, was his adamant reply, tempered with the caveat, "but I am interested in people who build images, and there's no getting around that." Then, in a regretful aside, he added that there were a few abstract-artist friends, like LeWitt and Marden, who have declined to be painted by him. "I respect that. I wish they felt otherwise, but that's okay. But if Sol and Brice were in there with the others that might tip the balance toward abstract artists a little bit."

Those who sit for him soon realize that, unlike posing for a traditional portrait painting, which can entail many sessions over lengthy periods of time, posing for Close involves little, if any, sustained communion between artist and model about the portrait. Once his sitters have completed their tasks, he thanks them profusely and bids them farewell. Ungracious as it may sound, he says, apologetically, "The last thing I want or need is to have a model hanging around in my studio for a few months while I paint his or her portrait." Fair enough, but having made a number of shots of the model in a few hours at the most, how does he decide which one to use, or even if he will use one? His models, between takes, are also witnesses to

what's transpiring, and some, he says, subtly lobby for one photograph over another. His answer is, "Certain images have more urgency for me. They demand to be painted," and not just because of his regard for the subject. "I also look for things in the photographs, like interesting edges and complicated shapes." In painting any face, he adds, "I just want to present it very neutrally and very thoughtfully. I don't try to orchestrate a particular experience or crank it up for high-impact emotional effect." As a precedent for this objectivity, Close cites the photographs made by the German master August Sander (1876–1964), who chose his models from every walk of life. Artists, musicians, athletes, aviators, bricklayers, prison wardens, industrialists, blacksmiths, chimney sweeps, and scientists all looked unsmilingly into his lens. As Close observes, approvingly, "They are some of the most compelling pictures of ordinary people that have ever been made. There was no attempt to make them look happy or sad about what they did for a living, or to make them look noble or humble."

Unlike other artists who work out their thematic and compositional ideas in drawings, Close confines himself to photo-maquette studies of his sitters. "I have never kept notebooks or sketchbooks," he says, "and there are no diaries, letters, or journals," dryly adding, "I always felt that if I were a real artist, I should be doing that." Whatever drawing he does these days is in the service of the photographic image, whether as pencil-and-ink variations on it or crosshatched incising on an etching plate. He has an uncanny ability not only to capture—"possess" might be more accurate—a subject's countenance, especially his own, and recycle it with fresh intensity, but also to present it in varying emotional contexts. As evidenced by his inked fingerprint drawings on toned paper, he internalizes the original photographic image to such an extent that it becomes an eidetic symbol he can repeat at will in apparently endless variations, techniques, and materials. Once a sitter's face enters his consciousness, it remains there, indelibly. So completely does Close own it, he could very likely summon it forth, like Banquo's ghost, in whatever material he desires—and not merely in paint or other conventional mediums. One could easily imagine his making one of those deeply internalized faces from a scattering of breadcrumbs or a few handfuls of gravel. Close is well aware of his considerable facility, and by relying on systems of grids, he sets up situations whereby he can work against it. Long before his illness, he had imposed limits on himself that were inherent in his methodology of working with increments to make a whole.

Afterward, strong physical limits were suddenly imposed upon him, even as he sought to continue working in the same manner. As Leslie Close drily observes, "It's like a sick joke when he talks about working against his facility and trying to impose limitations on himself. He had to learn to work from the shoulders and to hold the brush in two hands." He does not always need a strapped-on device to make a mark on a surface. During some of our discussions, he would grasp a pencil or ballpoint pen in both hands as he looked over some text I had written in order to check a quote or description of a photographic or printing process. Sometimes, his reaction would be to make a simple check mark; more often, though, it would be a word or phrase written in large-letter script. He writes with the same control that he has in painting—from the combination of arm and shoulder rather than the wrist.

Although a conservative compositionally, restricting himself to the monohead template, Close has always been technically adventurous, both in mastering new processes and in dramatically expanding the limits of traditional ones. His paper-pulp portraits and inked fingerprint drawings of the early 1980s exemplify his interest in unconventional media and methods. Some twenty years later, he began a romance with the near-forgotten medium of daguerreotype, picking up where its nineteenth-century practitioners had left off and pushing it in new, expressive directions. Yet, as intrigued as he has always been with exploring the limits of a methodology, Close generally prefers working in more conventional media. He has painted in oils, acrylic, and watercolor, made drawings in ink, colored pencil, and pastel, and is much celebrated, appropriately, as a virtuoso of traditional print-studio techniques ranging from woodcuts and linoleum cuts to etching, aquatint, and silk screen.

Photographs into Paintings

While Close continued making photo-maquettes after the initial one for the *Big Self-Portrait,* he was less interested in the technicalities of taking photographs than in painting from them. He turned increasingly to professional photographers, who worked under his direction. One was Bevan Davies, now a book dealer in SoHo, who collaborated with him in making black-and-white and color photographs for several years, beginning in 1970. The models photographed during one memorable marathon half-day session that year in Davies's studio included Leslie Close, the

writer Linda Rosenkrantz, and the sculptor Jud Nelson. Davies used a 4-by-5 Calumet camera with a Polaroid back for the black-and-white shots of one group of sitters; for color photographs of a second group that day, he used an 8-by-10 Synar camera. For each of the photographs, says Davies, "Chuck wanted each person to look a certain way—expressionless. He was fussy about this and spent a lot of time getting each of them to hold this calculatedly nondramatic pose. No smiles, but he wanted some of them to have their mouths slightly open. It was like photographing sculpture." He also wanted a limited depth of field for these carefully directed shots, but one deep enough to accommodate the model's features without blurring or distorting them. Once Davies and Close had set the lighting and positioned the camera, the rest was nearly automatic, as one sitter quickly succeeded another in the model's chair. Davies made a quick Polaroid test shot to check the pose and lighting of each setup and, once Close approved the results, proceeded with the final shot.

The color transparencies made by Davies during this and subsequent sessions led to a sequence of technically amazing Close portraits in acrylic on canvas. Stylistically, these were an extension of the black-and-white works that began in 1968 with his *Big Self-Portrait*, but there were substantial differences. Their highly descriptive color, which echoed the subjects' skin tones, allowed for an even more immediate realism. Another reason for their strong presence was the exceptionally arduous process Close had devised to make them. Instead of mixing his pigments on the palette, he achieved the precise coloration he desired by other, far less conventional means. In effect, he turned himself into a human printing press by paralleling the technology of photomechanical reproduction. He literally deconstructed the color photograph for each painting into its primary color components, with the result that each was composed of transparent layers of red, blue, and yellow that he successively applied by airbrush to an eggshell-smooth, gesso-covered canvas. In effect, each portrait was actually three separate ones, superimposed. Painted in large scale, some as tall as nine feet, they are astonishing in their photographic verisimilitude—almost clinically so—with every nuance of skin tone faithfully represented. This especially obsessive phase in Close's career would continue for almost a decade. One of the first of these intensely factual, superscale representations was a 1971 portrait of Kent Floeter. The culminating work in the series, the 1978–1979 *Mark*, was an arresting portrait of the painter Mark Greenwold, a friend of Close's since 1969.

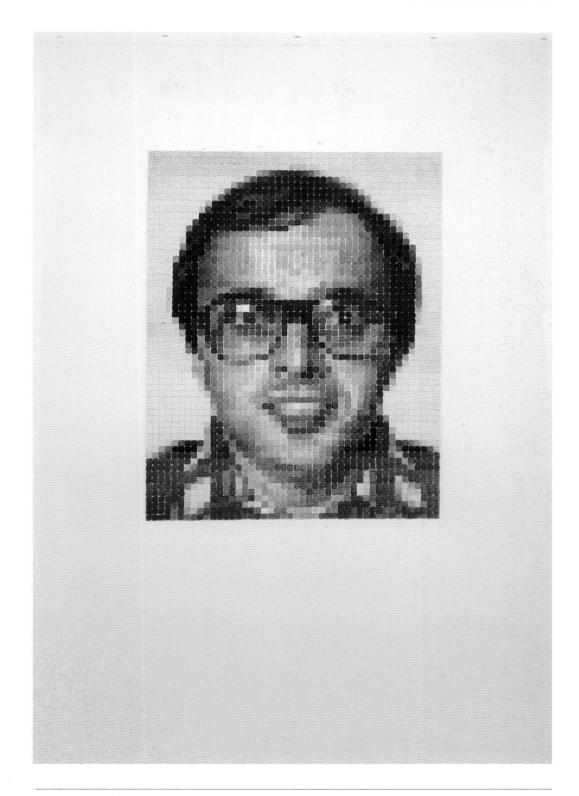

Mark Watercolor / Unfinished, 1978. Watercolor on paper, 53 ½ x 40 ½". Collection of Frances Lewis

Mark, 1979. Acrylic on canvas, 108 x 84". Private collection

Greenwold's face was also the subject of many Close works on paper, including an ink study, a couple of pastel drawings (one almost four-and-a-half feet high), a watercolor, and an ink-on-paper fingerprint drawing in magenta tones. Of these, the most intriguing for its clear explication of Close's working method, is the aptly titled *Mark Watercolor/Unfinished* (1978). It was painted in a technique that foreshadowed the artist's use of transparent overlays in the acrylic-on-canvas portraits that followed. In effect, this tripartite work graphically reveals Close's means of building a painting in successive layers of color. The first layer, grid squares in varying intensities and values of red-violet, filled the rectangle that would contain Greenwold's face. Roughly discernible within a narrow band of squares at the bottom were the subject's neck and part of his plaid shirt. Close then shifted his attention to the section above, adding blue washes of varying shades upward to the top of the rectangle. These cool-over-warm washes have an eerily phosphorescent effect in relation to actual flesh tones. Once Close painted yellow washes over the underlying red-violet and blue ones, everything came together. Those last washes did their job perfectly. The area they covered, from eyeglasses upward, was now rendered in tonalities that matched those of Greenwold's own ruddy skin.

In contrast to the didactic approach Close took in this watercolor, the tall acrylic painting *Mark*, does not readily reveal the arcane, labor-intensive process of its making. Without being in on the secret, it's hard for a viewer to grasp how Close achieved its nearly unnerving quality of reality. As with other portraits in this series, the painting is considerably more than an exact representation of photographic reality. Rather, it is a direct confrontation with it. It was as if Close had determined not to accept the reality registered on film during the photo sessions and, instead, decided to more than match it in his own analytical, if idiosyncratic way.

This painting was begun in 1978 and completed eight months later. The youthful, good-humored face belies its subject's age, then thirty-six. Greenwold's wide-eyed countenance, notwithstanding his hip, late 1970s aviator glasses, is innocent-looking and trusting, with none of the art-world cool that characterizes the faces of many other Close subjects. "Chuck joked that I looked like Reddy Kilowatt in it," he says, alluding to the round-faced cartoon figure that for so long served as a power company icon. For all the spontaneity the painting projects, its realization was anything but improvisational. Photographs of Close at work on it during various stages of the color-layering process make clear just how complex it was.

The second *Mark*, an oil painting dated 1997, is the polar opposite of the first, not just stylistically but emotionally. Its model, so amiable and upbeat-looking in the first painting, looks anxious, even a shade melancholic in this grisaille, derived from a photograph Close had cropped so severely that only part of the face would be visible when its information was transferred to canvas. Its extreme close-up format was similar to that Close had employed in a 1997 *Self-Portrait* and in a painting he made of Rauschenberg that same year. Through round-framed glasses, Greenwold regards the observer with uncertainty. His mouth is slightly open, his expression almost poignant. By his own admission, he looks "vulnerable." In fact, he likens the painting's emotionalism to that which he perceives in Close's recent self-portraits. As examples, he talks about four black-and-white paintings from the early to mid-1990s, which he characterizes as "heartbreaking" in their openness. And, Greenwold asks, despite his good friend's protestations to the contrary, why wouldn't they be so open? "He's a very emotional man, after all. He laughs a lot and he cries a lot. He may be working in a Minimalist's mode, but he has larger-than-life feelings, so why wouldn't those feelings be part of his work?"

Even though Close's self-portraits are virtually an overview of every style and technique he has employed at one time or another, for whatever reason, he has never used his three-color overlay technique in a painting of himself. Possibly, he felt he had already achieved an equal degree of exactitude in representing himself, without the benefit or distraction of color, in his 1976–77 *Self-Portrait*—not an acrylic painting but an authoritative black-and-white watercolor mounted on canvas.

Close's knowledge of photographic processes was considerably enhanced when, in 1979, along with fellow artists Jim Dine and Joel Janowitz, he was invited by the Hayden Gallery at the Massachusetts Institute of Technology to participate in a project called "Focusing on Faces," held at the gallery. The objective was to have various artists explore the potential of Polaroid's large-scale "20 x 24"-inch view camera, named for the size of the print it produces. This was not Close's first experience with Polaroid's equipment: he had already used its cameras at the company's Cambridge headquarters to make photographs that ranged from self-portraits to still lifes. The 20 x 24 camera is a considerably updated version of the ground-glass view cameras used by nineteenth-century photographers. Like those predecessors, it is a wooden box, but an exceptionally large one equipped with sophisticated innards. One of five such instruments made for Polaroid in 1976—all still in use—it sits on steel legs

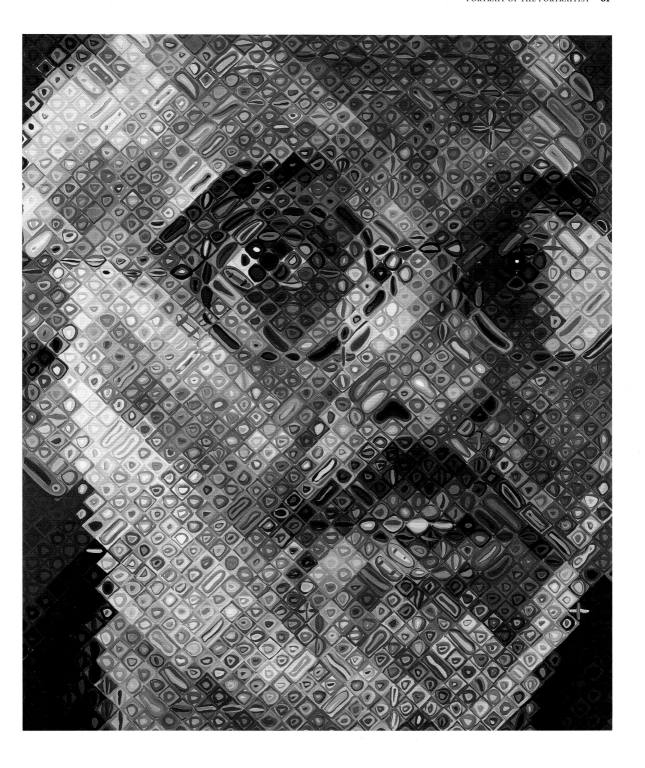

Mark, 1997. Oil on canvas, 102 x 84". Collection of Irma and Norman Braman

attached to a dolly, so that it can be moved forward and backward easily. Sporting a hand-operated dark red bellows, its relatively shallow box has a back door that opens to reveal a glass viewing-plate. To make a photograph, the door is closed and a fast, window-blindlike action occurs as the operator pulls the cord at the bottom of the box, simultaneously popping open a chemical-filled pod as he pulls the stuck-together negative and printing paper through metal rollers, and then through the long slot at the bottom of the box. Carried to a nearby table, the print is peeled away from the negative, and presto—there's the image. Like other view cameras, the 20 x 24 at the Hayden Gallery incorporated a ground glass for focusing on and composing the desired image, but it differed from them in an especially important way: it could produce a color print within sixty seconds. Once the print was pinned up on a wall, whatever adjustments in the model's pose and the lighting were required could quickly be made, Close recalls approvingly. The sessions at the gallery were conducted open-workshop style; visitors, primarily students and faculty, could follow the progress of each artist's work by looking over the pinned-up daily results.

A year later, Close would work with an even larger-format Polaroid camera known as the "40 x 80" housed in a converted gallery space in Boston's Museum of Fine Arts. That space, described by John Reuter, the Polaroid technician with whom Close has worked since 1982 on a number of large photographs, was roughly thirty by forty feet and contained a light-sealed enclosure, a twelve-foot-high, fifteen-by-twenty-foot box that housed the camera's mechanism. This instrument, as used in the museum, was basically an updated, high-tech version of the camera obscura, the not-so-secret weapon of many a Renaissance painter intent on translating reality as faithfully as possible to canvas or paper. That venerable prototype was, in essence, a darkened room with a small hole in one of its walls through which light rays created an inverted image of a figure, still life, or landscape on the opposite wall. With the aid of strategically fitted lenses and mirrors, these borrowed views could be directed downward to a canvas or sheet of paper placed on a flat surface, where the artist could then trace their outlines. The museum, in an arrangement with Polaroid, used this device for roughly ten years to make one-to-one or near-full-scale reproductions of popular paintings in its collection for sale to the public.

The Boston camera has since been acquired by a private photography studio in lower Manhattan, not far from Close's downtown studio, where he occasionally uses it to make portraits, figure studies, and still-life images. A circular opening in one

side of its large, room-like enclosure accommodates lenses of various focal lengths for shots ranging from close-ups to wide-angle views. What happens within the parallels is what occurs in the Polaroid 20 x 24 camera. When the button is pushed, light through the lens (the image being photographed) strikes the negative during a split-second exposure. The negative, pressed through sheets of positive printing paper, is pulled through sets of rollers in the enclosure. Sandwiched between the negative and paper are pods of chemicals that, during the brief development period, transfer the image to the positive paper. As with the smaller camera process, the negative is then peeled away to reveal the photographed image.

Given his past experience with Polaroid equipment, Close was particularly eager to use the 40 x 80 at the Museum of Fine Arts and campaigned energetically to have access to this impressive instrument. He thinks he may have been the first artist to have been granted that access. In 1984 he used it to make a number of photographs of male and female nudes, including dancers recruited for the job. Some of these were composed of two or three adjacent vertical prints. Others, horizontal in format, were large-scale images of reclining figures composed of five vertical contiguous prints, each portraying a different sector of the body. The camera was in a fixed position. The models reclined on a rolling aluminum painter's scaffold, which was moved the appropriate distance alongside them for each shot. Though, compositionally, these Polaroids of reclining nudes were echoes of his recumbent Amherst lady, unlike the highly complex black-and-white composite photograph that led to that huge painting, they were, in Close's view not studies for paintings but completed works. So enamored was he with the 40 x 80 camera that, fitting it with a short-focus close-up lens, he also used it for a series of remarkable flower studies that were quite a departure from his usual subject matter. A departure, yes, but in their sensuous forms and fleshiness, those flower images are oddly redolent of human anatomy.

Of various early images Close made using both Polaroid view cameras, the most arresting by far were two huge self-portraits, each composed of a group of contiguous prints. The first of these, *Self-Portrait/Composite/Nine Parts* (1979), was made with the 20 x 24 camera in Cambridge. His face in this loosely assembled composition, more than six feet high and five feet wide and assembled of congruent parts, is hypnotic. His eyes shut, he seems to be in a meditative state. Every detail of his mustache and beard appears with startling clarity. His slightly open lips reveal gleaming teeth. In some ways the image is a series of contradictions

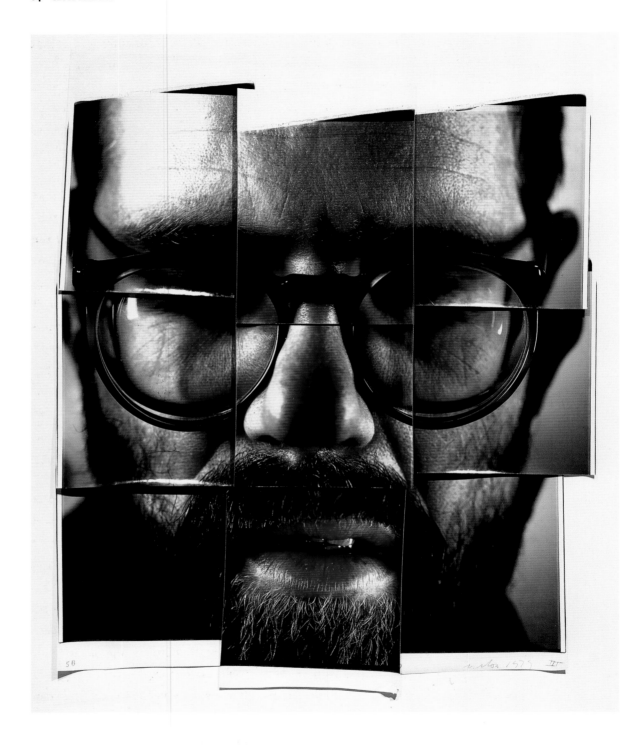

Self-Portrait/Composite/Nine Parts, 1979. Nine color Polaroid photographs mounted on canvas, overall: 76½ x 61½".
Collection of Whitney Museum of American Art, New York; gift of Barbara and Eugene Schwartz

between absolute clinical reality and an almost casual assembly of components that do not quite match. The overall image is replete with seeming disconnects. His skin tone varies from one print to the other, reflecting slight differences in the various exposures; even the frames of his glasses are discontinuous—all the result of his quasi-improvisational collage process. Close had cut the top edges of the upper three panels at a slight bevel, so that the whole arrangement had a temporary look about it.

In 1980 Close made a second multipanel self-portrait, this time with the 40 x 80 camera at the Museum of Fine Arts. Consisting of six sections, three vertical components over three others, it depicts the dour-faced, brooding countenance of the artist in slightly thinner-framed horn-rimmed glasses. Especially arresting is the in-and-out focus of this composite view. His beard is a dense thicket, some hairs startlingly clear, others a mild blur. So radically compressed is the depth of field that it is as though he conceived of this image as a vertical cross-section of his face, revealing with absolute clarity all that occurred within a single plane and allowing the rest to appear less distinctly. Soon after its completion, the work was shipped off to the Walker Art Center, where, installed in the museum's high-ceilinged entrance area, it was a late but dramatic inclusion to his first retrospective exhibition. Its multiple panels, each lightly tacked to the wall, overlaid each other in seemingly casual fashion. In some instances, contiguous panels matched up perfectly in color and lighting; in others, the relationship was perceptibly off.

Close would have even greater access to Polaroid technology when, in 1986, the company moved its studio to lower Broadway in New York, with John Reuter in charge. Reuter has since overseen the studio and works with many artists—among them Lucas Samaras and William Wegman, two of Close's best-known subjects—who also book time for use of the 20 x 24 camera. The studio, located on a high floor in a commercial building in SoHo, is a beehive of activity, with lights being shifted around over a black-curtained enclosure by a complement of young assistants and interns. All this activity transpires under the watchful eyes of Reuter.

On the day in December 2002 when I was present for a shoot, Close was elegantly turned out in a black turtleneck sweater, ready for his close-up. His beard perfectly trimmed, his newly shaved head agleam, he could have been a professional model hired to pose as a Russian nobleman for a vodka ad. Along one expanse of the studio wall was a pinup area, which in the course of the afternoon would be covered with trial shots.

Prior to the session, the camera setup was tested by focusing the lens on one of Reuter's young interns, whose larger-than-life, upside-down head filled the viewing glass at the back of the camera box. By moving a few side lights around, adjusting their translucent filters, and varying the illumination from an overhead light in a rectangular box, Reuter and his crew had arrived at a rough approximation of the general lighting conditions that Close prefers. Polaroid's "point-source" lighting system, which affords considerable flexibility in modeling a subject's face, can easily be adjusted to lighten or darken one side or the other. Having been through this process numerous times with Close and his many sitters, the assistants proceeded with amiable familiarity. Throughout all this—in fact, throughout the entire afternoon—music continued to play, ranging from Elvis to golden oldies by Aretha Franklin and Otis Redding, whose "Just One More Day," Close assured all present, was the sexiest song ever written.

While studying the lighting on the unlined, upside-down face of his stand-in, who, like Close, had a beard and goatee, Close marveled, "He looks like a younger version of me, except that he's got hair!" Adjustments were made to compress the camera's depth of field to about an inch and a half, so that parts of his face, especially the nose, eyes, and teeth, would be in sharp focus, while others would be slightly diffuse. Briskly wheeling himself into the enclosure and positioning himself about fourteen inches from the large, round lens, Close checked out his appearance by studying his reflection in the glass filter in front of the lens. As with his other subjects, he spent considerable time making sure that the image of his face filled the frame of the ground-glass viewer properly. It must be subtly illuminated in order to both reveal its form and to ensure the degree of flatness he needs for painting. The time spent on making such a photograph is exceptionally brief in relation to that Close expends on the painting, but those few hours in the Polaroid studio are of crucial importance. If he is to invest four months or more in painting a nine-foot-tall self-portrait, all the more reason to begin with exactly the right photo-maquette. He is well aware that whatever view of himself he offers in that photograph will be greatly intensified in the painting that follows.

Once Close had positioned himself before the giant Polaroid camera, it was clear to all in the studio just who was in control. At the conclusion of the "one, two, three" count, off went the strobe and that was that. As soon as the first print was pinned to the wall, discussions with Reuter began about changes to be made for the next shot: a little more light here, less over there. Generally, Reuter says, Close prefers those

images of himself with harsher rather than softer lighting. There was some joshing about his use of the "beauty lens," a long lens often used in portraiture that combines a 600mm front and a 360mm back, thus allowing the photographer to move in on his subject for a flattering, undistorted shot. Close made six black-and-white shots that day, each a slight variation on the preceding one. These were not six photographs of a single pose but of six different ones, each with slightly varied lighting. They ranged from frontal shots to almost three-quarter views. In some, the eyes were open wider than in others. Watching this steady progression of slightly changing images, I suggested to Close that his features seemed to be slowly mutating into Sean Connery's in these images. Possibly, he had heard that one before, because his disdainful riposte was "Yeah, but Connery won't even admit that he's bald."

After a short break, the crew reassembled to help Close make a set of color images of himself. The process—making each shot, pinning it up and studying it, readjusting the lights and filters—was similar to the earlier one. For the first three shots Close used Polacolor 6 film. The last three were shot, at Reuter's suggestion, using Turbo Film, a product that offers greater color saturation and less possibility of color shifts. Of the six color photographs Close made that afternoon, the most interesting, I thought, were those in which frontal lighting was minimal and the right side of his face was so strongly illuminated that it read as a bright, vertical sliver. It was the most dramatic of the self-portraits but, because of its strong expressionistic quality, I suspected it would be the print most unlikely to end up as a photo-maquette for a painting. In several of those side-lit shots, so strongly reflective were the thin metal frames of his glasses that his right eye seemed to be looking through a monocle.

By the end of the day, the pinning wall was covered with rows of Close faces. It was like looking at serial imagery or at a "process piece" from the 1970s, in which each image is part of the record of the making of the work. Faced with these line-ups of faces, it's easy to forget about conventional notions of portraiture. There is little evidence of probing a subject's inner being in these photographic impressions, because Close's sole objective in making them is to come away with images in whose greatly enlarged forms he can luxuriate and lose himself, while painting them. Whether the black-and-white shots or those in color would lead to a new painting was not clear that day. The final decision about which photograph, if any, would be used for a painted portrait usually occurs after Close brings back the day's Polaroids

to his studio. There, he puts them on the floor and tries various grid overlays on them, to see what comes forth. These include horizontal-vertical grids and diagonal ones, some with small squares, and others with large ones. The idea, he explains, is to determine what unique visual information each grid unit might contain and how to translate all that data into painted areas.

Back to the Studio

Close has conflicting memories of his lengthy hospital stay. He arrived at the hospital in December 1988 and left in July 1989. There was far too much time to brood about how he and his family would manage once he was discharged. There was also the gnawing question of whether he would recover sufficiently to paint again. Among his most haunting memories were those times when, half asleep, he would perceive his visitors as spectral, disembodied shapes. "They came and sustained me. At times, I would see their images lurking in the dark in my room. The bed was raised high, and over my feet at the end of the bed, I would see a head. The head would talk to me, comfort me."

When Close talks about his long recuperative days in the hospital, among his few positive recollections are the frequent visits from Mark Greenwold, who sought in every possible way to raise his spirits by talking, joking with him, and reading to him. "There was and is no friend closer or more important to me than Mark," avows Close. Greenwold, who since the early 1970s has lived in Albany, where he teaches at the State University of New York, traveled almost weekly to New York to see Close. They first met in Seattle in 1969, when Close had a summer teaching job at the University of Washington, where Greenwold was a faculty member of the studio art department. Physically, they could not have been more unalike. Greenwold, short and slight ("my old self," he says of the "slight" part), and Close, tall, lanky, and long-legged. Not long after meeting Close, Greenwold departed Seattle for a teaching job at UCLA that continued for two years. Though he occasionally traveled to New York during that period, to see Close and go to museums and galleries with him, his expeditions to the city grew more frequent once he made the move to Albany.

During Greenwold's many visits to the Rusk Institute, their conversations about art went on, often volubly and sometimes even as Close was undergoing strenuous

rehabilitation procedures. During one such visit, Greenwold, upon walking into Close's room, was stunned to see his friend, "all six-foot-three of him," in an upright position, his body strapped from head to foot to a tilt table. The idea, he says, "was to get Chuck used to being upright and stimulate his circulation. He looked like something out of a Frankenstein movie, with those straps all around him." That day, Greenwold had brought along a particularly hilarious review by Peter Schjeldahl of a recent Jeff Koons exhibition, which he proceeded to read to his trussed-up friend. "The more I read, the more Chuck laughed. He laughed so hard that he began crying. What a sight that was!" When, months later, Close was finally able to move about in a wheelchair, Greenwold would occasionally spirit him off to local bars for more wild conversation.

Not only were he and Close an improbable couple in appearance and personality, they were an even odder one in terms of their artistic production. Close, from the late 1960s on, never had any doubts about his choice of subject matter. He had determined early on that it would be the giant head—and had even used Greenwold as the subject of one of these paintings in 1978. Greenwold, also early on, had taken a far different tack. Though, like Close's, his subject matter was richly descriptive and based on photographic sources, it consisted of essentially narrative, overtly psychological scenarios. Close was often a subject in these dreamlike evocations. For that matter, Greenwold himself was a constant, minutely described, and often hapless presence. In *The Return* (1991–92), a group of figures stands before a narrow, gabled house, among them the artist's father and a former wife Marta, who holds an infant. At one side, in this composition with early Italian Renaissance overtones, directly below an angel-like being floating protectively in the blue sky above, the figure of Greenwold gently helps Close rise up from a wheelchair. Another, far different wheelchair image of Close, peculiar in its combination of fright and weird humor, is the circle-shaped painting titled *A Man's Worst Enemies* (1996–97), in which an overalls-clad Leslie stands by impassively as Close is about to be assaulted with an axe by his Barbadian housekeeper, Freda—in real life, ostensibly the essence of compassion. "I'm trying to stop this from happening," Close says of his role in the painting. "I am trying to hold her off." Of the painting's content, he remarks, "From my point of view, it was all a big burlesque," an over-the-top joke between the two friends. Whatever one of Close's long succession of therapists, or Greenwold's for that matter, might make of this threatening image

MARK GREENWOLD *A Man's Worst Enemies*, 1996–97. Oil on board, 11 ¾" in diameter

MARK GREENWOLD *The Return*, 1991–92. Gouache and watercolor on paper, 12 x 9¼"

can only be surmised. From the evidence, it would seem that their close friendship of thirty-five years has not been without its complexities, as Greenwold terms them, but it's clearly an enduring one.

Close knew his life would never be the same, but the good news was that he was regaining some mobility in his limbs and even beginning to function again as an artist. Getting him back to work was largely the result of Leslie Close's persistence and badgering of the hospital staff. "He was too ill to do anything for a couple of months," she says, "but when they moved him from the hospital to Rusk for rehabilitation, he was actually able to sit up for a few hours at a time. They had him doing certain things to work on his coordination. They were getting him ready to string beads, weave baskets, or whatever, but I said, 'No way!'" Even at that point, she says, he was determined to recover and get back to painting. "I cornered the occupational therapist in the cafeteria and said, 'He's an artist, that's what he does. He has to have pencils and brushes. If you are going to do any kind of occupational therapy, he should draw and paint. That's what he needs to be doing!'" Finding space to work was not easy. At first, it was in Rusk's occupational therapy area; later, he was moved to an "arts therapy" room in the basement. Once installed in his makeshift studio, Close, aided by his assistant Michael Volonakis, began to paint again. Thanks to intensive physical therapy, he eventually regained enough hand control to paint, holding a brush in a custom-designed splint, Velcro-strapped to his right arm. During this resumption, he made a small portrait of Alex Katz (*Alex II*) and worked on one of the artist Janet Fish.

Painting became an essential part of Close's recovery regimen. Volonakis would carefully prepare things for him, even mixing colors to his exact specifications, which he didn't have the strength or coordination to do for himself. At first, he supported Close's arm from below, as he applied each brush stroke. "I would yell at Michael," Close recalls, "'more green, more yellow, less white!' I was a nervous wreck. He would calmly stick the brush loaded with color in the holder around my wrist, and I would lunge at the canvas and try to get the color in the right square. I would say to Michael, 'You see, I can't do it!' and then he would say, 'Yes, you can, it's going well. You're doing okay.' Leslie and my physical therapist constantly encouraged me." While he has little recollection of being greatly depressed during that time, Close recalls that Michael did. "He told me that I was weeping a lot, even while I was working on the painting. I suppose I must have put some of that feeling

into it, but if I did, it was certainly unconscious." Leslie Close vehemently concurs: "You can't tell me that there's no more to that painting than a portrait of Alex! It's about Chuck's sadness."

Volonakis, who bore much of the brunt of this frustration, has his own memories of what went on. "The shelves in the room where Chuck worked were filled with crafts projects, examples of other patients' struggles to recover their motor skills. In the middle of all this, there was Chuck, making his art. Someone on the staff had made him an easel. His work was a bright island in the middle of that dark room." When the day finally arrived to leave the hospital, Close was determined to do so on his own power. Leslie and Ernest Morgan, a trucker who transported canvases and materials for Close prior to his illness, were at his side. According to Volonakis, Close said, insistently, "I'm going to walk out of here!" The burly Morgan gently helped him get up from the wheelchair. His arms tightly wrapped around Leslie's and Morgan's shoulders, he managed to walk through the hospital doorway. They drove directly to the Closes's summer house in Bridgehampton, which Leslie had equipped with plywood ramps so that Close could move about in his wheelchair. "His morale was pretty awful, but he was happy to be home. But home," she continues, "was an environment where he was used to doing thing for himself, so the impact on him and everyone around him was considerable."

Among the many adjustments Close had to make upon his return to painting in his 75 Spring Street studio, which he had moved to in 1984, was handling his large canvases—getting them onto an easel and being able to reach any part of their expansive surfaces with ease. At first, he used a forklift as a makeshift easel that he could raise and lower. Beginning with those small paintings he worked on in the basement of Rusk, he was teaching his arm to take over from his hand. As Arne Glimcher, his dealer since 1977, puts it, "He trained his arm, as people who train their other senses," to the degree, he adds, "that the paint strokes built a flawlessly connected image." Needing a more functional setting for his work, in 1992 Close moved his studio to its current site, a ground-level space on Bond Street in the area known as NoHo (north of Houston). The light-filled space is divided into two parts. A small area just off the street is lined from floor to ceiling with shelves of archival records of Close's work, as well as art books ranging from monographs about artists, past and present, to exhibition catalogues. An assistant at a long desk updates information about the location of works in various collections and looks after other office matters.

Close's painting space is a large, open area at the far end of the building. Its salient feature is a high-tech easel arrangement that, like the chair he sits in, was designed by Vladimir Kasa-Djukic, at the time a young Yugoslav artist working for an architectural firm in Munich, who was familiar with Close's work. When he learned of Close's illness, he sent him descriptive material about the easel he had invented. Close responded with interest and, after successive communication back and forth, asked Kasa-Djukic to install one in his new studio. Now an American citizen and resident of New York, where he works as a freelance designer, he and Close are good friends. The easel consists of a stainless-steel channel imbedded in a shallow rectangular box, flat against the back wall, that extends from the ceiling to the studio's basement. Attached to the tall vertical channel is a moveable open square composed of thin steel units that can be moved up and down. That component, to which the back of a canvas is affixed while Close paints, can be set to accommodate a horizontal-vertical grid painting or rotated forty-five degrees to hold a painting employing a diagonal grid. By means of foot pedals, Close can vary the height of the canvas and move it to the right or left in a wide slot in the concrete floor, thus allowing him to reach any part of the painting from a seated position. The same mechanism enables the canvas to be lowered to the basement, for storage purposes. This back part of the studio is simply furnished, except for a few tables and chairs; not visible to the casual visitor is a wide pull-down bed that Close sometimes makes use of when he has to be in the city the next day.

The atmosphere is relaxed as Close works on a painting, even during occasional interruptions. Given the many contacts with the outside world that are part of his day—numerous phone conversations (he wears an earphone-microphone attachment for these), meetings with technicians about ongoing printmaking and photography projects, sessions with curators working on shows with him—the wonder is that he is able to focus as intently as he does on the solitary act of painting, but focus he does. As he works, the radio is sometimes tuned to a local FM station. His musical diet is varied. During visits to the studio over the years, I've heard in the background stately symphonic selections, and the voices of Nina Simone, Ray Charles, and insistent Latino drumming. In earlier days, he sometimes had a television on at low volume while painting, which he would listen to rather than watch because "it had a 'comfortable' sound, and no concentration was required. And there was just enough noise to take the edge off what was going on."

During some of our conversations, Close would whip back and forth across the length of the studio in his wheelchair, which, with its sophisticated steering devices is as technologically impressive as the easel, to ask an assistant about the date of a photograph or to look over some newly pinned-up proofs of a print he was working on. Often we continued our discussions over lunch and a bottle of wine in a restaurant down the street. Close is a regular in several local eateries, all of which he has thoroughly cased in terms of his access and dining requirements. He has mastered the complexities of eating, given the persistent effects of his paralysis, and makes skillful use of a standard orthotic device: a fork-holder attached to his wrist with a Velcro band. It is a splint-like implement containing a pocket for the fork handle. In fastening it around his hand, he holds the Velcro band with his teeth.

The Power Grid

What clearer evidence of Close's enduring belief in the grid could there be than how he makes it such a visible part of his painting? Not only does it provide him with an orderly working method, it also enables him to decide if a photographic image is even usable. "I slide sheets of transparent Mylar over the photographs. These sheets have grids of various sizes drawn on them," he explains. "Some are horizontal and vertical, some are diagonal, some are coarser and others are finer. I move them around until I find one that breaks the image down in a particularly riveting way for me. If areas of the photograph look best to me under a coarse, or large-square, grid, that suggests a small painting. If I like the photograph better under a more detailed, small-square grid, that will suggest a larger painting. That's also how I decide." Rows of squares drawn on the canvas are containers for marks representing various areas of the photograph. Close's standard device for transferring photographic data to canvas is an alphabet- and number-coded grid. In a few instances when using processes that engender blurry, amorphous-edged forms, such as his fingerprint-on-inkpad drawings and paper-pulp portraits of the early 1980s, he used an enlarging projector "to locate a few key points on a subject's face, like the edge of an ear or the corner of an eye." In the course of our discussions about projectors, Close mused about the differences between his photographs of various subjects and the paintings they led to. However faithfully those portraits echo the photographs, they

are far from duplicating them, area by area. "So much happens during the painting process," he makes clear. "If you were to project an image of the photograph over the finished painting, nothing would really line up. After all, the painting was done by hand, and the photograph is a mechanical process. All kinds of modifications occur in transferring its image to the canvas, even though the grids in each are equivalent."

With the grid firmly established as the governing element, Close could make key decisions about the painting's structure well in advance. For his early black-and-white portraits he "snapped" the grid lines onto the canvas, in traditional sign-painter fashion, using a chalked string. Later, he drew their lines in pencil. Not only is he a believer in such orderly systems, he also works on his paintings from the top down. "I always paint that way," he deadpans, "because I tend to spill things. So if I kick the canvas, drip paint on it, or spill my lunch on it, it would be on the blank bottom part, and not on something I've already completed. I also work from left to right, which is also a sequential, incremental thing." For a black-and-white portrait, he lays in tones of gray in broad strokes in each compartment to approximate those values in the photograph. When the portrait is in color, he uses a variation on this process, filling in each grid square with disparate-hued marks. A second top-to-bottom pass brings forth a profusion of sketchily brushed circles, squares, crisscrosses, and squirming and twisting amoebic shapes. In the third and last layer, he makes whatever shape and color adjustments are needed in order to bring the painting into consonance with the photograph. Each of the squares in the final work contains a separate—and wholly abstract—small painting.

Apart from whatever ideas about systems Close's grid might reflect, it serves another, more personal purpose: by guaranteeing order and continuity, it acts as his safety net. His dependence on it has been a way of coming to terms with patterns of behavior traceable to his early youth, they have as much to do with remembering things as with making decisions. "Because I was dyslexic and learning-disabled as a child," he explains, "I didn't like the idea of reinventing the wheel every single day. Instead, I wanted to continue doing today what I had done yesterday." While working on a painting, he still feels that continuity is all. "Every day in the studio, I add to what I have already done." He found freedom in the grid's strictures. He could deal with each square at whatever pace and with as much invention as he chose. Warming to the topic, and blissfully oblivious he might be on thin ice by using a non-"p.c." example, Close describes his method of painting as "almost mechanical and not unlike what people used to refer to as 'women's work'—quilting, crochet-

ing, things like that." He adds, "If you think about why women worked like that, it's because they were so busy doing other things. They would work on their knitting, lay it down so they could feed the baby, knit some more, prepare dinner, pick up their knitting again, and keep going."

Recently, Close offered a more personal example of this no-nonsense approach, as he reminisced about his grandmother Blanche Wagner, an inveterate knitter and crocheter. As a child, one of the pleasures of visiting her was to watch her at work crocheting white stars and flowers that, sewn together, would become tablecloths. Her afghans and comforters composed of brightly hued squares of wool were, he says, "like little Joseph Albers paintings." Wistfully recalling the process of their making, he says, "It was all about small things combining into big things." Close remembers seeing his grandmother's newly made tablecloths, tautly fastened to stretchers in her backyard, their surfaces alive with rhythmic marks. "Her hands were never idle; she was always at work on some project or other, and if what she was making wasn't turning out right, she had no hesitancy in unraveling it and starting over again." The time spent on a project was incidental, she explained to her young grandson: what really mattered was getting it right. So enthralled was he by watching her at work that he suspects the experience may have had some subliminal effect on how he goes about making and combining complex patterned shapes in his own work.

Integral as grids have been in Close's work, occasional comparisons with the work of other artists who employ them can be a little dismaying for him. In response to such observations, he has evolved an obliquely Zen-like reaction. "When people say my work has things in common with Sol LeWitt's or Agnes Martin's because all of us use grids, my response could be, 'You know all those signs on the highway that say "If you lived here, you would be home by now?" Well, back when I used to spend weeks hand-sanding a gessoed canvas, I'd say to myself, 'If I were Bob Ryman, I'd be done now.' Then I'd draw a grid on it, and I'd say, 'Well, if I were Agnes Martin, I'd be finished now.' So, I don't think Sol and I really have a great deal in common except, maybe, a belief in order and systems. And Agnes, God knows where her stuff came from! She was out there in outer space." Yet, he opines that whatever connections may exist between his work and theirs certainly go well beyond their common espousal of the grid and, in his mind at least, are far more significant. "They are artists who have importance in my life and with whom I have had a long dialogue through our work. It's like having another kind of family."

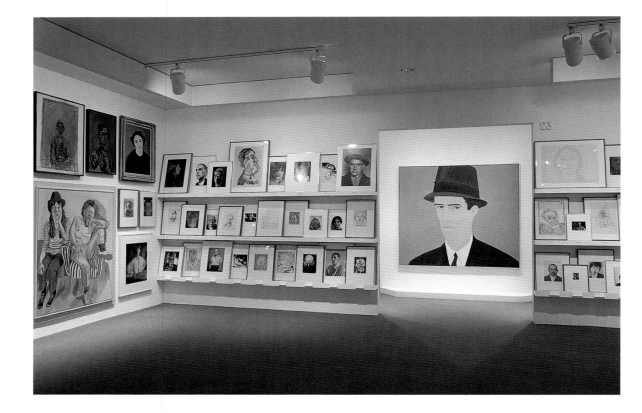

Two views of the "Head-On/The Modern Portrait" exhibition held at The Museum of Modern Art, New York, 1991

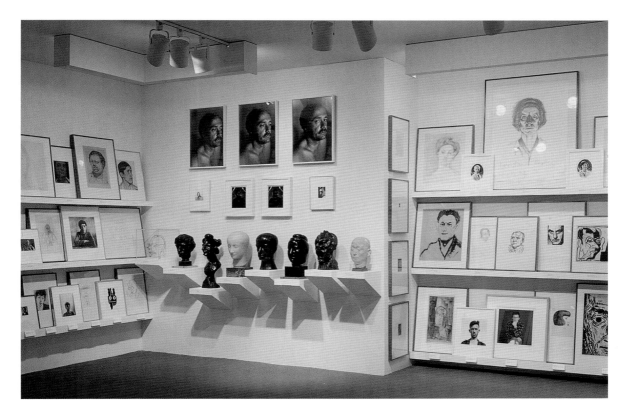

On the subject of grids, by no means did Close limit his thinking to its two-dimensional manifestations. So ingrained was the concept of building form by the accretion of incremental units, that, when the occasion arose, it manifested itself in an entirely new way for him. In 1991, the now-deceased Kirk Varnedoe asked Close to become involved in a small exhibition of portraits, to be drawn mainly from the Museum of Modern Art's collection. Varnedoe, who was then Chief Curator of the Department of Painting and Sculpture, had extended an invitation that was a masterstroke in that it matched the perfect artist with the perfect theme. Though well known for painting single heads on canvas, Close had a much more wide-ranging interest in the work of other artists. The idea of the exhibition, consequently, was that he would select works that he especially responded to and would group together in any way he wanted. Given his catholicity of taste, it was no surprise that his selections for the project, "Head-On/The Modern Portrait," were extremely diverse and far from predictable. Nor was it surprising that, given his legendary obsession with detail and control, the selection process began with familiarizing himself with every portrait, self- or otherwise, owned by the museum. In the exhibition's brochure, Close says that he made his selections over "something like twenty-four eight-hour days at the Museum, going through the collection" (*Chuck Close: Head-On/The Modern Portrait*. New York: The Museum of Modern Art, 1991, p. 3). What appealed to him about that process, he continues, was that he could move freely from department to department, learning about the museum's holdings in painting and sculpture, drawing, photography, and prints. In structuring his exhibition, he says he found himself including some works in styles he knew little about, or was especially enamored of, such as German Expressionism.

Thematically, the exhibition's unifying element was to be the head. Neither period nor geography were factors in what would be an extremely subjective presentation. Close's selections were mostly framed works on paper, some shown on shallow shelves and partially overlapping. There was no particular chronological or stylistic order—or so it may have seemed to the casual observer—but, as Close explains in his text, there was a system of sorts, if a highly personal one. He wanted "to put something together that had more to do with the ways in which I experience art, rather than just picking out some pieces that would give you my definition of what quality is." The result was a slightly confusing but decidedly engaging juxtaposition of images, styles, techniques, and media, with inclusions as diverse as a Man Ray pho-

tograph of Duchamp, a Matisse self-portrait in ink, self-portrayals in oils by Lovis Corinth, Christian Berard, and Alfred Maurer, a drypoint etching of himself by Max Beckmann, and a charcoal-and-pencil self-portrait by Marie Laurencin. Of the sculptures he selected, there was a bronze head of Baudelaire by Duchamp-Villon and one of Gertrude Stein by Jacques Lipchitz. One of the few "superstar" works from the collection was van Gogh's portrait of the postman Joseph Roulin.

On view also were two images by Close: a 1988 etching-and-aquatint dot-drawing self-portrait and a 1989 painting of the artist Elizabeth Murray. Larger than most of the paintings was *Passing*, the signature 1962–63 self-portrait of a dour Alex Katz in a dark suit jacket, tie, and hat. In effect, what Close had created for "Head-On/The Modern Portrait" was a lively, provocative installation work that reflected his highly subjective ideas about thematic and stylistic connections beyond the conventions of art history.

Aside from its revelation of Close's wideranging tastes and interests, the exhibition was instructive in other ways. By combining works from different periods, places, and in such varied media, and juxtaposing them so near to one another, he imbued his presentation with an improvisational look. It was as though he had set up a situation in which he could study the effects of one work on another, but had left open the possibility of coming back and trying a few other arrangements. The shelves were implicitly part of an imaginary grid, and each image, whether a drawing, print, or sculpture, functioned as a unit in that arrangement. In effect, the configuration of each wall of shelves, with their top to bottom arrays of images, was an approximation of a Close painting, formed on a grid.

The Magic Mark-Maker

Close marvels at the internal logic of forms seen under a microscope. "Some defining force controls these," he is certain. "You sense the rightness of it all. I want to feel that same rightness in the marks I use in my paintings—that they have to be the way they are." Some of his paintings, especially those based on "coarse," large-square grids, have taken on a tougher, more improvisational look: their marks are entirely invented, far from direct transcriptions of what he saw in the photographs. Though never more than arm's length from the canvas as he makes them, Close instinctively knows how they will interact to form an image. "I've made enough of them to know

how they will read from a distance. I don't have to back up and look at them. The analogy might be to a composer scoring a composition for a number of musical instruments. He knows what the bassoon, the oboe, or whatever, will sound like when they are played together." Pursuing the musical analogy, he says, "I guess what I'm making are color chords, of a kind. I assign qualities to certain marks, by giving them colors. When they're played together—or *seen* together—the color chord melts in the mind (as they used to say about 'acid'). They come together to make some kind of color world."

What really makes the mark work, Close explains is the English, or spin, he puts on the brush stroke. That inflection is critical, "whether the shape is oblong or circular or puffy." This outpouring of shapes, organic and geometric, is an instant conversion of illusionistic form to abstract symbols—but symbols with no glyphic meaning. Whatever some of them might suggest, they are no more than what you see. Commenting on this strong connection between perception and reaction, Leslie Close says, "I really do believe that it's an organic anomaly, and that there is some connection that his brain makes that other people's don't. I do think that he just sees that stuff. It's like a language that he speaks. It's not intellectualized and I don't know which part of the brain it comes from."

As much as Close stresses the structural role of marks in his painting, he also realizes that some viewers might read his loosely drawn circles, squares, and squiggles merely as decoration. Not at all what he has in mind, he asserts. "I've never been interested in decoration, and neither have I been interested in biomorphic shapes. But here I am, with tons of biomorphic shapes distributed on a surface and a really very decorative situation." He concedes that there are unresolved tensions between form-as-structure and form-as-decoration in his work and, with the example of Pollock in mind, philosophically accepts this dualism as one inherent in modernism. "Any time you have allover painting, especially Pollock's kind, with lots of pastel colors, it's certainly very easy for it to lapse into sheer decoration." As to the prospect of his painting's verging on the decorative, he allows, with a shrug, "It's a constant struggle to make it tough and rigorous." For all their descriptiveness, they are primarily about abstract invention. They are arenas in which abstract shapes jostle, crowd, and all but consume one another. Given the heightened role of abstraction in his painting, might it one day, I half-innocently inquired, be more than merely the subtext of his paintings and turn out to be its real subject? Was there any

possibility that he would become so enamored of mark-making that heads would disappear? "Not even remotely," was Close's amused, reassuring response. "You may have to look harder to see them, but they'll be there. They are in the service of the image and don't stand on their own. I have no interest in having them take over and be the subject matter."

Then, shifting the focus of our discussion slightly, he said, "My paintings are more about language than they are about abstraction. Their pictorial syntax is made up of clusters of marks that are like words that read from left to right and from top to bottom. They tell you a story. They bring you an image." If he were to use them only as shapes in themselves, he said dismissively, "I would just be decorating the surface, and since I was never very good at pure abstraction anyhow, they would just lapse into handwriting." And that would be unfortunate, he added, "because one of the bad things about handwriting is that it becomes lazy and repetitive. You just do what your hand most easily wants to do. Unless you're trying to get that mark to be specific in order to build something, there's just a tendency to have fun."

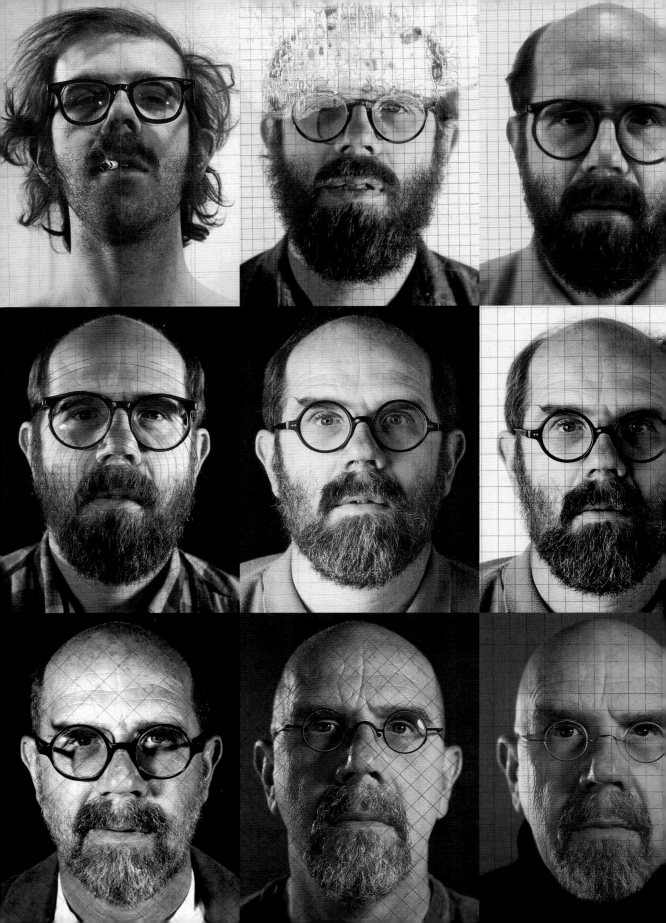

LOOKING INTO HIMSELF: The Self-Portraits

Revelations

The term "self-portrait" suggests self-revelation, but just what is being revealed, beyond the artist's features? An exact likeness can sometimes show just that, not much more. It can tell us something about the times that produced it, but little about who painted it. Some self-portrayals afford remarkable access to their creators' interior lives—think Picasso—while others can be armored and psychologically impenetrable, such as Dürer's cool, sixteenth-century renditions of his flaxen-haired Teutonic self. For Rembrandt and van Gogh, a couple of moody Dutchmen a few centuries apart, the self-portrait was less about reality than about what was going on behind its facade of illusion. We are moved by Rembrandt's haunted face emerging from the shadows and by van Gogh's feverish color-streaked visions of himself.

Asked about the influence, if any, of such legendary self-portraitists on his sensibilities, Close blithely rolls a verbal hand grenade across the floor (What harm, after all, in a little artistic heresy?). Predictably, when it comes to seventeenth-century Dutch art, he prefers Vermeer's sharp-edged clarity, in which every part of the painting is brought to the same high degree of finish, to Rembrandt's vaporous descriptiveness. Something about the mystical, psychological content of those Rembrandt paintings puts him off. He is wary, he says, of images in which the artist's personality dominates the subject. (Rembrandt's drawings and etchings are another story, he says; he admires them greatly.) None of this comes as a surprise, given Close's solid grounding in the purist, take-no-prisoners orthodoxies of 1960s Minimalism and Conceptual art. Revealing the structure of a face, rather than its expression at a given moment, describes his approach to portraiture. He prefers sharply defined images to indistinct ones and, to achieve this goal, gives the same obsessive attention to every square inch of the canvas.

Important as Close's paintings of his artist friends and family have been in his production, those he has made of himself have particular resonance. Though his brush with death in 1988 obliged him to look deeply into himself, he had been experiencing another kind of introspection well before the onslaught of his illness. This took the form of the scrupulously detailed self-portraits he had been making at irregular intervals. The first was the 1968 *Big Self-Portrait,* a still startling, nine-foot-high black-and-white work on canvas begun in 1967, soon after setting up his first New York studio. These self-depictions offer a remarkably detailed core sample of the

changes in style and technique his art has undergone over some thirty-five years. Given their intense personal focus, they are a genre within a genre. Close made them sporadically, pretty much as the spirit moved him. A new photo-maquette would usually lead to a painting and perhaps to a few works in other media, but several years might go by without his sitting before the camera for another round of self-scrutiny. The resulting canvases have always been much more than objective exercises in technique and have increasingly offered intriguing insights about the mind and feelings of their creator.

Because Close routinely asks his sitters to assume expressions as neutral as possible while before the camera, he expects no less of himself when he is his subject. Yet, if most of his models appear to have emptied their minds of temporal concerns when facing the lens, the same cannot always be said for him. "I try to check my attitude at the door when I put myself before the camera, and try to be as straightforward as I can," he says, but concedes that such detachment is not always possible. Even in his early black-and-white days, he had definite ideas about the persona he wanted to project. Other factors, however, psychological ones among them, have often come into play. "I may be 'presenting' myself," he admits, "but I'm not really thinking about that." Whether he even aspires to such objectivity may be moot, given his mastery of self-presentation. The fact is, Close instinctively understands how to position himself before the lens. He understands photographic lighting perfectly and, after each shot during a session, makes microadjustments, slightly intensifying the illumination at one point, lessening it at another.

Maybe it's because there's enough of a critical mass of these self-portrait photographs that subtle changes from one to the other in how he presents himself are traceable, but in my opinion they are less neutral in sensibility than his camera studies of his other models. That sensibility, intensified in the sequence of large paintings that the photographs have engendered, is as apparent in their vivid brushing and inventive form as in the mesmerizing ways in which he presents himself. In these self-portraits, it's as though outside forces—or conflicting interior ones—were subtly subverting Close's much-vaunted control over his painting process. And while he may have aspired to the same objectivity in them that he seeks in portraying other subjects, in my view this has not always happened. His self-portraits, especially those made since his illness, are, to me, more accessible emotionally than his concurrent portrayals of other subjects.

But why wouldn't that be the case? For over three decades Close has explored the topography of his face more often and in more detail than that of any of his other subjects. Having studied it from every angle and under all lighting conditions, it holds few surprises for him. So why wouldn't he, consciously or not, probe what may lay behind his own facade? This line of thought doesn't appeal much to Close, who reflexively rejects the notion that there might be something unique about how he elects to depict himself. Every time I raised the idea that the self-portraits seemed to be a group psychologically well apart from his other paintings, he resisted, forcefully asserting that the ways in which he portrays himself are no different than how he portrays other models. Temperamentally, he says, all of his paintings including the self-portraits are of a piece. Not only that, he adds, there are often times, while working on a self-portrait, when it seems to be someone else's head, so little personal connection does he feel to it. After looking at the same face on a canvas for several months, even his own, it's hard to think of it in personal terms. In fact, when there is a self-portrait on the easel, Close says, "I often refer to me as 'him.' I'll say 'his left eye is too bright' or too whatever. I probably refer to myself as 'him' because it reflects the distance I'm trying to maintain while I'm painting. Because I'm involved in translating small pieces from the photograph to the painting, it's possible to get lost and not really be aware so much they might be part of my nose. I might see part of my face as just a dark shape with an edge. When I break for lunch or come back to the studio the next morning and see the painting for the first time again, I'm immediately brought back to the fact that it's me."

Close grandly finesses the personal issue by maintaining that all of his paintings, irrespective of their subjects, are in essence self-portraits. His self-portraits are no more emotionally revealing than paintings he makes of others, he adds, in a sweeping self-protective observation. But questions persist. Why do they seem to differ from his paintings of other subjects, and what, if any, special insights into his artistic psyche do they provide? Few in the art world are more adroit at deflecting such personal questions than Close, who will happily discourse on the processes and techniques he uses in his paintings, drawings, prints, and photographs and who can analyze in absorbing detail the thematic and stylistic approaches of other artists—even to the extent of making highly speculative observations about the inner feelings, the emotionalism he perceives in their work. However, in discussing such matters in relation to his own art, he can be a sphinx—an amiable one, but still a sphinx. For all his

assertions that his self-portraits are no more subjective than his other paintings, the evidence suggests otherwise. Not only is his face his most recurrent theme, it is the one to which he has been most ineluctably drawn. If on one level, these self-depictions are a way of taking his psychological and physical bearings from time to time, on another and deeper one, they are periodic checks on his mortality.

When it comes to painting the same face over and over, Close would have a hard time finding a more compelling one than his own. At sixty-five his face has aged grandly. In real life, it is not the somber countenance his self-portraits project, but an animated one. During conversations, his expression—usually benignly attentive—can shift swiftly from weighty introspection to wicked humor. His head is long and well formed, as its completely shaved state readily reveals. His skin is relatively smooth, though his forehead bears deeply etched horizontal and vertical frown lines. As we looked over some recent daguerreotype self-portraits in the studio, he directed my attention to a few creases at the temples. "Just look at those lines! Doesn't my skin look like leather?" he asked, with feigned dismay. Below a pair of expressive bushy eyebrows, his eyes are bright blue. His nose is short in length and wide at the base. His upper lip is partially obscured by a mustache of coarse, gray-flecked hairs, which are echoed in a carefully trimmed beard. A catalogue essay for his 1980 retrospective at the Walker Art Center has a forty-year-old Close solemnly declaring that painting himself is a painful experience, "in the way that therapy is painful—facing yourself—facing the way you look, and magnifying it." From that time on, he says, philosophically, "I accepted the reality that I was never going to look the way I wanted to look" (*Close Portraits*. Minneapolis: Walker Art Center, 1980, p. 16).

If Close still has such concerns, he hides them well. As he observes, with engaging self-deprecation, "When you've started to go bald in your twenties and are really bald by thirty, you get used to not looking the way you want to look. You can either go out and buy an expensive hairpiece, or you can say, 'Well, that's the way it is. I'm never going to have hair.'" Growing a beard, he says, was "really all about laziness and about not having a chin. I've saved thousands of hours by not having to shave." He offers an oblique rationale of how he came to terms with his appearance: "People have written about Cindy Sherman's work from the point of view of 'the male gaze,' the point being that if you're a woman and you 'present' yourself, you have the whole tradition of how men look at women to deal with. I don't think men have the

same notion about presenting themselves. My self-portraits are not images that have anything to do with 'the female gaze,' or how women might look at me. I can't imagine myself being a sex object." Maybe not, but the idea inspires a little more wry self-analysis. "I don't think I'm a very vain person. I don't think I'm any more concerned about how I look in the paintings I make of myself than I am about how other people in my work look. In fact, I'm probably more concerned about how they look because I worry whether or not they're going to think I made them unattractive. While I've removed an occasional wart or something else from a subject's face, I would not do that to my own. In other words, I feel freer to exploit myself than someone else, and to let it all hang out."

While many psychological and formalist theories can doubtless be posited as to why Close is so often his own subject, his bland explanation is that he is conveniently available. So much so that since 1970 he has included at least one self-portrait in every gallery show of his new work. Most are close enough in sequence that changes in his appearance from one to the next are fairly minimal. Yet each bears the seeds of the next, to such an extent that it's tempting to think of them as a single, continuous work that magically mutates from one canvas to the next—a useful hypothesis, since each is a giant univisage symmetrically positioned against a depthless background. To pursue the analogy further, were we to line up these paintings edge-to-edge in chronological sequence and walk slowly alongside them, the effect would be cinematic, as one huge face would wondrously metamorphose into the next. This imaginary stroll would parallel Close's journey into his unique realm of realism, where illusionistic surfaces are alchemically transmuted into abstract fragments. Aside from the continuous dissolution and reconstitution of shapes, we would witness the inexorable transformation of his physiognomy. His undisciplined 1960s locks would be neatly trimmed, then thin, recede, and ultimately give way to a gleaming pate. His much-magnified visage would undergo discernible changes. The lines in his forehead, like those at the sides of his mouth, would deepen. A leavening subtheme in this succession of grave self-portrayals would be a minihistory of eyewear offered the viewer. We would watch the frames of his glasses change, almost from picture to picture, in a lively counterpoint to the more gradual facial changes he so faithfully limns. Most of all, we would sense a psychological shift in how he has presented himself over the years—at first, coolly assertive, later, increasingly introspective.

The First Big One: The 1968 *Big Self-Portrait*

The serendipitous genesis of the 1968 *Big Self-Portrait* has taken on near-legendary status. As Close recounts it, he had just finished photographing his *Big Nude* painting, using a borrowed Rolleiflex. "It was summer, and very hot in the studio. That's probably why I wasn't wearing a shirt. At the time, I had been thinking about painting some big heads, much bigger than the one in the *Big Nude*. But, stupid as this probably sounds now, I was also thinking about continuing the nude series. So, at that point, with the film that was left in the camera, I decided to make some photographs of my own head and shoulders. I did myself first because I was the only one around." All the while, he says, the idea of nudity stayed with him. "Even though I was photographing just my head, I thought this would imply that the rest of me had no clothes on—and I liked the idea of people looking at that head and wondering whether or not the guy has pants on." Nudity was still on his mind when, after finishing his self-portrait, he invited Nancy Graves to sit for a portrait. "In fact, I asked her to wear a low-cut, scoop-necked blouse for the photograph so that she might in essence also seem to have no clothes on. At that time, I was even thinking of showing the portraits of Nancy and me alongside the *Big Nude*."

Close's eyes in this arresting portrayal of his vastly enlarged, wild-haired countenance coolly meet those of the viewer, as a cigarette droops loosely from his lips. There is more than a whiff of attitude in this self-presentation. The dark frames of his glasses are as sharply described as the glints of reflected light on their lenses and the curling hairs on his chest. This is no portrait of the artist as sensitive young man, but in the edgy social consciousness of the day, it is a portrait of a stare-you-down rebel. Not only was the *Big Self-Portrait* a germinal work whose centrally placed monohead would be the template for all his paintings, its far-greater-than-life scale is redolent of a particularly vivid era in American art and culture. It is a pure late-1960s American artifact in its unblinking self-assertiveness and casual usurpation of the viewer's space. Though in Close's subsequent self-portrayals, we have grown accustomed to seeing his face as heavily bearded, he sports little facial hair in this percussive debut painting, except for a scattering of chin, cheek, and neck stubble. However, this more or less pre-*GQ* unshaven look was as much an anomaly in his life as in his art, because he had had a beard for about nine or ten years, and, in fact, his wife had never seen him without one.

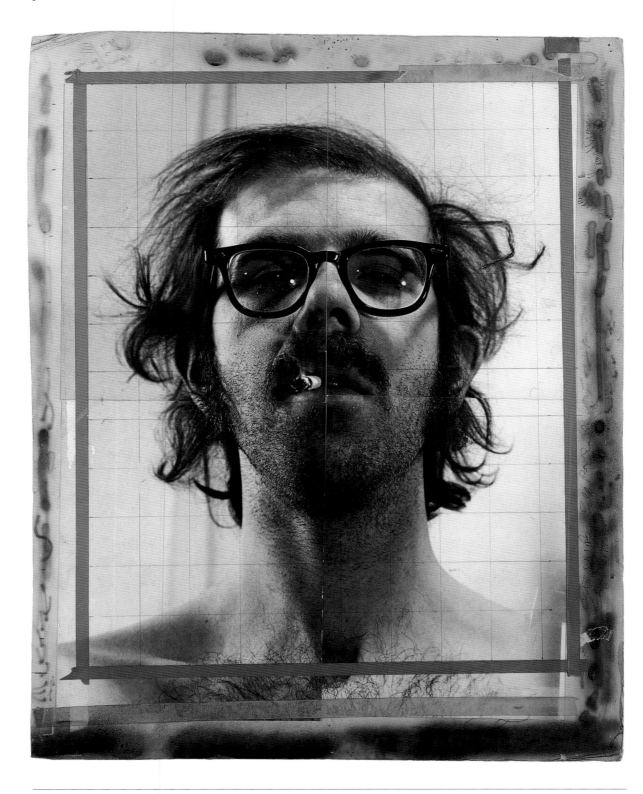

Maquette for *Self-Portrait*, 1968. Four gelatin-silver prints scored with ink, masking tape, and airbrush paint mounted on foamcore, 30 x 24". Collection of Mr. and Mrs. Robert Greenhill

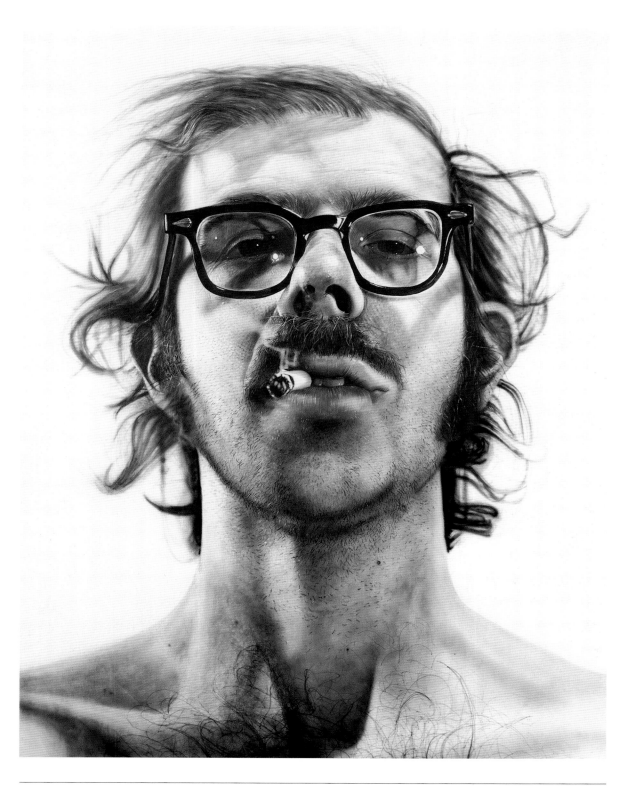

Big Self-Portrait, 1968. Acrylic on canvas, 107 ½ x 83 ½ ". Collection of Walker Art Center, Minneapolis; Art Center Acquisition Fund, 1969

Accounts of how Close came to divest himself of the beard and subsequently to photograph his face without it are integral to the *Big Self-Portrait*'s creation myth. As he tells it, "We didn't have hot water or heat where we were living then, so every few nights we would take baths in somebody else's place. One night we went to a place on the Lower East Side, where a friend had a bathtub in the kitchen. You know, the ones with a tabletop on them? When it was my turn and I was already in the tub, Leslie dared me to shave my beard, so I took the scissors and just hacked it off. Then, the minute I did it, she said, 'Yech! I liked you better before.' So I had to grow it back." It was during that brief but crucial beardless interregnum that he made the photograph that spawned the painting. Of that fateful period, he further observes, "There's a 1968 photograph of me without the beard, standing next to the finished painting, so I must have been without it for about three or four months. This was really the only time, since the late '50s, when I didn't have one. I haven't been clean-shaven since." (Almost true, except for a few backsliding weeks in the summer of 2003, when he shaved it off to see how he would look without it, he says. And once again, he decided to stick with it.)

Practical as it may have been to be his own subject, implementing the idea was another matter. The first thing Close discovered was that he needed a stand-in, of sorts, in order to get the process going. In the absence of someone else's face to point the camera at in order to make sure his features would register sharply, he came up with a novel solution. After focusing the lens on a mark he had made on a wall, he cut a piece of cardboard to the exact length of the distance between the lens and the mark. Then, positioning himself before the camera, with one edge of the horizontal sheet of cardboard against the lens and another against his eyes, he used the cardboard's length, ruler fashion, to determine the exact point at which his features would be in focus. Having found that crucial distance, he clicked off a few shots. However labor-intensive, the process went according to plan. One of the photographs made that sweltering day, printed in slightly lighter and slightly darker versions, would be the source for the *Big Self-Portrait.*

Soon after, when Alden Mason first laid eyes on the finished painting, so great a departure was it from Close's previous work that he hardly knew what to make of it. "I couldn't believe it," Mason confided, "when Chuck showed me what he had done. I hemmed and hawed and didn't know what to say. At first, I thought it was a photograph." Once persuaded that it wasn't, he was still incredulous, "because of the

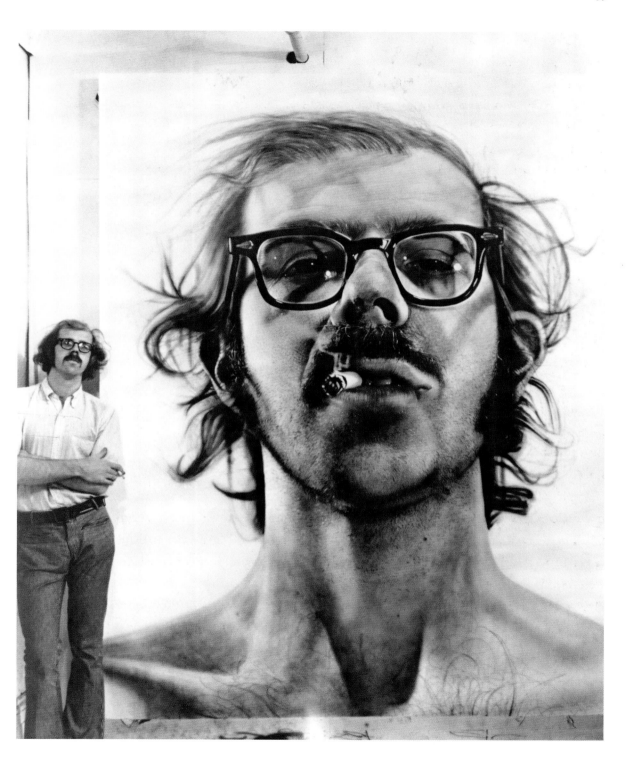

Close standing next to the *Big Self-Portrait*, 1968

sparsity of the picture surface." It was so opposite to "the slathered-on pigment, the great masses of paint, like in a de Kooning" that had characterized Close's student paintings in Seattle. In those days, said Mason, "both of us made big, splashy expressionistic paintings. We used to buy our paint by the gallon from the Bay City Paint Company in San Francisco, and we just wallowed in it." He was even more amazed to learn that Close had made the huge self-portrait not with a brush, but with an airbrush filled with the contents of a forty-cent, studio-size tube of acrylic pigment diluted with a little water. When Mason and I spoke recently, he reflected on the changes that had occurred not only in his former student's approach to painting but also in Close himself since his Washington days. "Chuck was an aggressive, nail-biting personality then," who, when he finished a painting, would bang on his teacher's door, haul it into Mason's studio, and anxiously solicit his opinion. "He wanted attention then! He's a lot more relaxed now."

As even a cursory look at this first Close self-portrait reveals, strange and unanticipated things can happen as a photographic image is enlarged and transferred to canvas. Minor irregularities in a subject's features can assume epic scale. Close must have known that photographing himself from just below eye level would guarantee some arresting effects. His nose, a bit askew in real life, is much more so in the painting. In fact, it's the painting's focal point, and as his head tilts back, we find ourselves looking up into what he ruefully describes as "my lima-bean-shaped nostrils." As his good friend, the playwright John Guare, has written, "The great faces that Chuck Close paints remind me of the statues found on Easter Island" (*Chuck Close: Life and Work 1988–1995*. London: Thames and Hudson, 1995, p. 15). Close readily accepts Guare's comparison, saying of the Easter Island primal heads, "You can look right up their noses, too." For all the *Big Self-Portrait*'s hyper-realistic qualities, Close took a few liberties here and there in translating to canvas what the photograph told him. His face in this realization is a shade wider than in the photo-maquette; a darker line of stubble separates his chin from his neck; and the in-your-face cigarette is more prominent, its plume of smoke more visible. Minor adjustments, but they add up.

Among the felicitous by-products of being his own model on that hot 1967 summer day was a twenty-nine-inch-high pencil drawing in which Close's face appears reversed. His wispy hair is parted on the right, as opposed to the camera-derived rendition in the *Big Self-Portrait,* and accordingly the cigarette projects pointedly

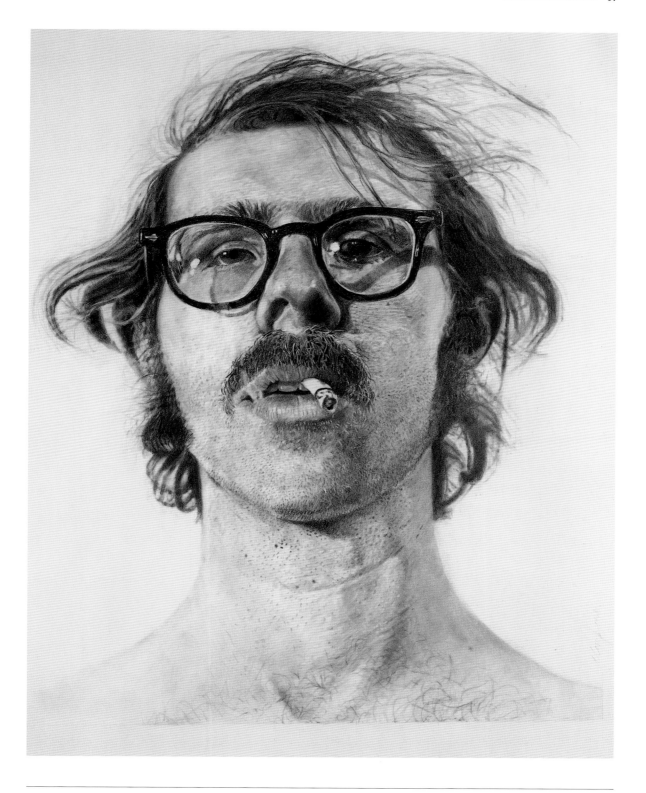

Self-Portrait, 1968. Pencil on paper, 29 x 23". Collection of the Museum of Fine Arts, Boston; gift of Susan W. Paine in memory of Stephen D. Paine and in honor of Clifford S. Ackley

Maquette for *Self-Portrait*, 1968. Ink and felt-tip pen on collaged photograph with masking tape, 20 x 16". Collection of William Bass

not from the right, but from the left side of his mouth. When I asked Close how he arrived at this particular turned-around image, his insouciant response was that it was the product of a darkroom mistake that appealed to him. While handling the self-portrait negatives, he said, "I accidentally flipped one over and made a few prints from it—backward, but backward was how I always saw myself in the mirror, so everything looked all right to me." That contrary reversed print, overlaid with a fine netlike grid, would serve as a photo-maquette for many other works in various techniques.

Five years later, for example, it led to another drawing, an almost six-foot-high cigarette-free rendition of himself on paper, which he mounted on canvas. Its title, *Self-Portrait/58,424,* was derived from the number of barely perceptible grid squares that composed the drawing. Within the pencil lines of each square were minuscule dots in varying degrees of gray. In 1980 he again used the turned-around photograph, this time for a sketchy self-portrait in charcoal, some forty inches in height. That same year he made a "fingerprint drawing" from it by pressing his right index finger and thumb against a black inkpad and then pressing them against a sheet of toned paper. As in subsequent fingerprint drawings, both of himself and other models, the blurry-edged, whorled shapes in shades of gray cohered into instantly recognizable features.

It was about the time of that huge dot drawing that Close made a dismaying discovery. "I was walking up Madison Avenue, on my way to the opening of my first dot-drawing show at the Bykert Gallery in 1973. There were about thirty works in it, including one of me. I walked by a magazine stand, and hanging there was a copy of *Scientific American.* On its cover was a digital image of Jefferson that had been made on a computer. I was nearly knocked off my feet! I thought, 'Oh, my God, nobody's going to believe that I made those dot pieces without knowing that this technology existed, or in fact that I didn't use some of it to make my pictures.' I bought the magazine and took it to the gallery, reading it and poring over the illustrations." He remembers thinking that there had to be some connection between "the kind of averaging of information that the computer did and the way that I digest information and make marks in grid squares to represent it." While Close sensed some kind of connection between his work and the *Scientific American* cover illustration, he says, "I quickly realized I wasn't interested in having the machine do the work for me, or in having any kind of artificial layer between the image and me."

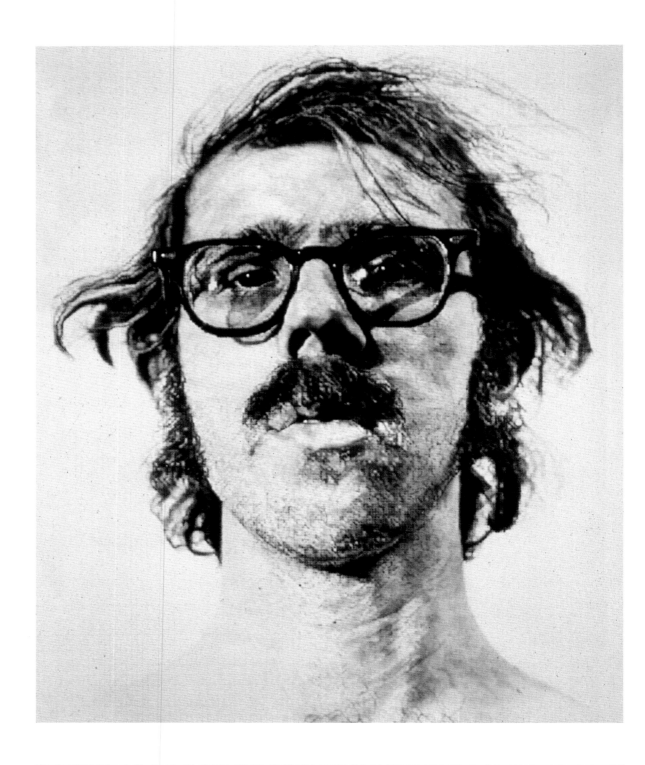

Self-Portrait / 58,424, 1973. Ink and pencil on paper mounted on canvas, 70 ½ x 58". Collection of William Bass

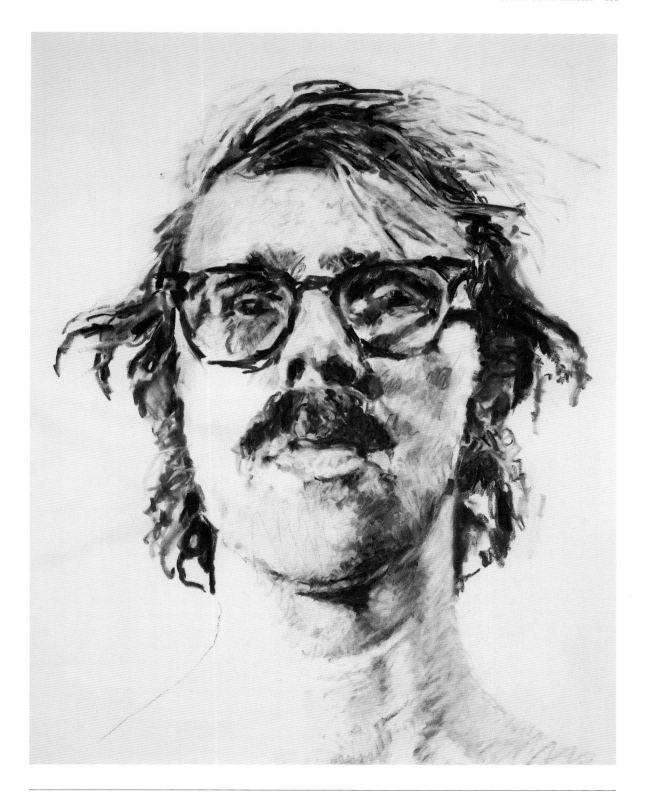

Self-Portrait, 1980. Charcoal on paper, 43 x 30¼". Private Collection

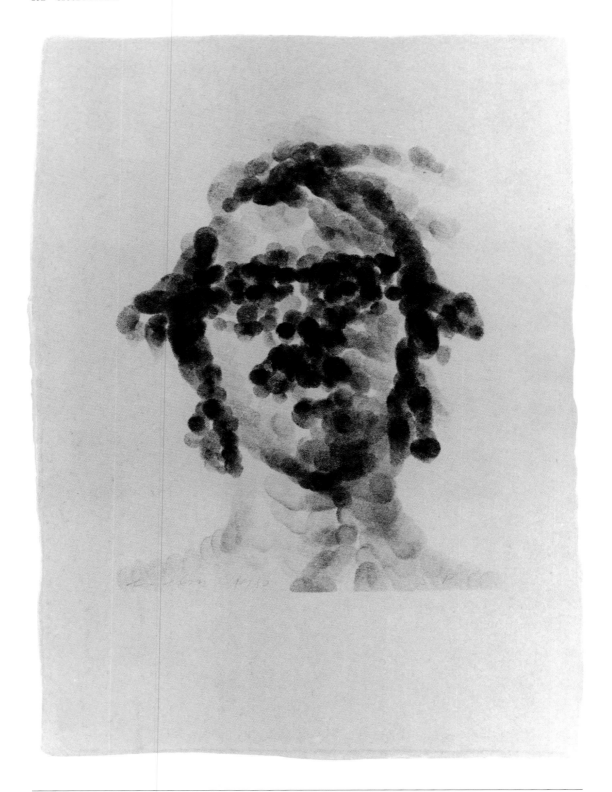

Self-Portrait, 1980. Stamp pad ink on gray paper, 15 ¾ x 11 ½". Collection of Vivian Horan

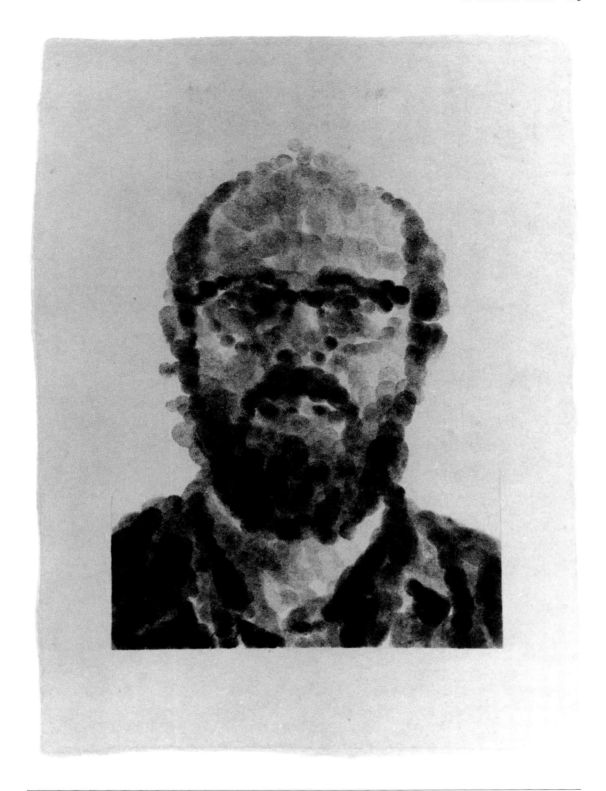

Self-Portrait, 1980. Stamp pad ink on gray paper, 15 ¾ x 11 ½". Private collection

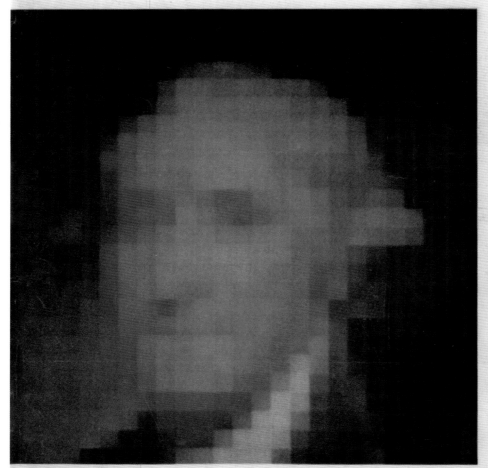

Cover of *Scientific American*, November 1973

The truth is that "I've stayed pretty computer-illiterate. People have offered me computers to work with—but no thanks!"

As Close and I compared photographs of the *Big Self-Portrait* and the large 1973 pencil drawing, I suggested that he looked a touch more arrogant in the painting. "Arrogant?" was his mock-horror response. "You're reading arrogance into that painting?" "Well," I persisted, "maybe it's the cigarette and the sneer?" He shook his head, pityingly; it was painfully evident that I just didn't get it. After all, he sighed, where was I in the late 1950s and '60s? "Anyone who ever saw Jean-Paul Belmondo in *Breathless* with a cigarette in his mouth, or Humphrey Bogart with one between his lips, would certainly understand what was really cool then."

The Hairy Revolutionary: The Descendants of a 1975 Photograph

In 1975 Close made a series of instant shots, some of himself, others of family and friends, using a Graflex single-lens-reflex 4 x 5 box camera fitted with a Polaroid film-holder back. The most memorable one, of his wild-eyed, heavily bearded face, would be an especially fertile source for a series of self-portraits in drawings and prints. Though this photograph never led to a painted self-portrait, it was the vehicle for so many ideas about deconstructing descriptive form into abstract marks that it warrants being singled out. By the time it was taken, Close's appearance had undergone a few tonsorial changes since the late 1960s, when he was first his own subject. He had grown a thick beard and heavy mustache, and, in place of the dark rectangular-frame glasses, wore heavy-framed circular ones. The photographic image would have a strong hold on him—for some seventeen years, in fact, during which he used it periodically in numerous inventive versions. Bordered by aged, roughly torn strips of masking tape and overlaid with heavy, cagelike grid lines, it has a beguiling antique look that brings to mind dark and moody associations. Its transfixed face could be that of some zealot, left over from the October Revolution.

In addition to ink-and-graphite dot drawings, each about ten inches high, there were other incarnations of the 1975 photo-maquette image. Some dot drawings were made with an airbrush. By carefully controlling the pressure of each burst from the nozzle, Close applied the exact amount of ink needed in each grid square to match the photograph's black-and-white tonality. The hazy marks in each square

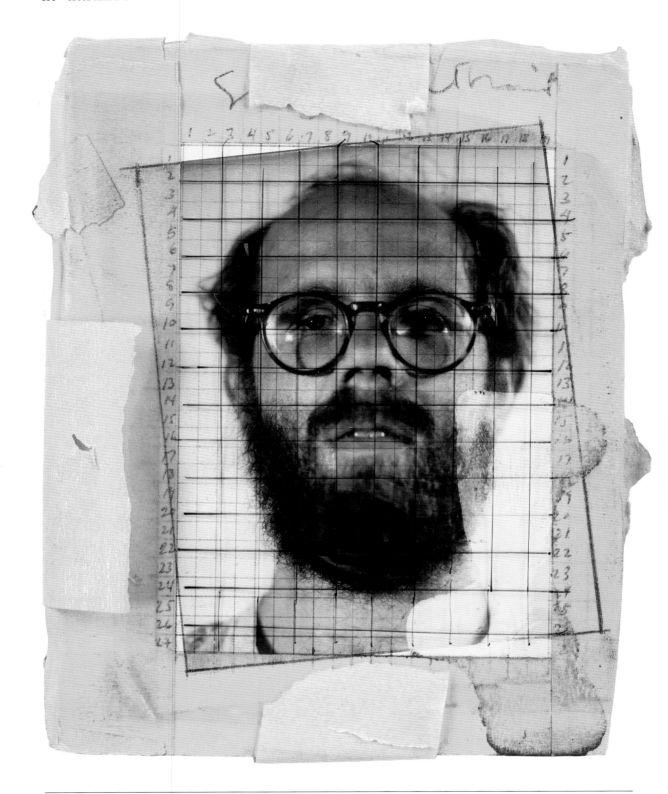

Maquette for *Self-Portrait*, 1975. Black-and-white Polaroid photograph scored with ink, masking tape with ink, and acetate, 4½ x 3⅛". Collection of the artist

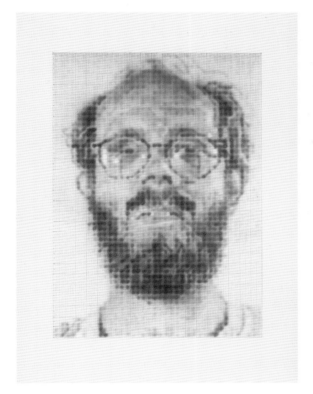 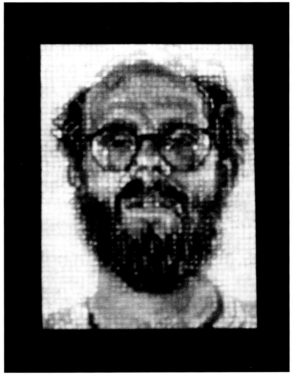

(left) *Self-Portrait/Dot*, 1975. Ink and pencil on paper, 30 x 22". Private collection **(right)** *Self-Portrait/White Dot Version*, 1976. White ink and pencil on black paper, 30 x 22". Whereabouts unknown

seem to hover in the distance, imbuing the drawing with a quality of spatial ambiguity. While these dotted images retain the artist's scruffy look in the photograph, they also manage to romanticize it a bit. His face, tense and shadowy as the camera saw it, is so vaporous in these translations that it looks atmospheric. In these drawings Close began using abstract marks to build form, an idea he would soon employ in his dot paintings.

Also traceable to the grungy countenance in the 1975 photograph were equally distinctive self-portraits in various media. In one, a richly textured 1979 pencil-and-conté drawing, there is a noticeable lightening of mood, to the point that Close seems almost to be smiling through the haze of delicately drawn scrawls. But by far the most radical offspring of the original photograph were two images, made in 1982 and 1983, using liquid paper pulp as his medium—a process that represented uncharted waters for him. This work with globs of viscous material was a drastic departure from the controlled methodology of linear marks that underlay his drawings and etchings. His mentor, and ultimately his collaborator in a new group of works realized in an entirely new medium, was the late Joseph Wilfer, master printer and a master of paper-related technology. Wilfer persuaded an at first reluctant Close to translate some of his portrait images into paper-pulp editions. Close, intrigued by the prospect of working with so strange a medium but also sensing the technical problems that would entail, somewhat reluctantly accepted Wilfer's invitation.

As Close quickly learned, the process was low-tech and quite messy but ingenious. Its rudimentary equipment consisted of aluminum and plastic diffusion grids adapted from fluorescent light fixtures, as well as an arsenal of squeeze bottles filled with liquid paper pulp in various tones of gray that matched those in the grid-overlaid photograph. Making these images was a highly calibrated process that entailed forcing small quantities of the gooey medium into the grid's multiple compartments. Close's first subject was not himself, but his longtime friend the composer Philip Glass, whose expressive late-1960s Dionysian countenance he had already immortalized in a large acrylic portrait and many drawings and prints. He set about matching the black-and-white values in a watercolor painting he had made of Glass by employing a Kodak gray scale with eighteen graduated shades, to which he added six more in order to widen its range. Assigning each tone in the painting a number, he coded each grid compartment into which the viscous fluid would be poured similarly. What was revealed when the metal grille was lifted was

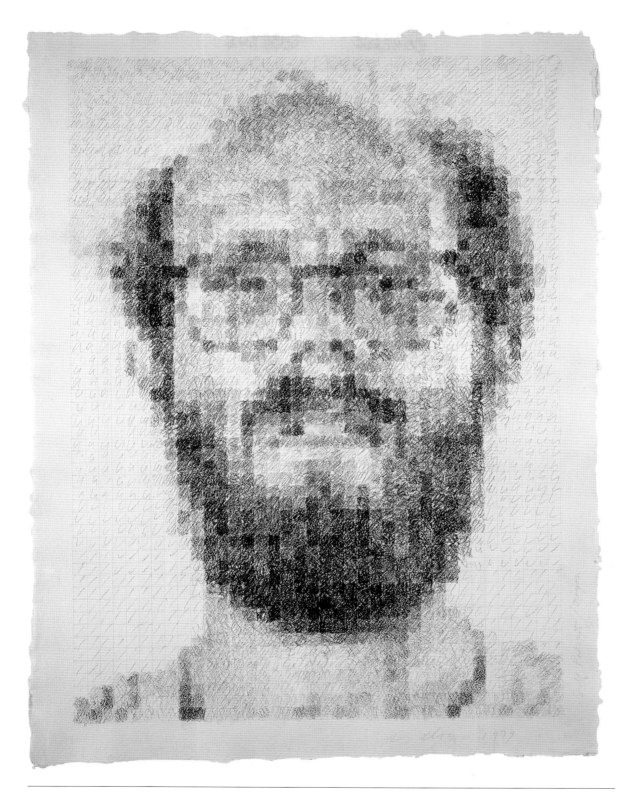

Self-Portrait / Conté crayon, 1979. Conté crayon and pencil on paper, 29½ x 22". Private collection

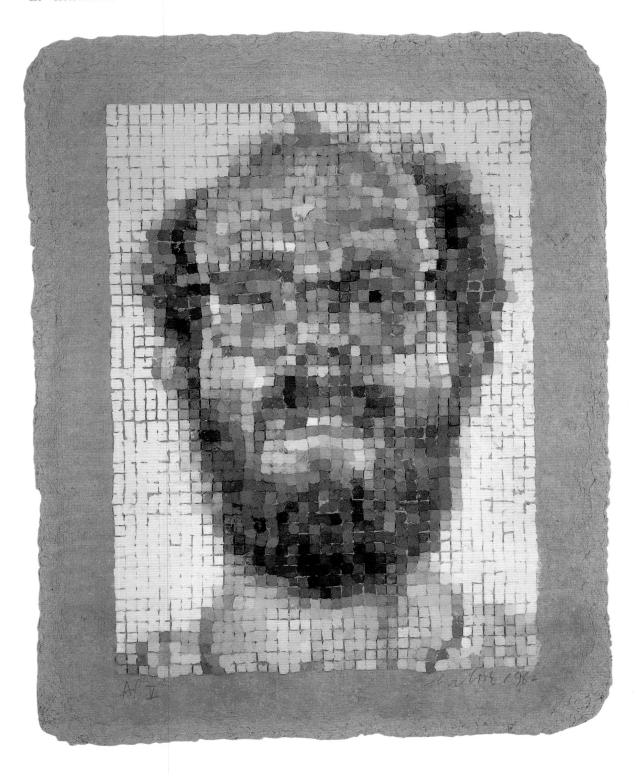

Self-Portrait/Manipulated, 1982. Handmade gray paper, ½-inch grid, manipulated and air-dried, 38 ½ x 28 ⅛".
From an edition of 25

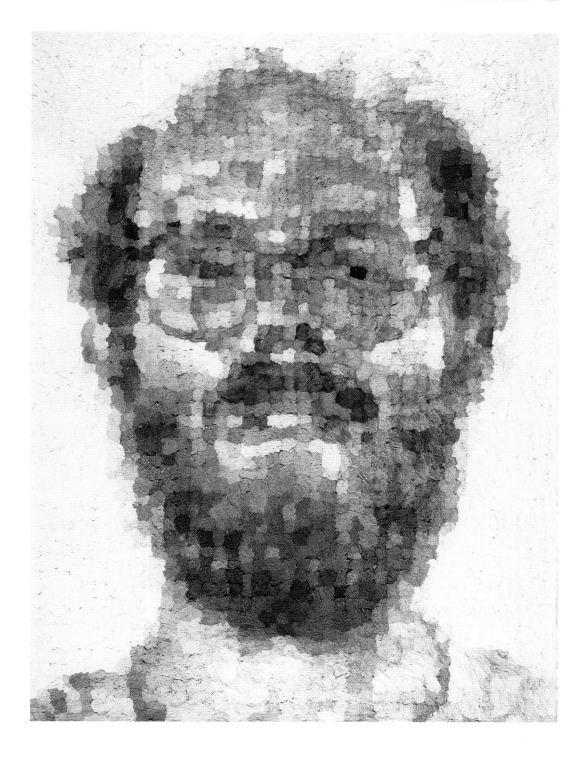

Self-Portrait, 1983. Pulp paper on canvas, 54 x 40". Collection of The Museum of Modern Art, Wakayama, Japan

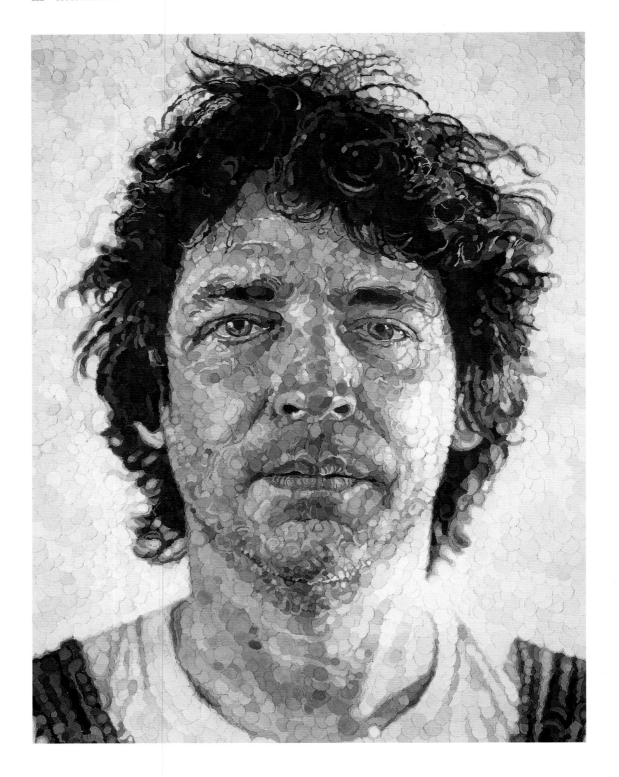

Jud, 1982. Pulp paper collage on canvas, 96 x 72"

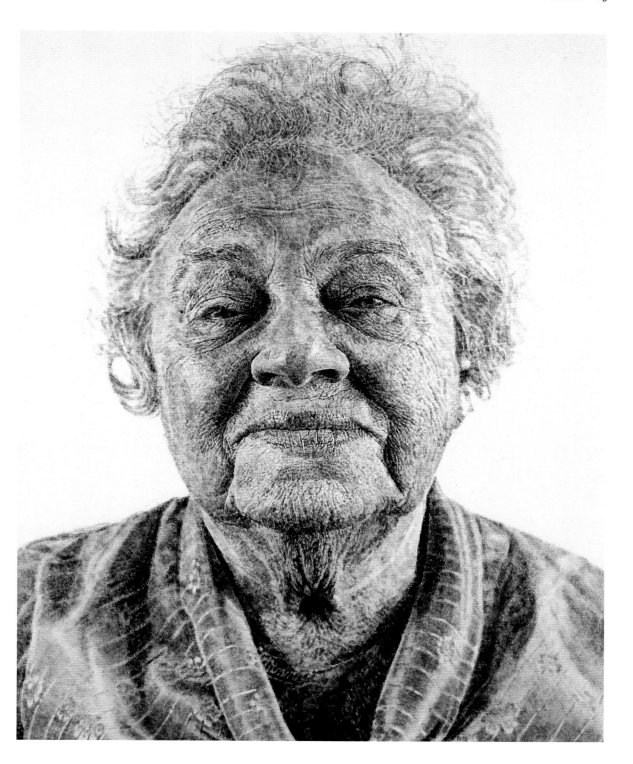

Fanny/Fingerpainting, 1985. Oil on canvas, 102 x 84"

a square-by-square transcription of Glass's face. With that experience successfully concluded, Close was ready to make paper-pulp portraits of himself. The first, a 1982 edition of twenty-five images, consisted of large wobbly squares adhered to sheets of ragged-edged gray paper. In 1983 he made a second self-portrait in this medium, a one-of-a-kind work formed directly on a canvas. Over four-and-a-half-feet high, this hypnotic image is more complex and contains more mosaiclike fragments than its editioned predecessor. In both rough-hewn, oddly charismatic heads, with their inescapable allusion to Byzantine iconography, a wide-eyed Close could be channeling John the Baptist.

Mid-'70s Meditations

Just as fertile a source of imagery as the legendary 1975 photograph, in which Close looks a little on this side of feverish, was another one, dated 1976–77, which shows him as serene and a touch otherworldly. Except for his wide-open eyes, he might be in a state of meditation. He was not. He was simply following the same rule he asks all his subjects to observe: empty your mind of all transient thoughts, and present a neutral face to the camera. This photograph, the source of several drawings and prints and a watercolor, was really two photographs—or, more accurately, one image printed in two versions and on two separate occasions. Both were gelatin silver prints made from the same negative, but one a year after the other. The differences between them were as great as their similarities. In the first, a 1976–77 print scored with a coarse pencil grid, Close is a fugitive presence; only part of his face is visible, his forehead having been washed away when a storage area in his studio basement flooded. With its patina of discoloration and mottling, it could be a memento from another age, but even in its fragmentary state, it intrigues us. Gazing into space, his mouth slightly open, his eyes fixed on some faraway point, Close looks as though he were under a spell. He made a second print from the same negative in 1977, but in order to see what the image would look like on an etching plate, he deliberately reversed it in the darkroom. Having been through the reversal process earlier—if accidentally, in 1968—he was well aware of its effects. Close liked the reversed image well enough to use it for two images each fifty-four inches high: an etching and an aquatint printed in white ink on black paper.

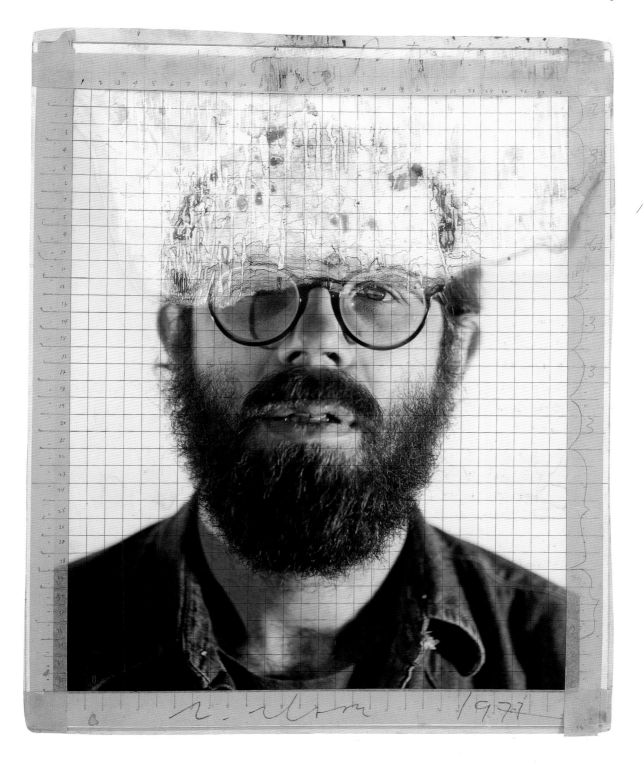

Maquette for *Self-Portrait*, 1976–77. Gelatin-silver print scored with ink and masking tape, 20 x 16". Collection of the artist

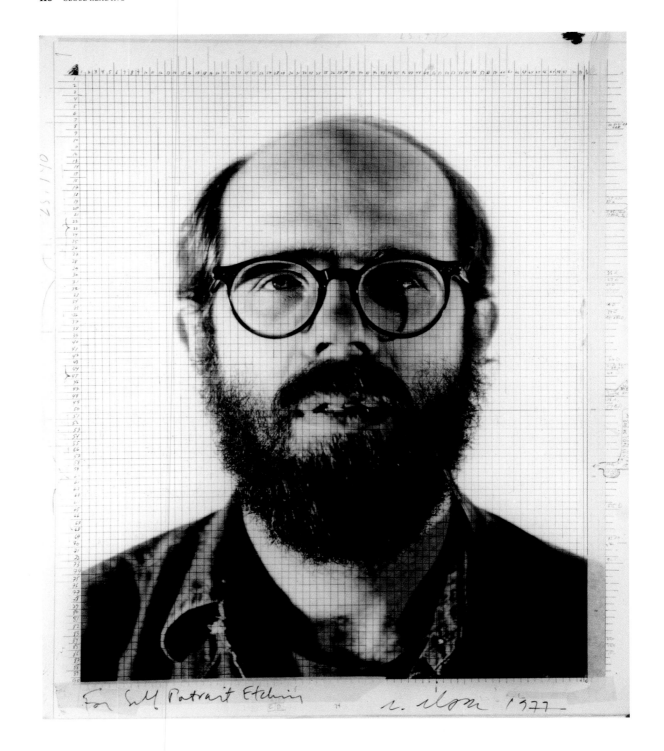

Study for *Self-Portrait Etching*, 1977. Gelatin-silver print, 20¼ x 16¾". Collection of The Metropolitan Museum of Art; gift of Jim Dine, 1979

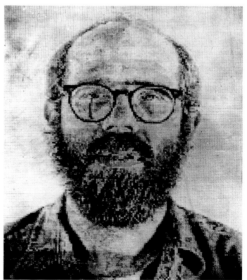

(top, left) Study for *Self-Portrait Etching, Plate*, 1977. Gelatin-silver print, 14 ½ x 12" **(top, right)** Study for *Self-Portrait Etching, Plate reversal*, 1977. Gelatin-silver print, 14 ½ x 12" **(bottom, left)** Study for *Self-Portrait Etching, Plate (flopped)*, 1977. Gelatin-silver print, 14 ½ x 12" **(bottom, right)** Study for *Self-Portrait Etching, Plate reversal (flopped)*, 1977. Gelatin-silver print, 14 ½ x 12". Collection of The Metropolitan Museum of Art; gift of Jim Dine, 1979

As self-portrayals, both versions of the original 1976–77 photograph are at an extreme from how Close had previously presented himself. Unlike those edgier photographs—the 1968 bare-shouldered artist-as-scruffy-young-man and the 1975 artist-as-shaggy-revolutionary—these offer a far more under control view of Close. His expression is so mellow that he could be entering the alpha state. And, although the reprinted 1977 photograph reveals less hair on top than before, what there is has been nicely trimmed, as have his mustache and beard. In the resulting print—the one with greater light-and-dark contrast—the deep shadow extending from the top of his forehead over the bridge of the nose darkens the eye area (in reality, the left one), and the curved shadow of his glasses falls directly over that eye. All of which was intentional, Close says. Nothing about the lighting setup that produced that effect was even remotely accidental. "Usually my photographs are lit from both sides, but more strongly from one side than the other. For this one, though, I went a little further with side lighting because I wanted to cancel out the eye area with a fuzzy mark right across it." As he smilingly acknowledges, "My doing this kind of thing would probably drive portrait photographers crazy, if they even bothered to look at my photographs. They would also want the glare off the lens, but it's the glare that tells you that there's glass there."

Tracking the by-products of the original 1976–77 photograph, whether straight-on or reversed for the purposes of printmaking, can be confusing because, among other reasons, Close was working in several stylistic modes then. His penchant for abstract marks found fresh expression in a succession of etchings and aquatints, whose grid squares he filled with orderly dots and diagonal lines. His face in these compositions is composed of innumerable, blocky gray tones as it emerges from backgrounds resembling graph paper. The larger the squares that he combined to make the face, the more abstract the images were. An elegant example of this technique, in which descriptive and abstract forms are in perfect balance, is the small 1977 black-and-white *Self-Portrait/Pastel*. For all its counterpoint of abstraction, so faithful is this self-rendition, and so sure was Close's touch with the pastel stick, that it is as though he were standing on the other side of a wide-mesh screen door.

Even during his steady experiments in dissolving and reconstituting form, Close could come up with an occasional surprise. One of these was the startlingly photographic, almost seven-foot-high black-and-white watercolor *Self-Portrait* of 1976–77, the same date as the water-damaged, sepia-toned photograph that led to it. In the

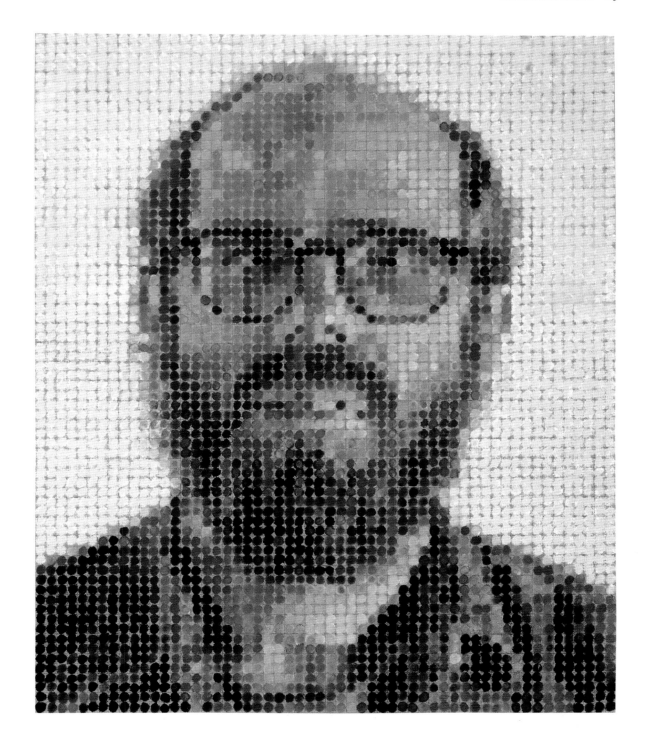

Self-Portrait/Pastel, 1977. Pastel and watercolor on paper, 30 x 22". Collection of Virginia Museum of Fine Arts, Richmond; gift of The Sydney and Fran Louis Foundation

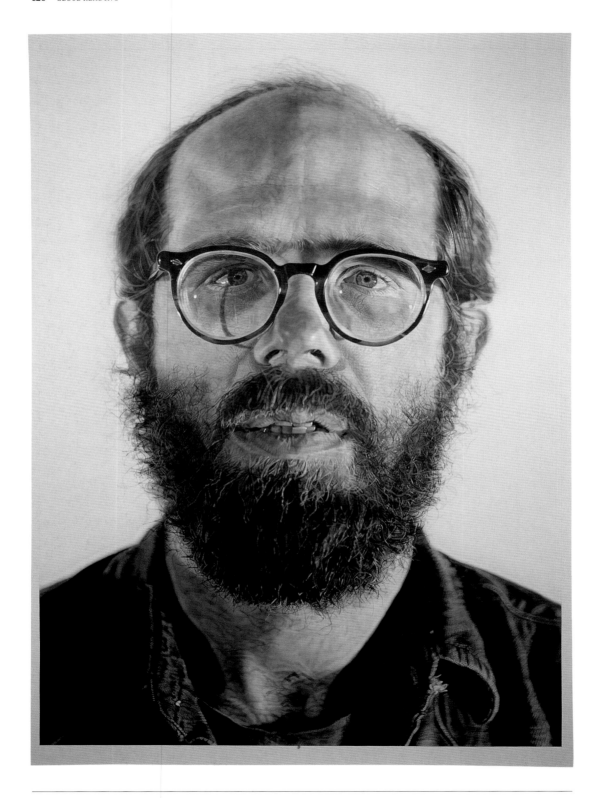

Self-Portrait, 1976–77. Watercolor on paper mounted on canvas, 81 x 58 ¾". Collection of Museum modern Kunst Stiftung Ludwig, Leihgabe der Österreichischen Ludwig Stiftung, Vienna

photograph, his face, though partially washed away, is as the camera recorded it, with no reversal of his features. The absolute factualism of the large watercolor is a throwback to his continuous-surface acrylic paintings of the late 1960s and early 1970s. It is also an amazing tour de force of watercolor technique. Its wealth of detail actually seems to exceed what is visible in the salvaged photograph, its true DNA ancestor. Still, Close allowed himself a little freedom in translating that image to paint. He lessened the darkness over the right eye in the painting, so that it would be as clearly represented as the left. Reflections play a large part, whether as spots of bright light on his glasses and the whites of his eyes or indications of moisture on his teeth and upper lip. As in the photograph, the depth of field is tightly compressed. While the artist's features are in exact focus, the contours of his head and shoulders against the picture's depthless white background are less so.

For all its scale, the *Self-Portrait* watercolor is an intimate painting. There is an odd vulnerability about this view, notably absent from the assertive black-and-white portrayal that launched his career. It was realized in washes so thin and transparent that Close's face, however monumental in scale, seems weightless. This monumental self-depiction had another distinction: it was the last of his hyperrealistic self-portraits.

Dotted Faces: 1986 and 1987

By the mid-1980s Close had reached a stage in his painting that left little question about his intention to explore the nature of reality by probing well beneath illusionistic surfaces. His approach shifted from a more or less rote use of information extracted from the photo-maquette to a systematic translation of what he saw into abstract marks. The consequent importance of the grid, which was playing a more prominent part in his painting, is apparent in the two self-portraits painted in 1986 and 1987, respectively. Composed of vibrant color dots suspended within the grid's numerous squares, these are a chromatic continuation of the dot drawing concept he explored so thoroughly in the mid-1970s. He no longer sought to emulate the photograph's smooth surface, but instead deconstructed the data he found within it in order to reassemble it in new ways. The 1986 *Self-Portrait*, at four-and-a-half feet high a mid-sized painting by Close's standards, is one of his first dot, or "broken surface," paintings, and the first of himself in oil. Its source was a strongly illuminated

C-print made from a color negative. In the photograph he wears a mustard-colored shirt open at the collar and a loosely knotted blue tie. Everything about the photograph, including its color, is dense and heavy. His eye sockets are in shadow; deep lines alongside his sharply triangular nose extend down past his mouth into his beard; dark brown patches of hair on either side of his bald dome match his beard and mustache.

Close's own assessment of that photo-maquette is not warm. "The shadows from the overhead lighting darkened my eyes, and because of that lighting, my mustache seems to turn down more than it does in other photographs of me. Then, because the transparency I used to make the print was so dark, you couldn't see my teeth very well, but they're back there." Despite these drawbacks, he was "satisfied enough" with this less than perfect image to paint from it. Maybe not the wisest decision, he says, shaking his head in remembered exasperation, "because I had to fight the photograph the whole damn way. Let's see if I can make an analogy: Say you're trying to do something with a certain tool, but it's not working right, and you wish to hell you had equipped yourself differently. But in the end, there's something about dealing with all that resistance that can be interesting. I guess that's how I felt when I was making this painting."

Part of the problem could have been that Close was progressively less interested in replicating a photograph's smooth surface than in extracting whatever data he needed from it. Like his other dot paintings then, this self-portrait was a radical departure from rote limning and has surprisingly little connection to its color print source. The 1986 painting is less dense in feeling than the photograph; there is a sense of air moving through it. Its surface is active and yeasty, and for all its compulsive dot-by-dot execution, the overall effect is richly organic and sensuous. Flecks of pale blue pigment coexist alongside pale pink ones in the face and in the pearly background. The artist's mustache and beard, so dark and undifferentiated in the C- print, are lighter and more variegated in the painting. Even his teeth, barely perceptible in the photograph, turn up here, if startlingly transmogrified. While Close had no overt intention to emphasize them, they materialize as peculiar shapes from rows of dot-filled circles between his lips. So peculiar, he says, that when Arne Glimcher first saw the painting, he asked him, "'Are those pimiento-stuffed olives in your mouth? Those circular green things with the red centers?' The minute he said that, I could never see the painting as anything but *Self-Portrait with Olives*."

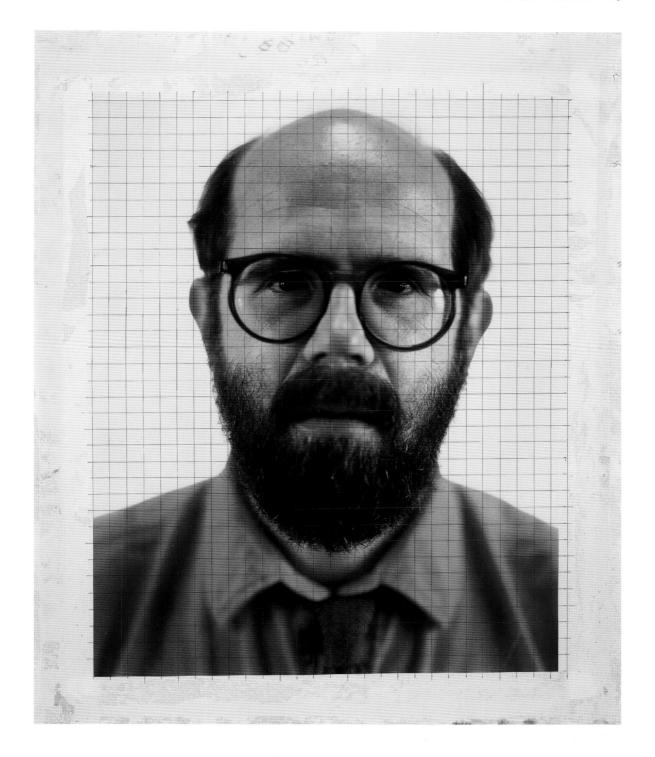

Maquette for *Self-Portrait*, 1985. C-print scored with ink and tape mounted on foamcore, 24 x 19 ¾". Collection of the artist

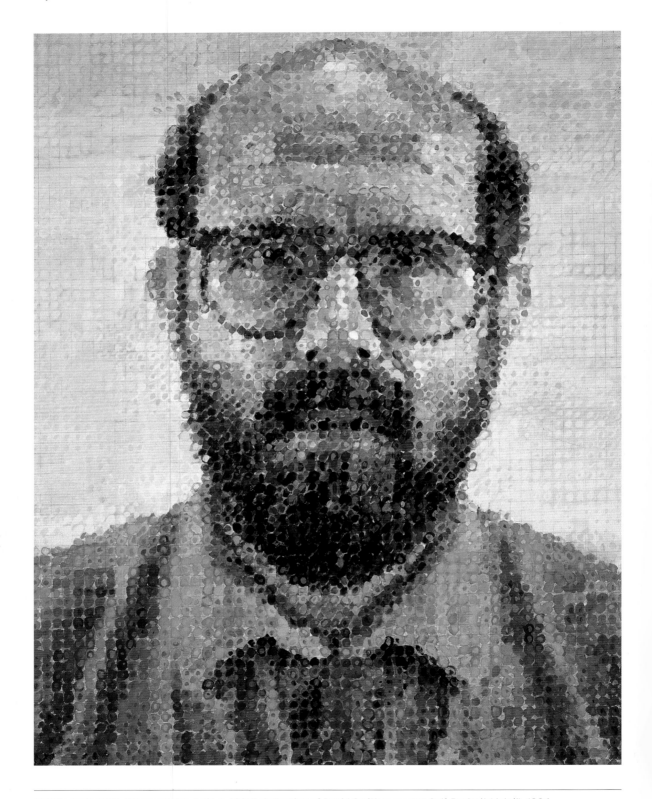

Self-Portrait, 1986. Oil on canvas, 54½ x 42¼". Collection of David Smith **(opposite)** *Self-Portrait* (detail), 1986

For all its surface agitation, this painting retains the somber gravity of the photograph in many ways. In addition, Close's fluent use of oil paint, which by now had replaced acrylic as the medium of choice, introduced a rich new expressionistic quality into his painting. The malleability and translucency of that medium allowed him to distribute his marks over the surface in a more spontaneous, energetic fashion. Formal as his pose is in this self-portrayal, it is no static vision, but rather has an almost improvisational look. There is a gritty immediacy about it. Close explains, only semiseriously, that he made it during a time when he strongly identified with the "workingman" ethos. He has always thought of himself as an ordinary craftsman, he says, "sort of like a plumber or carpenter, or anyone who turns out a day's work." Aside from whatever identification with the proletariat the 1986 *Self-Portrait* may have signified for its creator, it stands as an early example of his shift from absolute dependence on photographic sources to increasingly free improvisation on them. Close looks uncertain and a bit stern in this self-portrayal as, through heavy-rimmed glasses, he returns the viewer's objective gaze with a dour, steady look of his own.

If the color-daubed surface of this painting is reminiscent of Impressionism's dotted domain, the methodology behind it alludes more to Seurat's orderly vision of that world than, say, to van Gogh's fervent embrace of it. Allowing one's eyes to wander a Close facescape such as this one, with its carefully positioned color fragments, it is hard not to think about Seurat. Close has also thought about him from time to time, enough to reflect on possible connections between the great pointillist's form-building techniques and his own, but what interests him most are the differences between their approaches. "If you actually study a Seurat landscape carefully, like *La Grand Jatte*," he points out, "you'll see that the vast majority of dots in any given area are essentially the generic color of that area. For instance, when he paints grass, most dots in that area will be green. There will also be red, yellow, orange, and blue dots there to modify the green, but it's mainly the green ones that carry the message." By contrast, Close suggests, his own use of color is governed less by the actual hue of whatever he might be painting, such as a subject's skin, hair, or eye color, but rather how he perceives that color. Even so specific a form as the "white" of an eye, he argues, is actually composed of many hues: blues, pinks, ochres— almost everything but pure white.

When it comes to antecedents, Close muses, "I really think my paintings are less related to Seurat than to Roman floor mosaics." He admires the remarkable ability of

those early artists "to grab a handful of rocks and make a head out of them. Not just any old head, but one that can move people. When you look at them, you can feel the artist's insistence that all their incremental units should be seen at the same time as the images that he made by combining them. You keep flipping back and forth from the parts to the whole. That's not something I had thought much about earlier, while making my own work. But I do now." The idea of building form through the accrual of shapes that also function independently has long fascinated him. (For a while he had a mid-1920s aerial view photograph titled *The Human American* pinned to his studio wall. It showed a great winged bird, formed of 12,500 soldiers, nurses, and horses based at Camp Gordon, Georgia, patriotically crowded together.)

He is somewhat less responsive to a later manifestation of the mosaicist's art, that of Byzantium, which he saw during a two-month fellowship in 1995 at the American Academy of Rome. During that sojourn, he traveled to Ravenna for a firsthand look at the mosaic portrayals of the Emperor Justinian and his empress, Theodora, in the mid-sixth-century Basilica of San Vitale. While the general view is that abstraction prevails over naturalism in Byzantium's austere iconography, Close, offering a dissenting opinion, asked an assistant in his studio to bring him a volume on the Ravenna mosaics. "The artists who made those portraits looked closely at real people," he insisted, as he turned the pages and found illustrations of the imperial pair. "Just look at that face!" he said, pointing to the fierce countenance of Justinian's ornately bejeweled wife. "You could arrest that person!" For all his admiration of the Ravenna images, his preference was clearly for those earlier manifestations of mosaic technique that he saw during the same Italian journey. In the end, it was classical Italy's pagan naturalism rather than Byzantium's hieratic figuration that won the day for him. "The Pompeian mosaics that I liked so much were images of flowers, animals, and people," he says. "They were much cruder than the Byzantine ones. They had no gold leaf or shiny backgrounds. They were also more physical, more approachable, and had real urgency."

In contrast to the murky photograph Close used for the 1986 *Self-Portrait*, that employed the following year for a second dot self-portrait is artfully illuminated, has clear contours, and at first seems to present him as the personification of self-composure. His fastidiously groomed, forty-seven-year-old self regards us calmly, with only the slightest suggestion of a smile. Like its deeper-toned predecessor, the photograph offers a few clues about how he perceived himself. Below its calm surface, contradictory impulses subvert any purely placid reading. It hints at the complex

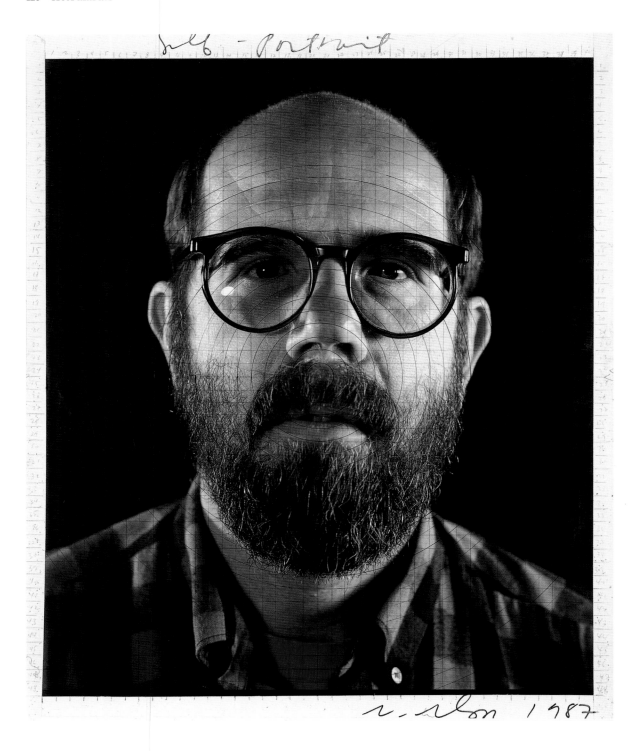

Maquette for *Self-Portrait*, 1987. Polaroid Polacolor ER photograph scored with ink and mounted on cardboard, unique 24 x 20". Collection of Mr. and Mrs. Dexter Paine III

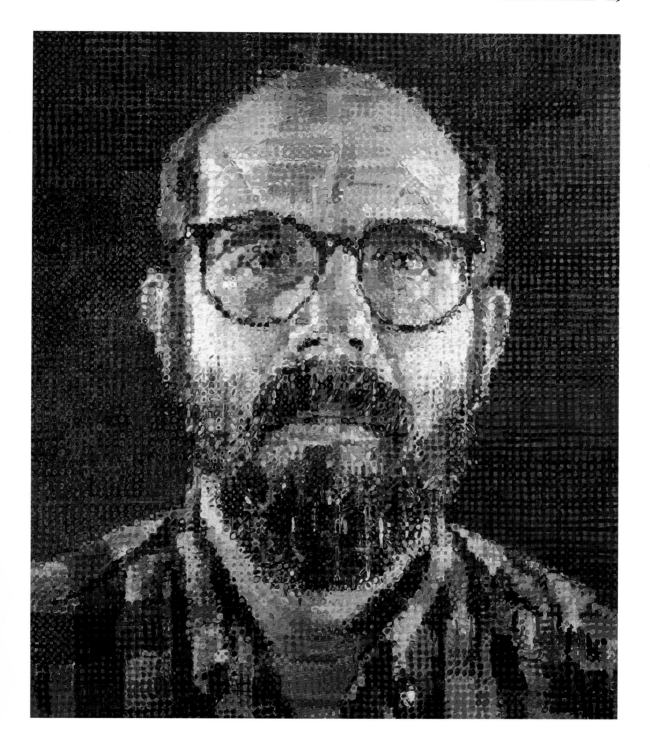

Self-Portrait, 1987. Oil on canvas, 72 x 60". Collection of Arne and Milly Glimcher

psychology of an artist-sitter who, for all his efforts to present himself as neutrally as possible, seems unable to do so under such scrutiny. Something other than Close's vaunted objectivity—maybe a little defensiveness—seems to take over.

The surface of the six-foot-high 1987 *Self-Portrait* scintillates with small dots roughly daubed over larger ones. So strong are its textural qualities that the edges between Close's features virtually dissolve into one another, and no sharp contours define the frames of his glasses or separate them from the face behind them. His face is described here in a limited palette of pinkish flesh tones with a scattering of white highlights; a subtle blue gray underpainting throughout this area keeps the picture from taking on a roseate hue. This was his last self-portrait before his December 7, 1988, seizure.

Posthospital Mirrorings and Phantoms: 1991–95

Close describes his illness as being "curiously liberating on some level." He claims to have not gone through a period of anger and denial, even though, he says, "I kept feeling as though I should have. People told me I should have gone through that phase, but I never thought, 'Why me?' You're supposed to get religion when you get in serious trouble, and it occurred to me when I was in intensive care that it might be a smart thing to pray. But, then, I thought, 'Nah, I wouldn't have any respect for any God who would listen to me only after something horrible happened, especially if I hadn't been talking to Him or Her for all these years.'" After the trauma of his seizure and lengthy rehabilitation at Rusk, it would not have been unreasonable to expect his paintings of himself to differ markedly from the previous ones. While I feel that they do, emotionally and formally, the questions remains, Just how much did his sudden illness and long hospitalization have to do with the increasingly open quality of his work? Glimcher maintains that Close's painting was already on the way to greater openness and that his illness "absolutely accelerated what was already happening." Its effects, however, he ventures, "might have allowed him a little self-indulgence that he held back before. Now, he allowed himself to paint extravagantly." For his part, Close is also certain that, whatever major changes others may perceive in the paintings, he was already working in more expressive ways before his illness. As an example, he cites *Cindy II*, his second painting of Cindy Sherman,

which is constructed on a circular grid. "It was the last painting I did before going to the hospital, and it was as open and loose as any I have done since then."

Responding with a sigh to my question about the effects of Close's illness on his psyche as well as his art, Leslie Close said, "I don't think it really changed him as a person. It intensified things about him. He became more who he is, except that his activities have changed. The weight that his work has for him—its meaning for him—has changed, but that might have changed as he got older. The kids are gone. He can't do things he loved to do before. What he does in the studio is what he does best. In the years before his illness he never worked seven days a week. Now he works all the time. His work and his social life are the things he does. He has no hobbies. He is very focused. Nothing deters or distracts him from his work. He is painting away in the studio. The Yankee game is on. His face is two inches from the canvas. He has an unbelievable, almost pathological ability to concentrate. You could have a three-ring circus in the house and all kinds of upheavals, but he is undeterred."

Although "expressionistic" is the term Chuck Close might least care to have applied to his work, the posthospital self-portraits, with their heavily brushed, roughly defined abstract units, most certainly qualify. Much as he may have sought to avoid dealing with the personal in his painting, how long, after all, could an artist of his sensibilities maintain a stance of emotional detachment, especially when he is his own subject? Fate had suddenly granted him an unsought opportunity to look deeply into himself, and what he saw affected how he would present himself in his self-portraits. More and more, it might have been Rembrandt, not Vermeer, looking over his shoulder.

The first four posthospital self-portraits are in monochromatic tones of warm gray. But they have another commonality: they portray a Close more emotionally exposed than in prior works. He acknowledges, however guardedly, that a new sensibility does pervade them. Of the 1991 *Self-Portrait*, he says, with an amused shrug, "It seems to be warmer and more accepting of me." He makes light of the question "Why?" by responding, "Who knows? Maybe it's a 'kinder, gentler' portrait because Bush Senior was still our president." With less levity, he continues, "I was a changed person—but, at the same time, I don't think I had changed that much at all. That's the paradox of having something major happen to you. Many of my friends marvel at how much the same person I am, except for the fact that I'm confined to a wheelchair."

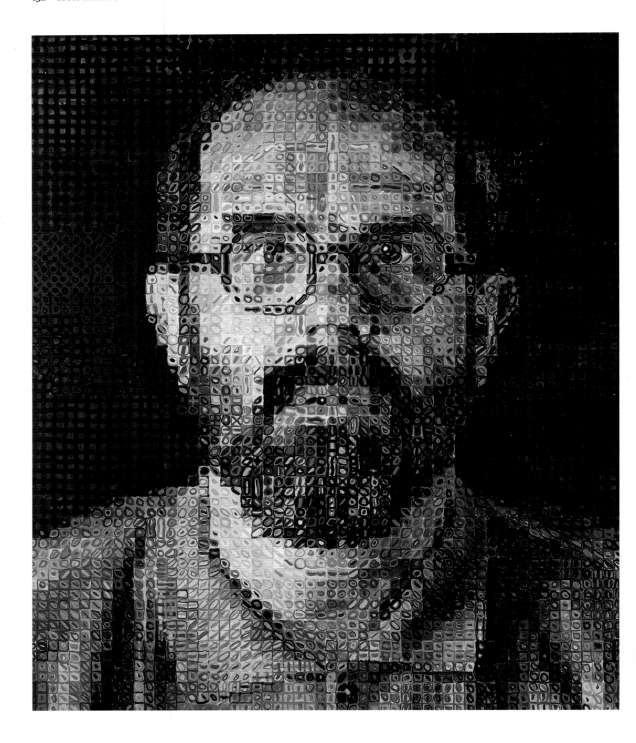

Self-Portrait, 1991. Oil on canvas, 100 x 84". Collection of The Museum of Modern Art, New York; partial and promised gift of UBS, 2002 **(opposite)** *Self-Portrait* (detail), 1991

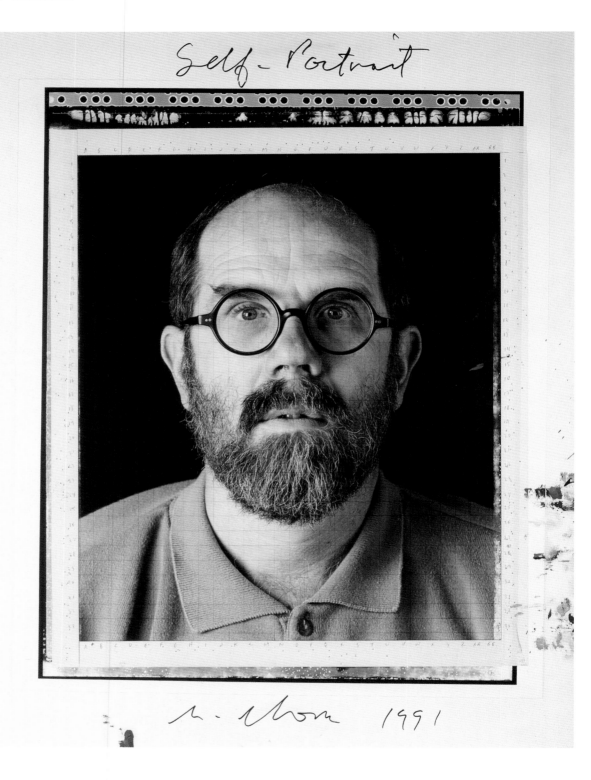

Study for *Self-Portrait*, 1991. Black-and-white Polaroid photograph scored with ink, unique 24 x 20". Collection of Mr. Doron Sebbag

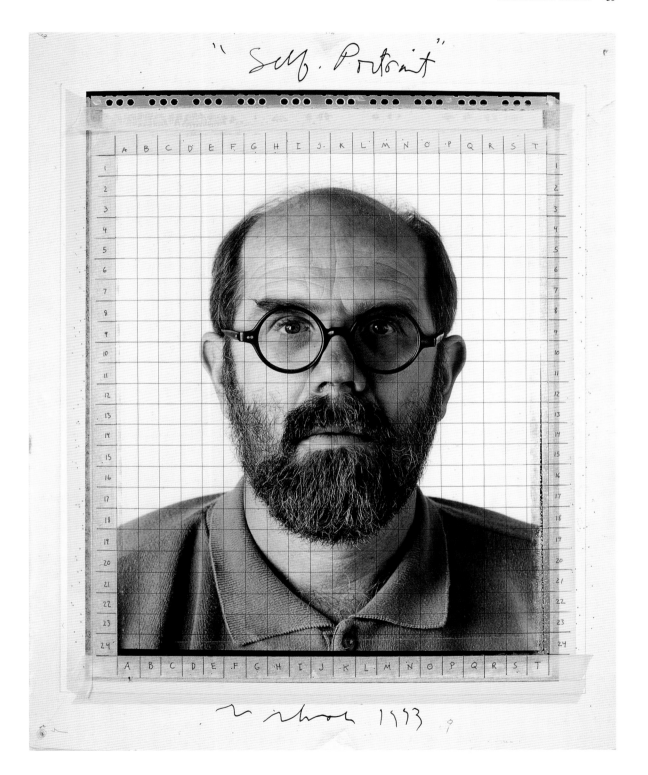

Maquette for *Self-Portrait*, 1993. Gelatin-silver print from Polaroid negative scored with ink and masking tape, 24 x 20".
Collection of the artist

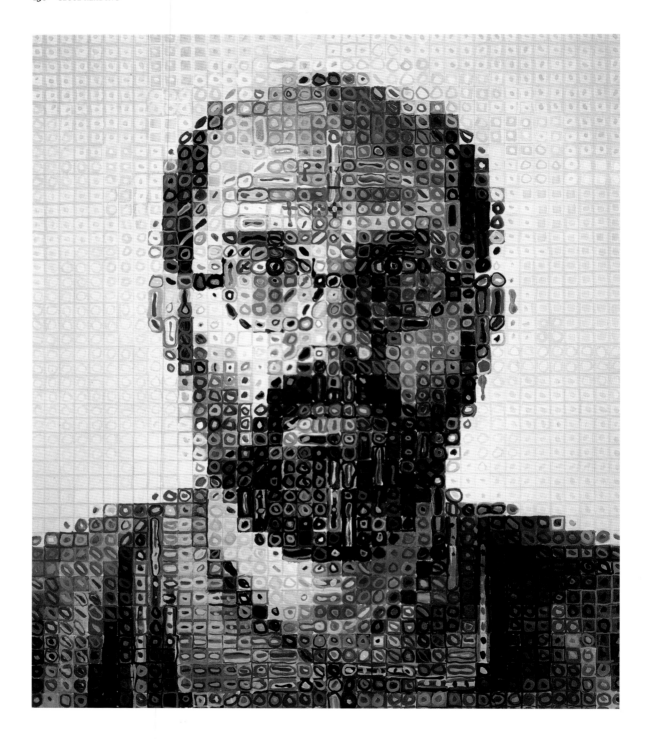

Self-Portrait, 1993. Oil on canvas, 72 x 60". Private collection

It's fair to say that Close has strong reservations, if not actual distaste, for such subjective readings of his work. "For me, my painting is predominantly about formal issues, and that's all there is to it. I leave it to others to read it otherwise." True, but it's hard to ignore the evidence—the not merely tenuous clues both in how he presents himself before the lens and in interpretation—which goes well beyond facial expression. There is quite a division of opinion among the artists who Close painted, and with whom I spoke in writing this book. Some sense a profound self-revelation in Close's self-portraits—while others emphatically do not. Quite a few comment on the greater openness of these works after his illness. In their view, and mine, that evidence of vulnerability neither diminishes nor conflicts with Close's objective to make a painting, whether of himself or any other subject, as formally rigorous as he can.

In looking at the photo-maquette that the 1991 self-portrait was made from, it's difficult not to be conscious of Close's more emotionally exposed self. It has him gazing with great concentration into the lens. Lighting is the only variable in this otherwise elegantly symmetrical composition. The right side of his face is strongly illuminated, the left in darkness. The painting Close made from the photo-maquette is even more subjective. Detailed as it is, it feels intangible and more about essences than exterior form. Close's countenance in this opalescent synthesis of description and abstraction has been transmuted into a vast field of abstract marks. By now, the color dots of his previous paintings had mutated into a vibrant new iconography of squashed ovals and wobbly squares. Static as his pose is, the surface of the painting flickers with energy. Even more open formally and psychologically is the painting Close made of himself in 1993. Smaller than its predecessor (six feet high, as compared to the 1991 portrait's roughly eight feet), it radiates an almost mystical feeling.

Both paintings derive from photographs made during the same 1991 session. (Close admits that he is not too consistent in dating such photographs. He might date one at the time it was taken, another, when it is used for a painting.) The salient difference between the two is that the first has a dark background, the second a light one. Far greater, though, are the differences between the paintings they gave rise to, differences not only in form but in expressiveness. Although the 1993 *Self-Portrait* is, like its predecessor, a dense accumulation of gray squares, its representation of the artist is less precise, even a little out-of-focus—and yet, because of that indeterminacy, all the more arresting. It is an adventurous work formally, and a compelling

one emotionally. In this strangely amorphous rendition, the contours of his head and shoulders literally dissolve.

What emerged in both paintings were contradictory views of Close. In making them, he seems to have sought a balance not only between absolute description and total abstraction, but also between intimacy and generalization. That balance differs sharply from one painting to the other. The pragmatic explanation for this is simple: when the grid squares are small and plentiful, as in the 1991 painting, the image is more factual, more detailed; when larger and fewer, as in the 1993 portrait, Close's face is so indistinctly indicated that it seems to dematerialize. The psychological fallout of such manipulation of form is both intriguing and wondrous. Even for an artist so concerned with process over emotion as Close is, powerful feelings have a way of manifesting themselves during that process.

So caught up was Close with portraying himself in somber black-and-white images that in 1995 he took it to a powerful extreme in a pair of phantomlike, six-foot-high paintings, one a front view, the other a profile. These differ drastically from his first two, relatively muted posthospital portraits, as much for the eeriness of the countenance they portray as for the restless abstract shapes that comprise them. Even as his paintings became increasingly radical in their shift away from illusionism, the photographs that he made them from took on greater subjectivity. Prior to making this curious pair of paintings, Close had taken several photographs of himself against a black background. In the head-on-view maquette, an artist looking more relaxed than usual, dressed in a dark jacket over a startlingly white shirt, smiles tentatively at the camera. In all, there is a new accessibility about how he presents himself. His eyes engage the viewer's; his expression is far less strained than in the previous photographs. In fact, it's quite mellow. Signs of age have accrued: more furrows in his forehead, more gray in his beard and mustache, close-cropped thinning hair. The light in the photograph is mostly from the front, with some side-light modeling. His by-now-familiar device of emphasizing the shadows cast by his glasses results in curved dark lines on his face, an effect that he capitalizes on in both ensuing paintings. The front of his white shirt extends, biblike, over the lower part of the masking-tape rectangle, an effect that makes Close look like a nineteenth-century Scandinavian parson in a Bergman film. The left profile photograph reveals a less engaged subject, self-absorbed and unaware of whatever might be going on around him. The heavy frames of his round glasses ride low on the bridge of his nose; deep forehead creases

echo the curve of his eyebrow. The Close profile is a distinctive accumulation of diverse, prominent parts—high forehead, short, rounded nose, small mouth, and slightly recessive bearded chin—that cohere into a pensive, empathetic whole.

What Close extracted from these photographs underwent convulsive change by the time he put it on canvas. What came forth were two giant masklike faces composed of frenetic, metastasizing black-and-white marks. Both images verged on the bizarre. The grid, until then a reasonably discreet component in his self-portraits, now took over so aggressively that the artist's features were deeply enmeshed in its network. Contributing substantially to the dynamism of these portrayals was Close's use of the diagonal grid. In both 1995 self-portraits, we are less conscious of systems being followed than of the unsettling tensions they project. Both are concocted of a primal stew of diamond shapes, flattened circles, and elongated dumbbells.

The starkly frontal *Self-Portrait I* is especially hypnotic. For all its blocky descriptiveness, its forms are transparent. Its spectral face, like an image from an alternate reality, regards us so calmly that it is unsettling. Close appears to have brought forth his doppelganger. An intensely subjective exploration of his facial terrain, this painting, more than any other he had made of himself until then, may offer a clue or two about what motivated it. In light of his illness and the laborious recovery process, it reads as a meditation on the transitory nature of life—his own, especially. *Self-Portrait II* is no less phantasmagoric than its companion painting. If in the frontal view Close's face seems to morph from ectoplasmic mass to UFO alien, it undergoes equally weird changes in this profile depiction. The marks that compose it resemble arcane symbols from another place and time. They bring to mind the prophetic tattoos that covered the face and body of Queequeg, Melville's mystical harpooner. Contemplating this view of Close's face, who could imagine that some twenty roughly drawn squares and rectangles, jammed tightly next to one another, would from just a few feet away transform themselves into so convincing a rendition of an ear?

Color Close-Ups: 1996 and 1997

In 1996 Close returned to painting himself in color. That year, he made a small full-face self-portrait in sensuous, warm tones as part of a family series that also included paintings of his wife and their daughters, Georgia and Maggie. So tightly

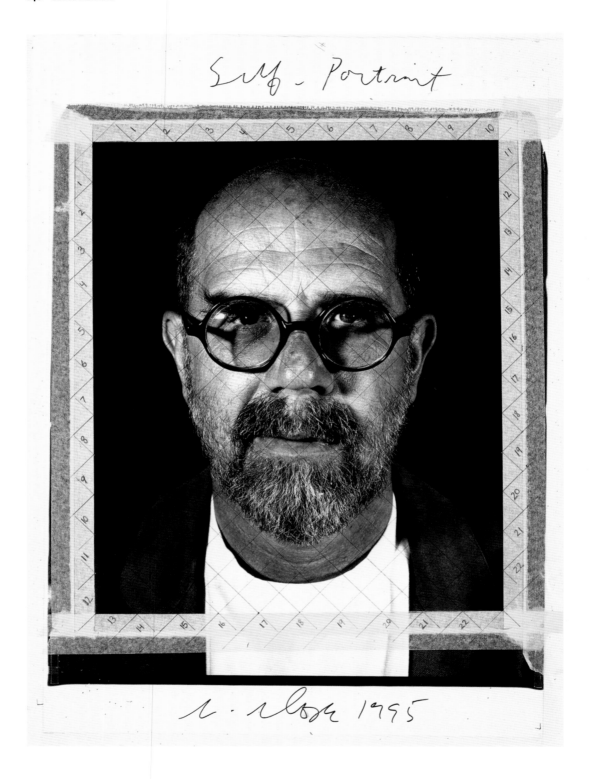

Maquette for *Self-Portrait I*, 1995. Black-and-white Polaroid photograph scored with pencil and tape on foamcore, 24 x 20". Collection of the artist

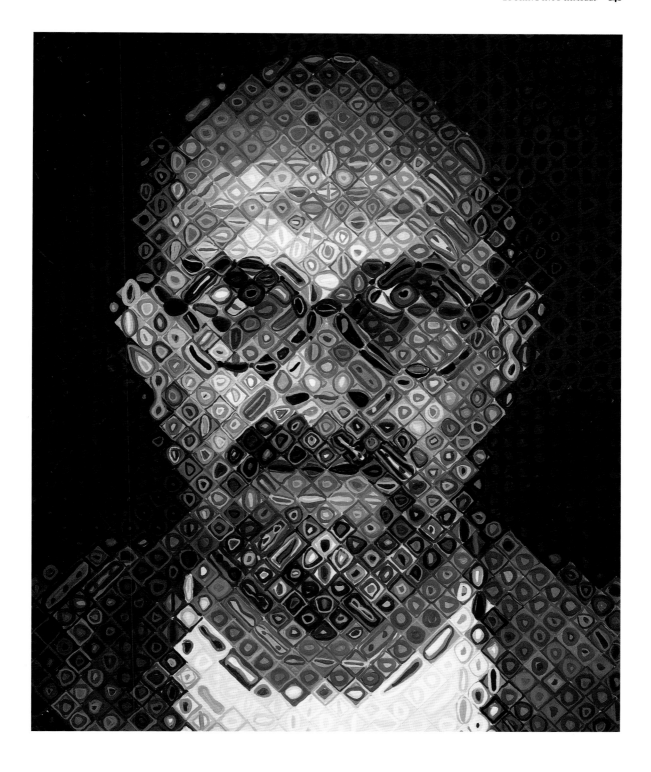

Self-Portrait I, 1995. Oil on canvas, 72 x 60". Collection of Jon and Mary Shirley. Bequest Henry Art Gallery, Seattle

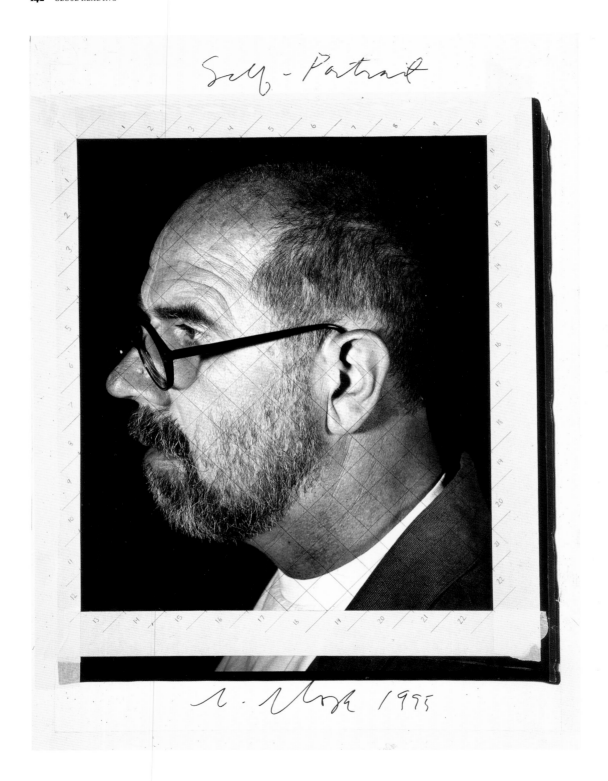

Maquette for *Self-Portrait II*, 1995. Black-and-white Polaroid photograph scored with pencil and tape on foamcore, 24 x 20". Collection of the artist

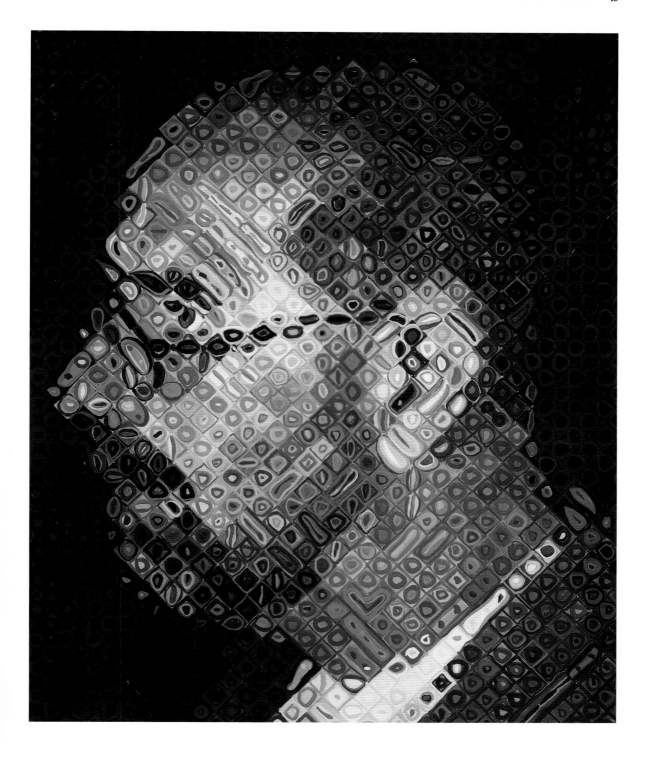

Self-Portrait II, 1995. Oil on canvas, 72 x 60". Collection of Jon and Mary Shirley. Bequest Henry Art Gallery, Seattle

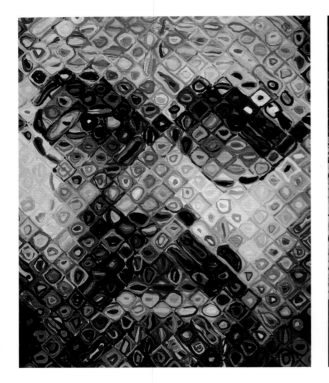 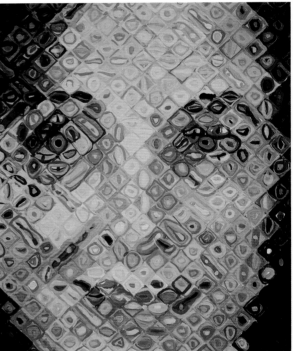

(left) *Self-Portrait,* 1996. Oil on canvas, 30 x 24". Private collection **(right)** *Leslie,* 1996. Oil on canvas, 30 x 24"

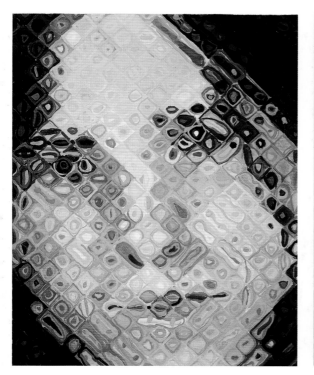 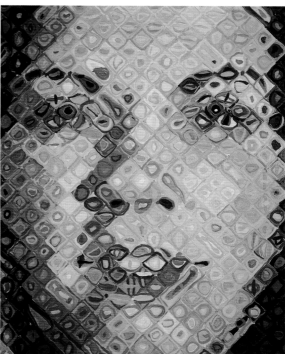

(left) *Maggie*, 1996. Oil on canvas, 30 x 24". Collection of Maggie Close **(right)** *Georgia*, 1996. Oil on canvas, 30 x 24". Private collection

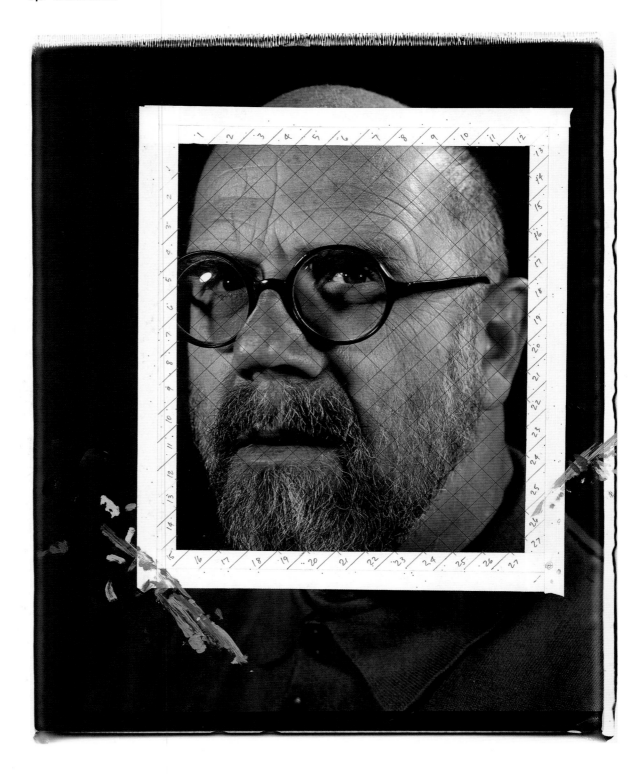

Maquette for *Self-Portrait*, n.d. Photograph on foamcore, 35¾ x 23½". Private collection

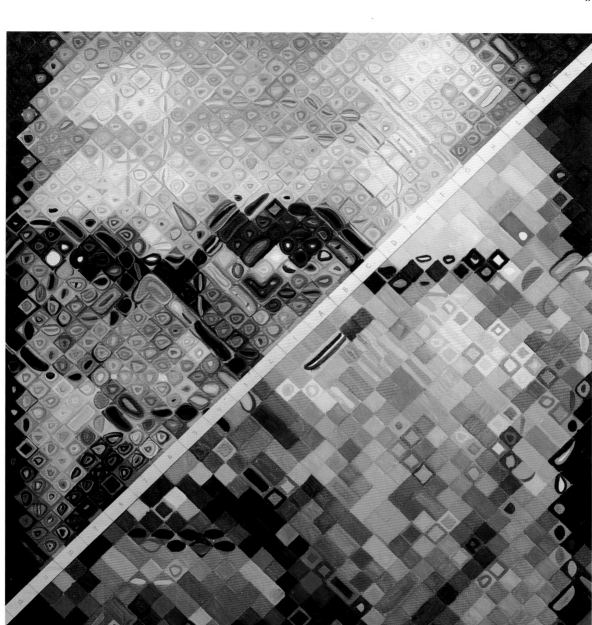

Work in progress for *Self-Portrait*, 1997

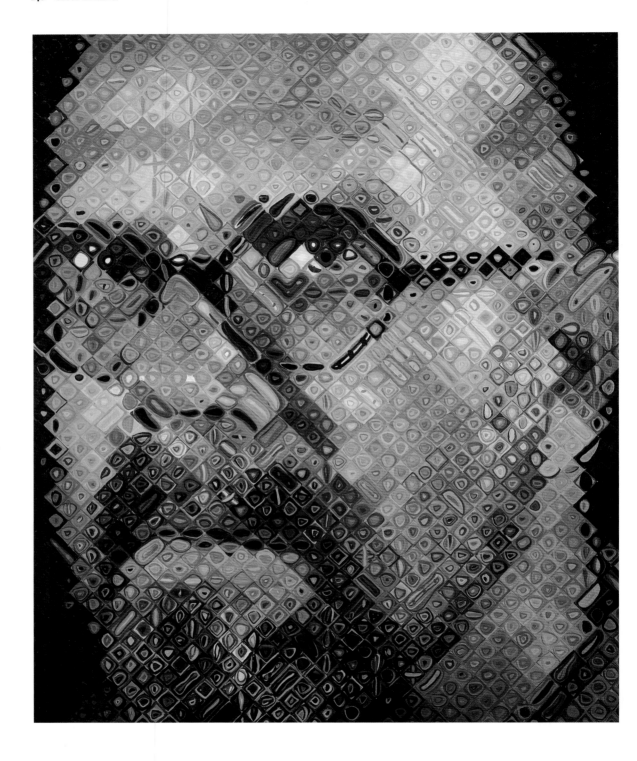

Self-Portrait, 1997. Oil on canvas, 102 x 84". Collection of The Museum of Modern Art, New York

cropped is this image that it's like the face of some blurry-featured being looming outside a window. All that is visible of Close are his eyes, nose, and mouth, the latter mostly obscured by his mustache and beard. The painting's loosely drawn diamond-shaped units are unusually large in relation to its small scale, its violent pink and deep burgundy liquescent shapes flowing into each other. For all its abstraction, this is a vivid and intimate self-portrayal, alive with color shifts and rendered with the urgency of a fast sketch. On the basis of its deep, effulgent color alone, this small jewel could well have been a study for the masterful, richly complex painting of Close that followed the next year.

The undated Polaroid for the 1997 *Self-Portrait* has the artist looking slightly querulous, even a touch amused. His skin is ruddy, his beard and mustache silvery, and there is little of the tentativeness of the first posthospital photographs. The photograph is intriguing, both for this new portrayal of Close and as an unintended record of how it was used as he worked on the painting. Adhered to its surface is a rectangle of white tape evenly marked with grid numbers that defines the area he enlarged on the canvas. A few multicolor streaks of paint on its surface are further evidence of its role during the painting process. An accidental effect, explains his assistant Michael Volonakis, it was probably the result of a minor collision between the photograph, which was clipped to a pole rising from the paint table, and a lazy Susan–like brush holder next to the easel. Whatever their origin, both they and the white-tape rectangle imbue the photographic image with a certain collagelike "found" effect.

For all Close's faithful reliance on the three-quarter-view photograph in making the 1997 *Self-Portrait*, the change of mood from it to the painting is remarkable. He looks baleful, even a shade defiant, in this oil paint rendition, which is more than eight feet high. Its color fragments are in constant agitation, even as they combine into Close's features. Among that portrait's most arresting attributes are its crazily abstract eyeballs, each designated by three black spheres that look like pawnshop balls. It's amazing to see the pupil of an eye emerge from the fusion of those spheres and to observe how other tightly packed abstract elements fuse and mutate alchemically into his beard and mustache. Throughout the painting, Close uses overlapping and interlocking planes in radically compressed space in a peculiarly original, latter-day variation on Cubism.

Taken as we may be with the painting's ultrarational structure, we are just as susceptible to its moody subjectivity. For an artist so avowedly antiexpressionist in his

earlier years, Close had undergone quite an emotional sea change by the time of this masterful self-depiction. Whatever the reasons, certainly among them the enduring effects of his illness and the irrefutable evidence of his aging, he was ready and able to deal with subjective issues more openly. He went far beyond the preliminary photograph to expose more of his inner self. "I really wanted to fill the rectangle with a face, with a soul," he said, as we looked at a transparency of the work. Before painting this self-portrait, he continued, "I had always been concerned with trying to make allover paintings, where everything—the face, the hair and beard, the shirt, and the background—was of equal importance." In a dramatic painting like this, the face, and only the face, is the focus of attention.

A Jovian Close: 2000–01

Impressive as Close's 2003 exhibition of recent paintings at PaceWildenstein was, with its compelling renditions of Robert Rauschenberg, the late Paul Cadmus, and the young abstractionist James Siena, nothing on the walls had the immediacy of his 2000–01 *Self-Portrait*, a compelling synthesis of richly descriptive form and high-style abstraction. Viewers standing before this systematic inversion of academic realism on such a monumental scale—just over nine feet in height—were all but immersed in a turbulent sea of hypercells. For this towering self-depiction Close reprised an earlier template in which the subject's eyes were well above the viewer's eye level, which he had used to great effect in the now-iconic 1968 depiction of his long-haired, cigarette-puffing youthful self, gazing coolly at the viewer below him. As distanced in style and mood as the new painting is from that vividly engaging prototype, it commands our attention no less insistently. Its magnified visage contemplates us appraisingly, and for all the crackling of its multi-faceted surface, there is an eerie stillness about it.

By the time this work came into existence, Close had photographed, painted, and drawn his facial topography so many times that it held few mysteries for him. When he was seated before the lens, the challenge became less about describing a countenance that he knew better than any other than about finding new ways to do it. In some respects, as in the 1968 painting, this has taken the form of role-playing, but within the most limited emotional and formal strictures. Close does not so much

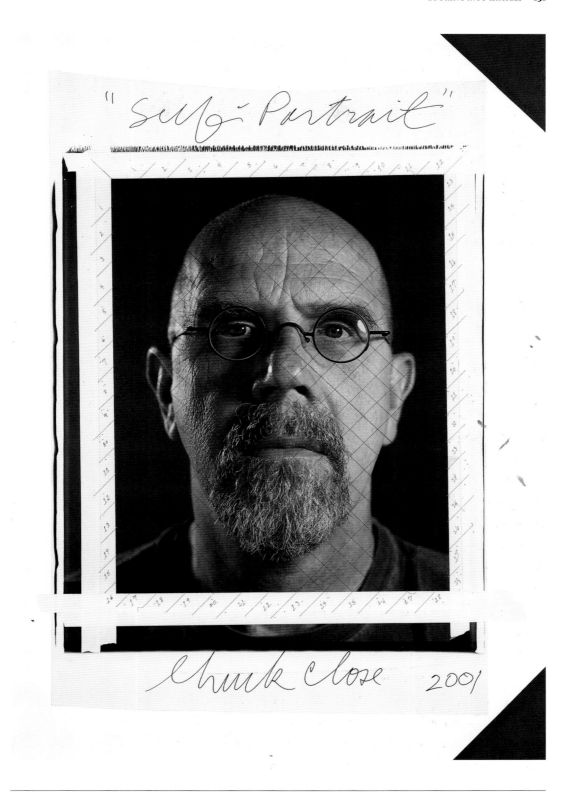

Maquette for *Self-Portrait*, 2001. Polaroid with artist's tape mounted on museum board and gater board, 33¼ x 22". Collection of the San Francisco Museum of Modern Art

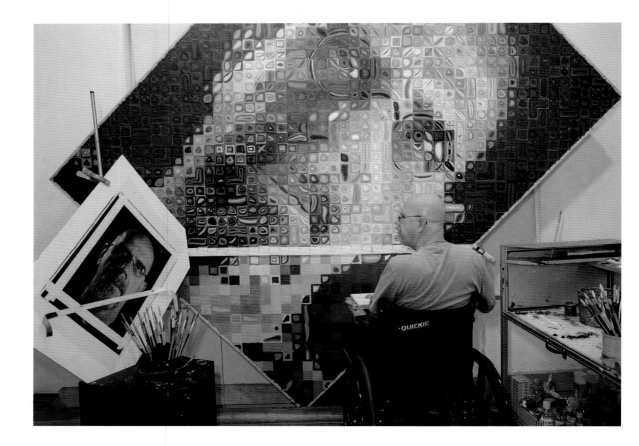

Close working on *Self-Portrait*, 2000-01

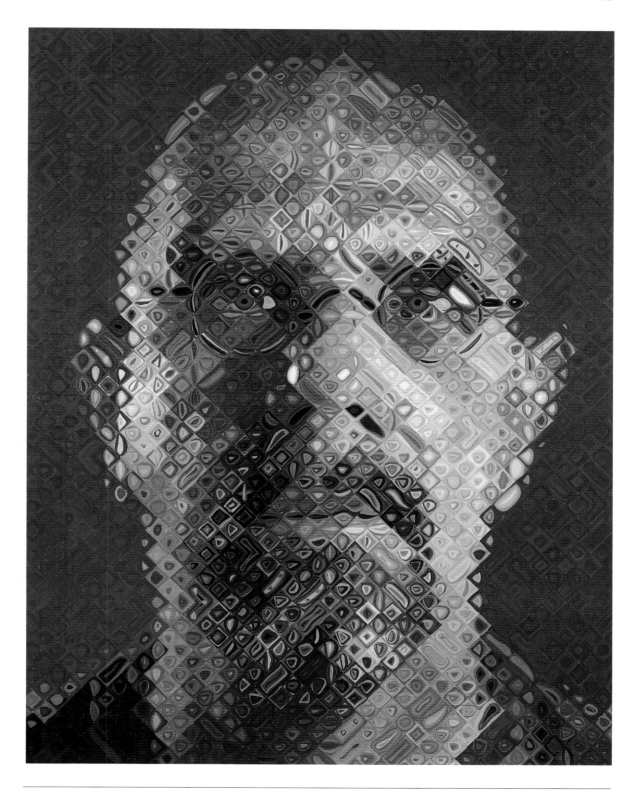

Self-Portrait, 2000–01. Oil on canvas, 108½ x 84". Collection of the Art Supporting Foundation to the San Francisco Museum of Modern Art

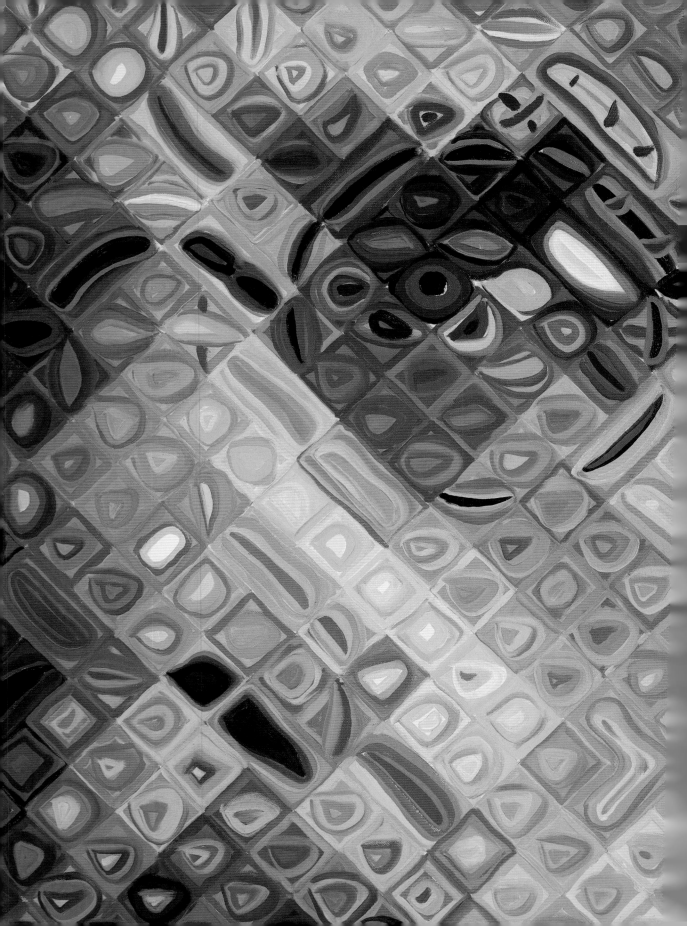

take on other personae, but slightly—very slightly—varies his own in choosing how to present himself. Accomplished performer that he is, he positions himself knowingly before the lens, briskly oversees the lighting, and instinctively assumes the desired "nonexpression" expression the instant before the button is pressed. After he scrutinizes the proofs, minimal adjustments of lighting are made until he is satisfied with the pinned-up results. As always, he looks for an image he can work from, one filled with the detailed information that he needs to set the painting process in motion. It's hard to believe that more subjective considerations do not enter the selection process. For all his professed objectivity, Close has a pretty fair idea of the self-image he wants to project. For the 2001 photo-maquette, he selected an image in which there is no hint of the tentativeness, the sense of uncertainty that characterized his previous posthospital photographs. In this representation his head is sculpturally modeled in light and shadow; the frown lines are deeply etched.

In the 2000–01 *Self-Portrait* it led to, that certainty of expression takes on monumental overtones. Close appears as a Jove-like presence ready to pronounce weighty judgment. As in the self-portraits that immediately preceded it, the studied neutrality of expression he had long sought has given way to a more inward-looking expression. Certain ideas, less psychological and more analytical, come to mind in looking at recent self-portraits such as this one. They abound with arresting contradictions: despite the assertive modeling of the head, its outlines disintegrate into an aureole of diamond-shaped fragments. It is as if, in making the picture, Close were operating on two levels of consciousness. One is overt and has to do with describing in paint the shapes he perceives in his photographic likeness. The second is a form of free association, a kind of automatic writing, an intuitive filling-in of squares with seemingly arbitrary marks. Although all his broken-surface paintings are lively counterpoints of deliberate and intuitive actions, there is no better evidence of this than the 2000–01 *Self-Portrait.* We sense the tension between both processes throughout the picture, a tension as palpable as the description-abstraction dichotomy that pervades it. As an instance of these opposite impulses at work, consider how Close went about describing his features in this latest self-portrait. For all this painting's gravitas, it has its lighter moments. The pupils and whites of the eyes are clusters of amoeboid shapes; the lower part of his face, his mouth and beard, is packed with loopy circles and paisley teardrops, all seemingly in a state of metamorphosis. Each shape has its own energy, the effect in large measure of the improvisational manner in which Close

brushed them onto the canvas. Though his face is brightly illuminated from both sides, a heavy dark shadow, evocative of a giant ragged brush stroke covers the right side, overlaying the forehead and eye socket and extending alongside his mouth. In this vast rectangle, each shape dissolves and reconstitutes itself.

Back to Raw Basics: Black-and-White Masks, 2002-03

A year after painting the heroic-scaled, crystalline, color-saturated 2000–01 *Self-Portrait*, Close took a furlough from color to depict his countenance in black and white. This exercise took the form of two paintings, seemingly identical except for their difference in size: the first was six feet high, its immediate successor only two and a half feet. The last time he had abandoned color was in a sequence of four posthospital paintings, dating from 1991 to 1995. As in that initial group, Close says he wanted in these new works "to get color out of my system by making something rougher and less ingratiating." He describes his periodic "flipping back and forth" between color and black and white as a much-needed diversion. "If I'm up to here with color, I'll get rid of color for a while. If I feel black and white is too limiting, I'll get rid of black and white." His black-and-white self-portrayals are probably "less likable" than those in color, he concedes. He has special respect for those collectors who acquire them, "because they're a little more difficult to live with. They don't have wonderful, juicy surfaces. They're almost like deserts, because the paint is so dry."

The source for both of the 2002–03 black-and-white self-portraits was not the usual Polaroid but a 2001 daguerreotype, one of a set of studies he made of himself with the assistance of the photographer Jerry Spagnoli, who uses it for his own large-format images. It was at the suggestion of Colin Westerbeck, Curator of Photography at the Art Institute of Chicago, that Close first tried his hand at daguerreotype. Westerbeck was well aware of the artist's obsessive absorption with recording detail photographically, having had firsthand experience of it when he included some of the Cambridge photographs in a 1989 exhibition of large-format Polaroids of nudes and flowers at the Art Institute titled "Chuck Close." It may have seemed an odd combination of themes, but they were among the ones Close was then pursuing, and Westerbeck clearly perceived the connections between them. In Close's vision, the forms and surfaces of flesh and flowers shared some attributes. But if the sensuality

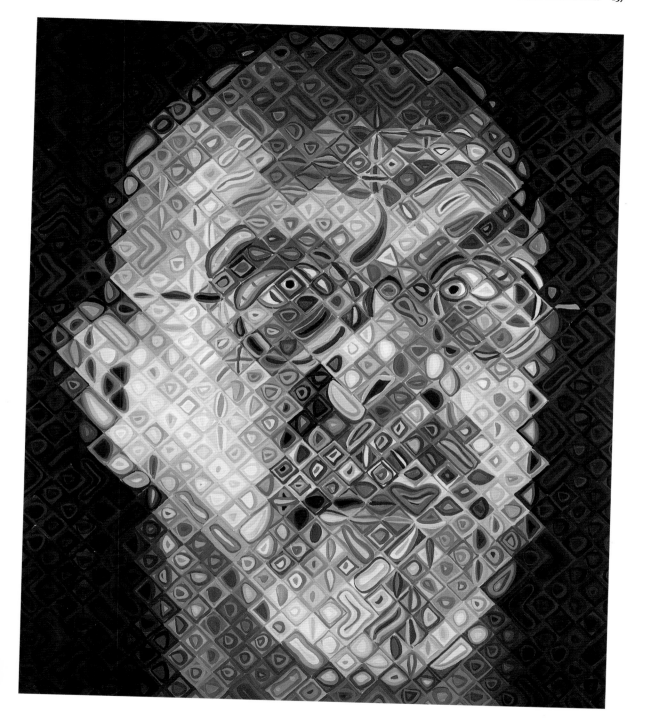

Self-Portrait, 2002–03. Oil on canvas, 72 x 60". Collection of the artist

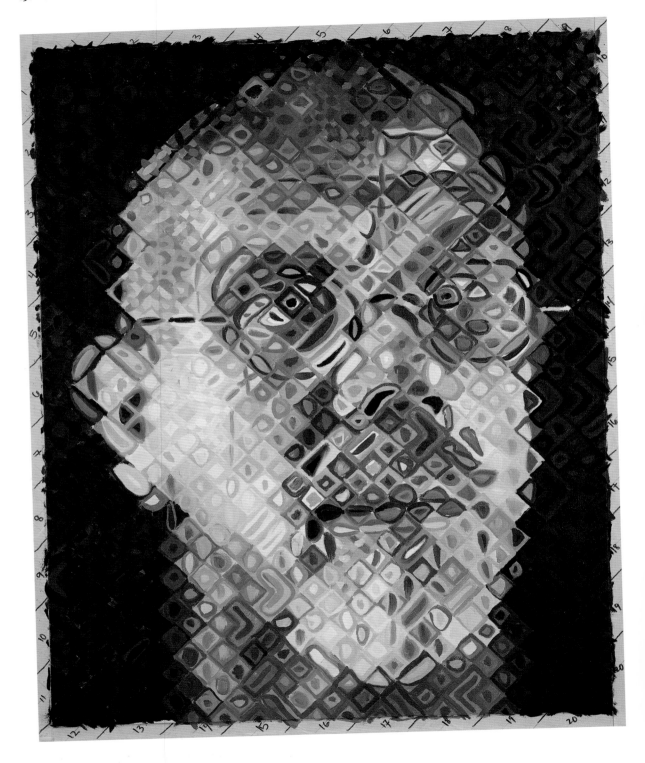

Self-Portrait, 2002–03. Oil on canvas with wooden measuring strips, 30 x 24". Collection of Carlo and Rosella Nesi

of the figures was downplayed in the almost clinically lighted photographs, those qualities came to the fore in the flower pictures. In fact, Westerbeck says, "Chuck's tight-focus shots of flowers, with their stamens protruding from deep wells, were much more sexual than any of his nudes."

Some ten years later, with that exhibition still in mind, and with the thought that Close might like to experiment with another photographic process that would lend itself to his unvarnished view of reality, Westerbeck proposed to the artist that he try working with daguerreotype. For one thing, it was essentially a direct process; for another, it offered the photographer a continuous-tone image. "Even before they asked me to work on daguerreotypes," says Close, "I was greatly interested in the process, so I was ready to take up the offer." Upon his acceptance, Westerbeck obtained funds from the Lannan Foundation and arranged for Grant Romer, the distinguished photography historian, conservator, and daguerreotype specialist at George Eastman House in Rochester, New York, to join him at Close's studio in order to introduce him to that venerable process. One day in late July 1997, Romer appeared with an assistant and a van full of equipment to set up a temporary photography studio in the basement of the studio.

Romer and Close's experiments were made with a Hasselblad camera, although daguerreotype photography typically uses a standard view camera. Instead of a negative, it employs a copper plate coated with silver and buffed to a high polish, which is developed by exposure to fumed mercury. Compared to conventional view-camera photography, this is a long procedure, but it can be somewhat abbreviated by the addition of accelerators such as bromine. A daguerreotype portrait, as Romer acknowledges, can be "a brassy look at reality," its effect that of "a hard eye that falls on the face." Daguerreotype portraiture can produce some strange color results. Any redness on the face of a subject, for example, will register as a much darker tone. "Even the healthiest, best-looking models," says Romer, "might not come off too well, being exposed to the strange truth of the daguerreotype process."

After three days of experimentation in Close's basement, during which the artist was his own subject before the camera, the resulting 2¼-inch-square photographs were both intriguing and disappointing to him. Fascinated as he was by the process, there were enough glitches along the way to give him pause. Since the light meter has no role in daguerreotypy, many trial exposures are required in order to arrive at a few usable images. Not only were these small in scale, but their degree of clarity

varied greatly one from the other; several were considerably solarized, possibly owing to overexposure. Despite such difficulties, Close was interested enough in the daguerreotype to learn more about it, so Westerbeck, who had some Lannan funds left over from the first trials, made arrangements for Close to work with Spagnoli.

At Spagnoli's Chelsea studio, Close was conveniently able to explore this temperamental technique under expert guidance. Two summers after being introduced to the process, he steeped himself in its arcane methodology by making a series of arresting studies of himself, his wife and daughters, and his art world friends. Some of these images, in their atmospheric quality, have the character of a vintage photograph. There is a memorable one of a white-bearded Whitmanesque-looking James Turrell, the visionary light and land artist; a pensive study of the young photographer Gregory Crewdson; and an eerie pair of "eyes-open, eyes-closed" faces of the avant-garde theater impresario Robert Wilson.

But Close produced more than daguerreotype portrait heads at Spagnoli's studio. He also returned to an old theme, the nude, but in radically different and far more austere fashion. These daguerreotypes, begun in 2000, are of male and female bodies seen from the knees up and the neck down. "Headless Torsos in Photography Studio" could be the headline, since the viewer has no idea to whom they belong. The models come in all shapes and sizes, ranging from well-toned young people to those well past their anatomical prime. Each photographed body is perfectly centered within the picture rectangle, some with arms raised high, some with arms on hips, others with hands lightly clasped over genitalia. A few extreme close-ups of lower abdominal areas complete the series. What Close's daguerreotypes of heads of known subjects and his torsos of anonymous ones share is detail, enormous amounts of it. And he photographs his naked models through a high-resolution lens, with the same compulsive objectivity that pervades the head shots of his painting subjects. Skin texture, wrinkles, warts, and scars are faithfully documented— mercilessly in some cases. His approach to documenting nude bodies is equal parts typological and aesthetic. "I try to photograph them with the same mug-shot attitude I have when I do my portrait heads."

Of the daguerreotype portrait heads, the most mesmerizing by far are those that Close made of himself, which take full advantage of the idiosyncrasies of this venerable process, notably, in Romer's perceptive characterization, "its capacity to render light, space, even a sense of time." Using a short lens on the camera, Close radically

James, 2001. Daguerreotype, 8 ½ x 6 ½"

Robert, 2001. Daguerreotype, 8½ x 6½"

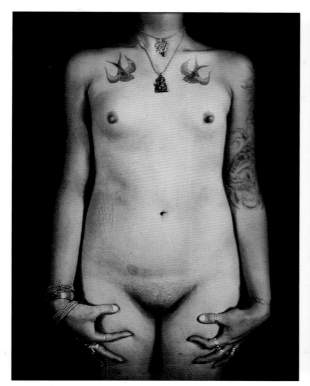 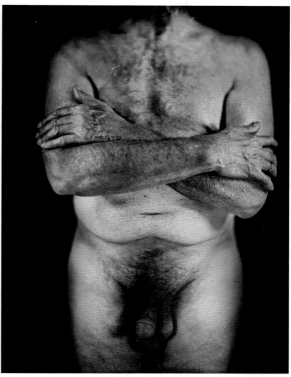

(left) *Untitled Torso Diptych*, 2000. Left panel, daguerreotype, 8 ½ x 6 ½" **(right)** *Untitled Torso Diptych*, 2000.
Left panel, daguerreotype, 8 ½ x 6 ½"

compressed the image's depth of field, an effect that contributes to the photograph's sense of portent and mystery. Because the daguerrotype process is slow, the lens is kept wide open in order to admit as much light as possible; the effect of such a wide aperture is to reduce the depth of field dramatically. In a series of five 2001 self-portraits, each 8½ by 6½ inches, Close's solemn face materializes vaporously. It appears to document different stages of a slow rotation of his head—right profile, three-quarter view, frontal view, three-quarter view, left profile—as though materializing slowly during a séance. Only his eyes, nose, and mouth and the wire-rimmed frames of his glasses are in focus, while the outlines of his head and neck are hazy. The light is harsh and diffuse by turns. Parts of his face are recorded in almost excruciating detail, every line on the forehead and cheek, every hair in his mustache sharply defined; others, just a few inches back, are blurred and generalized almost to the point of abstraction.

In the 2001 daguerreotype that led to the 2002–03 self-portraits, Close's face is turned slightly to the left. He looks alert and attentive, as though taking part in a conversation. Yet, for all its subject's composure, the photograph has an eerie glow about it; it's like an emanation, in which only parts of his face are in focus. Except for the eyes, the skin around them, and the precisely defined mustache hairs, there is something tentative about how the rest of the face materializes. So restricted is the photograph's depth of field that the outline of his head, his right ear, and bearded chin are indistinct. His neck is even more amorphously portrayed. "Something unusual happens in that daguerreotype that doesn't happen in the Polaroids I take of myself," he says, describing how his facial features vary in focus within the daguerreotype's shallow depth of field. "So I thought that painting all that out-of-focus stuff in sharp little squares and diamonds could be interesting." With that objective in mind, he placed the daguerreotype in a flatbed scanner and made an ink-jet print that would serve as the photo-maquette for two paintings.

The first, six feet high, is dated 2002–03; the second, with the same date, is slightly less than three feet tall. Each has a coarse grid, with relatively few units. However, though both paintings have the same number of squares, different things go on in their comparable compartments, even though such area-by-area variations are sometimes initially hard to discern. Close is bemused by the fact that, on first view, the paintings look so much alike. However, the second, smaller self-portrait, he hastens to explain, was not a copy of the first but made from the same ink-jet

image. "Both paintings were based on exactly the same information, but so many different things happen in them. For example, look at the almost heart shape of the upper lip in the big one. In the little one, that form became three separate shapes. Or look at the mark that goes up between my brows—that kind of long, spermlike shape. In the big painting, it's one, long continuous shape. In the small one, it's two squares." Explaining the process of constructing each picture, he says, "It's like two riffs on the same melody by a jazz musician. The melody may be the same, but the actual notes will vary." He paints in similar spirit, he says. "For me, the pleasure in painting is seeing what happens as I work through the same kind of permutations. Every time I take a shot at an image, it's going to come out different. So at least I'm entertaining myself, whether or not I'm entertaining anyone else."

During a visit to Close's studio early last year when I first saw the larger of the two black-and-white self-portraits on the easel, rotated some forty-five degrees so that its diamond-shaped grid units read as squares, I wasn't sure what to make of it. Stylistically, it seemed a reprise of the pair of masklike 1995 front- and side-view self-representations. Like those memorable predecessors it was an aggressively prismatic image. Close's face, especially his eyes, had a tinge of the diabolical. There was a controlled but unmistakable harshness about this rendition; it was as though his face had been turned inside out. I don't think I've ever been so conscious of the raw force of that clatter of geometric and organic shapes that typically sweeps across his grid-revealing canvases. The head he painted looked almost robotic, composed as it was of intricately fitted together cogs, squares, squashed circles, and hordes of indeterminate biomorphic shapes. If the idea was to get away from seductive, sensuous surfaces, Close more than accomplished his objective. The connection to the original daguerreotype seemed distant. That photograph had a vaporous, almost fugitive quality about it—of matter dissolving into atmosphere—a quality that distinguishes many works in this antique medium from most photographs. Not long after, when I saw the small painting in the studio, I found it less haunting and less hard-edged, emotionally as well as physically. Admittedly, having seen the first one, I was prepared for the new version. It was as though the larger black-and-white self-depiction were being viewed not only through a reducing glass but also through some kind of psychological filter. While it differed in many details from its predecessor, it was nevertheless difficult not to think of it as a less mechanical, less insistent, slightly more humanized restatement of it.

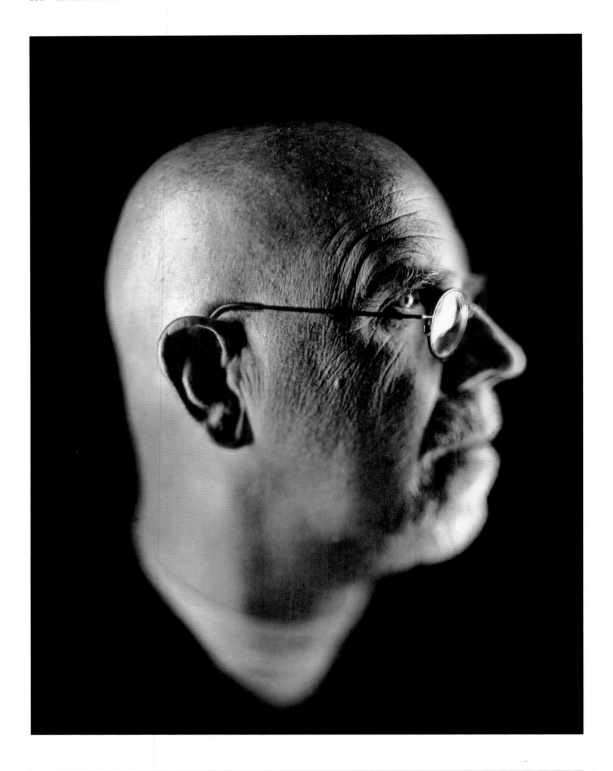

Self-Portrait, 2001. Daguerreotype, 8 ½ x 6 ½"

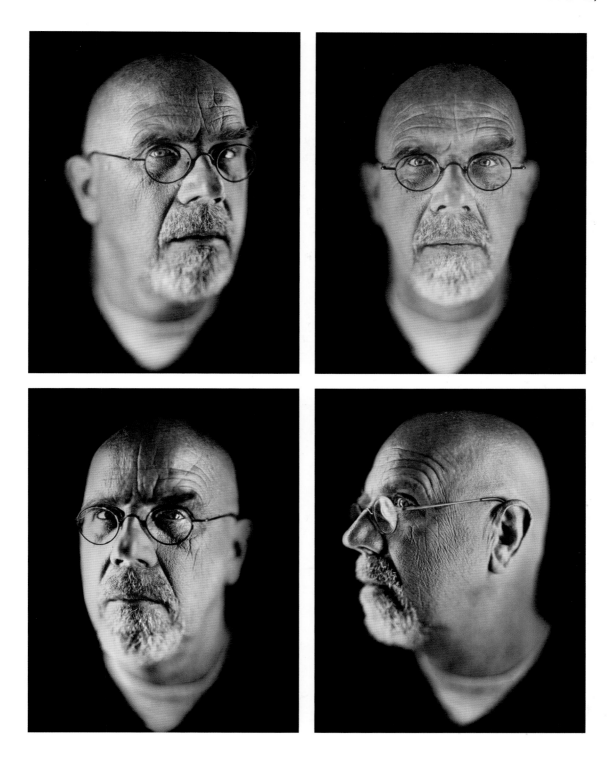

(top, left) *Self-Portrait*, 2001. Daguerreotype, 8½ x 6½" **(top, right)** *Self-Portrait*, 2001. Daguerreotype, 8½ x 6½"
(bottom, left) *Self-Portrait*, 2001. Daguerreotype, 8½ x 6½ **(bottom, right)** *Self-Portrait*, 2001. Daguerreotype, 8½ x 6½"

Simplifying the Syntax: 2004-05

In the fall of 2004 Close began a self-portrait vastly different in feeling from the two monochromatic paintings of the previous year, which were based on a moody daguerreotype image. He describes working on this new painting and the one that immediately preceded it, a portrait of the artist Linda Benglis, as a liberating experience, he says. Just before starting them, he says, "I had gone through a period of extreme self-doubt about what I was doing and stopped painting for a while. I felt I had to do something different, to find some new syntax, to use marks in new ways. I decided to make freehand drawings using India ink. I used grids for each of these, and the marks I made in each of the squares were calligraphic shapes." Despite the enduring effects of his illness, he had, through sheer persistence, long since achieved the necessary dexterity to get back to work. With the brush or pen in a bracelike apparatus firmly strapped to his right hand, he had the requisite control for the task. "It's the same way I hold a brush when I paint. To make a mark I push my left hand against my right one to steady it. So, in a way, I'm a two-handed artist."

But Close adds sadly, "After three or four months of making black-and-white drawings and destroying them, nothing was working out. I couldn't find a way to make them that interested me and I was really frustrated. At the end of all this trying and trying again, I said, 'I've had it with this! I'm going back to what I like to do and not worry about whether it represents any real change.'" Those anxious months away from painting were far from a total loss, however, he now observes with palpable relief. In the end, being away from the easel for a while "was like taking a bunch of rocks out of my shoes." Once he resumed painting, things improved dramatically. "The work on the *Linda*, then later on the *Self-Portrait* flowed easily. They were a great deal of fun to make. I had so much momentum that I just roared through both of them." The change he had so futilely sought by making drawings manifested itself now in other, if surprisingly revisionist, ways. Both paintings represented not only a return to full color but also to the tried-and-true horizontal-vertical grid format, as opposed to the diagonal one he had used for so many other recent works. And there was yet another strategic retreat to past practices, he cheerfully admits. "No profile or three-quarter views this time around, just straight-ahead, dead-on."

Yet, one aspect of his painting process did not undergo any change: the way he applied color, one layer over the other. As with *Linda* and, for that matter, all his color

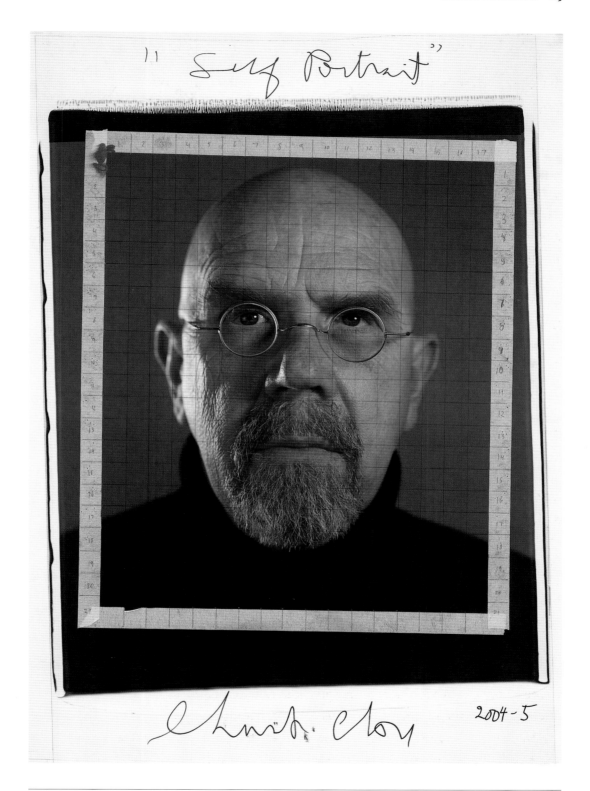

Maquette for *Self-Portrait*, 2004–05. Color Polaroid, tape, and ink mounted on foamcore, 33¼ x 22″

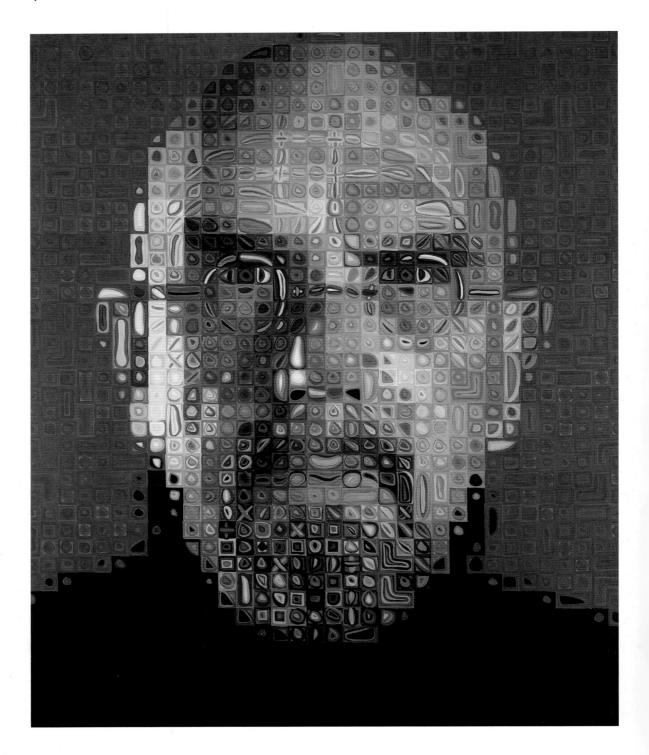

Self-Portrait, 2004–05. Oil on canvas, 102 x 84" **(opposite)** *Self-Portrait* (detail), 2004–05

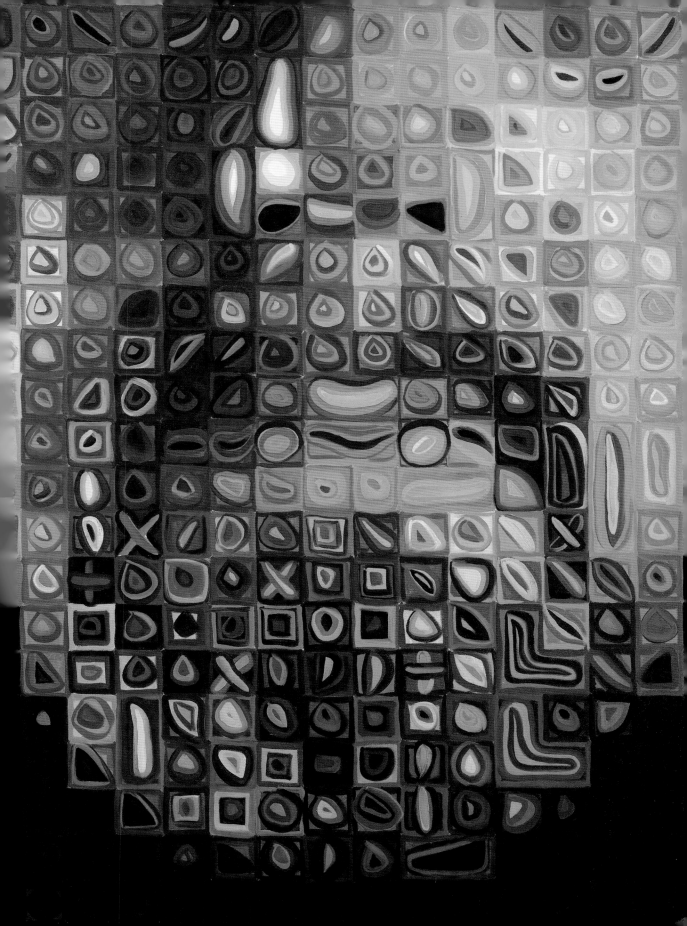

paintings, the underpainting of the almost nine-foot-high *Self-Portrait* consisted of neatly described, vivid-hued squares, many containing abstract shapes. Working his way down the canvas again, Close brushed additional pigment over each of these units of color, transmuting them into areas of ivory, coral, terra-cotta, umber, and blue-gray. For those who follow the evolution of his visual vocabulary, burgeoning of simple signs is apparent in the new paintings—more Xs and Os and a profusion of neatly defined "Albers-like squares," to use Close's characterization of them.

The overall impression of the new *Self-Portrait* is of incandescence—of light from within. As we talked about the various marks he used, Close directed my attention to the rendering of the eyes: "There are constellations of pie-shaped marks revolving around square centers, like moons around a square planet. They really shouldn't work at all. There's no reason why they should ever resolve into an eye, and they flirt with not quite congealing into a recognizable image. I think that lack of resolution is what makes them active and, at the same time, almost difficult to look at."

Yet what is at work here is far from orderly Albersian geometry. Not only did Close manage to simplify the shapes he works radically, he rendered them with such directness that they are barely contained within the painting's grid. Compared to its stately predecessor, the 2000-01 *Self-Portrait*, this self-representation projects almost primitive force. Even its color areas—the face an expansive field of strong, basically violet hues, some lightened almost to white, the background composed of almost fluorescent blue and green squares—are jarring in their juxtapositions. For all the brio of the painting's execution, Close's expression in it is a touch remote, more somber than in its first cousin, the 2000-01 *Self-Portrait*. However, with its glittering faceted forms and surface alive with sharply contrasting dark and light values, it is far from a static vision of him. A wedge of harsh light models the right side of his face, a blocky shadow extends from forehead to bearded chin, and the contours of his shaved head are transformed into an aureole of color particles. For all its compositional formality, the painting's symmetry is continuously disrupted by the interplay of light and shadow across its subject's austere countenance.

Behind His Faces

Despite Close's disinclination to talk about psychological qualities inherent in his self-portraits, it's difficult not to conjecture that some form of self-revelation is tak-

ing place. Though derived from photographs, like all his paintings, the emotional distance between them and what the camera sees has visibly increased in recent years. Inexorably, photographic illusionism in his paintings has given way to another kind of descriptiveness, a parallel reality from which has emerged a succession of giant heads of himself that are at once enigmatic and strangely confessional. Still, so overwhelming is their scale and complexity that, on first encounter, they tell us far more about Close's wizardly processes than about who created them. It's hard, in fact, to penetrate these oscillating force fields to whatever may lie behind them. Which may be exactly what the artist has in mind because, in their precise methodology these riveting self-depictions can at first seem more about formal issues, such as revealing the abstraction inherent in even the most detailed realism, than about personal revelations. Like all his portraits, they are also about control, which is vividly apparent in his ingenious processes of magically modifying the photographic images he transfers onto canvas, images that provide such beguiling terrain for the viewer's eyes to wander. Indeed, such absolute control is as central to Close's painting—no matter the subject—as it is to how he conducts his life. "I've always been a control freak!" was his unabashed self-assessment during one of our conversations. Before his illness, he said, "I always thought I could take the whole world and move it whenever and to wherever I wanted. Not anymore, though," he added, because "one of the posthospital things that happened to me was the realization that I had to have some kind of patience and couldn't sweat everything."

Close may have since gained a modicum of that desirable quality, but his hyperactive control gene hasn't sat idly by. It operates constantly on at least two levels, personal and artistic, the border between them porous. But control of what? Of the viewer's perception of his work, but also of whatever subjective feelings it might project, a guarding against revealing signs of emotion, however fugitive, that might temper the vaunted neutrality he aspires to in every painting. Whatever personal issues may be inherent in his portraits, he makes clear, are subordinate to formalistic ones, no matter who their subjects may be. Even those of himself are journeys into the quasi-abstract realm of his own invention, not into his psyche. Having given countless interviews to curators and critics, Close is a past master at steering conversations about his work in directions he thinks they should go. Queries about aspects of his personal life that might bear on his artistic approach are deflected with witty, self-deprecating responses. "If somebody asks me a question that I don't want to deal

with, I can ignore it and answer one that wasn't asked," he says with a knowing smile. So much for breast-baring. He has had a lifetime of practice in evasive tactics.

Even as a child, he says, he knew how to project a sense of control as well as of normalcy during difficult situations at school. "Because of my dyslexia, I had learning problems, but I used my verbal abilities to cover them. I think that probably gave me some kind of skill in controlling the agenda. It was just like group therapy," he blithely explains. "When I was in group therapy, I immediately tried to control what everybody had to say. Then over the years I thought, 'Well this is crazy, why do I want the dialogue to be just what I'm most comfortable with? Why would I want to deny other people their very real, personal reaction to my work or to me?' And the minute I accepted that as a possibility, I thought, 'Oh, what a treat; maybe it's not something to be feared, but something to be savored.' So I became a better listener because I wasn't trying to roll over people and control things." He has even mellowed to the point, he claims, that he is less interested in controlling the reactions of others to his work. Of those innumerable interviews with persistent curators and critics about his work, he admits, with dubious resignation, "I can control what's said about it only so much." Then, his guard down momentarily, he wonders aloud, "What if they're able to get right beneath its surface very cleanly, very quickly, even though I'm not?" And then, what? Learn things about his psychology that he thought were securely hidden behind those surfaces?

Of course, obsessive control has long been at the heart of Close's painting. His self-portraits conceal as much about him as they reveal. It is manifest in their carefully laid-out, mark-filled grids but also in less immediately apparent ways. These self-portrayals, the most magisterial of his works, dramatically beguile the viewer, but yield their expressive content slowly. Although Close's countenance in each self-portrait seems at first to be relatively static and unaffected by transitory events, successive paintings reveal much more than an impervious face. There is an undertone of emotion in the ways that he describes himself—alternately apprehensive, a touch defiant, or decidedly vulnerable. Along with control, the term "avoidance" comes to mind in relation to these paintings, but avoidance of what? Allowing emotion to take over from formal invention? After all, such expressionistic excess was anathema to the purist theology Close subscribed to early on and was therefore to be avoided. Easy enough to say but not to accomplish, because personal experience has a way of pervading even the most austerely conceived work. In Close's case, dramatic evidence

of this appears in the pair of 1995 large black-and-white portraits, a straight-on view and a profile. For all his reliance on an objective system of mark-filled squares to create them, there is a sense of unrest, even of turmoil, in these demonic self-representations. And although subsequent paintings, such as the magisterial *Self-Portrait* of 2000–01 seem embodiments of calm and order, several of the previous paintings of himself are far rockier emotionally.

Asked if portraying his fellow artists was more than a way of remembering their faces but also of exerting subtle control over them, Close doesn't disagree. But memory was what he wanted to talk about. Painting the faces of friends was an act of reinforcement, he said, "a way of keeping people who are important in my life in my consciousness." As astonishing as it may seem, Close, who has such clear recall of things he has seen, places he has visited, and works he has made, claims that his memory is full of lacunae. "I can't memorize anything. I can't add without using my fingers. I don't even know the multiplication tables. I could never have passed the SAT to get into college." During a conversation in 1996, he mentioned a battery of tests he had just taken. Concerned about his memory lapses, he had consulted a perceptual psychologist associated with New York's Mount Sinai Hospital to find out if there had been any diminution of his capacity to absorb and process information. For the information-processing evaluation at the hospital, he was to repeat as many words as he could from a list of some thirty that was read to him. After the first reading, he could repeat only the last word on the list. After the second, he could repeat two. When the list was read a third time, he managed to recall three. By that point, Close had the impression that the test giver was sure he was doing all this on purpose. The next test administered to him, though, was another story, in that it focused on a different kind of thought process. Its objective was to measure a participant's space-perception ability by having him combine apparently unrelated shapes into a coherent whole—in this instance by fitting together, jigsaw-puzzle fashion, undifferentiated fragments of neutral-toned cardboard to form an animal shape (a rhinoceros or maybe a hippo, he recalls). After studying the scattering of abstract shapes on the table, Close reassembled them into the desired form with an alacrity that surely had to be a chastening experience for the astonished test administrator. When all was said and done, his scores were either in the lowest 2 percent or 99 percent range, but nothing in between.

Memory problems continue to plague him. He often has difficulty remembering peoples' faces, he says, even of those with whom he has recently spent a fair amount

of time. "I may have sat across someone at dinner the night before and listened, so attentively, to everything he said," he recalls "and I will remember forever anecdotes he told me, but if I saw him the next day I wouldn't know him." And that was just the easy part, I learned, as Close continued his baleful confession, because his inability to remember faces is by no means limited to people he has just met. The more we talked about this, the closer to home the conversation got. It seems that I too could have been among the ranks of the unremembered. "You first came to my Greene Street studio in 1969 and saw the *Big Self-Portrait*," he reminded me, "but if I hadn't seen you again in a few days or a few weeks later, I probably wouldn't have recognized you." So how did he finally decide who I was on my next visit, I wryly inquired? By interviewing me, of course, he said: by asking me a few supposedly casual questions intended to place me in some identifiable context. "I have a series of those questions that I ask people. It's a technique I got very good at." His inability to remember faces applied only to people he did not know well, he added reassuringly, and of course, he had no problem remembering mine. After all, we had known each other for so long. Still, I got the idea.

Through all of this, another message was coming through. Close's portraits not only celebrate his friendships with their subjects but are also his anchors to reality. If, as he maintains, he needs to see people over and over again in order to remember who they are, aren't his portraits of some of them, worked on for months at a time, a way of doing that?

How might this approach apply to Close's self-portraiture, if on one level such obsessive self-scrutiny is his way of taking personal stock periodically, on a deeper one could it also be a means of constantly assuring himself that he is indeed who he thinks he is? It's hard to think of an artist of Close's accomplishments as needing approval from others, but that's been the case since childhood, he asserts. Because he was unable to shine either as a gifted student or popular athlete in high school, he says, "I was always desperate to interest others in my personality and skills." He wanted "to be a nice guy, at all costs." Indeed, this generosity comes across in his many friendships with fellow artists, museum people, and others who know him well. He is an inveterate visitor to exhibitions of work by young artists, as well as those of his more established acquaintances. He describes himself as "an intensely social being" who prefers conciliation over confrontation and is well aware of his ability to charm and persuade, even under the most negative circumstances.

However thoroughly Close may have studied the faces of his sitters and however often he may have painted some of them, none of those countenances have undergone as much obsessive scrutiny as his own. His own face is the one to which he is most ineluctably drawn. By allowing it to materialize in so many ways on canvas and paper, he has virtually mythologized it. While at first he represented it with startlingly photographic fidelity, it soon became a vehicle for more searching expression. Something else entered the mix once he transferred the photographic image to canvas: an ineffable expressionistic quotient. How else to explain changes in emotional tone between the preliminary photograph and the painting? Once he left the hospital, the gulf widened between what the camera saw and what he chose to reveal of himself, both in shifts in his facial expression and in the heightened complexity of the painting's surface.

On self-revelation in his paintings, it was clear during our frequent discussions that Close thinks about it a fair amount. "I may have done a good job at concealing who I am," he says, "but that doesn't mean that who I am isn't always there in the work." As he explains, his efforts to keep his work free of transitory feelings—if that were even a possibility—predate his exposure as a young artist to the Minimalist credo, with its low regard for expressionistic excess. In large measure, such suppression of emotion is attributable to his upbringing. To illuminate the point, he asked, rhetorically, "Martin, you spent how many years in Minneapolis, living with all those Scandinavians? So, you must know all about Midwestern Lutherans. Nobody talks about anything emotional or psychological there. The most they'll talk about is what route they took to get to your house. Well, I was raised in the same kind of culture, because the Pacific Northwest is a lot like the upper Midwest. I was raised among people who never exposed a great deal of themselves. It was considered unseemly if you did. Everything there was based on denial. God knows, you should never talk about anything personal. So now, after twenty years of therapy, I think I'm quite free and open, compared to how I was before.

"I don't think I have a tremendous number of demons, but I've never made a painting in which I wasn't troubled with self-doubt at some point during the process. The thing is, it's not longlasting. Most of the time, I'm at peace and happy and optimistic. Still, once in a while I'm plagued with moments of self-doubt and self-loathing. Why? Well, because you wouldn't be a thinking person if you didn't have those moments when you say to yourself, 'Oh, God, why did I say or do that?' Or 'I wish I'd been more thoughtful and not so rude.'"

Whatever doubts may have haunted Close—not the least, the physically limiting effects of his illness and concerns about being able to continue making art—he seems to have come to terms with these and is comfortable, at least outwardly, with his place in the world. Inveterately gregarious, with a lively sense of humor, he cherishes his frequent contacts with his art world confreres. Still, there have been enough unresolved personal issues in his life to have periodically warranted therapy sessions, one of which he recounts with mordant wit. "I went to this shrink someone had recommended. I was in his office and he was smoking a pipe, but he told me I couldn't smoke." Right then, Close realized, a power struggle had begun. "He began telling me he had analyzed me through my paintings and that he thought they were a mask I put on to stand in for me, to interface between me and the public. And he said I was hiding behind the mask!" A classically simplistic opening gambit that immediately set Close on edge. Before the would-be patient even had a chance to say a word, the psychiatrist had already made his diagnosis. "He might have waited awhile until he told me this," says Close. "I thought what he said was so outrageous that I didn't return, and I found myself a different shrink."

However elementary the psychiatrist's instant assessment, it was hard to refute, Close says, because "in all honesty, there was probably a little bit of truth in it." Something else the bluntly spoken doctor said during that first and only session stayed with him. "He told me, 'When something goes out in the world from you, it stands for you.'" Close says he especially took this observation to heart because "when that something is an image of me, it stands for me more than a portrait that I make of Phil Glass or anyone else." Pondering what he has just said, he adds, "I haven't overtly dealt with such personal issues in my painting, but that doesn't mean that they don't creep in."

How unique are the self-portraits in Close's production? In one respect, they belong to a much larger continuum, since just about everything that occurs in them, whether changes of technique or style, is to be found in his paintings of other subjects. But in another, a quality verging on the confessional comes through, especially in the paintings made after his illness struck. His later self-portraits are increasingly open in what they tell us about him. According to his friend Sol LeWitt, these later images of Close differ from his paintings of other subjects because "they go beyond the morphology of a head and the idea of portraiture;" they also go beyond conventional expressions of emotion because "in their sense of the spiritual, they transcend it." LeWitt sees this quality as something inherent in the work and not as something that

Close consciously seeks. "Chuck doesn't think about such issues, and he shouldn't. To think of oneself in those terms would be hollow and pompous, and he is neither."

At this stage of his life, and with so much achieved artistically, Chuck Close seems the embodiment of confidence and equanimity—at least outwardly. Even as he has come to terms with his physical condition, philosophically accepting its harsh limits, he has continued to explore new approaches to making art. His signature theme remains the human head, and of his many expressions of this theme, none is rendered with more formal inventiveness and subjectivity than his own.

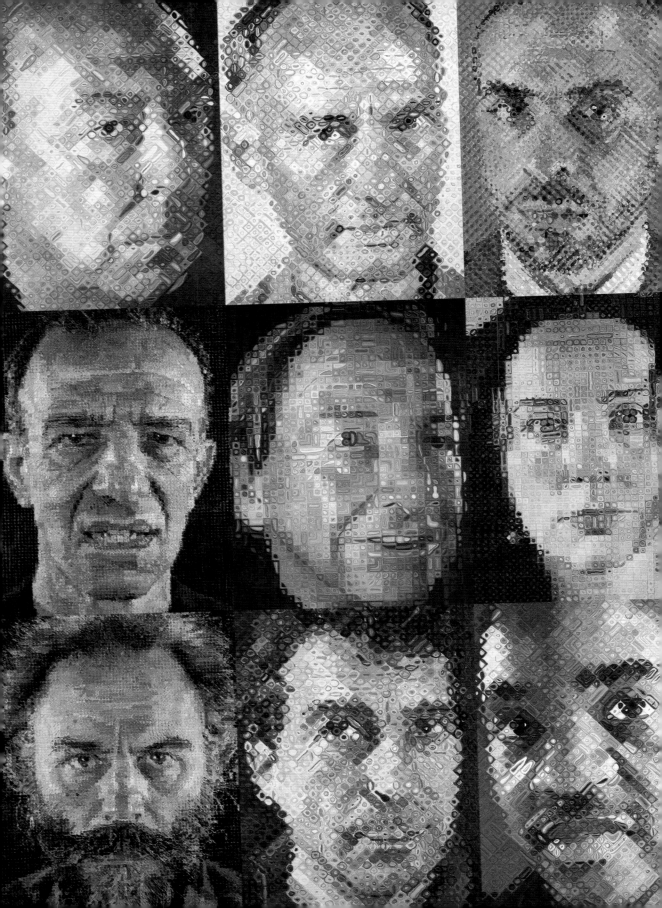

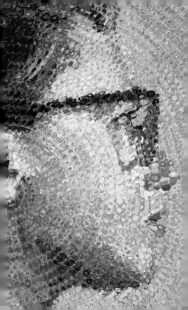

Artists Painting Artists

Apart from his self-portraits, Close's best-known paintings are of his artist friends, several of whom had been his fellow students at Yale University School of Art and Architecture in the early 1960s. Among his models from the Yale-in-New-York diaspora were the sculptor Richard Serra and his then-wife, the artist Nancy Graves, and the painters Janet Fish and Kent Floeter. Other fellow artists apotheosized by him in large black-and-white paintings were the painter Joe Zucker and Robert Israel, the latter now known for his designs for the stage. The modernist composer Philip Glass was and still is a favorite and frequent subject. Close's 1969 photo-maquette of Glass's shaggy-locked countenance, eyes fixated on some far-off point in space, mouth agape like that of a stoned bacchant, has spawned numerous images, from a heroically scaled 1969 painting in acrylic to a host of drawings and prints in various media. (So many versions, in fact, that Glass, in a droll evocation of Monet's signature theme, describes himself as Close's haystack.) Today, Close's much-expanded art world pantheon abounds with luminaries, just a few of whom are Richard Artschwager, John Chamberlain, Alex Katz, Lucas Samaras, Francesco Clemente, Dorothea Rockburne, Judy Pfaff, Jasper Johns, Robert Rauschenberg, Kiki Smith, Lorna Simpson, William Wegman, Eric Fischl, Cindy Sherman, the late Roy Lichtenstein, and, more recently, the bad-boy photographer Andres Serrano, of *Piss Christ* notoriety. To these well-known names in contemporary art circles, he added another from an earlier generation when in 1994 he painted the realist master Paul Cadmus, whom he had befriended a few years earlier and who died in 1999 at age ninety-five.

Artists painting artists is no new phenomenon in modernism's history. For whatever reasons—ready availability to each other as models or a desire to affirm friendships—this practice has an honorable ancestry, though one usually more associated with late-nineteenth-century European studio conventions than today's art scene. Degas, for example, was not only given to cool, carefully posed self-depictions throughout his long career, but often painted his artist colleagues, prominent among them Édouard Manet and from today's perspective, a few lesser lights such as the fashionable society artists Léon Bonnet and James Tissot. Manet, too, was an avid practitioner of this specialized genre, as is eloquently exemplified by the many drawings and paintings he made of his artist sister-in-law, Berthe

Morisot, as well as Claude Monet and literary luminaries such as Charles Baudelaire, Émile Zola, and Stéphane Mallarmé.

The grand prize, however, for such representations must go to yet another Manet contemporary, the painter Henri Fantin-Latour, who, thanks to his wide circle of distinguished friends and his accomplished late-nineteenth-century brand of soft-focus realism, was the era's premier cataloguer of artistic eminences. In his 1870s wall-scale tour de force, *A Studio in the Batignolles,* he celebrates a grand assemblage of Parisian painters and writers, their features subtly modeled and ennobled by soft overhead light. Whether they struck such poses as an ensemble (probably unlikely, one theory being that Fantin-Latour limned their likenesses from photographs on their cartes de visite) or were painted separately for this heroic allegory of cama-raderie was not so much an issue. What mattered more was that these luminaries were gathered together, at least metaphorically, under the artist's all-embracing eye. By painting such tableaux, Fantin-Latour both underscored the importance of his many artistic and literary friendships and did so with a careful eye to history.

Like those august French predecessors, Close emphasizes his intimate connections to the art world in portraying his artist friends. Leslie Close describes him as an "art world citizen. He has a very strong sense of history, and he's in love with that world. He never tires of art world events, night after night. I don't have the appetite for it, but he does." That sense of responsibility has taken many forms in Close's life. An indefatigable attendee of artists' openings,—he is a prime mover in other ways. He had a brief tenure on the Council of the National Endowment for the Arts in 1983 and 1984, he has been an active member of the American Academy of Arts and Letters since 1992, and a trustee of the Whitney Museum of American Art since June 2000. His involvement with these establishment institutions—where his insights, eloquence, and incisive wit are much valued—is, I suspect, attributable as much to his desire to make sure that things are done correctly by them as to an acceptance of his proper due as an art world mover and shaker.

What follows is a series of pieces based on my discussions with ten artists painted by Close, who talk about his portrayals of them, his self-portraits, and the role of self-portraiture in their own work.

For more than fifty years, Richard Artschwager has had a double existence as an artist. Celebrated for sculptures that approximate chairs, tables, and doorways, their weighty elemental forms sheathed in wood-grain and marble-textured Formica, he is also admired for his idiosyncratic paintings, many depicting human figures and faces. Until a few years ago, much of his art emanated from the scruffy, rambling spaces of a Brooklyn studio, but these days he works in a deconsecrated Methodist church near the town of Hudson, in upstate New York. "Not quite an industrial space in the SoHo sense," he says of it, but there is enough room there to paint, draw, and work on other projects.

Although the subjects of Artschwager's portraits have mostly been selected from anonymous "found" images, he has been his own model on a few occasions. Except for the first of these, a small, quite traditionally realized 1951 oil painting in which his aquiline features are subtly modeled in fugitive tones of gray, these self-portraits are tentative, rather generalized, and just this side of abstract, linear compositions. He has also been the subject of two portraits by Close, both derived from photographs Close made during two sittings, seventeen years apart. The first, *Richard A*, a small ink-and-graphite black-and-white dot drawing, was based on a 1974 black-and-white photograph. The second, *Richard (Artschwager)*, derived from a large color Polaroid, is a six-foot-tall 1992 painting in which Artschwager's countenance materializes within a vibrant matrix of warm-toned cellular forms. The drawing reveals a slightly grumpy-looking, fiftyish Artschwager, wispy hair in mild disarray, who appears to have been talked into posing, much against his better judgment. In this three-quarter view, he looks away from the camera.

Close agrees with this reading of the picture, recalling that Artschwager exhibited similar hesitancy when he sat for the photographs Close made for the second portrait. Of that session at Polaroid's downtown New York studio, Close says, "Richard was a reluctant subject. He was so self-effacing that it was hard to get him to engage the camera and look at the lens. He'd put his head down and look at the floor. The painting that came out of that session is one of the least concrete and apparitionlike of my images. There's almost nothing there. Usually there's a strong corner of the mouth, or a shape that defines the nostrils, but in this painting he seems to be dematerializing in front of your eyes." Was there some possibility, I

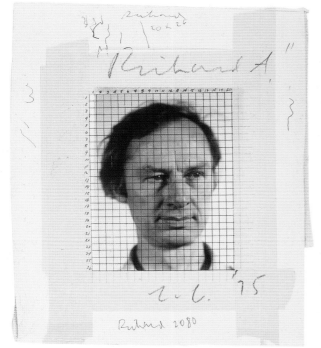
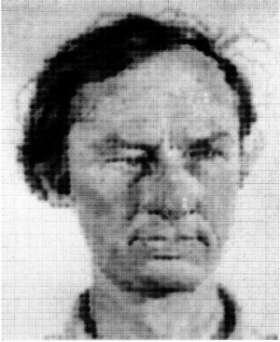

(left) Maquette for *Richard A*, 1975. Polaroid mounted on foamcore, 4 x 5". Collection of the artist **(right)** *Richard A*, 1975. Ink and graphite on paper, 30 x 22". Collection of Fred Escher

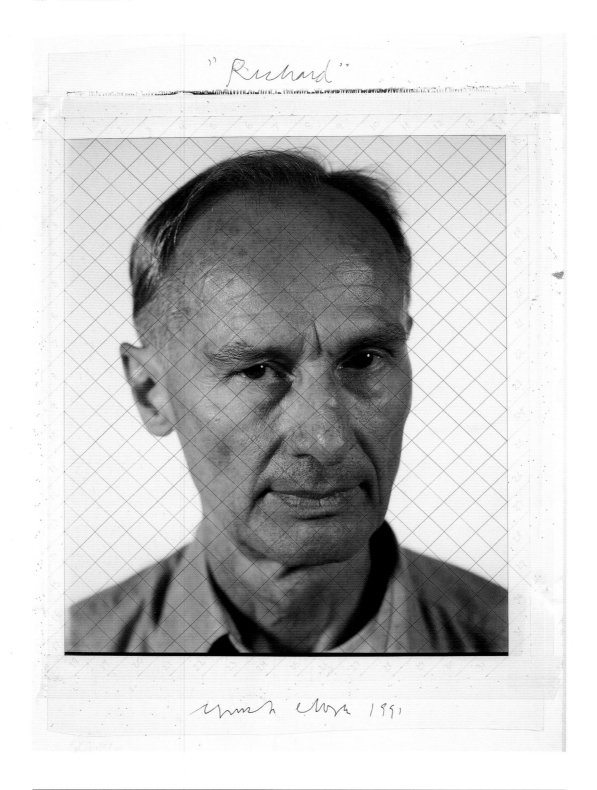

"Richard"

Chuck Close 1991

Maquette for *Richard (A.)*, 1991. Polaroid mounted on foamcore, 24 x 20". Collection of the artist

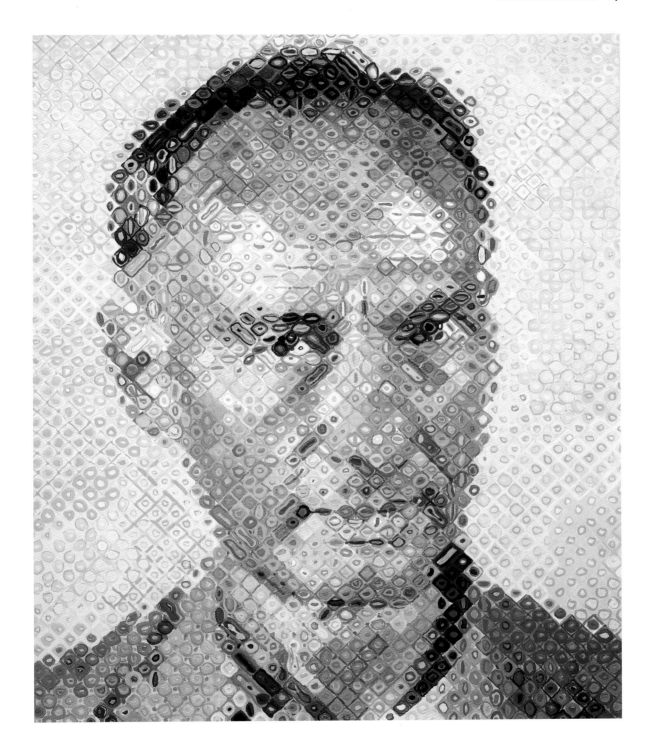

Richard (Artschwager), 1992. Oil on canvas, 72 x 60". Collection of Genevieve and Ivan Reitman

asked Close, that in painting the portrait he might have been projecting his own ideas about Artschwager's elusive personality and that, therefore, he had intentionally kept it in an unresolved, atmospheric state? Not necessarily, he answered. "To tell you the truth, the photograph was a less-than-perfect Polaroid, very pale, very green, not much contrast, and I probably shouldn't even have tried to make a painting from it. But my affection and respect for Richard made me want to paint him, and I didn't want to drag him back for another sitting in front of a camera, because it seemed so painful for him. But I went on to make the painting, and I suppose I tried to add some things that weren't necessarily embodied in the maquette. Usually, getting a likeness is an automatic by-product of the way I work. I never think about it. Never. But in Richard's case, it was a struggle to get the painting to look like him."

In *Richard (Artschwager),* the patterns of squares and circles of pale violet and rose, with flecks of blue and green, that comprise his face radiate a warm tonality. A pair of diagonals, almost a subliminal X shape, cross at the bridge of the nose. The outlines of Artschwager's face and hair flicker and dissolve into an aqueous background. As Close portraits go, this is one of the most tightly drawn and even-surfaced. Artschwager, too, sees it as less radical than, say, Close's painting a year later of Kiki Smith, with its wide-eyed stare and four-leaf-clover eyeballs. The face in *Richard (Artschwager)* bears only tangential resemblance to what the artist looks like now. True, he is twelve years older than when Close painted it: he is eighty-one and even more gaunt-looking. His skin is paler, his cheekbones more pronounced, his hair thinner and grayer, and his mustache, begun in the mid-1990s, is nearly invisible. In many ways, this 1992 painting is very much an exterior, even idealized, view of an exceptionally complex, inward-looking artist whose thin-featured face can at times seem haunted and whose observations about life and art can shade into the visionary.

As Artschwager approvingly observed during our conversations, he and Close have always had a few important things in common in their attitudes about painting, despite the obvious incongruity of their styles. Also, when he looks at a Close portrait, he says, with a certain degree of pride and satisfaction, "I can see someone who has been marginally influenced by me." After all, he continues, Close had once acknowledged his gratitude to him for practically inventing black-and-white painting, an approach that the younger artist so eagerly embraced in the late 1960s, at the beginning of his own career. Reflecting on their other shared attributes, Artschwager observes that both of them have always regarded photography as an integral step in

making their paintings. For both, it has been more than just a research tool in choosing a subject; it has been a point of departure into the exploration of form. While pondering other possible commonalities in their respective approaches, Artschwager cites their mutual reliance on the grid to transfering photographic images to their painting grounds—in Close's case, to canvas, in his own, to pebbly-surfaced Celotex.

Yet, for all such affinities of attitude and process, their paintings could not differ more radically. Unlike Close, who from the outset of his career has made or overseen the making of every photograph he uses, Artschwager almost always relies on images retrieved from old magazines, periodicals, and discarded family albums he finds in secondhand stores. The identity of a photograph's subject matters little to him: it is enough for his purposes to find one or more nameless faces in those faded mementos that can hold his attention and that he can transform into a painted image. The examples are many. Atop the chest of drawers in *Portrait I*, a 1962 sculpture overlaid with painted faux-wood grain, is a framed, larger-than-life portrayal of an anonymous face whose wide-open eyes urgently engage us. Just as arresting and at the same time oddly nostalgic is *Sailors,* a four-panel 1966 painting whose figures could have come from a World War II–era newspaper photograph of gobs in their summer "whites" on shore leave. We know we have seen those faces before, but can't recall when or where. Such is the seductive magic of an Artschwager image: it exists in a limbo between the specific and the generic. Somehow, he is able to tap into the history of a photographic illustration and bring forth wonders. Strange, beguiling things can happen, he explains, when gleanings from old newspaper illustrations are seen under a magnifying glass, especially mechanically reproduced images from the 1940s and '50s. When seen enlarged, their ink-on-coarse-paper textures suddenly become fields of eccentric marks, a process implicitly alluded to in his paintings.

Close enthusiastically talks about the importance of Artschwager's influence on him. "When I was teaching at Amherst and would come to New York to look at art, those people who were making representational imagery were particularly important to me. Not only Andy Warhol and Alex Katz, but Richard too." Artschwager's work, he recalls, was "halfway between representational form and Minimalism, an idea that really appealed to me then." As their friendship developed, one of the older artist's most intriguing qualities, Close says, was his "ability to talk in metaphors and make a point without speaking directly to it," a quality that he notes is still perva-

sive in Artschwager's work. "I loved the way he used the texture of the Celotex ground, by rubbing paint on it to give it the quality of a half-tone reproduction. When you think about how he did this, you can't help but think about Lichtenstein's first use of benday dots, when he used a stipple brush to push pigment through a wire-mesh screen onto a canvas. There was a decidedly handmade quality to all those early Lichtensteins and Artschwagers."

Close characterizes Artschwager's use of black and white as having the force and grittiness of a vintage Weegee photograph of some grisly subject or of early documentary war films in which things seem more real in black and white than they would in color, observing that "nothing portrays reality like black and white, because your mind fills in the appropriate color." Though Close began exploring a more chromatic universe in the early 1970s, Artschwager has never wavered in his attachment to black and white. When I asked him why color was such an inherent part of his three-dimensional pieces, but so fugitive an ingredient in his paintings (at most, a pale green sky in a landscape or a yellowish tone in an interior), his bemused reply was, "I really don't know. It puzzles me. Hardly a month goes by that I don't try to use color in my painting."

During our conversation, Artschwager marveled at the fortuitous chain of events that led Close to his central theme, the human head. He was aware that Close's first self-portrayal, the 1968 *Big Self-Portrait,* derived from a set of photographs he had made of himself soon after his move to New York. What especially fascinated him about this story was Close's unerring instinct to use one of those photographs for his first large-scale portrait, and thereby instantly arrive at both the theme and format of all his subsequent works at the easel. He feels that Close must have had some instinctive notion about the possibilities for his future work that were inherent in those seminal shots of himself. "After all, that's how you have to work in this trade. You don't throw anything away right away. You might stick it in a drawer, but you don't throw it away. So Chuck takes the shots, uses up the rest of the film—it's a trifle. But then the film gets developed, and then maybe he sees something going on in the contact strip or even in a print that he wants." After all, isn't that how artists should react when confronted by enticing, but unanticipated, situations? In fact, opines Artschwager, commenting on Close's selection of one of the photographs for use in making a painting, "He didn't even know that he wanted it until he saw it."

Artschwager has worked at various jobs in the course of his long artistic career, but few of them have had as much effect on his art as his experience in woodworking and photography. From 1951 to about the early 1970s he ran a cabinetry shop, where among other objects he made tables and housings for loudspeaker units. For one client, a nearby Catholic church, Artschwager and his brother-in-law made a variety of ecclesiastical objects, from prie-dieux and altars to Bible stands. By his own admission, he ran their furniture business into bankruptcy as he diverted its resources to making his sculptures.

While the influence of Artschwager's woodworking career is readily perceptible in the blocky chairs, tables, stairways, and windows for nonexistent rooms that he subsequently produced, just as formative in the development of his imagery, especially his painting, was his brief career as a portrait photographer. How photography came to be part of his life is one of the more peculiar episodes in his checkered career. "In the early 1960s," he explains, "when I was casting about for a profession that would give me some control over my life and still allow me to be an artist, I seriously thought about being a plumber, an electrician, or a carpenter. I needed a job that would let me work at my own pace and whenever and however I wanted." The solution came in the form of a *New York Times* classified ad for a photographer that stipulated, as he remembers, "must have car and twin-lens camera." The potential employer was a cotton diaper service that had an arrangement with a commercial photography studio. Each family that signed up for Stork's pickup and delivery was eligible for a free five-by-seven-inch baby photograph. Armed with ten roles of film, Artschwager sallied forth daily to do his job. Once he photographed a baby, the idea was to show his contact sheets to the proud parents and thus convince them to place orders for additional photographs. But his Stork days were numbered, and he was soon fired because "I had never bothered to acquire a light meter and therefore had too many underexposures." In need of income, he began working on his own as a baby photographer in Stork-free neighborhoods. Less interested in darkroom technology than in what it brought forth, he found someone else to do his developing and printing, but reserved for himself the task of hand-coloring the sepia-toned prints that his processor provided him.

That freelance career, too, was short lived, for making pictures of children was far from Artschwager's calling. His interest in photography soon took less specific and less commercial forms. He began thinking of it not as an expression in itself but

RICHARD ARTSCHWAGER *Janus II*, 1981. Acrylic on Celotex with mirror and Formica, 52 ¼ x 33 ½ x 19". Collection of Jeffrey and Marsha Miro

as secondary to his painting concerns—in fact, as a step toward painting. Further, in his use of photographic imagery, such conventions as specificity gave way to generalization. We sense this in the curious indeterminacy of time and place in the portraits he made from photographic sources. His renditions of the human face, his own included, verge on the atmospheric. In fact, in the 1981 *Janus II,* one of Artschwager's few self-portraits, about all that is recognizably him is the attenuated, angular figure. The painting depicts half of a seated person, the other half its reflection in a mirror at right angles to it. He made it by tracing the outline of a grid-enlarged photograph on vellum, then transferring the results to the rough-surfaced ground. "I used half of a photograph of myself to make it," he says. "It was an unstable figure, split like half the letter 'A.' I stabilized it by using the mirror." This seated Artschwager, more a drawing than a painting, is a paradoxical tentlike shape with a single, spectral head and a body that sports two sets of crossed legs. Realism, certainly in the Chuck Close sense, is wholly absent in this baffling self-portrayal, which the artist acknowledges is "a rather schizophrenic image—really two pieces of one person. When I took that picture with a Rolleiflex, I wanted a photo of myself sitting in a stool or chair, but not something quite as bizarre-looking as this."

Not only is Artschwager's atmospheric approach to portraiture distinctive from Close's pragmatic one, his renditions of the human face and figure are virtually ectoplasmic in their insubstantiality. His faces, bodies, and backgrounds share the same substance—or, in his case, nonsubstance. One of his most recent self-portrayals is *Artschwager,* a 30-by-26-inch acrylic painting made in 1999. Unlike the otherworldly *Janus II,* it is a more traditional study whose directness hearkens back to his youthful, quasi-academic 1951 portrait, with enough modeling to suggest the volumes of his head and neck. The whorls of the Celotex ground are a strong textural counterpoint to the tightly described contours of the face that overlays them. Far different in mood and execution than that poignant rendition of him is a 2003 self-portrait, a countenance viewed as through a thin sheet of crackling ice. This is a more remote Artschwager who regards us dispassionately. In sharp contrast to the network of crisscrossing straight lines that describe him is the painting's vivid apple green background, a hue that he describes as "baleful green."

In view of the tenuous way in which Artschwager represents human physiognomy, his admiration for Close's methodical, densely painted treatment of the same theme may seem surprising—but not to him. His regard for Close's ability to use

color so palpably and structurally, and to assemble his paintings "stone by stone," might also seem oddly placed, given the intangibility of his own painted forms—but he sees no inconsistency there, either. So convinced was he that Close looks at the world in a uniquely focused way that, during our conversations, he came up with an exotic metaphor to characterize that specialized vision. He used a Spanish phrase, *mirada del coyote* (rough translation: the all-encompassing gaze of the coyote), that neither I nor the lexicographers at the Hispanic Society of America in New York had ever heard before. When I later asked Artschwager about its origins, he casually replied that it was a characterization he had invented, then went on to compare Close's acute powers of observation to those of that feral creature. "The coyote," he explained, with a whiff of 1960s Carlos Castaneda mysticism, "must be able to see everything at once, everything in front of him and everything peripheral to his vision, because his life depends on his capacity to find food and protect himself from constant danger." While under no such duress, Close, in Artschwager's admiring estimation, possesses the same capacity to register with equal intensity everything within his visual framework. "Chuck has the ability," he says, "to see details and the whole, all at once. It's not a back-and-forth effort. It's all at once, and it's all the time, too." Artschwager regards Close as having great control over the viewer, whom he places in strange perspectival situations. The viewer's eye level, is well below that of the subject. In fact, it's about at the subject's collar-button level, he says.

Artschwager also talks about less tangible matters, about what he calls "co-reality," the shared space inhabited by the viewer and the painting. Close greatly expands that space, he says, both by the scale of his works and by the force and complexity of their marks. When I asked about other painters whose work has a similar effect, his surprising response was van Gogh, an artist whose feverish brush strokes, like Close's dot-filled cells, have lives of their own. When I suggested that Close might be equally surprised as flattered by the comparison—especially given the insistent neutrality of his painting approach, which is so opposite to van Gogh's unbridled expressionism—Artschwager's orphic pronouncement was, "Passion comes later. It's more in the eye of the viewer than in the artist's." Anyway, as far as he was concerned, the most interesting aspect of Close's work was less its psychological content than its visual qualities. In particular, he observes, what distinguishes Close's imagery is the unique ways in which he fractures and recombines forms in order to achieve his singular brand of reality.

RICHARD ARTSCHWAGER *Artschwager*, 1999. Acrylic on Celotex, 30 x 26"

RICHARD ARTSCHWAGER *Self-Portrait*, 1951. Oil on canvas, 11½ x 15½". Collection of Eva Artschwager

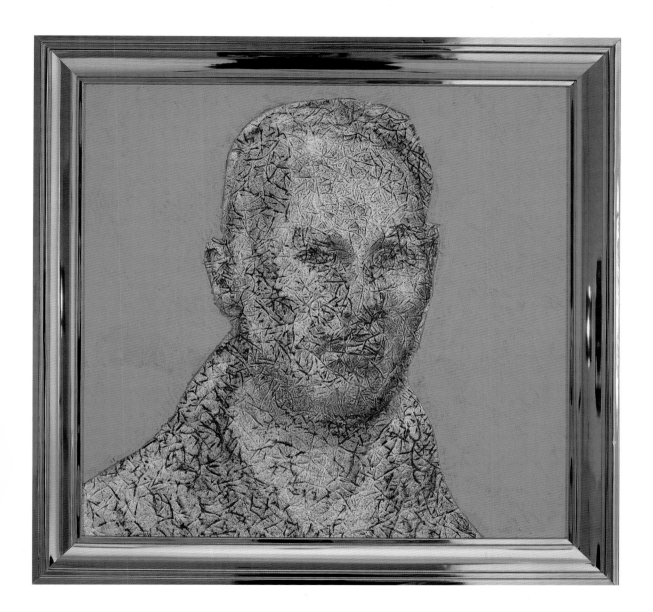

RICHARD ARTSCHWAGER *Self-Portrait*, 2003. Acrylic, fiber panel on Celotex in artist's frame, 24⅛ x 25⅛″. Collection of Sheila and Milton Fine

FRANCESCO CLEMENTE (b. 1952)

Though the Naples-born Francesco Clemente is widely celebrated for paintings and drawings that inextricably fuse real and fanciful worlds, his images of his instantly recognizable self are among his most recurring. His serene countenance dominates his imagery, sometimes as a central element, other times, as one of many faces in a group. While attentive to my questions about his and Close's respective approaches to self-portraiture, he could at times seem impassive and detached, even while speaking. His friend the writer and artists' representative Raymond Foye characterizes this trait as symptomatic of his "avoidance of a fixed identity, a state possibly reinforced by the painter's long dialogue with Buddhism and various Hindu philosophies." Nevertheless, during our conversations, Clemente would periodically leaven the sobriety of the moment with some amusing observation and an engaging smile.

As Close's two portraits readily reveal—*Francesco I,* dated 1987–88, and *Francesco II,* 1988—Clemente has a long, well-formed head, close-cropped hair, a carefully trimmed short beard and mustache, fine features, and an expression that borders on the mystical. In both paintings, his blue-gray eyes reflect the lights of Polaroid's studio, where he sat for the photograph they derive from. His long, dark eyebrows are upside-down Vs, his lips are compact, the lower one full. The lines alongside his mouth contribute to his mildly aloof expression. In both paintings Clemente's tie is slightly loosened around a partially open shirt collar. His jacket is a murky blue field peppered with dots of red and violet paint. Though made from the same photo-maquette, these portrayals are distinct from one another in technique and feeling. The artist's elegant features in *Francesco I* appear as though viewed through a fine-mesh screen. The dotted surface is dense and richly variegated. The contours are strongly modeled; in fact, one of this painting's distinguishing features is its strong sense of palpable form. The diagonal cells that comprise Clemente's face are small and numerous. *Francesco II,* composed of larger and coarser diamond shapes, is a more tentative rendition, and with its blurry outlines, the more subjective of the pair of images.

When Clemente and I met on a gray winter day in his lower Broadway studio, his attire was more exotic than when he sat for Close's photograph. Dressed in a long, rust-colored Indian-style silk shirt over dark trousers, he had a fashionable, few-days-old beard and was sporting a pair of South Indian gold earrings, each

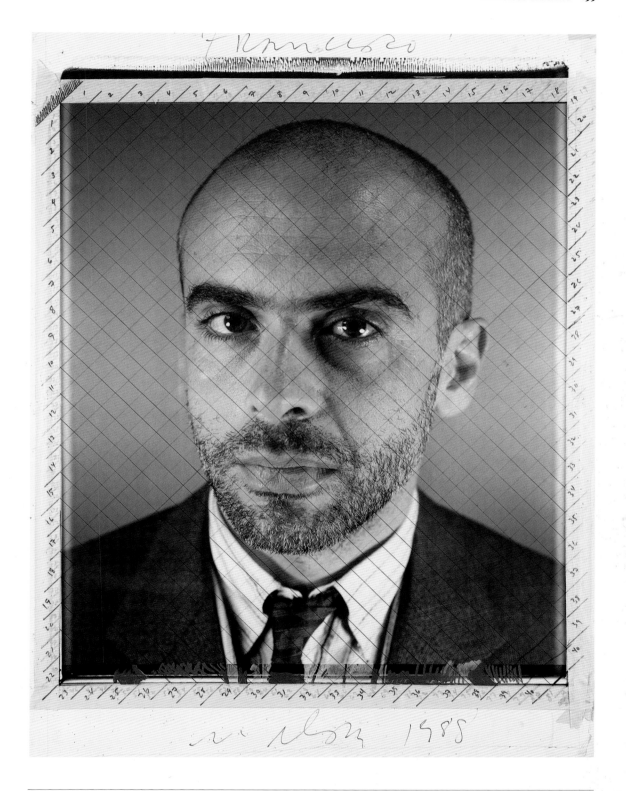

Maquette for *Francesco*, 1987. Polaroid mounted to board with tape and ink, 20 x 24". Collection of the artist

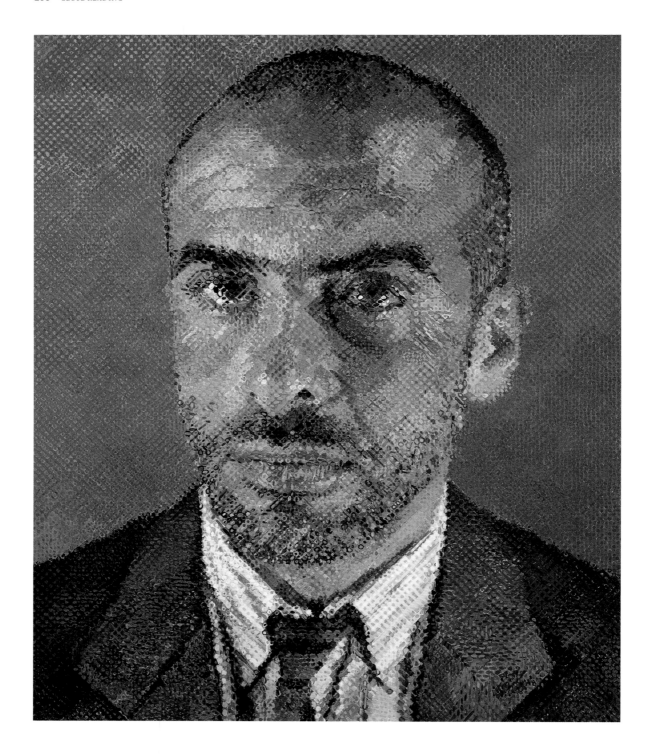

Francesco I, 1987–88. Oil on canvas, 100 x 84". Collection of Ron and Ann Pizzuti

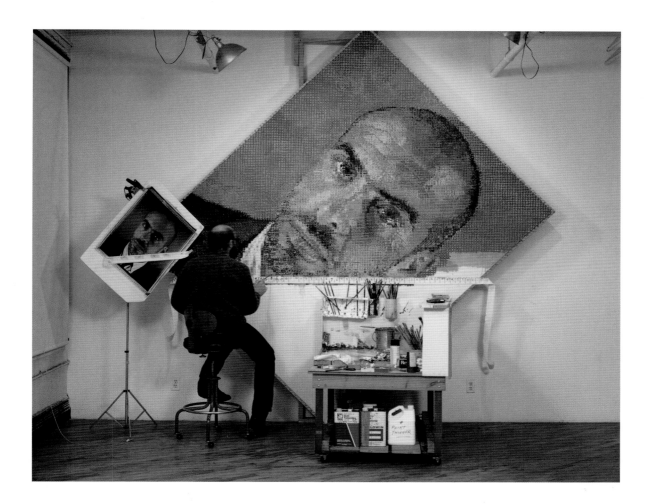

Work in progress for *Francesco I*, November 1987

containing a rubylike stone. This was in keeping with a small altar covered by a red cloth and topped by several Hindu temple figures, as well as a few unidentifiable, quasi-abstract objects. A few recently completed large paintings were leaning against the walls in various parts of the huge loft, some an unlikely but intriguing fusion of anatomical and architectural shapes. Painted with great care, their surfaces were smoothly brushed, with each area accorded equal attention. In recent years Clemente has steadily moved away from the vaporous, semitransparent shapes he was known for, even prior to his move to New York in 1981.

He and Close are comparatively recent friends, even though, he says, "we have known each other since I've lived here—but mostly by waving at each other across crowded rooms." Though Close invited him to sit for a photograph in 1988, he was unaware that soon after, that image of him had mutated into a painting. "I kept getting congratulations for my portrait at Pace." The first few times this happened, Clemente said, he felt a jolt of surprise, wondering, "What is my self-portrait doing there?" He soon adjusted to the fact that it was not one of his own works, but Close's painting of him. As for being photographed by Close, as he remembers, "It was pretty fast. All I really did was walk in and walk out." Knowing Close's preference for having his models assume purely neutral expressions, I asked Clemente if he had been asked not to smile, to which he cooly replied, "I never smile in pictures." Close's painting process—one during which the subject is not present—could not have been more opposite to Clemente's. "I don't work from photographs," he says. "I work from life, so that means that the person has to sit with me for long hours."

When I asked if he thought that Close's self-portraits differ stylistically or psychologically from those that he makes of others, he replied, "My instinct would be to say that they don't differ, because in principle, they shouldn't." Then he added, "What throws me off is simply the word 'psychological' because I don't know that any painter today has an interest in that element, including myself." His own portraiture, Clemente notes, is not shaped by photography or a mechanical process. "I would say that my works are about the spirit of the person. But Chuck's, I think, are about something else. They are about the kind of soul or resonance even a mechanical construction can have." After a moment of reflective silence, he added, "I don't think they are as much about him as they are about process."

We talked about changes he may have perceived in Close's paintings of himself, his recording of the effects of aging, the heightened sense of introspection in these

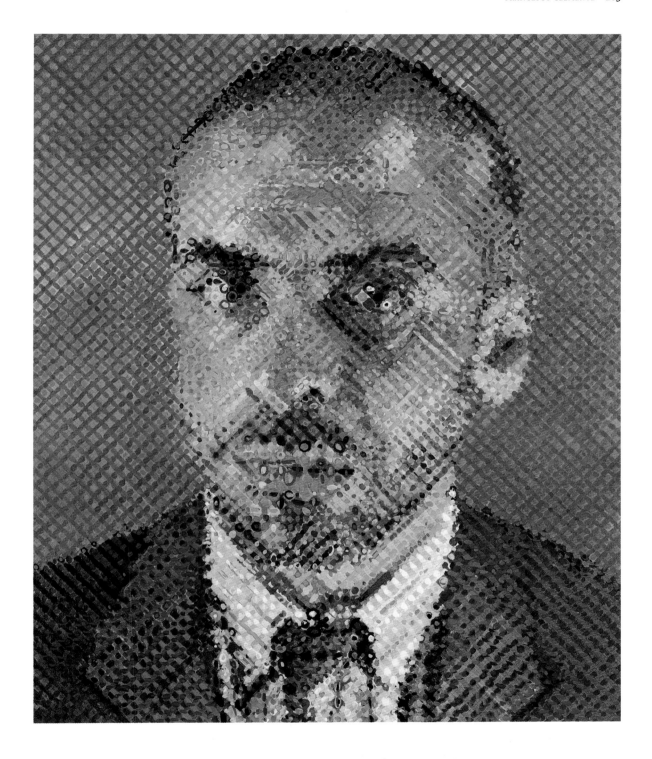

Francesco II, 1988. Oil on canvas, 72 x 60". Collection of Darwin and Geri Reedy

portrayals, and their increasingly turbulent paint quality. Don't these changes in Close's work, I wondered, add up to a greater sense of subjectivity in his painting? Didn't they imply a distancing of himself from his purportedly neutral stance? After another moment of thoughtful silence, Clemente's oblique reply was, "Can I say something really funny? I don't know if it is funny, actually, but since I also have grown older and don't have the same eyesight I used to have, I look at all paintings that way. You see a self-portrait of a young Rembrandt: it's extremely precise and accurate and minute." But as Rembrandt grew older, he continued, "his self-portraits were, let's say, sloppier and sloppier, more open and more fuzzy. I'm sure there are existential reasons for it, but there is also really a technical reason: as you grow older, you can't see as precisely as when you were young."

Was Clemente, then, perhaps suggesting that Close was not seeing so precisely these days? "Not at all," he replies. "It has to do with the way one sees, as an artist. I don't want to be so strictly anatomical—but you do see less because you see in a more open way. When you look at the sequence of Chuck's paintings, there is a very open universe in each one that was not so evident at the beginning. Whereas maybe their structure was understated at the beginning, but now it's more frankly stated, I would say." And in a more open universe, Clemente suggests, abstraction increasingly competes with illusion. As we talked about the fact that Close never varies the centralized, single-head format of his paintings, but makes incremental changes in their surfaces over successive works, Clemente's observation was that it was his way of revealing the structure of an interior world. In his view, Close's painting is a uniquely American phenomenon because of its extreme focus on form-building. American artists, Clemente thinks, are pragmatic in that sense: they build form in the most unexpected ways and places. In reacting to Close's imagery, he seems to equate form-building with the use of systems. "Chuck sets for himself these very strict limitations at the beginning of his work."

Clemente admiringly characterizes Close as an artist who has positioned himself well outside the rules of today's modernism. "Here we have an American painter who paints faces, who paints eyes that are staring at you, who paints self-portraits, who paints things that are not really central to the perpetuation of the mainstream. They are sort of taboos, all of them, you could say." Weighing what he has just said, he goes on, after a short pause, "Mainstream is not what I mean. I should have said, basically all of those elements that belong to the grand tradition of painting that

young American artists believed they could emancipate themselves from—like the New York School and all that. They wanted to give up all of the elements, yet he has reintroduced them."

In Clemente's opinion, artists who paint self-portraits today do so for the same reasons as those in the past: they want to learn something about themselves and, in the process, find new ways of doing this. I reminded him then of his observation that some artists don't want to be burdened with the expressionistic or psychological freight that characterizes so much historical portraiture. If that is so, what other reasons would there be for painting a self-portrait? More specifically, why does he paint them? Clemente's response, however circuitous, was insightful. "In my experience, the self-portrait is actually a reminder of the fragmentation of the self, of the fact that you are born again and again, and that you are not the same person twice in your lifetime. That's the way I have always seen it. In a sense, that's what every painter in the past has done; he returns to what he has been. On the one hand, the face is never the same; on the other, it is the emblem of what is permanent in your life, the silent witness that sees your identity change from moment to moment. This sounds very Oriental," he admits, concluding his speculative riff with a self-deprecating laugh. He acknowledges his explanation may also sound a bit spiritual, but why not? America, of all places, is where you can discuss such concerns openly, "because it is built on the 'prophecies' of people like Thoreau, Emerson, and all those who have legitimized religious experience as individual, not given to you from above."

In numerous drawings and paintings of himself, Clemente has managed to schematize his own distinctive features, with a few lines, to startlingly accurate effect. Since he fully understands the topography of his face, he has no problem making subtle changes in its representation from one image to the next. In all his self-portraits, the eyes—feline and slightly hooded long shapes—are the dominant forms. Then there is his all-but-shaved head and full, sensuous mouth. He often presents himself as an elongated nude figure, sometimes gazing into a mirror, sometimes reclining on his back as though in an ecstatic stupor. Many drawings of his head feature large phantom images of his nude body floating behind smaller, more exactly rendered ones. In a series of pastels made in 2000, a ghostly Clemente hovers behind a more palpably drawn one. His facial expressions and those of his looming alter ego in these drawings verge on the trancelike. The self-representations fuse unexpectedly; in one instance, the dull pink mouth of the background face imprints

FRANCESCO CLEMENTE (top) *Untitled*, 1994. Pastel on paper, 26¼ x 40¼" **(bottom)** *Untitled*, 1996. Pastel on paper, 42 x 59"

FRANCESCO CLEMENTE *Untitled (Self-Portrait)*, 1996. Pastel on paper, 42 x 59"

itself on the forehead of the face in front of it. In these images, so redolent of traditional Hindu iconography, the artist seems in mystical dialogue with himself.

Clemente says he uses himself in his paintings and drawings because it's the subject he knows best. When he represents it, he is not dealing with surfaces but with emotions. The fact is, he says, that "without emotion you can't make any rational decisions and that, ultimately, the trigger of any rational decision is an operational emotion based on your need for survival." This is not a nebulous romantic idea, he assured me, but a scientific one, "because if emotion is reality, painting is its language." As to how and when he decides to make a self-portrait, Clemente maintains there is no urge that says to him, "It's time, Francesco, to make an image of yourself." No more so, in fact, than any other work he makes. Like his depictions of other subjects, a self-portrait "is meant to consolidate a crossing of events or coincidences or suggestions, just this sort of happy confluence of elements." As it develops, he says, it has the capacity to surprise him and take on a significance he hadn't thought about earlier. "It has to do also with a sense of place. It has to do with the necessity to confront yourself with where you are."

Despite Clemente's high regard for Close's systematic form-building, he is well aware of the changes in the artist's work since the advent of his illness in 1988. "The cells that constitute his painting have become much more open and alive, and almost disturbing because they really pulsate with life. But life that is quite frightening—mechanical, relentless pressure." It's not everyday life, he speculates, but visceral shapes like those under a microscope. Asked to reflect on the considerable differences between his approach to self-portraiture and Close's, he replies, "His self-portraits are based on . . . how can I say this? . . . He seems to be looking at what is permanent in a face. When I make a self-portrait, it is the opposite. I want to break down that total image into as many images as possible."

It was as much his fascination with Clemente's involvement in such matters as his arresting appearance, Close says, that prompted him to invite the worldly Italian to pose. "I always enjoy the dialogues I have in the art world with people like Francesco, whose work is so different from mine and who have such different reasons than I do to paint. He talks about spirituality and other things that I have no idea about but can still relate to. It's all about 'the other,' a concept that I'm infatuated with." I asked Close what it was like to paint someone like Clemente, whose ideas about art and life were so remote from his, but whose large two-dimensional

image would be his companion in the studio for four to six months as he worked on it. No problem, Close replied, because shortly before his sequence of Francesco portraits, he too had borrowed a few ideas from non-Western sources to deal with a comparably exotic subject, Lucas Samaras. In *Lucas II,* Samaras's mesmerizing face is embedded in a matrix of jagged color fragments reminiscent of those found in ancient Roman and Byzantine mosaics, an especially appropriate formal context for so otherworldly a contemporary art world figure. So, when the time came to paint Clemente, Close says, "I was still conscious of the mosaic thing, probably more with Francesco than just about anybody else I've painted, other than Lucas."

Clemente obviously appreciated the distinction of being painted by Close because in 2002 he reciprocated by asking Close to pose for one in a series of horizontal-format portraits that he had begun the year before. The paintings, each three and a half feet high by seven feet long, represented their subjects in partially reclining positions. Among those depicted were the artist's wife, Alba, the poets Robert Creeley and John Ashbery, the dancer Bill T. Jones, the painter Helen Marden, and the photographer Annie Liebowitz. These partially factual, partially stylized renditions are permeated by all sorts of historical resonances. The strongly conventionalized recumbent poses vaguely allude to the sculptures on Etruscan sarcophagi; their flatness, ochre tonality, and minimal modeling echo the figures of Giotto and the Trecento; their large-featured, quasi-realistic faces evoke those painted on Coptic mummy cases. There is even a whiff of the 1930s clinical realism of Neue Sachlichkeit à la Otto Dix about these portraits, in their intense focus on an outsized head. In making these paintings, Clemente says, "I spend five and a half hours on the head and fifteen minutes on the body."

While the focus of Clemente's painting of Close is clearly the head, also visible, if in reduced scale, are his upper torso and part of the right leg, on which his hands rest. The remainder of the body, well below the picture's rectangle, is therefore unseen. In modeling for this contorted view, Close almost seems to be crawling into its elongated picture plane and striving to maintain his balance. As he describes it, this was a fascinating, if arduous experience, especially given his physical condition. "Francesco asked me to pose in a reclining position. He was working on the floor, and the painting was propped up at an odd angle against a piece of furniture. I don't know how the hell he stays down there on his knees, but he does. I couldn't work like that for a second, even before I was in a wheelchair. We would take a break from

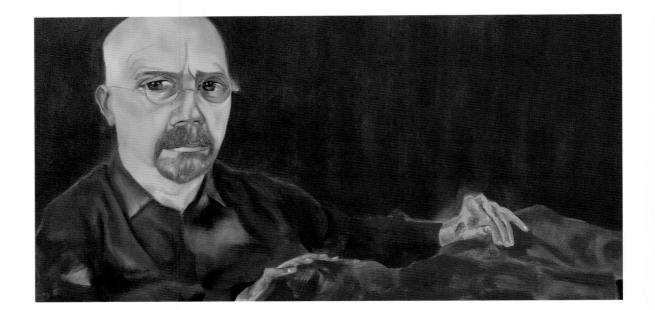

FRANCESCO CLEMENTE *Chuck Close*, 2002. Oil on linen, 42 ¼ x 84"

time to time and he would turn the painting around for me to look at it, and I would think, 'Oh, how many more hours is this going to take?' After five hours, he hadn't gotten any further than my forehead and an eye and a mouth, and whatever. But the rest did go very quickly."

What really caught Close's attention during the posing process was Clemente's relentless brushing of paint on the canvas. "I was struck by how different the physicality of his painting process was from mine. I remember the sound of his brush and thinking, 'I don't make noise like that when I paint.' There was all that scrubbing, scrubbing, scrubbing, and working the pigment into the weave of the canvas. I was also taken by how much he kept looking at me. The intensity of his scrutiny while I was posing for him was palpable." So was the fevered pitch of his painting. "I thought that with all that concentration, his painting of me would be more factual than it is. Clearly, he was looking for something, but it was not necessarily what I would look for when I paint." Mere factualism, however, obviously wasn't Clemente's objective. While his painting depicts Close's features with fidelity, so exaggerated are they in scale that they bear a disquieting relationship to each other. He has a somewhat strained, troubled look. His eyes are preternaturally large, and Clemente has made much of his forehead's vertical frown line. He has also invested Close's normally ruddy face with an odd pallor and lightened his dark, gray-flecked beard and mustache.

But perhaps the most arresting thing about the painting is that the model's features somehow resemble Clemente's as much as Close's. Given this paradox, who indeed is the subject of this painting? In painting this image, Clemente may have taken the concept of self-portraiture into a new realm. Whatever the case, this portrayal offers another side of Close, who in his self-portrayals rarely permits fleeting moments of uncertainty or impatience to enter the picture plane. By contrast, Clemente's painting of him is of a particular moment—actually one long session—during which his cooperative but uncomfortable model was positioned awkwardly on a low couch. It is certainly an unguarded Close that Clemente gives us here.

LYLE ASHTON HARRIS (b. 1969)

The tall, lithe photographer Lyle Ashton Harris looks younger than his years, an impression heightened by his ebullient, boyish manner. During conversations at his Chelsea loft and my apartment, he responded to many of my questions about his work and Close's with a few skittish, sometimes amused queries of his own. Why would I ask him something like that? What did I really want to know about him and his work? During our elliptical discussions, no sooner did I raise one topic than he would hop to another. By turns, he was guarded, sardonic, and completely accessible.

Harris has been a favorite Close subject since 1999, when he sat for the eight-and-one-half-foot-high *Lyle* portrait, a close-up, three-quarter view of his face transmuted into a vibrant field of diamond-shaped cells. Compared to the intimate photo-maquette that spawned it, the painting is more remote in feeling. The photograph shows a tentative-looking, even wistful subject whose skin not just glows but glistens. Whether this effect was due to the heat from the lights in the enclosure where he sat for several hours of shooting or his edge of uncertainty about even being there, Harris seems hesitantly accepting of being a model. In the painting, his features are visible through rapidly zigzagging blocks of grid squares. The vigorous abstraction trumps whatever emotional shadings the photograph projects.

"Chuck really struggled with that painting. It was an opportunity for him to take color to another level in representing African-American skin," says Harris, contrasting its rendering of his face with the way Close had depicted another African-American artist, Lorna Simpson. While the face in the 1995 *Lorna* painting, Harris observes, is rendered in tones of brown, gray, and black, Close went well beyond those conventions in *Lyle*. There, he capitalized on the luminosity of Harris's deep brown skin by representing it in varieties of saffron, ochre, and violet. For Harris, this portrayal of himself emits energy and airiness. "That's what I get from it, because it's about light and shapes." Close must have felt similarly about the representation, because he used it in other ways—first, in the 2000 *Lyle*, a soft-ground etching, approximately eighteen inches high, rendered in wobbly lines and eight colors. The jumbo-size 2003 silkscreen print *Lyle,* just over five feet high and composed of no fewer than 149 colors, has the same crackling surface animation as the painting that led to it.

Harris has also posed for several Close daguerreotypes: a headshot, and front and back studies of his nude form. In the eight-and-a-half-inch *Lyle,* 2000, he is so

(left) Maquette for *Lyle*, 1999. Photograph mounted on foamcore, 38 x 26". Private collection **(right)** *Lyle*, 2003. 149-color silkscreen, 65 ½ x 53 ⅞". From an edition of 80 printed by Brand X and published by Pace Editions, Inc., New York

Lyle, 2000. Eight-color soft-ground etching, 18¼ x 15¼". From an edition of 60 printed by Pace Editions Ink and published by Pace Editions, Inc., New York

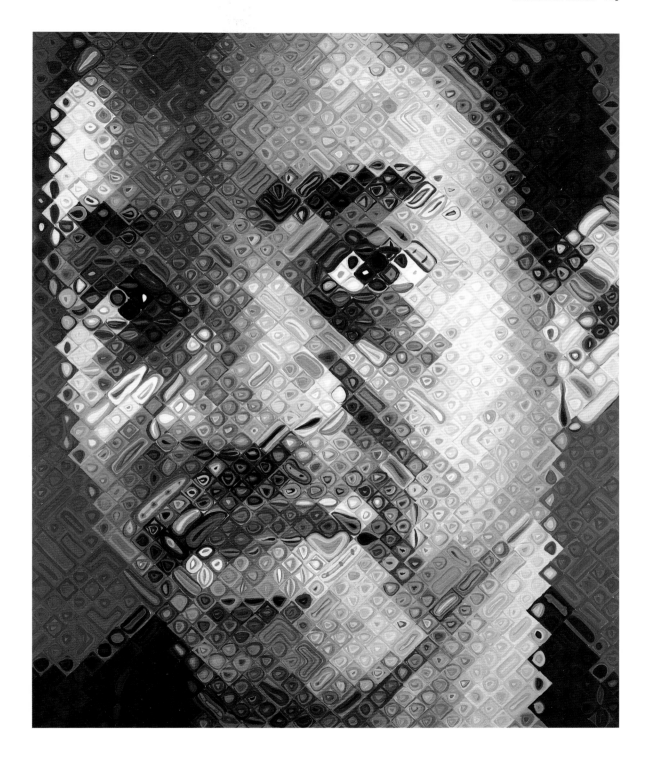

Lyle, 1999. Oil on canvas, 102 x 84"

serene and inward-looking that he seems transfixed. His slight beard, mustache, and plaited hair imbue the photograph with a kind of historical aura. Harris sees the connection, "This same nineteenth-century process recorded black people during a traumatic period in this country," he points out. Indeed, this portrayal is hauntingly reminiscent of daguerreotypes of freed slaves made after the Civil War. It was obvious, he said, that "Chuck was definitely not looking for a glamour shot, or just the right angle when he made it." While some ways of shooting can enhance a person's features, this photograph was no such example, he ruefully observed. "It looks rough to me," he added with an ironic laugh. "What I mean is, my skin was broken out when Chuck made it. A lot of people have commented that this is a very sad portrayal of me. I was in a very intense place in my life then, and I think I allowed him to capture that. In a sense, it furnishes evidence of that particular period. I don't want to come off as being vain, but it is a harsh reading of me. Yes, and that's the beauty of it!

"It's difficult being a photographer, and giving that power over to somebody else," Harris philosophized, "particularly someone who is such a master at what he does. What's interesting about sitting for someone like Chuck—I mean, I've been photographed by a few other people—is that there's a knowingness about the process." A knowingness on the part of the viewer as well as the photographer, he continues, citing Roland Barthes's dictum that those who sit before the camera literally "construct" themselves while doing so. Furthermore, the sitter goes through the same procedure "whether it's for a Kodak moment or a 20-by-24-inch Polaroid." While sitting for Close, he says he felt "hyperaware" of this self-constructing process.

Though many of Close's nudes in this antique photographic technique are of everyday human anatomy, Harris's body is one of the exceptions. "Lyle is an unbelievably beautiful man," Close says, casually letting slip the fact that Harris had been a model for some of these figure studies. The majority of Close's daguerreotype nudes are unidentified, but occasionally the truth will out. If the names of his naked models are usually closely held secrets, as he piously avers, there are a few other exceptions. Consider, for example, his well-publicized renditions of supermodel Kate Moss, reproduced in the September 2003 issue of *W* magazine.

The two daguerreotype nudes of Harris are front and back views in which he is symmetrically positioned, arms at this sides, hands resting lightly on his thighs. The front view is from the neck down to just below crotch level, the back one, from the

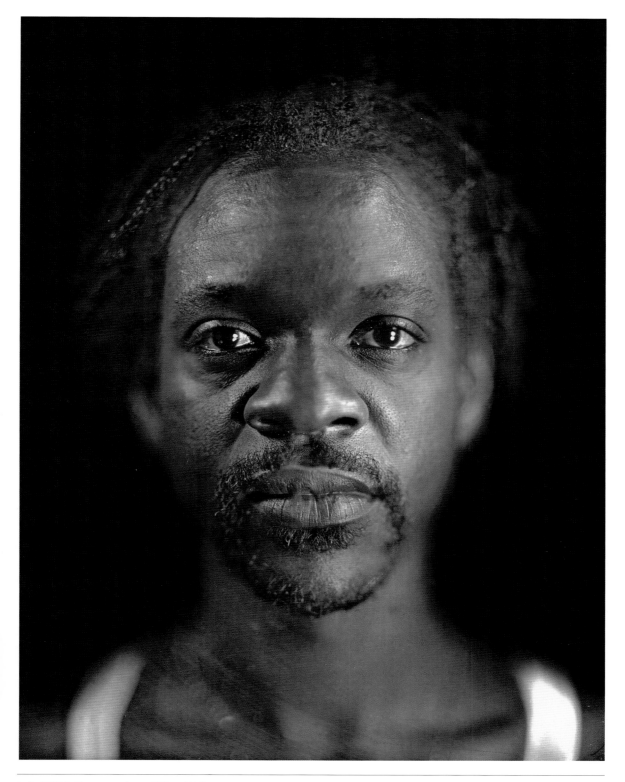

Lyle, 2000. Daguerreotype, 8½ x 6½"

neck down to just below the buttocks. For all the sumptuous light-and-dark modeling of their subject's smoothly muscled form, they resemble other works in this ongoing series in that they are curiously detached in feeling. Reflecting further on Harris's virtues as a model, Close adds, "Lyle is also an unbelievably beautiful woman in many of the pictures that he takes of himself," referring to those photographs in which Harris assumes the personas of the great divas Josephine Baker and Billie Holiday. In the Josephine series, his profile is seen in a succession of overlays evocative of Cubist and Futurist representations of motion. Spit-curled, 1920s style, with huge loop earrings, he is attired in a costume of glittering coinlike metal disks held together like bits of chain mail. In his Billie Holiday incarnations, in which he materializes out of an indigo haze (Harris shot these dye-transfer Polaroids under black light, not the usual studio lighting), he wears a pearl necklace and an opulent white signature-Holiday flower in his hair; his eyes are half closed, as though he/she were in midsong. "I've been fascinated by Billie for years," he says, "and I've read everything on her, including her autobiography. There's something about her music that soothes my soul."

There is another—and highly contrasting—manifestation of Harris's fertile imaginings. If his time-traveling self-representations in drag are expressive of his feminine side, he also deals, in another set of equally fantasizing photographs, with issues of aggressive masculinity. His character in them is that of a prizefighter, a subject widely associated with macho black identity. "I'm not sure how that happened," he says, but suggests a possible origin. "The *New York Times Magazine* asked a number of artists—Chuck Close, Nan Goldin, Duane Michaels, Malerie Marder, Robert Frank, and me—to make self-portraits for a special May 2000 issue with the title 'What's Really on the Minds of Americans?' well before the national elections. I did a portrait of myself in handcuffs, which was a precursor to the boxing series. It was pivotal because, though I had played a lot with gender bending, I'm embodying a male persona in this photograph."

Close says that that one of the reasons he was drawn to Harris's work was its sexually ambivalent nature. Its gender switching and emphasis on role playing indicated affinities with the imagery of two other photographer-subjects who had sat for him, Lucas Samaras and Cindy Sherman. Like them, Harris explores disquieting psychosexual terrain through the photographs he makes of himself—a terrain where complex issues of racial and sexual identity make for a volatile mix. During

LYLE ASHTON HARRIS *Blue Billie*, 2003. Monochromatic dye diffusion transfer print (Polaroid), 24 x 20"

LYLE ASHTON HARRIS *Je ne sais quoi #3*, 2002. Monochromatic dye diffusion transfer print (Polaroid), 24 x 20"

an early 2004 exhibition at the CRG Gallery in Chelsea, the boxer series was prominently on view, and Harris came across in the photographs as an unlikely-looking combatant. Though outfitted with a pair of heavy boxing gloves, the slender photographer appeared more like a dancer than a fighter. There were other disparities. Instead of droopy boxer trunks, his ring attire consisted solely of the jockstrap that would normally be worn under them.

"As a kid, I hated boxing. I always thought it was really brutal," Harris tells me, "and I was traumatized in the street by certain codes of masculinity." Still, the idea of boxing stayed with him. "I'm interested in it as a metaphor—as an arena fraught with issues of race and sexuality," he says. And so eager was he to learn it that he took lessons several times a week at a downtown gym where professionals train. "It's the Church Street Boxing Gym," Harris explains. "It's where Evander Holyfield trains when he comes to the city. It's not like one of these chi-chi, Chelsea gyms; it's a really hardcore place, you know, where people go to box and work out." As the boxing series progressed, Harris presented himself as increasingly beat up. In some photographs he reels under the blows of an unseen opponent; in others, he savagely and unaccountably pummels his head with his glove. A decidedly masochistic streak runs through them. A culminating shot has him looking especially horrific and dehumanized, his head an elongated, amorphous shape, two wobbly white circles in it that just might be eyes. From top to bottom, this print bears bloodlike streaks.

"The boxer image of me is as much a 'drag' thing as the Holiday one," Harris maintains. "There is a certain equivalence between them." When he showed these photographs to acquaintances at the gym, he says, they had no idea what to make of them, so far removed were they from conventional boxing photographs. He titled the series Memoirs of Hadrian, after a novel by Marguerite Yourcenar predicated on an imaginary letter that the emperor Hadrian sent to his youthful successor, Marcus Aurelius. Harris thinks of them as meditations on conflict and the loss of self—concepts that he says pervade Yourcenar's fictive psychological sally into classicism.

Just before these explorations of his inner self, Harris had dealt with race and identity in other ways—mainly through a series of sepia-toned photographs begun in 1998. Known as the Chocolate series, these depicted racially diverse models from all walks of life, many of them photographed from the front and back. Most arresting of this group are his portrayals of backs of heads, some with long flowing tresses, others with hair intricately plaited. "To me," he explains, "those views suggest a

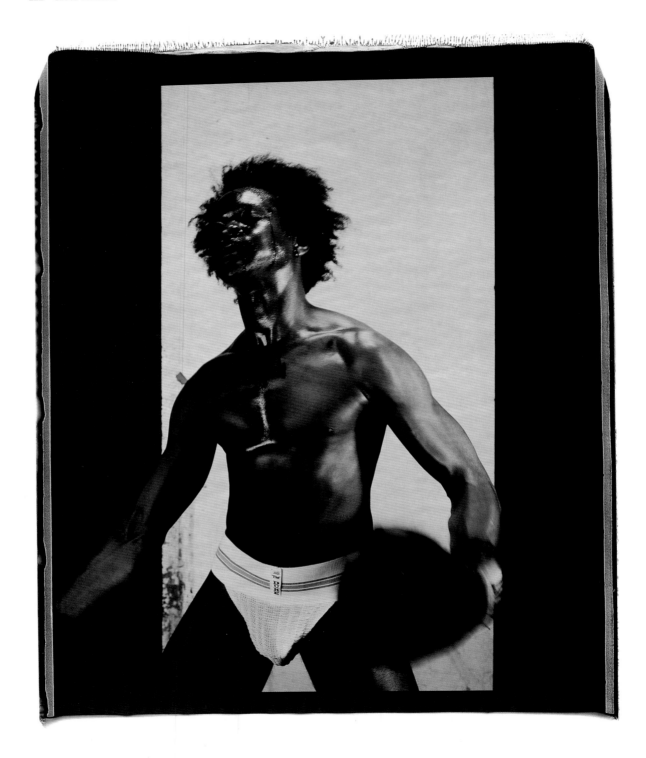

LYLE ASHTON HARRIS *Memoirs of Hadrian #26*, 2002. Monochromatic dye diffusion transfer print (Polaroid), 24 x 20".
Collection of Ann and Ron Pizzuti

certain vulnerability." The subject of one such view, which bears the appellation *Untitled (Back #17 Mystery),* was Mystery, a deceased go-go dancer. Fascinated by what he terms "indexical markings," Harris talks about a "strangely beautiful scar" on the back of the dancer's head, the result of an accident during a performance. One of the more engrossing attributes of this series, especially the frontal views, is the way that the shared coloration of the subjects seems to minimalize racial differences. A consummate technician, Harris attributes the deep sepia tonality of these mono-chromatic dye-diffusion transfer prints to his use of a cross-toned process that combines two types of Polaroid film to produce a solarized effect in which highlights are suppressed and shadows are especially dense.

One of the first subjects in Harris's new technique was a benign-looking Chuck Close wearing a white band-collar shirt. His face in Harris's *Untitled (Face #2 Chuck),* is softly illuminated, its right side mostly in shadow. Like the daguerreotype portrait Close made of Harris two years later, it has a vintage look. Not just for its brownish surface, so evocative of old albumen prints, but because of Close's bearded and patriarchal mien, to which his wire-frame glasses add a further time-gone-by note. On the experience of photographing Close, Harris recalls laughingly, "He kept telling me, 'Please, be gentle.' There were a couple of options for lenses, one more flattering than the other. So, it was a running joke. 'Be careful,' he warned me, because he was going to photograph me next. I wouldn't say that he was threaten-ing, but being a photographer, he was well aware of the possibilities." He candidly admits that his photograph of Close is "definitely not an attractive portrait. Its tech-nique brings up the lines in his face, and his eyes look pretty intense."

When I asked Close what it was like sitting for Harris, a savvy photographer who, like himself, knew the tricks of the trade, he conceded that it was all he could do to allow himself to take direction from someone else. So conditioned was he to posing for self-portraits, he said, that "some of my attitudes can carry over when I sit for other photographers." However, once before Harris's camera, he claims, "I tried hard to avoid such controlling behavior and allowed myself to be directed by him." As my conversation with Harris turned to Close's self-portrayals, the photographer said that he felt these were far more subjective than Close's representations of other models, presumably including those of Harris himself. "What I'm really drawn to in them," he says, "is the repetition, the continuing investigation of the self. It's a dif-ferent kind of investigation than the one I do. I take on certain roles, one could say,

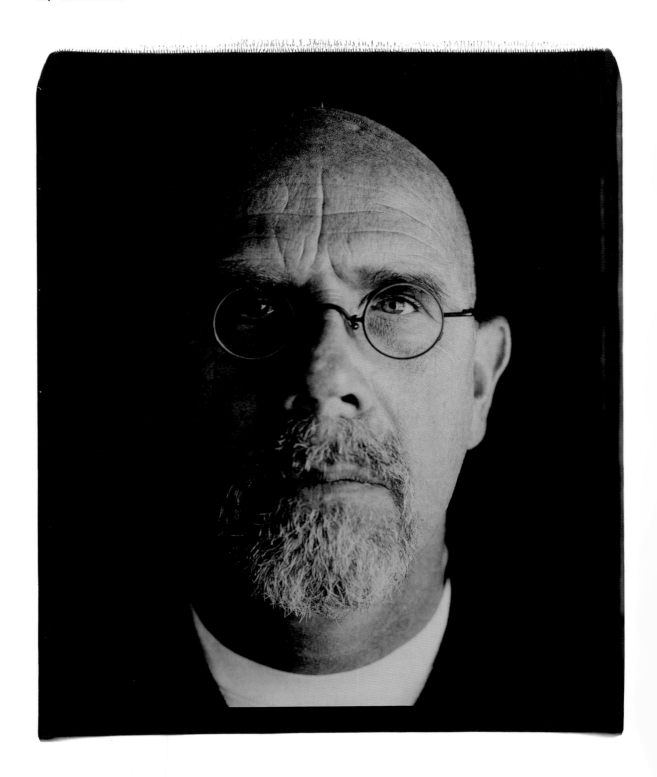

LYLE ASHTON HARRIS *Untitled (Face #2 Chuck)*, 1998–99. Monochromatic dye diffusion transfer print (Polaroid), 24 x 20".
Collection of David Teplitzky and Peggy Scott

but these are less about me performing as a boxer or singer than about revealing certain emotional states." Although Close may seem to always present himself from a strictly objective standpoint, Harris goes on, "by photographing himself just as he is, I think there's performance in what we both do. We work with different props, so to speak, but I think there is similar investigation of the self. There are equal levels of disclosure in our work. With Chuck, this is a very subtle thing. One could say, 'Oh, they're always the same self-portrait,' but they're not. There are always slight shifts of, let's say, facial expressions and the placement of the heads on the canvas. Even the smallest changes in detail from one painting to another—the color of a sweater, the shape of a collar—are, in the end, his subjective choices." So much so, Harris maintains, that "nothing about a Close self-portrait is accidental."

Of the many artists in Close's pantheon, Jasper Johns has a special place but is probably the one he knows least. When Close was still in graduate school at Yale in the early 1960s, Johns was the acknowledged "art hero" for him and his youthful confrères. They were awestruck by his understated imagery, the carefully built-up surfaces of his paintings, and his capacity to invest the most ubiquitous of forms—targets, maps, letters of the alphabet—with portent. Though by his own admission, his conversations with Johns have never been easy or spontaneous, Close never got over his early adulation of the older artist. "I've been at many dinners and other events with Jasper, where he says almost nothing. Then I would talk, way, way too much, and the more I did, the more self-conscious I became about how I was just filling the air."

They first met in 1977 when Johns was still living in New York. If they seem worlds apart in their outlooks, the reality is that Johns's attitudes about form continued to influence Close well past his Yale days. The example of his career has been as inescapable as it has been alluring for Close, whether for his celebrated targets of the mid-1950s or his elegantly brushed painted surfaces, such as those in his gray alphabets composition, their letters contained within tightly packed squarelike compartments that foreshadowed Close's cell-filled paintings of the mid-1980s. Possibly the major lesson from Johns was that any subject, no matter how mundane, could take on psychological resonance. There was mystery indeed in the mundane. How could this not have appealed to a young artist casting about for alternatives to Expressionism?

Jasper, Close's 1997–98 painting of Johns, had an unusual origin in that, unlike any of his other paintings, it was a commissioned work. In 1997 he received a call from Dodge Thompson, Chief of Exhibitions at the National Gallery of Art in Washington, D.C., informing him that he was in charge of a project to commission well-known artists to paint outstanding Americans in various fields of endeavor. These portraits, to be on view at the National Gallery, would ultimately become part of its collection. Would Close, he asked, be interested in making a painting of the poet Maya Angelou? While expressing his appreciation, Close explained that he painted only people he knew well—members of his family and fellow artists. As their conversation progressed, though, it was apparent that Thompson really wanted Close to participate. The gallery already had an earlier Close in its collection, the 1985 oil *Fanny/Fingerpainting,* a highly empathetic rendition of the heavily lined, rathe

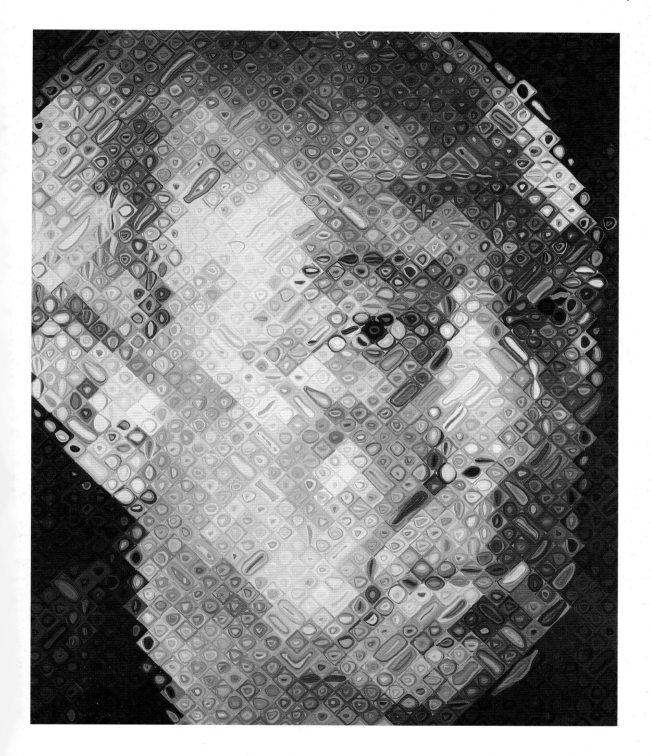

Jasper, 1997–98. Oil on canvas, 102 x 84". Collection of the National Gallery, Washington, D.C.; gift of Ian M. Cumming

Buddha-like visage of Fanny Lieber, his wife's grandmother. How appropriate it would be to have another, more recent, work on its walls. His interest piqued, Close asked if any major American artists were being considered as subjects for the series—Jasper Johns, for example. Yes, Johns was indeed on the list, Thompson replied, but the English painter Lucian Freud had already been invited to paint him. "Well, my response to that," Close recalls, "was what if neither Johns nor Freud is up to the twenty or thirty sittings that a portrait by Freud would require? If neither one is, let me know." Some months later, Close received a second call from Thompson, advising him that the Johns project was his, if he was still interested. He was.

Once he took on the assignment, Close's anxieties about it suddenly came to the fore. Here he was, he recalls, suddenly faced with the possibility of painting an artistic eminence he greatly esteemed but barely knew. "Since I'd never done anything remotely like a commissioned picture, I was worried about what it would be like to paint under those conditions. For one thing, I never know who will own one of my paintings after it's done, and for another, I've never wanted to feel like I was working for someone else. And finally, I didn't know if Jasper would even agree to do it. He's such a private person, so why would he want to do this? I was too nervous to call him, so I got Douglas Baxter (at PaceWildenstein Gallery) to make the call. He phoned Jasper several times, and I kept saying to him, 'If he doesn't want to do it, tell him it's OK. He doesn't have to!'" The wheels turned, and Johns finally agreed, however unenthusiastically, to sit for a photo session at the Polaroid studio in New York.

Painting Jasper Johns, as Close describes it, was one of the more unsettling experiences he has had in the studio. The photography session was conducted in relative silence, which was especially difficult for Close, so used to bantering familiarly with his subjects about matters large and small, but Johns was having none of that. He sat dutifully and dispassionately, as though keeping a necessary appointment with someone he knew only slightly. After an hour or two, the shoot was over and Close was left with a sheaf of images of his reluctant subject. Back at his studio, he selected the one that seemed to have the most possibilities and commenced transferring its data to a canvas. While most of his paintings go relatively smoothly, this one certainly did not. He began encountering problems early on in its structure and its very concept. If Johns's masklike expression during the photography session had unnerved him, it had a comparable effect as it materialized so much larger than life. The portrait, for all its apparent calm and organization, was turning out to be

a psychological battlefield for Close, who says, "I've never had more trouble with a painting than I had with that one." The fact that it was a commission was doubtless a factor in his unease. Most Close portraits take four months to complete, but he worked on *Jasper* for at least six. "Emotionally, I was in incredible pain, and almost abandoned it, because it just felt like work, like a job, from start to finish."

Getting a likeness of Johns was no problem, Close says, but getting beyond that likeness was. "In fact, I think my paintings always look more like the people who sit for them than the photographs of them that I work from. I think that's because I'm subconsciously putting in stuff that I know, from just hours of being around them and having looked at their faces." Because there was "minus that connection" to Johns, he suggests, "I was perhaps dealing more with the information embedded in the photograph than with what I actually knew about him. I don't know what the net effect of that struggle was. Did it make me more conservative in how I painted the picture? Perhaps. At a certain point, though, I felt like I might abandon it, so I had nothing to lose. But then, I had another take on it and began making broad, wholesale changes. And there was something about that momentum that I was swept up in. So then, I thought, 'Oh, this is going to work, after all.'" In retrospect, Close says he's not sorry to have gone through the struggle. "It was interesting, in fact, having that degree of difficulty in making the picture. Sometimes you want enough resistance so that you're not just sitting there happily filling in squares. You want a degree of difficulty, but of course not to the point where it's so painful, or where the decision-making process is so nerve-racking that you aren't free to work as intuitively as you would like."

Close's *Jasper,* more than eight feet high, is a portrait not of some ineffable mythic figure but of a strongly corporeal one. Even with its assertive tectonics, it manages to project something of Johns's self-contained, cryptic persona. His inscrutable physiognomy, the embodiment of reserve, is of course part of his legend. In Close's view of him, Johns does not look directly at the observer; rather, his slightly narrowed eyes gaze almost indifferently to the side. While for many Close subjects, assuming an expression of such neutrality, even briefly, may have required special effort, this must have been no problem for Johns. His naturally reclusive expression was ready made for Close's purposes.

Close's rendition of Johns is distinguished by two especially strong stylistic attributes. It employs a diagonal grid like the one used in his 1997 *Self-Portrait* and,

also like that painting, presents its subject in a three-quarter view. *Jasper* is a strongly modeled rendition of the older artist's face, with highlights on the right side of the head and alongside the nose. Constructed of crossing diagonals, it is an ornate tapestry of diamond-shaped compartments filled with circles and rectangles rendered in tones of pink, dull violet, and russet. The grid's regularity is interrupted in areas around the eyes, nose, and mouth, where color circles and dots mutate into long ovals and oddly biomorphic shapes. Johns's nose is transmuted into an astonishing complex of capsular forms and stretched-out rectangles. At close range, it's hard to imagine that these improbable color shapes could combine into such assertive volumes, but they do.

Since the mid-1990s Johns has lived in a large early-twentieth-century stone house in the verdant, rolling landscape of northwest Connecticut. Converted from what was once a stable, the well-equipped studio where he paints and makes prints is a short walk from the house over a broad expanse of grass. During a recent visit on a sunny November day, we talked about the 1997–98 portrait Close had made of him, as well as his own ideas about portraiture, especially those infrequent images he has made of himself. During our discussions, the famous Johns reserve frequently gave way to laughter as he recalled the serendipitous origins of some of the paintings and drawings in which images of himself materialize. Not since 1964, when he incorporated a photo-booth shot of himself in two paintings, has this famously secretive artist portrayed himself so directly. True, there are innumerable references in his other paintings to his arms, legs, and other parts of his anatomy, but so generalized are these forms that they could be anyone's. The fact is, a carefully nurtured anonymity pervades even those paintings. Johns has long avoided direct self-mirroring and has rarely allowed himself to be a subject for other artists. Given his well-known reticence, it was all the more remarkable that he agreed to sit for the photograph that would lead to a painting by Close. "I did it because I'd been asked to do it," was his bland explanation. As he gazed at a large transparency of the painting, he commented on Close's unique capacity to deal with the structure of a face in almost three-dimensional terms, by building its volumes with color, light, and shadow. "It's like all his paintings, fascinating from that point of view." Observing that he and Close see things quite differently, he added cryptically, "I don't have ideas like that."

Though maintaining that the idea of portraiture has never had much appeal for him, Johns felt that Close's take on it was special. "It's interesting when you see something

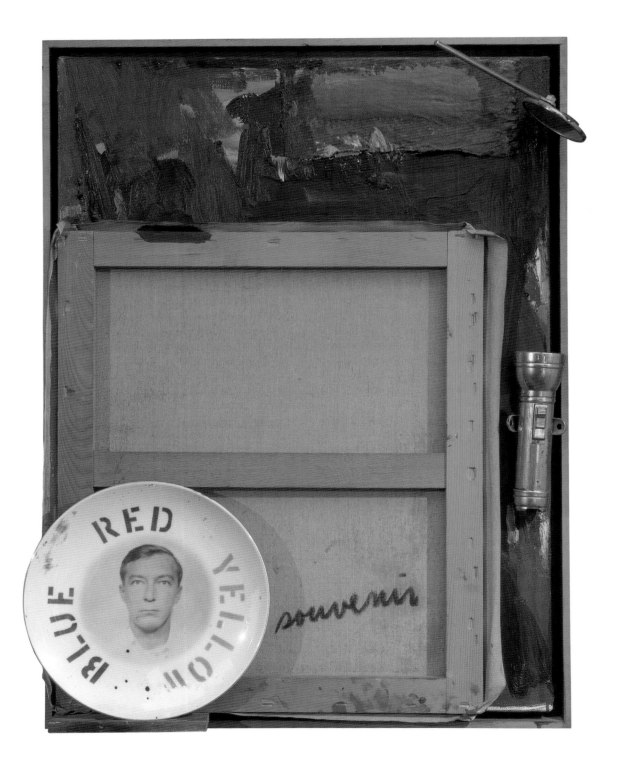

JASPER JOHNS *Souvenir 2*, 1964. Oil on canvas with objects, 28 ¾ x 21". Private collection. Art © Jasper Johns /
Licensed by VAGA, New York, NY

done with it that's so disruptive and novel, as it is in many of Chuck's paintings." The first Close paintings he encountered, he recalled, were filled with "all those active small divisions, all those little individual paintings. That was of course startling to see, and interested me, I guess, because it was a portrait." Though Johns has seen the completed *Jasper* on several occasions, my impression was that he responds more to Close's unique capacity to build strong, definitive forms from an accumulation of myriad elements than to any other quality the portrait might possess. He characterized Close's paintings as having at least two lives, "because first you do see a resemblance, then you see a world of activity that doesn't seem to have anything to do with that, even though it is those details that make up the resemblance."

Johns admits he has a problem with other artists' portrayals of him, mainly because "I just don't care to look at pictures of myself. I'd rather look at pictures of somebody else." Yet, there was a time, if a brief one, when he incorporated photographic images of himself in his work. While in Japan for a few months in 1964, the then-thirty-four-year-old artist made two paintings, *Souvenir* and *Souvenir 2*, each slightly more than two feet high, that included the same deadpan head shot of himself. That they were photographic images, however, was the only conventional thing about these likenesses, because they were printed not on photographic paper but on large white ceramic dinner plates. The origins of the paintings were in a 1962 trip to Hawaii and Japan, and the objects in them allude to experiences during those travels. In both, a real but unlighted flashlight affixed to the right edge of the canvas points to a sideview car mirror above it. Symbolically, the reflected light of the flashlight illuminates the artist's photographic image below. That motif, Johns explains, came from something he had seen during a concert in Hawaii, when a woman opened her compact in the darkened hall and unwittingly cast a pattern of light on the ceilings and walls. It was a few months later, while in Japan, that he utilized that remembered experience in the Souvenir paintings.

Like most Johns themes, these paintings had a convoluted genesis that drew on experiences from more than one time or place. "The first night I was in Japan," he says, "I was walking with some friends to have dinner, and we passed a souvenir shop where there were dishes with photographs of Japanese baseball players on them. 'Oh,' I said, 'I want one of those. I'm going to do something with it.'" Soon after, he determined that what he would do would "involve a light, a mirror that would reflect the light, and an image on a plate." Deciding that his face should be

that image, he brought an instant photo-machine picture of himself to a platemaker and asked that he print it on a plate. In the process of working with it, Johns says, "I accidentally broke the plate so I went back and had him make me two more, one in color and one in gray. I'm sure he thought I was a lunatic." Around the image of his face he stenciled the words "RED," "YELLOW," and "BLUE," each in its appropriate color, then attached the plates to the lower left corner of each canvas.

The Souvenir paintings are as much about Johns's memory of transient phenomena as about self-portrayal—in fact, probably more so. Confronted with these head-on-a-plate images, we can't help asking questions about their meaning. Why, for example, is the plate in *Souvenir 2* attached to the back of the small canvas, which in turn adheres to the face of the painting? Does the smaller one's unseen front contain yet another Johns self-portrait, a hidden one? When asked why he used the back of a canvas so mysteriously, Johns replied obliquely, "I don't know what was on my mind then. I guess it was the idea of being in a foreign country and making things out of things I found there." But then he added, "I also brought my own ideas, like any tourist does." He offered no profound reasons for this portrayal and deflecting speculation about hidden meanings, described the plate images as being "no more than self-portraits of an artist who happens to work with red, yellow, and blue, who takes trips occasionally, and who is sometimes behind the canvas."

Although the Souvenir self-portraits are anomalies next to more abstruse allusions to himself in other paintings, Johns began early in his career to evolve an iconography of quasi-abstract forms based on his face and body. Sometimes, these self-references were impressions on large sheets of paper of his torso, hands, and feet. Consider, for example, the autobiographical clues in *Diver,* a large 1963 sepia-toned charcoal-and-pastel drawing. The handprints at both ends of a pair of long, boardlike shapes in the lower half of the composition are his, as are the footprints on a second set of long, vertical shapes at the top of the drawing. Although no diver himself, Johns says of this work, "I was trying to diagram my idea of a swan dive. I had it very clearly in my head at the time. Everything in the drawing followed some progressive gesture involved in someone's diving from a high board. I thought of it as a diagram that one could understand about something that was happening over time." As to why he used his own hands and feet in making the drawing, his answer was, "I am very available when I'm in my studio, so when I need something it's easy for me to call on myself. I have rarely worked with models. I'm not inclined to think

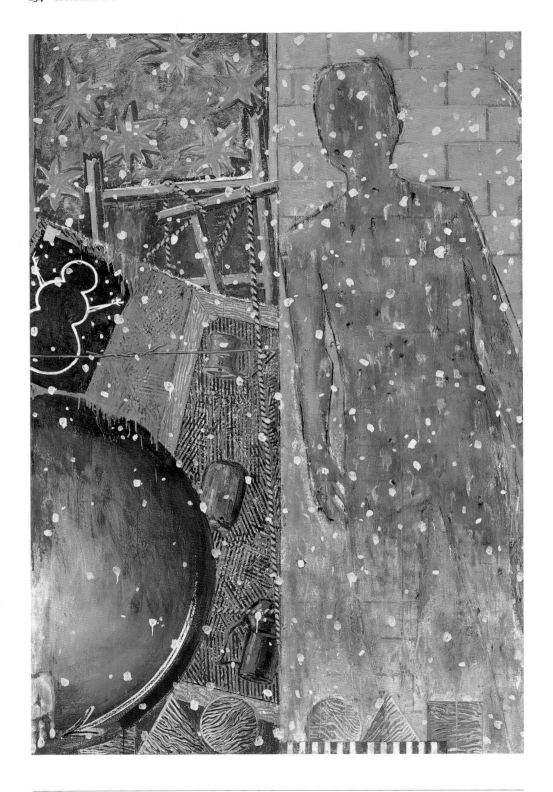

JASPER JOHNS *Winter*, 1986. Encaustic on paper, 75 x 70". Private collection. Art © Jasper Johns /
Licensed by VAGA, New York, NY

in that way. I often have an idea to do something and then see what happens. So things as simple as putting ink on my hand and pressing it against the paper just come sort of naturally to me. I'm sure there is the possibility of some psychological interpretation that I am not able to make."

In 1964 he took on autobiography in more immediate fashion. To make the images in the Study for Skin series of charcoal drawings, he pressed his oil-covered head and hands against drafting paper. His palm prints are fairly direct impressions, but those of his head are anything but. In fact, they are spread out so widely over the paper that his ears, so far away from the rest of the face, seem to float in space. "My idea was to get a kind of map of the head," he says. After going through the initial, oil-printing procedure, "I put charcoal on top of that, so wherever there was oil, the charcoal became black. So, you could say, these were sort of different ways of 'unrolling the head.' I remember Merce [Cunningham] looking at the drawings, and when someone said something about not understanding anything about them, he said, 'I understand what's happening there. The same thing happens in dance. The dancers run toward the wall and roll against it, and you see the mark they leave there.' So I was very pleased with that."

In a second set of body drawings made in 1977, John's approach was even more physical. These were impressions of the midpart of his body, just above mid-thigh. In making them, he says, "I don't know if I was on the wall or the floor. Either I laid down on it, or I pressed myself against the wall with oil on my body." Johns showed me photos of two Rorschach-like images, *Skin I* and *Skin II,* both essentially front and back imprints of his anatomy. To make them, he turned himself into a human ink roller, pressing his oil-soaked self against large sheets of paper. The ensuing horizontally spread-out impressions recorded his turning process. Tentatively identifying areas of his body for me in the blurry results, he noted, "These are the lower part, I guess. That must be the buttock. This would be the penis, and this would be the other half of the buttock. So, it was a complete turn. This was just a continuation of the things I'd done with the head, trying to make a map, I guess, by representing a three-dimensional surface two-dimensionally."

More recent examples of Johns's using his body as a subject are the four paintings *Summer, Fall, Winter, Spring,* made between 1985 and 1986. Each abounds with fragmentary juxtapositions of familiar Johnsian motifs: American flags; ladders; pairs of goblets whose contours resemble profiles of faces opposite one another; wood and

JASPER JOHNS *Study for Skin I*, 1962. Charcoal on drafting paper, 22 x 34". Collection of the artist. Art © Jasper Johns/ Licensed by VAGA, New York, NY

JASPER JOHNS (top) *Skin I*, 1973. Charcoal on paper, 25½ x 40¼". Collection of the artist. Art © Jasper Johns/ Licensed by VAGA, New York, NY **(bottom)** *Skin II*, 1973. Charcoal on paper, 25½ x 40¼". Collection of the artist. Art © Jasper Johns/Licensed by VAGA, New York, NY

stone floor patterns quoted from his late-1970s herringbone-like Usuyuke paintings; cones, spheres, cubes; and boardlike arms and palmprints reprising those in *Diver* and other Johns paintings. A hazy, phantom image of a seemingly nude Johns inhabits each of the Seasons paintings; it's as if his flat, weightless self were floating in and out of their picture planes. This static, slightly modeled frontal image had its origin in the island of Saint Martin in the Caribbean, where Johns has a house. Johns had asked a friend to trace the outline of his shadow on a sheet of paper on the ground, near the swimming pool. The Season paintings could be a metaphoric record of his life journey, with each season classically symbolic of a particular stage: youthful spring; summer as vigorous young adulthood; fall as a time of maturity; and introspective, memory-laden winter years. Not exactly a revolutionary concept in art and literature, but a durable one.

When I asked Johns if thoughts about his own mortality led to this quartet of spectral image, he answered, "Not particularly. Not any more than anyone else has when faced with a conventional idea like the seasons. I was trying to make four paintings that would relate to one another, yet be different." But then, he blithely conceded, "if you want to call that figure autobiographical, you can, but I can't say things like that." If his paintings of the seasons were less about self-portraiture than other issues, what then, were those issues, I wanted to know. Again, a simple but ambiguous answer: "They are about change and transformation. I think that's the key thing. My work is often about that. You can say that."

Johns habitually deals with intangibles in his portraiture with the same degree of obsession that characterizes Close's approach to specifics. Whereas Close describes every area of a subject's face with equal clarity, Johns prefers indirection, even in alluding to parts of the body. In a Johns painting, allusions to heads, arms, and torsos, however tenuous, are far more telling than literal descriptions would be. No question but that such a sensibility pervades everything he makes. At the same time, his instinctive ability to summon up and give form to past experiences imbues his paintings with intriguing autobiographical qualities, thereby contributing to the great Johnsian guessing game of ever-shifting forms and multiple meanings. "Enigmatic" must be the most overworked term used to characterize a Johns painting.

However reluctant Johns is to discuss the personal content of his own paintings, he talks knowledgeably about the work and ideas of other artists, even those whose imagery is completely unlike his. When, for example, we spoke about Close's

dependence on grids to build his portraits, he astutely observed that Close was continually inventive within his self-imposed limitations. By no means does Johns think that the use of systems like grids rules out strong personal expression. "If you look at Chuck's work over a period of time, you see great variety inside it. I have also made use of grids, but probably approached them in a different way. I painted grids filled with numbers that were fairly orderly. I don't know if I took any liberties in using grids that Chuck wouldn't have taken in his work." Johns is well aware that in his own painting, personal expression is inescapably present in the "kinds of handwriting, divisions of space, and little gestural shapes" that emerge. No matter how controlling the system an artist uses might be, he reflects, "At a certain point, you're just yourself. I think that's also probably true of Chuck's paintings. They are the result of who he is."

Alex was teaching painting and drawing at Yale when I was there, but I never studied with him because he scared the hell out of me," Close recalls smiling. "He seemed to have an almost gurulike relationship with his students. I was working abstractly at the time and arrogantly thought, 'Why do I need to study with him, especially since he seemed so difficult?' Of course, I was aware of him, because I talked with other students about what they were getting from his classes, but he was not aware of me. From 1961 on, when I started coming to New York, I saw all his shows, and I thought that he practically owned large-scale figurative imagery, of a sort that was not backward-looking. One reason all those expressionistic realists hated Alex so much at that time was that he was trying to find a truly modernist approach to representation while they were trying to breathe new life into nineteenth-century notions of figure painting." Getting to know Katz can be difficult, he acknowledges. "People react to him in radically different ways. Even though he's really totally accessible, for some people he can be off-putting, but others feel very positive about him."

Close's paintings of Alex Katz hold special significance for him, both because of their long friendship and because of when he made them. "My first *Alex*," he says, "was a big color painting I made in 1987. It was in the last show I had at PaceWildenstein in late 1988, just before I went into the hospital." He uses the term "Maginot Line" to distinguish between the paintings he made before and after his lengthy hospital stay. Significantly, just on the other side of that fateful divide was 1989's *Alex II,* which he had begun as part of his recovery regimen at Rusk. Working on it after so long a hiatus from painting was both "frustrating and exhilarating." Though he often found it an unhappy experience, he has another view about it now. "There could be another reading of that small *Alex*," he told me, "not one of sadness but of celebration," because "my palette brightened—I used much happier colors, you could say. So I guess it embodied both pain and pleasure. Leslie won't let me sell it. For her, it's the most important painting I ever did. I don't feel that way, but I understand why she does. She says, 'This is the first part of the next part of your life.' Working on it was an incredible transition for me."

Alex Katz has a spacious, light-filled loft in SoHo. The transition from its comfortable living area to his orderly, white-walled studio is all but imperceptible. At the time of my visit, there was a recent, medium-size painting of Ada, his wife, muse, an

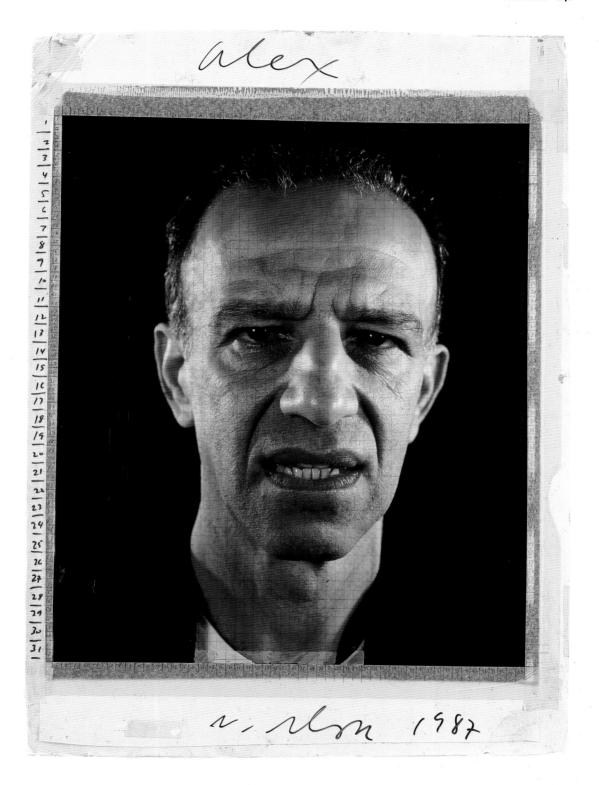

Maquette for *Alex*, 1987. Polaroid mounted on foamcore, 24 x 20". Collection of The Art Institute of Chicago

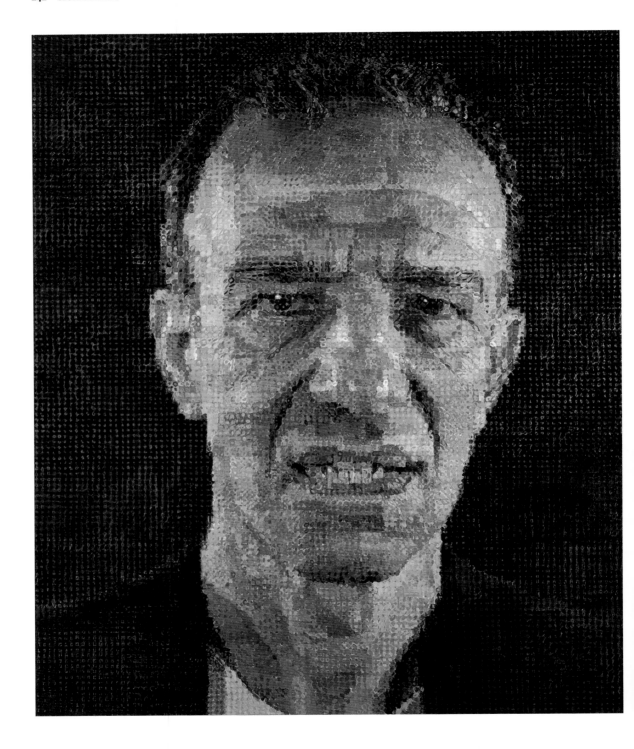

Alex, 1987. Oil on canvas, 100 x 84"

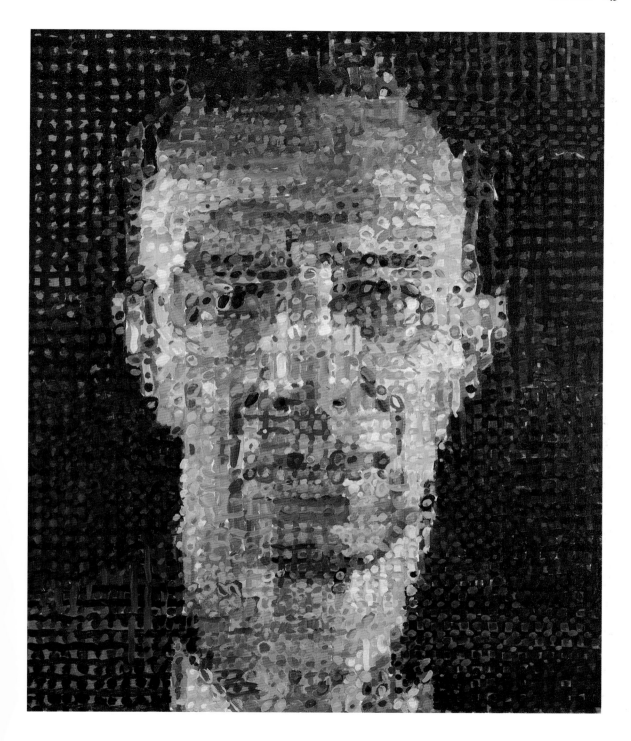

Alex II, 1989. Oil on canvas, 36 x 30". Collection of Leslie Close

constant model, hung on a wall between both areas. Other Katz paintings on view were a luminous, near-abstract close-up of flowers, an equally reductive water's-edge beach vista, and a haunting nocturne of downtown office buildings, a few of their horizontal windows indicated by yellow-white paint streaks, a theme with particular resonance in view of the events of September 11. Well aware of Close's high regard for Katz's work and his characterization of it as "happening with no fanfare, but with the fewest number of marks to make something happen," I was understandably interested in what Katz had to say about Close's own approach to painting. He remembers meeting Close for the first time shortly after the younger artist's debut exhibition at the Bykert Gallery in 1969. Like Close, he was making large-format paintings whose subjects were super-scale heads, some of himself, but mostly of Ada. As he turned the pages of the large binder filled with photographs of Close paintings that I brought with me—self-portraits and four portraits of Katz made from 1987 to 1991—his approving, oft-repeated reaction was, "It chills out!" He explained this meant that he was impressed by Close's ability "to make things really slow down, because he goes one dot at a time. There are no shortcuts."

Although Close routinely asks his sitters to banish fugitive expressions from their countenances as they sit for their portrait photographs, Katz's face might be one of the few exceptions to that dictum, because it is so far from passive, even in repose. What for him may be an everyday expression might suggest seething emotion, were it evidenced by other Close models. Painting that face, Close says, was a challenge he was eager to take on because "it's in constant flux. There are a lot of near tics, a kind of grimace that quickly turns into a smile, turns slack, then back into a smile. Because it's in perpetual motion, I thought the only way to really deal with it was to try to capture a frozen moment of that kinetic energy. I've painted him two ways; twice with his mouth open, and twice with his mouth closed. There is something almost post-Cubist about those paintings because they're like multiple views of him made at the same time."

Because Katz's dour, angular countenance is so recurrent a theme in Close's iconography—the subject not only of four paintings but of numerous drawings, prints, and photographs—it seemed only appropriate to ask Katz why he thought Close has made so many paintings based on their 1987 Polaroid session. His answer could not have been more direct. "We just had a dynamite session, a fabulous one!" Asked what he thought Close might have been looking for during that memorable

encounter, one thing was certain, responded Katz. "He was not looking for me smiling." Close fully concurs with Katz's enthusiastic recollection and, reprising the Miles Davis analogy, adds, "We were 'cooking' like a couple of jazz musicians playing together." Katz's compelling, mobile face made him so effective a subject, but so did his willingness to sit for numerous photographs and his avid interest in the process. In fact, Close says, he still has some unused images from that productive shoot that could well lead to even more *Alex* paintings. "Sometimes I'm lucky to get one photograph of somebody I really want to paint in one session, and sometimes I shoot them over and over and never get any. But with Alex, they just kept falling out of the other end of the camera."

However much Close's four *Alex* portraits differ in scale, detail, and paint application, each emits palpable tension. Though they all derive from several photographs made during the same 1987 sitting at Polaroid's lower Manhattan studio, they share few similarities. In the first and fourth paintings—each over eight feet high, the first in color, the last, in black and white—Katz's mouth is slightly open, his teeth agleam. The smaller "in-between" canvases, each thirty-six by thirty inches, are the 1989 *Alex II,* in color, and the black-and-white 1990 *Alex.* As a group, they are a case study of crucial stylistic developments that occurred in Close's work over their four-year span. The first *Alex* was Close's most factual translation of his subject's uniquely expressive features from preliminary photograph to painted surface. Its infinite, minuscule color dots fuse into ruddy flesh tones. Katz's skin glistens, as though slightly damp, and strong highlights model the sides of his head. The smaller-format *Alex II,* begun at the hospital, differs considerably in form and sensibility. Katz's visage, its contours much softened here, lends itself admirably to what could be a Close meditation on the transitory nature of form. With its tentative shapes of creamy white and amorphous tomato red afloat beyond the confines of their grid squares, the portrait seems a watery apparition. Close was clearly moving away from representing surface reality in favor of exploring abstraction's limitless domain. Small as the canvas is next to the tall first portrait, the viewer is obliged to step back a distance in order to experience its large, wobbly particles cohering into a face.

With the last two Katz paintings, Close took a brief furlough from color. By rendering each in closely related shades of warm and cool gray, he once again explored the allure of monochrome, so important an aspect of his first large portraits. The third *Alex,* in its liquescence, is virtually a black-and-white version of its equal-sized

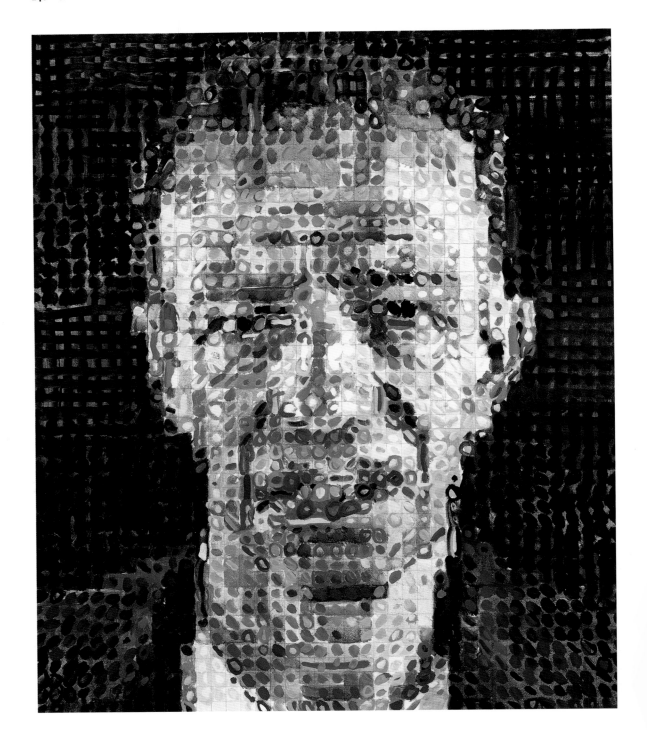

Alex, 1990. Oil on canvas, 36 x 30". Collection of Mark and Margaux Maybell

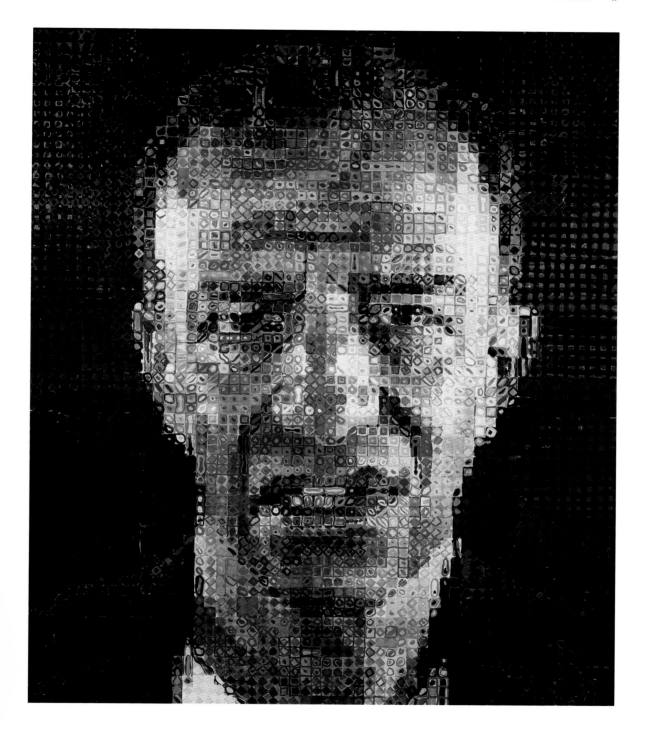

Alex, 1991. Oil on canvas, 100 x 84". Collection of The Art Institute of Chicago; acquisition and gift from the Lannan Foundation

immediate predecessor and is just as shimmery and abstract in feeling. After the indeterminate shapes that composed both preceding works, however, it was in the last painting of the quartet that Close took an even more incisive approach to abstraction. If this *Alex* is a bit revisionist for him, because of its finer-scaled grid and less amorphous shapes, it also embodies a new, far more complex approach to abstraction. It reads as an oscillating field of crisp-edged squares, circles, diamond shapes, and enough Xs and Os to suggest a giant game of tic-tac-toe.

Another image of Katz was definitely a star in the 2004 exhibition "Chuck Close Prints: Process and Collaboration," originated by the Bluffer Gallery at the Art Museum of the University of Houston. The six-and-a-half-foot-high black-and-white portrait *Alex/Reduction Block* is a 1993 silk screen based on a linoleum cut of Katz's dramatically illuminated visage. This galvanizing head was shown not only as a finished work, but also as a sequence of twelve successive images, illustrating the various states of its production.

As Katz and I talked about possible commonalities in his and Close's approaches, he remarked that they share a wariness of expressionistic excess, a stance by no means limited to recent art. Both of them, he says, have negative reactions to Rembrandt's portraits, for example, especially those so widely revered for their psychological qualities. Driving home the point, he disdainfully adds, "I find that kind of self-revelation disgusting." Disgusting? Did that mean he couldn't even look at a Rembrandt? "I can look at them, and some are great paintings," he admitted, if a little grudgingly. "Technically, I think he's fantastic." But what he can't abide is their overt emotionalism, "that pushing of so much content in your face before you get to the picture." Close's paintings, Katz approvingly observed, are free of such personal baggage. Maybe so, I wondered aloud, still pondering the Rembrandt situation, but didn't he think that what he perceived as pure objectivity in Close's paintings, especially those of himself, was giving way to more subjective feelings in them these days? In response, Katz conceded that while the posthospital self-portraits had indeed grown more complex, with their increasingly agitated brush strokes, he didn't necessarily equate such complexity with self-revelation. Whether or not that is the case, he feels that Close's paintings of himself have a unique place in his production. "I think the self-portrait is the central thing in Chuck's painting. He's more at home in it. It just feeds everything else. When he does other people, there's not the same familiarity."

And, even if Close doesn't directly confront his reflection in a mirror in order to paint it but works instead from grid-overlaid photographs, Katz feels these images are decidedly in the venerable tradition of self-portraiture. "Once he gets the information down," says Katz, "he's very relaxed in how he proceeds and how he uses his face to experiment with process." Even though the "content" of these paintings may be essentially that of "a person looking at himself," it's apparent "as you go through all these works," Katz continues, that "he uses his self-portraits to investigate techniques of representation." He thinks that Close's paintings are more about presence than about illusion, more about "the whole person, not just his appearance." As to possible insights about himself that Close might have gained in painting these, Katz suggests that we, as outsiders looking at these self-images, probably learn more about him than he did about himself as he was making them. What is clear to him is that Close has always pursued inventive ways of giving form to his ideas about representation. "I think he just gets absorbed in how to do it. Process is what it is about. The content is there, but it's an unconscious thing that just floats up."

Though he thinks Close's later, posthospital paintings are "less aggressive" than his early black-and-white self-portraits, Katz finds them more interesting in other respects because, in making them, Close finds ever more ingenious ways of inventing form. "It's amazing how he puts that stuff on those surfaces," says Katz, "those eccentric shapes that go this way and that way and end up being something so entirely different, but that's what his magic is. They've never been that magical, up close. But what's really amazing is that he can turn all those shapes into such power. I can't figure out how he did it, actually." On further reflection, Katz concludes, "Well, he did it by increments. He started with the idea of replicating a three-color printing process, and he made it work."

Katz may not think of Rembrandt as a role model, but he feels quite differently about a more contemporary Dutchman, Piet Mondrian, the quintessential mid-twentieth-century purist. In addition, despite the vast thematic and philosophical differences between Close and Mondrian, he perceives parallels between them. Like Mondrian's long odyssey into abstraction, Close's journey has been carefully reasoned from one stage to the next. Like Mondrian's, his imagery has evolved as a subtle fusion of reason and intuition. "Some painters jump around and change their styles and subject matter. Others evolve incrementally," says Katz, observing that Close personifies the latter because "he has a history of organic development." As to

other affinities between them, his unhesitant opinion is, "They're both obsessive, with a lot of passion." When I asked Katz if he felt that those qualities could possibly be ascribed to him, the answer was an amused but resounding no. "I'm not obsessive. I'm not passionate. Those are two things I'm not!" As much as he admires Close's work, he thinks of it as something well apart from his own. "I think Chuck's brilliant," he says, "but we're temperamentally in such different places. He's a terrific painter and always fun to talk to, but he's pretty alien."

In 1957 Katz began what he describes as his "static frontal" paintings of heads and figures against flat backgrounds. Like Close, he paints self-portraits but in almost narrative-like contexts. They range from complete figures to large-scale close-ups of his face. For all the graphic clarity they project, when he begins one of these paintings, Katz claims, he has little idea of how it will come out. Are there many surprises, then, I asked, when he is his own subject? "Any painting is always a surprise to me," was his crisp response. "Half the reason I make it is to find out what it will look like." Though he has made comparatively few self-portraits, he produced enough to warrant an exhibition of twelve of them in 1990 at the North Carolina Museum of Art in Raleigh. "Making Faces: Self-Portraits" included paintings from 1953 to 1989. In his catalogue essay, John W. Coffey, the museum's chief curator and the exhibition's organizer, tellingly wrote that Katz "deliberately disassociates himself from his subjects by treating them with cool objectivity" and subsequently, "he renders subjects as objects." (*Making Faces: Self-Portraits*. Raleigh, N.C.: North Carolina Museum of Art, 1990, p. 7). This attitude was certainly evident in the works that comprised the Raleigh show. As we looked through its catalogue, Katz remarked, "When I'm involved with the self-portrait genre, I don't want to get into content." Possibly not, I thought, but something is being put forth in these; psychological insights may have been furthest from his mind while making them, but he more than manages to give us some rather unique views of himself. He takes on various roles, perhaps to avoid being associated with one, in particular.

This performance aspect of Katz's painting was slow to emerge. After he made a sequence of raw-contoured, vigorously brushed figure paintings in the 1950s, in which he was the sole if rather anonymous subject, his self-portraits grew larger and more assertive. He is the immediately identifiable model for *Passing*, a large-scale 1962–63 painting of a dour-faced everyman, somberly attired in a hat, coat, and tie. He depicted himself, he says, not just as "a contemporary person, but as a generic

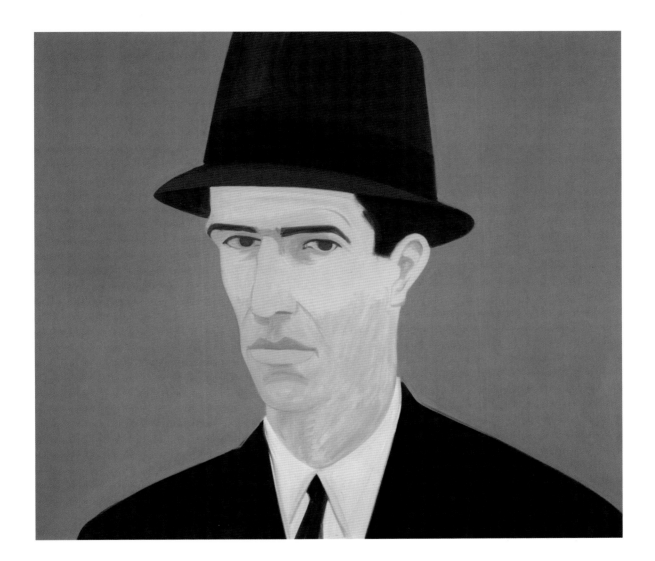

ALEX KATZ *Passing*, 1962–63. Oil on canvas, 71¾ x 79⅝". Collection of The Museum of Modern Art, New York; gift of Louis and Bessie Adler Foundation, Inc., Seymour M. Klein, President. Art © Alex Katz/Licensed by VAGA, New York, NY

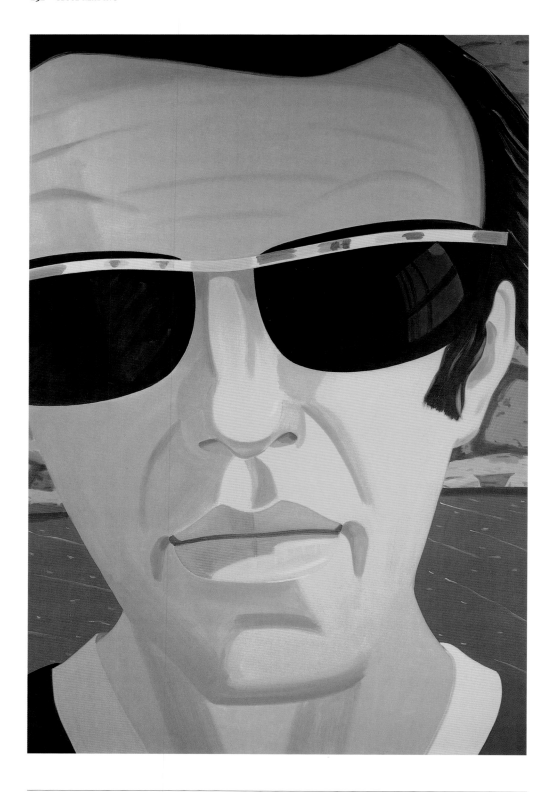

ALEX KATZ *Self-Portrait with Sunglasses*, 1969. Oil on canvas, 96 x 68". Collection of the Virginia Museum of Fine Arts, Richmond; gift of Sydney and Frances Lewis. Art © Alex Katz/Licensed by VAGA, New York, NY

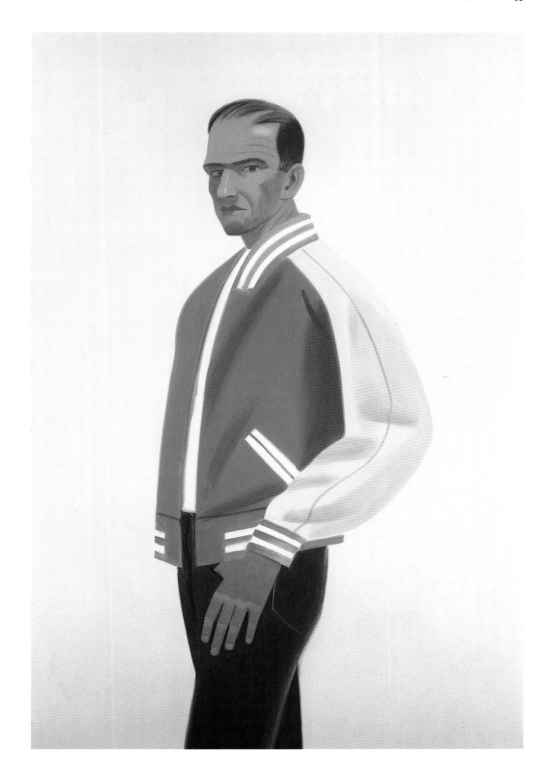

ALEX KATZ *Green Jacket*, 1989. Oil on canvas, 72 x 48". Private collection. Art © Alex Katz/Licensed by VAGA, New York, NY

image—like the 'man in the gray flannel suit,' a social type that hadn't existed before." In style, the portrait signaled a transition from the expressionistic descriptiveness that he now so decries to the flatter, almost posterlike rendition of form that would characterize his subsequent paintings. As the Raleigh exhibition inclusions revealed, there were other changes in how Katz presented himself. He traded anonymity for a special kind of visibility, as he portrayed himself in various roles. Unlike Close, who never strayed from his highly formalized, centered-on-the-canvas self-representations, Katz was constantly trying out new parts—some not without humor. In the 1968 *Alex*, a freestanding, cutout painting adhered to an aluminum backing, he is a dapper man-about-town, with a touch of gangster chic, wearing a pin-striped suit. In the 1977 smiling self-portrait, illustrated on the cover of the Raleigh catalogue, he presents himself in the guise of a deeply tanned, retro-style movie idol. "Here I am like Ricardo Montalban," he says, wryly amused by this fantasy, but drolly adds, "I decided I couldn't cast myself in that role and carry it off. It was a '70s thing." Of those role-playing images, one of the most audacious is the 1969 eight-foot-high *Self-Portrait with Sunglasses*, painted, notably, at the same time that Close was taking on the megahead theme in his own distinctive way.

Though his features are always recognizable in these portrayals, Katz is fundamentally a painter of archetypes who allows the viewer to add the details. After all, he muses, "realism is about illusions, and when you make illusions, people looking at them fill them in with their own eyes. That's what makes them seem realistic." In fact, the essence of his painting, including his self-portraits, is the tension between specificity and archetypes. As to the act of painting himself, Katz says, "it's about making something that is 'plausible,' or realistic. It's me, and then it becomes something else. It could be anybody. It could mean different things to different people at different times." The latest painting in the Raleigh show was the 1989 *Green Jacket*, in which he describes himself as looking like "an aging jock." Maybe so, but it was also an affecting image of a contemplative older man who, perhaps thinking about his own youth, might have borrowed a son's team jacket. When I asked if his interest in self-portraiture continues, Katz's reply was that he hadn't painted one in ten or twelve years, couldn't recall when he had painted the last one, and had no immediate plans for another.

'When Rauschenberg came to my studio to see the first painting I made of him in 1997," Close wryly recalls, "he talked about it at great length, but he sat with his back to it."

"I've known Bob forever. I knew him when Brice Marden and Dorothea Rockburne were his assistants, and we would occasionally hang out along with other young artists at that former Catholic orphanage, where he lived on Lafayette Street. Then, quite a few years later, when Leslie and I began going down to Captiva in the winter, I would visit him there."

Close made two paintings of the proto-Pop master Robert Rauschenberg. The first, *Robert,* an eight-and-a-half-foot-high oil on canvas with a diagonal grid format is an extreme close-up of the older artist's beaming face. So tightly did he crop the photograph for this painting that its subject is shown devoid of hair, ears, and neck. Embedded within its crackling facade are Rauschenberg's considerably enlarged features—his eyes, nose, and mouth vibrant clusters of zigzagging diamond-shaped cells. The top of the inverted dark triangle that forms the right eye devolves into sketchy ovoid bubbles, but its dark forms can also read as a heart shape. Rauschenberg's gleaming teeth are a lineup of whitish, but not really white, squares rotated forty-five degrees and filled with dots and plus and minus marks.

The second portrait, *Robert II,* a three-quarter view painted four years later, projects an entirely different sensibility. Unlike its predecessor, it is formed on a horizontal-vertical grid so that, right off, it is imbued with a sense of calm and order—or at least as much of those qualities as a Close portrait, vibrant with such intense color-particle interactions, can embody. The painting is a stately progression of row upon row of loosely defined cells that barely contain the chaos within them. From close range, it looks oddly flat—pressed out, in fact—but at the same time, its forms are almost sculptural. It rapidly gains dimension as one backs away from it, and from about fifteen feet away it has the feeling of a map, full of raised and depressed land areas. The multitudinous cells that comprise the Rauschenberg face cohere into a few large crenellated planes, some dark, others light, fitted together like jigsaw puzzle pieces. The separation between the planes is so abrupt that it's hard to believe that they could combine to form a subtly modeled face, but they do. A thin interrupted line of extremely light shapes illuminates the left side of the face.

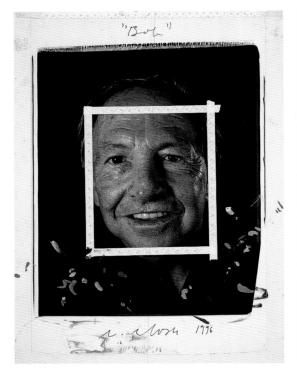

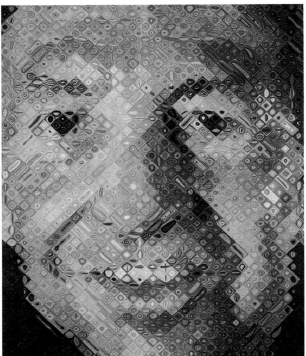

(left) Maquette for *Robert*, 1996. Polaroid Polacolor II. Photograph scored with tape, ink, pencil, and paint mounted on foamcore, 24 x 20" **(right)** *Robert*, 1997. Oil on canvas, 102 x 84". Collection of Vicki and Kent Logan

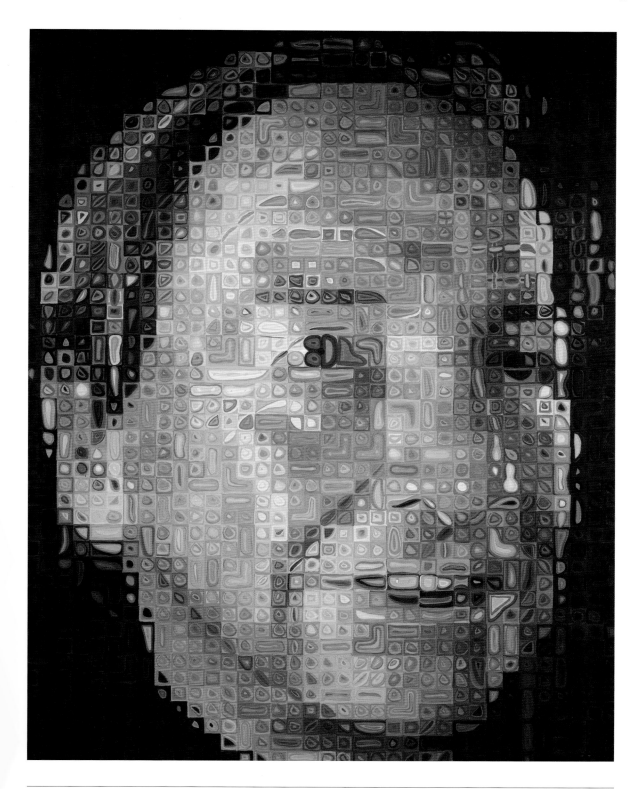

Robert II, 2001. Oil on canvas, 108 x 84". Private collection

More than most Close portraits of fellow artists, *Robert II* teems with the artist's special variety of hieroglyphs. An informal perusal of these might begin with those abstruse shapes that compose the right eye. That long, outlined shape is as Egyptoid, in fact, as any that has appeared in a Close painting. Its components are three dotted-center circles, a tall oval, and a curiously triangular shape with an undulating hypotenuse. Numerous variations on these indeterminate symbols proliferate over the surface of the portrait and are abetted by even more cryptic examples, among them slithery serpents (asps, perhaps? Maybe another Egyptian connection?); bottles with pinched-in waists; a scattering of teardrops; amoebae and possibly a few spermatozoa. In this second portrait, Rauschenberg's teeth are a line of gleaming, primarily pale pink and light blue, amorphous shapes.

Of the two Rauschenberg portraits, Close says he is somewhat partial to the second, because "it's a really weird painting. It has more funny run-together color shapes and these odd, sort of turquoise teeth that almost look like Southwest Indian jewelry." While the palette of *Robert II* is basically cream and a reddish brick tone, Close is certainly right in saying that it abounds with improbable colors. And they occur in the most unlikely places. How Close decides which colors to use in order to paint presumably noncolor areas, such as the whites of a subject's eyes or teeth, is a mystery. And why pick such strident ones as turquoise? Why not, while he's at it, orange or purple? The answers, as Close explains, are fairly obvious and lay in how we perceive reality. "The whites of someone's teeth or their eyes are never really white. For example, I'm looking at you now, and if I were to paint the whites of your eyes really white, they would look bizarre, because they're really a kind of purplish-bluish gray. In fact, they are quite dark, and it's only in the context of your entire face that they look white." Fair enough on the perception of the white part, but how does he go about choosing the colors that match that perception? It's simple, he says, "I just start putting colors together until the area looks right, and I don't use just any combination of colors. They have to be the right ones, but there are many ways to get to those."

Sometimes, Close will return to a favorite subject several years after making the first painting. While he may use the same photograph, as he has for his numerous paintings of Philip Glass, on occasion he might use another, taken during the same session at the Polaroid studio. Much as he liked painting the first Rauschenberg portrait, he decided that he wanted to do more with that subject. For one thing, he wasn't sure that Rauschenberg's identity was even that clear in the painting, so tightly had he

cropped the photographic image of his face in order to get the head to fill the whole rectangle. "In that first painting I thought it looked as much like Mike Wallace from *60 Minutes* as much as it looks like Bob. And then, it has this big, sort of shit-eating grin. Don't get me wrong, I like the portrait, but sometimes a painting doesn't tell the whole story, and there's a nagging sense of something missing in that version of a subject that you'd like to address in another one.

"Since I was thinking about making a second painting of Bob, I went through stacks of my photographs to see what might float to the surface. The minute I saw the three-quarter shot we made at Polaroid, it had such urgency for me that I just had to paint it. As always, when I look at photographs for my paintings, I ask myself, 'Will this be better if I paint it with a diagonal grid or a horizontal-vertical one?' So, after sliding different-size grids over the photograph to see what would be in each square, I decided to go back to the horizontal one because I thought it had a better rhythmic beat."

Photographing Rauschenberg was as easy, says Close, as photographing Johns had been hard. "It's not that there was anything wrong with Johns. It's just that Bob was an 'easy talk.' He's a raconteur, as well as a conversationalist, and we immediately started talking about what he did during the Nine Evenings events in 1969, at the 69th Regiment Armory, or his designs for Tricia Brown's dance pieces, and about other things we'd seen or people we knew. If you think about these photo sessions as sort of being in dialogue with the person sitting for you, everything from taking the photograph to making the painting is part of that dialogue. The process stands for what the nature of your relationship to that person is. The session with Bob was easygoing and funny, with lots of laughs and joking around, and so the paintings kind of got off the ground that way.

"When I photograph a subject I usually go for a rather neutral expression. But when I photographed him there was this wonderful smile. He's one of the few people his age whose upper teeth you can see. As we age, you usually see only the lower ones when we smile, because of how the flesh in our faces sags over the years. Because Bob has smiled so much all his life, he's kept all those muscles that pull your lip up over your teeth active. I tried to get him to have a more neutral expression when I photographed him, but he couldn't do it. He just looked silly when he tried, so we stayed with what we had. On the other hand, I had tried to get Jasper to look less solemn when he sat for his photographs, but that just didn't work. You've got to deal with what you get.

"You know, some people's faces embody both happiness and sadness at the same time. Frown lines or furrows in the brow cannot be disguised, even by smiling. I think that the sitter's basic optimism or pessimism always shows through. I think that's the case with Bob's face. There's a lot of mileage there. He's been around the block, and it shows. Even though his face has aged and has probably been worked on here and there—there are places where patches of skin damaged by the sun were removed—there's a wonderful boyish quality to it. Its combination of age and youthfulness is an incredible dichotomy."

Robert Rauschenberg has been as mercurial a figure in mid-to-late-twentieth-century modernism as Close, his junior by fifteen years, has been a solid anchoring one. That they represent two distinct generations with decidedly different philosophical and stylistic viewpoints in no way diminishes their regard for one another's work. Little as they have in common stylistically, each in his own distinctive way has dealt with issues of reality—Rauschenberg by combining actual objects and photographic images of past events within a matrix of gestural brushstrokes; Close by probing ever more deeply into the reality that lies behind photographic illusion, using his iconography of abstract marks. In Rauschenberg's democratic reality, occasional representations of himself are juxtaposed with mundane objects and photographic allusions to objects, places, and events he has been closely associated with. Some of his earliest self-portrayals have been as teasing as they were oblique. For a 1954 drawing, called *Lawn Combed,* he traced the outlines of his bare feet on a strip of found yardage that, according to the manufacturer's label incorporated by Rauschenberg into the drawing, was a sample of a weave known as *Combed Lawn.*

Biographically, things got more complicated in the 1960 mixed media drawing aptly named *Autobiography.* This relatively small work, sixteen inches square, is full of references to himself scattered among its many, far from specific shapes. It's a rebus of sorts, whose clues about Rauschenberg's life include a minuscule, upside-down photograph of his head in the upper left quadrant and a photographic portrait in the lower right, identified by the reversed letters RR. A large letter R, also backwards, floats on its side just above and to the right of the head. Other biographical tidbits include the letters P.A., for Port Arthur, Texas, Rauschenberg's birthplace, and 1925, the year of his birth. There are also allusions to his seminal combine, the 1955–59 *Monogram,* with its stuffed goat wrapped in a rubber tire, and to his notorious 1951 four-panel, all white painting, aptly titled *White Painting.*

ROBERT RAUSCHENBERG *Autobiography*, 1960. Solvent transfer on paper, with pencil, watercolor, gouache, and paper, 16½ x 16½". Private collection. Art © Robert Rauschenberg/Licensed by VAGA, New York, NY

One day in 1967, according to Sydney Felsen, codirector of Gemini G.E.L. print-making workshop in Los Angeles, "Bob had just arrived in town, and said that he wanted to 'make a self-portrait of inner man.' He really wanted to make a head-to-foot X-ray of himself." Felsen dutifully contacted a doctor friend of his at Kaiser Permanente Hospital to ask if such equipment were available in the area. It was not. Consequently, Rauschenberg decided that since he could not make a single, continuous X-ray of his body, he would settle for a series of separate ones whose images he would arrange from top to bottom and have translated into a set of printing plates at Gemini. The result, the 1967 *Booster,* more than literally met Rauschenberg's objective of portraying "inner man." This representation of his tall skeleton is surrounded by a constellation of arcane symbols printed on its underlying calendar grid: a pair of drill bits, a chair, part of another chair, and a small figure who looks as if he had just completed a high jump.

An inveterate recycler of favorite images, Rauschenberg utilized the *Booster* skeleton a few more times. It appears in *Autobiography,* a 1968 offset lithograph, as the top image in a vertical layout. Beneath it is an oval shape that suggests a fingerprint, whose concentric whorls are curving lines of minute text filled with autobiographical data. At the oval's center is a photograph of a very young Robert surrounded by members of his family. *Autobiography*'s bottom panel is a photographic representation of the then-thirty-eight-year-old artist on roller skates, harnessed to what looks like a parachute behind him. The photograph was taken at a 1963 event called *Pelican* that was initially staged in a Washington, D.C., roller-skating rink and whose other participants were the dancer Carolyn Brown and the Swedish artist Per Olof Ultvedt. (Subsequently, *Pelican* was performed in 1965 as part of the First New York Theater Rally, with the performance artist Alex Hay participating; it had two more incarnations, one in Los Angeles and another again in Washington.) Carolyn Brown, describing the initial performance, for which she was incongruously attired in toe shoes and a sweat suit, recalls that Rauschenberg and Ultvedt made their respective entrances kneeling on axles attached to bicycle wheels and pushing their hands against the floor to propel themselves. Once free of their "vehicles," the skate-shod pair sped around the arena, their parachutes filling with air.

In a small 1965 collage self-portrait (unhelpfully titled *Untitled*) that Rauschenberg made for a Dwan Gallery poster, his face appears amid such paraphernalia as a lithograph crayon and a spiral-notebook page. More cryptic symbols in this self-referring work are the reversed letter R at the top and photographic impressions of his hand on

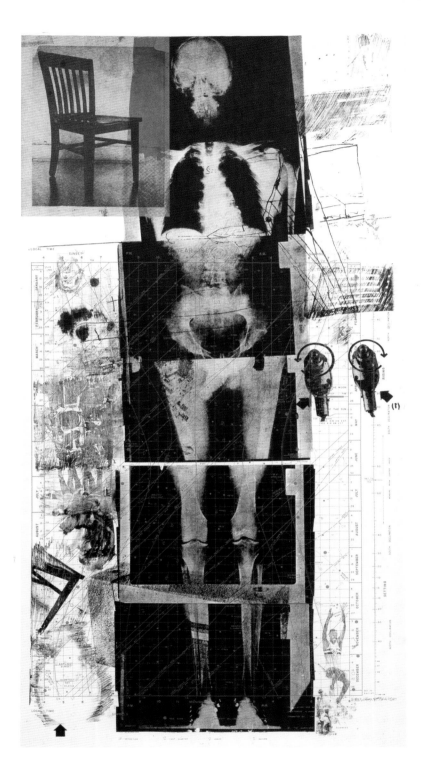

ROBERT RAUSCHENBERG *Booster*, 1967. Color lithograph and silkscreen on paper, 72 x 35½". From an edition of 38 published by Gemini G.E.L., Los Angeles. Art © Robert Rauschenberg and Gemini G.E.L./Licensed by VAGA, New York, NY

ROBERT RAUSCHENBERG *Autobiography*, 1968. Offset lithograph, 198 ¾ x 48¾" (3 sheets). From an edition of 2,000 published by Broadside Art, Inc., New York. Collection of the Guggenheim Museum, New York; anonymous gift, 1969. Art © Robert Rauschenberg/Licensed by VAGA, New York, NY

a notebook page and a somewhat foggy photo-transfer image of himself. For an artist who had so long played hide-and-seek in portraying himself, Rauschenberg had quite a change of heart when *Time* magazine informed him that his career would be the cover story for its November 29, 1976, "Joy of Art" issue. Further, the magazine commissioned him to create an autobiographical collage for reproduction as its cover. With that recognition, the fifty-one-year-old former enfant terrible of twentieth-century modernism was formally welcomed into the establishment temple. The images Rauschenberg chose for the cover not only referred to some of his most celebrated paintings, but also included a photograph of his smiling, windswept self in sunglasses and another of him with his son, Christopher, both of them in swimming trunks.

Certain images, those he has invented, others that he has appropriated, have long had a way of persisting in Rauschenberg's yeasty iconography. So imprinted on his psyche was the *Booster* X-ray that it found yet another venue, this time in a 1997 twelve-by-fifteen-foot panoramic painting titled *Mirthday Man [Anagrams (A Pun)]*. Along with his ubiquitous skeleton, this memento of his seventy-second birthday contains other Rauschenberg staples such as red-and-yellow-striped umbrellas, a bicycle wheel, and a pale impression of Botticelli's Venus arising from her seashell. To these he added such passing visions as a New York fire truck, a pair of zebras, rolls of puffy fabric that look a bit like white roses, fragments of sports jerseys with bright lettering and numerals, a dog seen through a car window, and a rearview mirror. A second and remarkably accurate version of this latter-day Rauschenberg epic is installed in his Lafayette Street studio in SoHo, where, though magically translated from its original painted-and-collaged surfaces to ceramic tile, it nevertheless retains the casual lyricism of the original. It occupies a high, white wall of what was once the chapel of Saint Joseph's Union Orphanage, the deconsecrated space that served as Rauschenberg's studio when he still lived in New York and which today functions as an office and archive for his work.

Recently, Rauschenberg has been involved in more intimate autobiographical recollections in a series of low-key palette intaglio prints he calls Ruminations, which utilize photographic images, much worked over by him, of his family and friends. Among these are meditations on his friendships with John Cage, Jasper Johns, and Cy Twombly, with the legendary dealers Leo Castelli and Ileana Sonnabend, and with Tatyana Grosman, who in 1957 founded Universal Limited Art Editions in Bay Shore, Long Island. Rauschenberg has continued to make prints at ULAE, the Ruminations series being his most recent work. These figures from his past, along with those of

ROBERT RAUSCHENBERG *Mirthday Man [Anagrams (A Pun)]*, 1997. Vegetable dye on transfer on polylaminate, 123⅝ x 180¾". Art © Robert Rauschenberg/Licensed by VAGA, New York, NY

family members, appear in the dark, shadowy images of the series, some of them just visible within the matrixes of brush strokes. They radiate a melancholy presence, filled as they are with a sense of the past. In one, a triptych of sorts, named *'topher,* Rauschenberg is seen as a smiling young man at the upper right of the page; just below is the figure of his former wife, Susan Weil, visibly pregnant, one arm raised languidly; and at the upper left is an image of their infant son, Christopher, in diapers, also raising his arm, as though in greeting. Rauschenberg appears in a few more Ruminations intaglios, one notably with Sonnabend and her late husband, Michael. That impression comes from a catalogue of the Sonnabend collection published in France. Hazy portraits of his parents, Ernest and Dora, and his sister, Janet, flicker through the series.

The careers of Close and Rauschenberg could not be more opposite in their trajectories. From the outset, Rauschenberg has sought to give form to all that he saw and felt, and to make every possible connection between himself and his surroundings. His famous dictum of erasing the borders between art and life has had no better exemplar than himself. There has never been a hierarchy of objects in his paintings, and he remains the ultimate transformer of prosaic "found" forms into magical ones. Close's world, in contrast to Rauschenberg's all-inclusive one, is far more circumscribed. He has defined the parameters of his painting by focusing on a single subject, the human head. A Close "head" is a constantly mutating universe, within whose outlines increasingly strange and wonderful things can happen. Though he embraces an imagery of logic, he, too, can be improvisational, by freely using abstract marks to project an alternate reality in which they take on a life of their own.

In late June 2004, Rauschenberg and Close had a phone conversation that Close initiated from my apartment in New York. Having recently suffered a stroke, and gamely coping with its debilitating effects by continuing to be productive in his studio, Rauschenberg tends not to talk much about his work these days, except with longtime friends. Beyond their friendship, which goes back to the younger artist's early days in New York, he and Close now have another bond: both are obliged to produce their work under severe physical limitations. Neither, however, has allowed those incapacities to diminish his wholehearted commitment to making art. This was pretty much the subject of the call that Close made to Rauschenberg in his Captiva Island studio. Asked what he was working on now, Rauschenberg said he was making some large silkscreened works, roughly seven and a half by ten feet, based on transfer images from Polaroids. Though he oversees every detail of the process, from

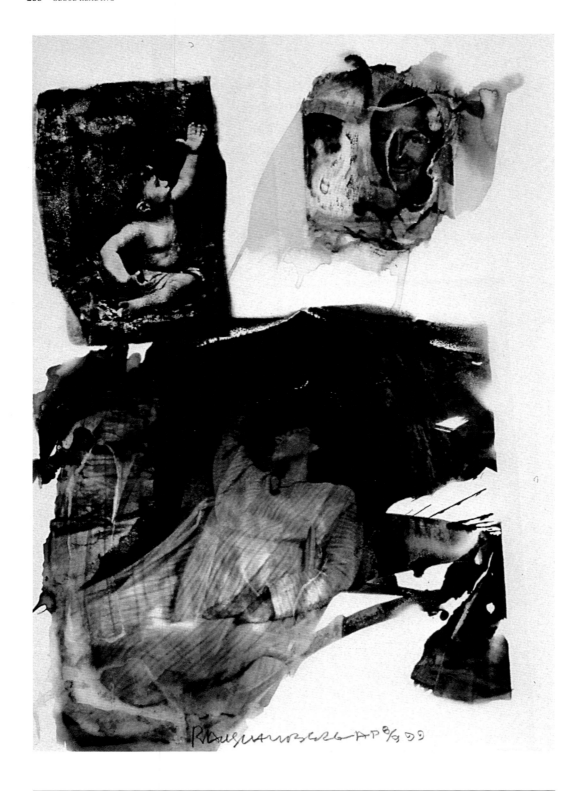

ROBERT RAUSCHENBERG *'topher (Ruminations)*, 1999. Intaglio, 39½ x 27½". From an edition of 46 published by Universal Limited Art Editions, Bay Shore, New York. Art © Robert Rauschenberg and ULAE/Licensed by VAGA, New York, NY

the choice of the images to their arrangement in the compositions, given the weakness of his wrists these days, he explained a bit ruefully, his assistants have the task of pulling the heavy squeegee over large expanses of silk screen to transfer the images to laminated supports, the top surface of which is rag paper.

Close commiserated, offering a supportive comment: "I remember what someone said to me in the hospital when my hands were paralyzed. 'You'll be all right, because you paint with your head and not with your hands.' And I think that's true, because we both do that." A line of thought that soon led him to raise the question of Rauschenberg's frequent use of his body in his work, such as the X-ray images incorporated in his prints and his celebrated parachute-wearing self-portrayal on roller skates. Why, Close wanted to know, did Rauschenberg allude to his body in so many ways? The older artist's response was as wistful as it was trenchant. Finessing the question, he talked instead about the uncertain present than the past. "Well, I think you know," he said, "I reach out with any part of my body to make sure that I'm still there." Close, concurring with this wry acceptance of physical limitations, responded with a slightly cryptic observation of his own. "I used to think that scale in my painting was pretty much the distance that my arm could reach covering the length and width of the canvas." Now, he says, his ideas about scale have changed because he is unable to cover those great distances with sweeping brush strokes; rather, he works from one small area to another, within the confines of the canvas rectangle.

When the conversation got around to the two portraits Close had made of Rauschenberg, the 1997 frontal view *Robert*, based on a closely cropped image of his beaming countenance, and *Robert II*, the more tranquil 2001 three-quarter view, Close asked Rauschenberg about his reactions to them. Rauschenberg's response was that he was a bit uncomfortable with the first image of him, "but the second one I really loved," he added enthusiastically. "It just seemed to be freer and closer to the way I feel." Close, accepting the critique with grace, stoically observed, "Sometimes it just takes me a while to get it right. The first painting was edge to edge, almost like wallpaper. In it, your face is spread all over the canvas. The second reads as a more conventional portrait, with lots of space around the head." Changing the subject, Rauschenberg brought up Close's painting technique. Like many other artists who have sat for a Close portrait, he was fascinated by the artist's labor-intensive way of working, "I was just amazed by your procedures in making those things," he said. "Nobody knows that they are so intimate. It's a well-kept secret and filled with surprises," he said, with a laugh. To which Close blithely replied, "The way I work is probably too crazy for anyone else to use."

Between 1978 and 1980 Lucas Samaras persuaded a number of friends and acquaintances to pose in the nude for him in a series of ornately staged tableaux. Close was one of his models. In a particularly arresting color Polaroid, the lanky Close, wearing nothing but cowboy boots, is seen from the side leaning over a chair, while next to him, in the shadows, sits a fully clothed Samaras. Recalling these sessions in Samaras's studio, Close says, "The setups for them were artificial, very contrived, with lots of chairs and ornate fabric backgrounds, and while all this hot imagery was happening out in front, there was Lucas on the periphery of things, with a sort of enigmatic expression on his face and a cable release in his hand. He was the voyeur extraordinaire. It was weird, because he insisted on having all the penises tucked out of the way. Maybe it was all about androgyny.

"My relationship with Lucas has been a very interesting one. He was absolutely instrumental in getting me into the Pace Gallery. He took Arne [Glimcher] to see my first show at the Bykert Gallery, and the fact that an artist like Lucas would even look at my work, let alone lobby for it, meant a lot to me then. But as instrumental as he was in my joining the gallery, the minute it happened I was fodder for his relentless sarcasm. He made my life a living hell there, something he now denies. Later, I realized it wasn't personal. We were two children competing for Arne's attention, and Lucas was the older sibling who was going to rough me up. I was so happy when Julian Schnabel joined the gallery because now he was the new kid in the family and all that stuff was transferred to him."

Samaras's attitude toward him has long since mellowed, Close says, and if Close had once regarded him as the gallery terrorist, he thinks of him more warmly now. How else to explain that he chose to paint Samaras not just once but three times, all from photographs made during the same 1986 sitting at the Polaroid studio? In these successive versions, Samaras's face is hardly that of a sadistic tormentor. In fact, the stern, otherworldly expression he often affects is transmuted in these paintings to that of an omniscient presence. "Lucas is so Svengali-like. If anyone could ever run for the job of ayatollah, he would be a great candidate because he would like to control everyone in the world. So when I made the second big painting of him, *Lucas II,* I thought it was totally appropriate to position the vortex of the circular grid on his face, a little like the 'all-seeing eye' in Buddhist art. Another reason

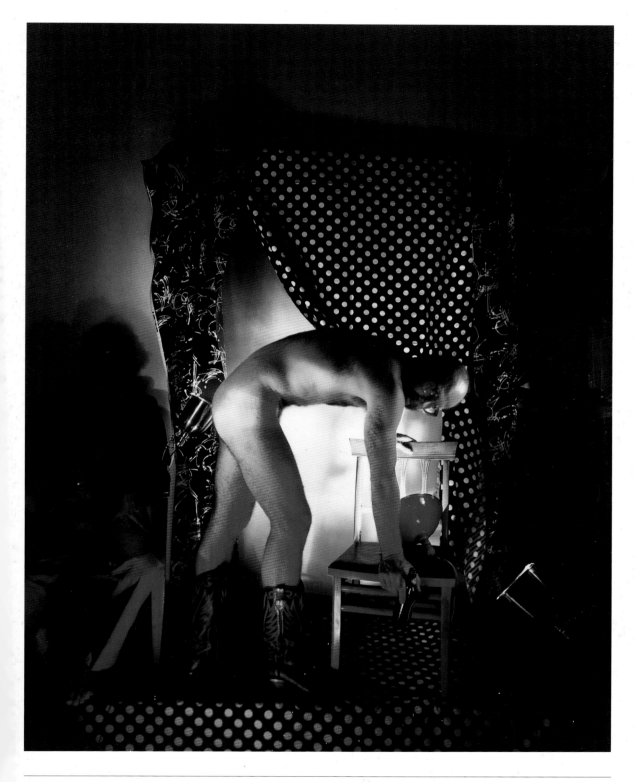

LUCAS SAMARAS *Sitting 8 x 10 (18)*, December 5, 1978. Dye diffusion transfer print (Polaroid film), 9½ x 7½".
Private collection

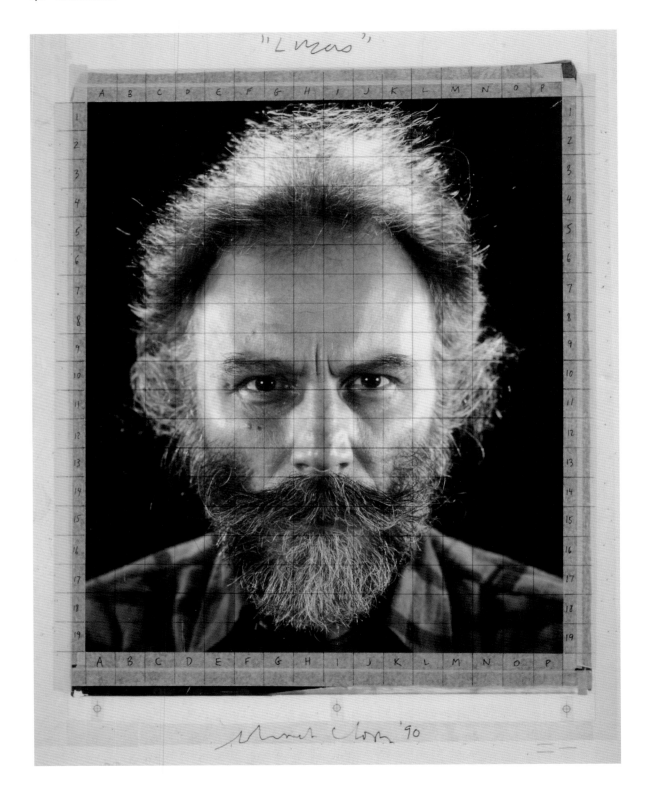

Maquette for *Lucas*, 1987. Polaroid, 24 x 20"

I thought that the circular grid, which I used for a 1987 portrait of him, was appropriate because it suggested a kind of mind control. Remember those 1930s and '40s horror movies in which there were a lot of mysterious characters, with radial waves coming out of their foreheads? They would look scary. Maybe their eyeballs would even go white. 'God, that's who Lucas really looks like,' I thought, 'like someone attempting to get into and control your mind.' So it just seemed appropriate to use those radiating forms to paint him."

As Close describes it, photographing Samaras was more complex than taking pictures of most of his other models. "Not only was Lucas a professional poser, he was also a photographer himself who knew exactly what was going on. That made things much more interesting formally." Of the many artists who have sat for him, he continues, "Lucas, along with Francesco Clemente, Cindy Sherman, and Bill Wegman, is part of what I call my 'artist-poser' series. Each of them makes lots of self-portraits and knows just how he or she wants to look when you photograph them. Other subjects are putty in your hands, but they certainly are not. Lucas understood exactly what he had to do for that hundredth of a second when the picture was being taken. He would pump himself up for each shot, holding this really intense expression for that short time, and the minute the camera snapped, his face would just relax."

A rapid elevator ascent leads to Lucas Samaras's sixty-second-floor aerie in midtown Manhattan. The hall door opens to a sprawling space. Two large apartments have been combined and fitted with elegant shelving and glass cabinets filled with vivid examples of the artist's work. In this environment, Samaras is in full charge of all that one sees. In addition to numerous wall reliefs, collages, small sculptures in wire and cast bronze, and heavily worked-over photographs, many of them bearing his image, the most prominent Samaras works on view are paintings of large, skull-like heads, their mouths open as though in midshriek. These fierce, strident-hued mid-1980s specters were, he explained, his sardonic takes on the foibles and machinations of the New York art world, of which he, of course, has long been a card-carrying member. Bearing such blunt titles as *The Artist, The Art Dealers, The Collector,* and *The Critics,* this jocularly perverse sequence of images even has room for one ironically called *The Failed Artist.* Samaras is not given to understatement.

Though now in his late sixties, slight, and with wispy, near-shoulder-length gray hair, Samaras has never quite lost his bad-boy persona of the mid-1960s, when he

emerged on the New York art scene as a dark-eyed, exotic-looking, wholly self-involved young artist operating on the far edges of Pop. His alternately autobiographical and abstract imagery featured self-portraits, often embedded in reliquaries encrusted with needles and glass shards. There were innumerable portrayals of his naked self, both in vividly chromatic pastel drawings and in intensively manipulated, small-scale color Polaroid photographs. Made from the early to the mid-1970s, these images presented the artist in a startling variety of elongated, twisted, and compressed poses. In this self-eroticizing Photo-Transformations series, he carried the principle of the funhouse mirror to new lengths.

By his words, actions, and above all his art, Samaras has carefully cultivated his public image, which is evermore inward, mysterious, and, some might say, weird. During our conversation in his pristine high-rise setting, heavy drapes blocked the spectacular views of New York from all but a few windows. The real panorama was inside. Hallway, study, and bedroom walls were completely covered with artfully placed objects of his devising, most of them assertively personal. There were close-up photographs and drawings of himself as a smiling young man, as well as portrayals of his reclining nude figure. Suspended on thin wires before a window was a delicate, transparent curtain of gleaming sharp objects—knives, scissors, and blades of various descriptions. In the small room that serves as his studio, a large computer screen was filled with a scattering of images of Lucas Samaras at various stages of his life. The studio, in its sparse, even chaste, character, differs little from other rooms in the apartment. Enigmatically, there was little evidence of the artist's hand at work: nothing was to be seen on the worktable.

It's not difficult to understand Close's fascination with the Samaras visage, surely one of the more arresting in the New York art world. And it was inevitable that that brooding, judgmental face would be the inspiration not only for a trio of paintings but also for a number of stark black-and-white photographs, two woodcuts, a linoleum-cut print, and a woven tapestry. For his part, Samaras says he is intrigued by the sense of art history that is always implicit in a Close painting, whether of Samaras himself or some other subject. Commenting on some of those historical connections, he cites Close's black-and-white paintings of the late 1960s. "The earliest of these, like Close's 1969 head of the sculptor Richard Serra," he says, "have a connection to the art of antiquity. They don't have the roundness of Hellenistic art or the grandness of the classical form, but they do have," he says with a touch of

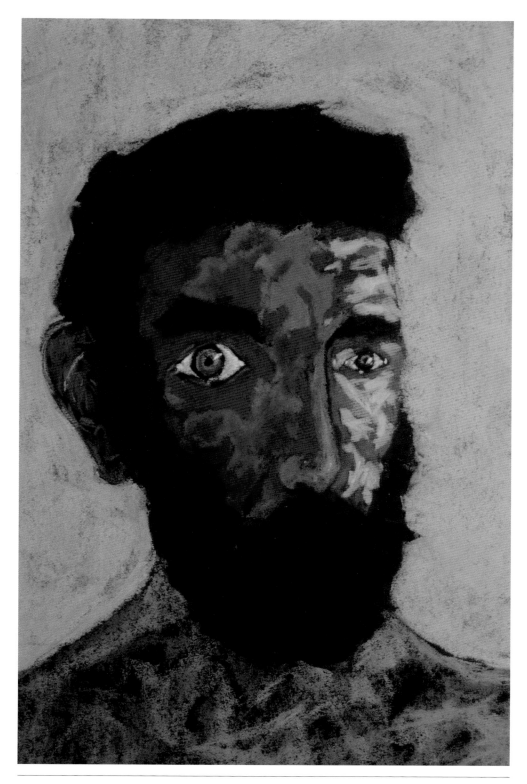

LUCAS SAMARAS *Head #118*, 1981. Pastel on paper, 17½ x 11¼"

condescension, "a kind of clumsiness that you see in late Roman sculptures." An observation to which Close responds with amusement that probably, in Samaras's terms, "it was not good enough to be Greek."

The first of Close's Samaras portraits, the 1986–87 *Lucas I,* based on a horizontal-vertical grid, is also the most conventional in its measured forms and rhythms. It's also a classic example of his dot-painting technique, in that innumerable particles of color, all roughly the same size, comprise the face, hair, beard, and dark-toned background. Samaras's eyes stare with somber intensity into limitless space. His shaggy dark mane and thick beard, in contrast to the passivity of the face, seem charged with static electricity. Given this promising initial exploration of Samaras's arresting physiognomy, it was inevitable that shortly after making this painting Close was again in its thrall.

The second version departed drastically from the orderly first one. In the high-voltage *Lucas II,* made in 1987, the forces of exact description and radical abstraction are in uneasy equilibrium. Within its concentric grid, Samaras's mesmerizing face is a circle within many circles that incorporate hair, beard, mustache, and whatever other fugitive forms may have lurked in the original photograph. The painting is a volatile synthesis of precise geometry and erratic expressionistic surface, in which Samaras's face becomes a turbulent energy field. From a point between his eyes, raylike lines extend to the edges of the canvas. Close was well aware of Samaras's Greco-Byzantine heritage, as Samaras himself terms it, and ingeniously alludes to it in this depiction: Samaras's countenance strongly recalls the brooding visage of the Christ Pantocrator gazing down upon the faithful from sanctified heights. The third of the *Lucas* paintings is a haunting monochrome painted in 1991 from a black-and-white photograph. Its in-and-out-of-focus treatment of Samaras's features suggests an X-ray image in the process of dissolution. It is by far Close's most abstract depiction of his artist friend. Even beyond that, it is a solemn meditation on the impermanence of form.

When Samaras first saw Close's giant portraits at the Bykert Gallery in the early 1970s, he must have related to something in them, even though they differed greatly from his own work in their relentless realism and scale. Perhaps it was a case of one ultracompulsive artist responding to another. Yet, stylistically, he and Close were at opposite poles. Close was embarked on his slow, steady course of making paintings that projected stability and in which each image inexorably foreshadowed the next.

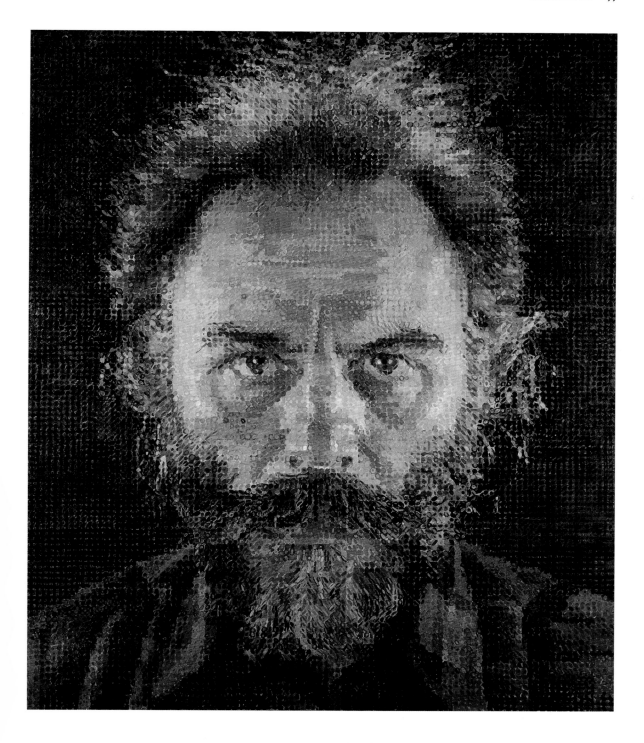

Lucas I, 1986–87. Oil on canvas, 100 x 84". Collection of The Metropolitan Museum of Art, New York; purchase Lila Acheson Wallace Gift and gift of Arne and Milly Glimcher

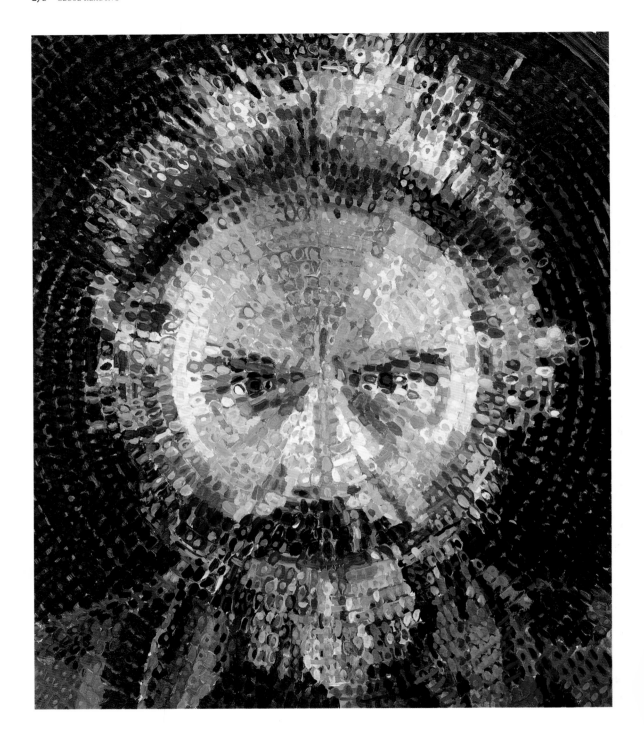

Lucas II, 1987. Oil on canvas, 36 x 30". Collection Jon and Mary Shirley

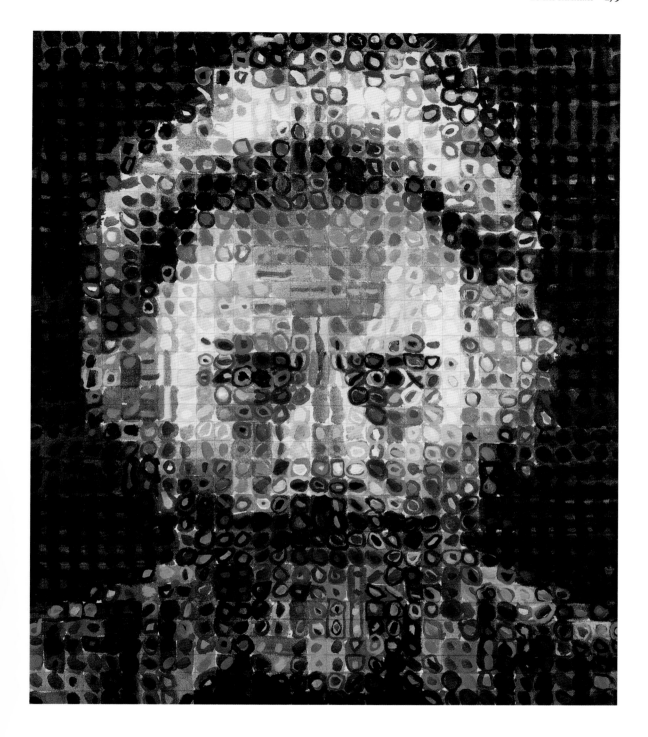

Lucas, 1991. Oil on canvas, 28 x 24"

The exact opposite was true of Samaras, who capriciously shifted from two to three dimensions, from photography to drawing and painting, and from quasi-abstract forms to descriptive ones. Arguably, for all its unpredictability, Samaras's art is about self-obsession. While images of himself dominate his art, his vexatious presence is actually in everything he makes, from pin-encrusted chairs to the disorienting mirrored rooms he invites unsuspecting viewers to enter.

Samaras's favorite Close self-portraits are the early ones, those with implicit narrative or at least role-playing qualities, which are especially well exemplified by the cigarette-smoking, tough-guy character in the iconic *Big Self-Portrait.* The movies, he suspects, had a lot to do with Close's attraction to scale. His large-format style could well have been inspired, he speculates, by epics such as *Citizen Kane,* in which Orson Welles appears against a giant blowup of himself. "With Chuck, the head takes up a wall. His heads are a shock, but not that big a shock because Pop Art, which preceded them, also presented big heads." But the heads he alludes to (think Lichtenstein, Warhol, Rosenquist), "were always connected to some cultural thing, whereas Chuck removed all such associations from his." As to other traceable sources of Close's style, he rather grudgingly credits Minimalism, the purist mode with which he has little patience. "You see, there's a kind of rigidity to all those people who are afflicted with that virus. An inability to say, every five years, 'I'm just going to go crazy.' No, they would never do that. They just can't."

As Samaras recalls, sitting for the Polaroid photograph that would lead to his portraits by Close was fairly short and direct. "The process was very simple. He photographed my head in five or six poses in one sitting. It wasn't a big deal. It wasn't having a cup of coffee with the photographer and talking about life or whatever. It wasn't essential for him to have a conversation with you." When it comes to posing, whether for a self-portrait in pastels, oils, or one of his "manipulated" photographs or for a portrait by another artist, Samaras has few equals. He was a model for at least six George Segal plaster figures, and though amenable to Segal's directions for posing, was always concerned, according to the late sculptor's wife, Helen, about how he would look once in permanent sculptural form. Mindful of that concern, I asked Samaras if he had offered Close any suggestions about how he should be posed. Not really, he replied, but then added, "except that I may have suggested something about lighting, so that my hair, which is not very dense, would not look as though it were disappearing in front of your eyes against the white background."

LUCAS SAMARAS *Ultra-Large*, 1983. Dye diffusion transfer print (Polaroid film), 80 x 44"

Not only may have but did, according to Close, who says, that it was the only time he allowed anyone to influence the way he set the lights for a photograph. "But," he adds, "Lucas was absolutely right, of course, in what he suggested because he understood the process so well."

Asked if he discerned changes in style or feeling in Close's self-portraits after the onset of his 1988 illness, Samaras reply was cautious. "I think we probably impose a reading on them, because we know about his physical situation, so that's very easy to do. But after that catastrophe there was a big change in what he did with other people's faces. There was more abandon. Before, he was very precise, you know, taking twenty hours to do one little centimeter. Later, a patch of color would stand for a patch of skin. But the closer you were to it, the more chaos of color blobs. Even though they were squares, there was still chaos." From a distance, though, the painting's underlying structure—its "design element"—came through and everything coalesced. He thinks that the sitters' features were more accentuated in Close's post-1988 paintings. "The idea of caricature comes in, but it really wasn't that."

In his opinion, Close's self-portraits are less autobiographical than they are extensions of the rest of his imagery, and he refuses to see more in them than what their surfaces may offer. Nor is he convinced that, as a group, they are especially central to Close's overall production. Such definitive pronouncements come easily to Samaras, who delights in upsetting the apple cart—or whatever else can be handily turned over. He theorizes that Close's self-portraits are actually performances, and that casting himself in roles such as a cigarette-smoking tough guy has been a continuous process for him. Even though these roles don't approximate the overt theatricality of that memorable 1968 image, he still thinks that Close's self-portraits are in essence about "posing and pretending."

Given the vast differences between their stylistic and temperamental approaches to depicting the human face, does Samaras think there are any commonalities in the ways they go about this? "Maybe there's one commonality," he replied, weighing the question pensively, "which is to frame a character through the face, to make whatever comments you're going to make about that character only through the face, and not with the rest of the body. A lot of my early pastels are like that. They're not bodies, they're heads, so the similarity is there." And, he added, there might be another characteristic that their self-portraits share. "It's a stupid, two-word thing, a 'charged gaze.'" Because every Samaras self-portrayal seems fraught with psychological issues,

LUCAS SAMARAS *Untitled*, May 28, 1990. Collage of gelatin-silver transfer prints (Polaroid film), 9 ½ x 7 ½"

I asked if he detected similar concerns in Close's. To which his cryptic response was that an artist could be thinking about countless other things other than himself, even while painting himself. Then I tried another question that I thought might especially resonate with him, given the ambivalent nature of his own work. Did he think that Close's self-portraits were essentially about concealment or revelation? Neither, Samaras said, adding that Close may actually disdain such subjectivity "because he grew up in a period like Pop art," a period when stylization prevailed over sentiment. "He ran away from sentiment, so maybe he continues that stylizing period."

When Cindy showed up at the Polaroid studio to be photographed, I didn't recognize her at first," recalls Close. "I'd always seen her with contact lenses, and when she arrived she had schoolmarmish glasses on, and her hair, which was a different color than when I had last seen her, was tied back in a bun." Probably sensing his surprise, Close says, "She explained that she was having trouble with her contacts that day and had to wear her glasses—but I'm sure that presenting herself the way she did then was a conscious decision. But the interesting thing was, when she stepped in front of the camera at Polaroid, there was no one there. She was a total cipher. I took shot after shot after shot, and they were terrible. They didn't even look like her, they weren't interesting as photographs, and there was no indication of psychological presence. I don't know if she could sense it, but things were going very, very badly. Here, I had one of the people I most respected in the art world in front of my camera, and I was having performance anxiety. I'm always a little hysterical when I'm photographing, but this time I was totally at the edge.

"For lack of anything better to do and because I was so desperate, I said, 'Well Cindy, why don't you just start moving around a little in front of the camera while I look through the lens, and let's see what happens.' So she started turning her head and bending her neck, and then, all of a sudden, I said, 'Oh, that's great! Now you're beginning to look just like a Brancusi sculpture.' And the minute that I gave her that role to play, she became one of those elegant forms. She twisted her head in an exaggerated way, so that it became a kind of oval shape on her long, willowy neck. She just transformed herself, instantly! After all that, I decided to make a profile shot of her, and again nothing was happening, so I asked her to move around and try a few different poses. As things got better, I said, 'Oh, these are looking great. Your profile should be on a coin or a stamp.'" Evidently that was enough encouragement to set Sherman's creative processes as a model in motion again, because, Close happily recalls, "she immediately lifted her head, and her countenance was suddenly like a queen's.

"I realized that that's how Cindy always works. She always has to have a role. Right from the beginning of her career, she was assigning herself roles—from her early movie stills to what she's doing now. It's the only way she can operate. There's no 'real Cindy' in any of that work. It's always a role. She's perhaps the art world's greatest actress—you know, in a Meryl Streep sort of way." Like Streep, Close points

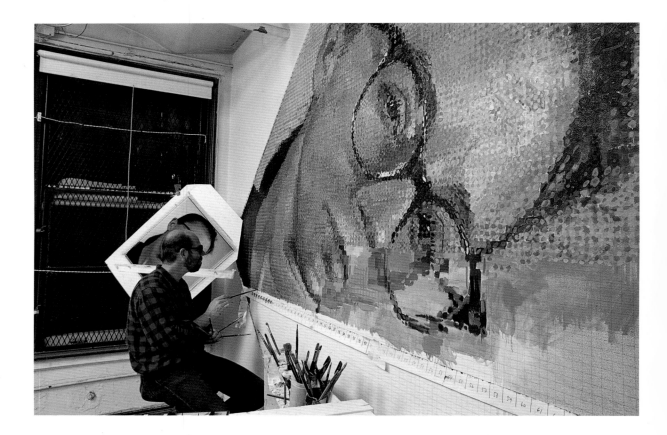

Work in progress for *Cindy*, 1988

out, who could instinctively transform herself, accent and all, into a Polish-Jewish refugee in *Sophie's Choice* or a Danish baroness in *Out of Africa,* Sherman can also magically take on the persona of invented characters in her richly detailed photographic tableaux. Of the many shots that Close made of Sherman during that anxious session, two were the bases of paintings: *Cindy,* the three-quarter view, whose pose he likened to that of a Brancusi woman, and *Cindy II,* the regal profile.

What for Close was an event that bordered on traumatic was for Cindy Sherman, as she remembers it, "a really fun and painless experience." She admits she was a reluctant model, and it was only because of her regard for him that she agreed to pose. "I'm not really comfortable with other people taking my picture," she confides. "I usually don't like it, but that session went just fine." She had almost forgotten about posing for him, when a few years later she saw the finished paintings. "When I did though, I was blown away. I didn't really think of them as portraits of me because, at that point, I had already seen many other paintings by him." Rather, she responded to them as examples of his "amazing" style. So intrigued was she by that style, she adds, that she didn't "really explore the particularities" of what he had done in his paintings of her.

Of the two paintings that Close made of her in 1988, Sherman regards the profile as more interesting because it's the more abstract and most resonant psychologically. She's certainly right about the differences between them. The first *Cindy,* for all the elegance of its pose, is a rather distant image of a sitter who avoids eye contact with the viewer. In sitting for the preliminary photograph, Sherman seems to have offered Close her face as an anonymous surface to activate in any way he wished. His response was a painting whose pensive quietude exactly matched that of the pose. In some ways, this painting of Sherman could be a portrait of an imaginary older sister, prim and a bit stern-looking in her horn-rimmed glasses. Looking at her today, it's hard to believe that she sat for this somewhat chilly image. In real life, she looks much younger. She is small and slight with bright blue eyes, pale skin, and angular features; her hair, brown and tightly pulled back in both portraits, is modishly long and blond. While not anonymous, her face has nothing especially arresting about it. It has served her as the perfect tabula rasa on which to create a succession of characters whose physiognomies are as memorably assertive as hers are recessive.

Even when compared to other Close artist portraits of that period, his three-quarter view *Cindy* is the essence of passivity. In this classic dot painting, the touch

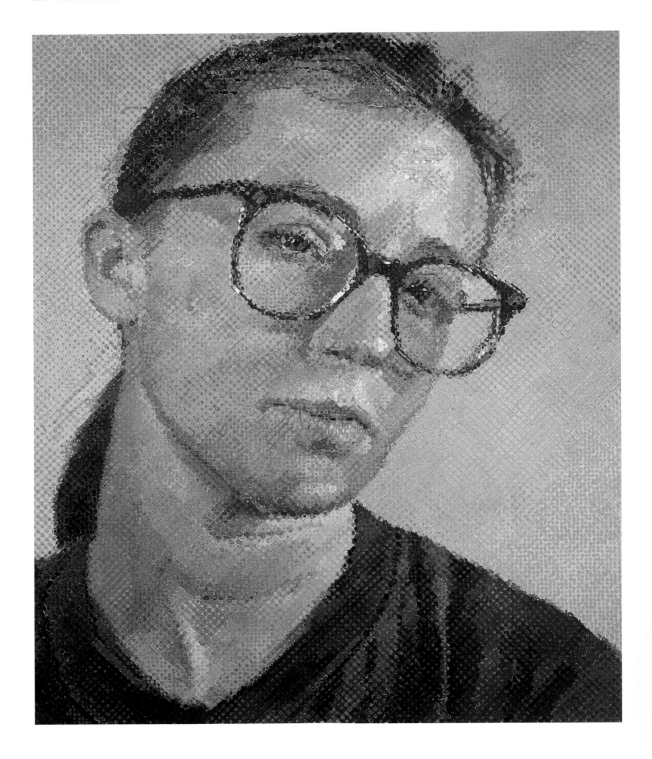

Cindy, 1988. Oil on canvas, 102 x 84". Collection of the Museum of Contemporary Art, Chicago; gift of Camille Oliver-Hoffman

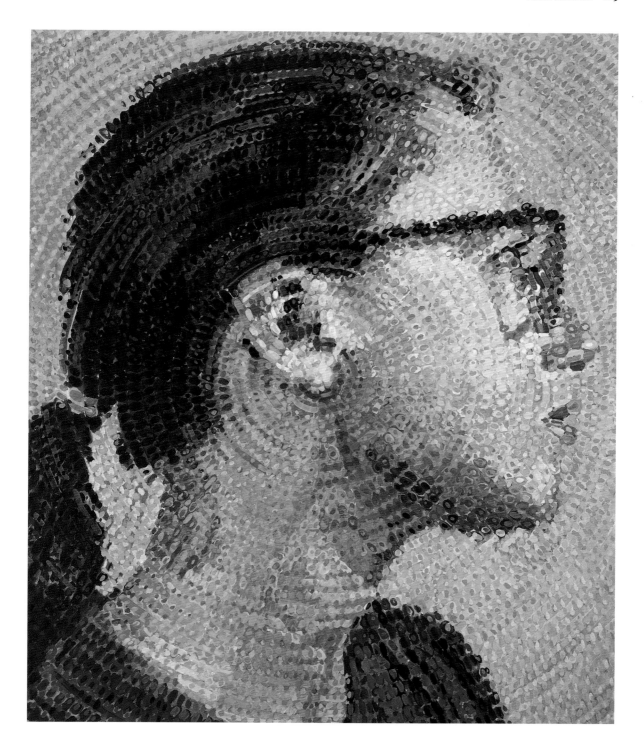

Cindy II, 1988. Oil on canvas, 72 x 60"

of his brush is even, its marks virtually the same throughout the canvas, whether describing Sherman's face and neck, her dark V-neck sweater, or the depthless background. If that first view of Sherman is about stasis, its successor, *Cindy II,* is about dynamism. "It was the last painting I made before I went into the hospital," Close told me. "It had the coarsest grid and the most expressionistic brush strokes of any painting I had made and was also much like what I would do after I got out." Sherman's expression, so passive in the first painting, is more open here, and there is even a hint of wonder in it—a slight but compelling edge of emotion. Her face, though composed of large, blurry bits of color, is subtly modeled. Almost a monochromatic picture, it is made up of Close's all-but-patented tomato red, pale azure, and flecks of creamy yellow in varying degrees of brightness.

The painting's hyperactive surface recalls that of the energy-charged painting of Samaras that Close had made the year before. It, too, was predicated on a circular grid, with radiating lines from its vortex. In his profile view of Sherman, however, Close used this grid to considerably different effect. While the grid's center in the Samaras portrait is midpoint between the eyes, in *Cindy II* it exactly coincides with the right ear. While I could understand his use of vibrant circles in painting Samaras, whose hypnotic visage was a natural for such vivid treatment, why would he use that scheme to depict Sherman, whose off-camera face was far from theatrical, I wondered? After all, in the Polaroids he made of her, she was nothing like any of the exotic characters she becomes in her own elaborately staged situations. In fact, with her wigs, costumes, and prosthetic-like body parts, she is never the same person twice in those. In view of all this, I asked Close, why so dramatic a compositional scheme to portray so reluctant a subject? At first, I thought that his answer, "Cindy's generation had a great ear for what was going on," was a little too pat and punning, but the more he talked about the motivating forces of Sherman's work, the more I began to see things his way. "Even though she was associated with 'appropriation art,' she always managed to move those ideas into her own arena better than anyone else. She would take on forms and concepts from the history of painting, like the Renaissance portrait, and make them entirely her own."

Sherman had met Close a few years earlier at an opening and remembers being "totally intimidated" by the experience. "He was such a big guy, and like a hero to me, but I was sort of scared of my heroes at that point." He had seen her exhibitions at Metro Pictures in the early 1980s, she recalls, and made a point of saying com-

plimentary things to the gallery about it. Close, a habitual visitor to galleries featuring work by younger artists, had even bought a few of Sherman's idiosyncratic photographs of herself. Her initial full-scale encounter with Close's work was during his retrospective exhibition at the Whitney Museum in 1981, organized the year before by the Walker Art Center. Especially impressive to her, in addition to the paintings, were several large-scale collagelike photographs of Close, one composed of nine separate fitted-together prints. "I still think of his paintings as so photographic that sometimes I forget that he's really a painter," she says. "Whenever I see one of his painting shows these days, I still think 'photograph.' When I think about the photographic images he takes for them, and about the processes by which he brings them into paintings, it's still incomprehensible to me."

Sherman lives and works in a high, sun-filled loft space in SoHo. Our companion over tea in the kitchen was Frieda, a voluble, vibrantly colored parrot who knows a number of words and did her best to interject herself into the conversation before Sherman removed her. Her commodious studio is equipped with tables, shelving, cupboards, and numerous pinning surfaces. Sherman uses one corner to make her photographs, and she works there unassisted. A mannequin head, at eye level on a tripod, serves as her surrogate as she focuses her 35mm camera and decides on the depth of field for the color transparencies she will shoot of herself. Given the sophisticated technical quality of her compositions, it seems inconceivable that Sherman failed a photography course at the State University of New York in Buffalo in the early 1970s.

The drawers of the small cabinet on wheels in the shooting area are filled with theatrical makeup. The bottom one houses a collection of pinkish doll parts. It was a surprise to see these fragments stuffed together in so small a space, especially as I remembered the early-'90s "sex pictures" in which they were used. They were far larger and more ominous in those photographs than these shards would suggest. Making those pictures, Sherman explained, was a kind of catharsis, following a difficult divorce. At the other end of the studio were pull-out shelves filled with other wonders: rubber novelty-shop masks and a subsection of anatomically accurate models of male and female genitalia, obtained from medical supply houses and traditionally used to educate medical students not just to the look, but to the feel of these organs. Stored nearby for ready access are other essential props. What in Sherman's staged photographs, especially her history of art-inspired ones, look like

CINDY SHERMAN (left) *Untitled #213*, 1989. Color photograph, 41½ x 33". From an edition of 6. Collection of Birmingham Museum of Art, Alabama **(right)** *Untitled #312*, 1994. Color photograph, 61 x 41½". From an edition of 6. Collection of the artist

authentic period costumes are really fragments of ornate cloth, pieces of costume jewelry, and other materials that she combines for the shoot.

Sherman's photographs are commentaries on current social issues as much as on the subjects they depict. Photography is the ideal medium to make such points, she explains, because people are so comfortable with it. "It's all around them, and they understand its relationship to what they see every day in advertising and in the movies." In that respect, her self-portraits are subversive because "I'm trying to get others to question comfortable assumptions about everyday life." Still, she does not think of herself as a self-portraitist, she maintains, because "my photographs are not really autobiographical. I'm not trying to show who I am or what I look like in my work. I'm really trying to hide myself in it. I really don't know why. I guess people think the work is somehow about my fantasies, but it's not." Though she dismisses the notion of using models, there have been times, as in the "sex pictures," when she has used "mannequins or dolls or things like that, in pieces that are basically like still-life photographs. Some people think that I'm still in those somewhere, but I'm actually not. Those pieces are harder for me to do because they have to be planned out as though I'm setting up a scene. It's a lot easier when I use myself."

Because her photographs are imbued with many levels of meaning, Sherman concedes that they offer the viewer considerable opportunity to speculate freely about their mysterious content. In the end, though, she wants her photographs to function like that and "not to be so revealing of me that people would necessarily recognize me on the street." When I asked Sherman what lasting effects, if any, the various roles in which she has cast herself have had on her, she answered, "Sometimes, I'm so possessed by what I am doing that I am transfixed by the image." She says that her history pictures have stayed with her, continuing to inform subsequent work. "They stayed with me through three different periods of shooting over the course of about a year and a half. And I suppose that a few of their characters resonated so much with me while I was working on them that I really felt transformed. I always look into a mirror next to the camera to summon up those characters. Sometimes I don't really know what I want from the picture I'm taking until I start playing with my reflection in the mirror. So when it really works well, it just seems like magic that a character I didn't even know has appeared."

In the context of today's modernism, Sherman remains a beguiling anomaly, as elusive privately as she is arresting in her compositions, in which she is the sole per-

CINDY SHERMAN *Untitled Film Still #56*, 1980. Gelatin-silver print, 6 3/8 x 9 7/16". Collection of The Museum of Modern Art, New York

former. Her photographs range from black-and-white reimaginings of 1940s and '50s film stills to elaborately costumed tableaux in which she assumes the roles of almost, but not quite, identifiable historical characters. Her subjects are not just invented beings, but generic ones that speak for a period or an age.

Leafing through the catalogue of a Sherman retrospective, we sense a restless narrative in which themes are introduced, amplified, succeeded by others, and returned to. Her sources are the fictive worlds of film, advertising, and art history. Her women are bizarre embodiments of the perceptions of others. They can be haughty Renaissance duchesses, weepy film stars, or predatory sex objects. She is both participant and sardonic commentator in these complex visualizations. She steers an amazingly personal course, touching on strange shores, immersing herself in the disparate worlds of fairy tales, sexual imagery, and horror films, but nowhere does she remain for long. A fierce, anarchic humor marks her quicksilver changes from generic housewife of 1950s advertising to bubbleheaded glamour girl to assertive feminist. During her forays into the domain of art history, she has lifted images from da Vinci to Rembrandt to Ingres, even substituting herself for Caravaggio's laurel-crowned Bacchus. Her surreal, mock-horror portraits of the mid-1990s echo of the mid-sixteenth-century vegetable-headed portraits of Giuseppe Arcimboldo. Nor are her Surrealist proclivities limited to earlier art. There is more than a whiff of Hans Bellmer's kinky sex-doll imagery in her scatterings of broken doll parts.

While self-portraiture is a recurring theme in Close's imagery, it is the only theme in Sherman's. And if for him the photograph itself is the first crucial step in making a painting, for her it is the final product. Sherman is a constantly changing figure in her self-representations, while Close is an instantly identifiable one in his. With these differences of self-perception in mind, I wondered what she thought Close might be saying about himself in his self-portraits. I also wanted to know in what ways she thought those paintings differed from those he made of others. They do differ, she thought, especially if seen as parts of a continuum. "It's somehow like he's exposing more of himself, especially in terms of the whole body of those self-portraits. Parts of his face are changing all the time—his eyes, his glasses, and his facial hair. It's like we're getting to know him a little bit more each time."

Connections between Sherman's and Close's imagery are at most tenuous, but each artist, in radically different ways, has helped change popular and critical

CINDY SHERMAN *Untitled #92*, 1981. Color photograph, 24 x 48". From an edition of 10. Collection of the Eli Broad
Family Foundation

CINDY SHERMAN *Untitled #264*, 1992. Color photograph, 59 x 75". From an edition of 9

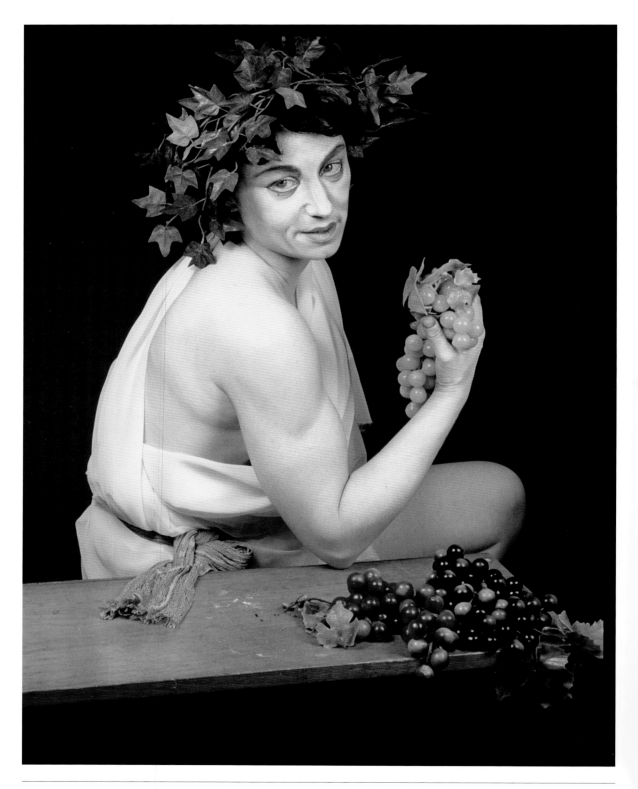

CINDY SHERMAN *Untitled #224*, 1990. Color photograph, 48 x 38". From an edition of 6. Collection of Linda and Jerry Janger

notions about photographs—Close by assiduously mining their contents for his paintings, Sherman by imbuing them with a new sense of psychological narrative. For both, the photograph has been a way of probing interior worlds. No matter how transformed or camouflaged she may be in her photographs, Sherman feels that her sensibility pervades them just as strongly as if they were images she had painted. Maybe, she reflects, it's that pervasive quality of self that relates her work, even tenuously, to Close's. She thinks of his painting, for all its technical virtuosity, as being more than simply about systems and processes and stresses its expressive quotient. "But then, maybe I'm reading things into it," she adds. "Maybe I want to see some emotional thing there, some emotional content." Because, she goes on, no matter how much artists might try to avoid dealing overtly with emotional issues in their imagery, such matters are not really under their control. "As an artist, you can't help but put something of yourself in there—even unwittingly—that is revealing."

"I first saw Chuck's painting of me in his studio when he was about halfway through with it," Kiki Smith says. "It made me laugh because he painted flowers in my eyes. I thought it was his joke about how hippie he thought I was."

Hippie-looking? Possibly. When she first came on the scene in the early 1980s, an artist whose work was known then mainly to other artists, there was something of the flower child about her, especially her penchant for exotic attire and blithely unconventional behavior. That unconventionality colored her art. Close recalls a 1992 exhibition of her work at the Fawbush Gallery, her first New York dealer, where he saw a painted wax-and-papier-mâché sculpture of a crawling nude woman with a long trail of an excrement-like substance behind her. Though a successful artist these days and—possibly despite herself—regarded as a member of the art establishment, Smith retains more than a touch of that idiosyncratic personal style updated with a few tattoos on her arms.

She lives in an 1840s house on an anonymous block, not far from Tompkins Square Park. The park has traditionally been the scene of political protests and anarchist riots, most recently in 1991, when the New York police evicted numerous homeless people and squatters who had taken up residence there and in the immediate environs. The ambience of the neighborhood, with its gritty alphabet-named streets, suits Smith just fine. During my visit to her house, she pulled a cardboard box stuffed with bits and pieces of paper, cloth, and less identifiable materials from under her couch, laughingly describing its contents as "my studio." Much of her art-making activities these days takes place elsewhere, such as the Johnson Atelier Foundry, in Mercerville, New Jersey, where she casts many of the delicate forms she shapes in wax, paper, and other materials.

To reach the second floor of Smith's house, the visitor ascends a set of steep stairs, a thick rope along the staircase wall serving as a makeshift banister. The large room at the top of the stairs is an open, airy space in casual disarray. Presiding over its scattered-about contents—piles of books and catalogues, small wax sculptures in progress, plants in various states of health, several couches, chairs, and tall wooden cabinets—was a softly cooing white dove that Smith identified as Birdy Bird. A few of her figurative objects and drawings, and works by several artist friends, were to be seen around the room. These included a wall-hung plaster cast of a bookshelf

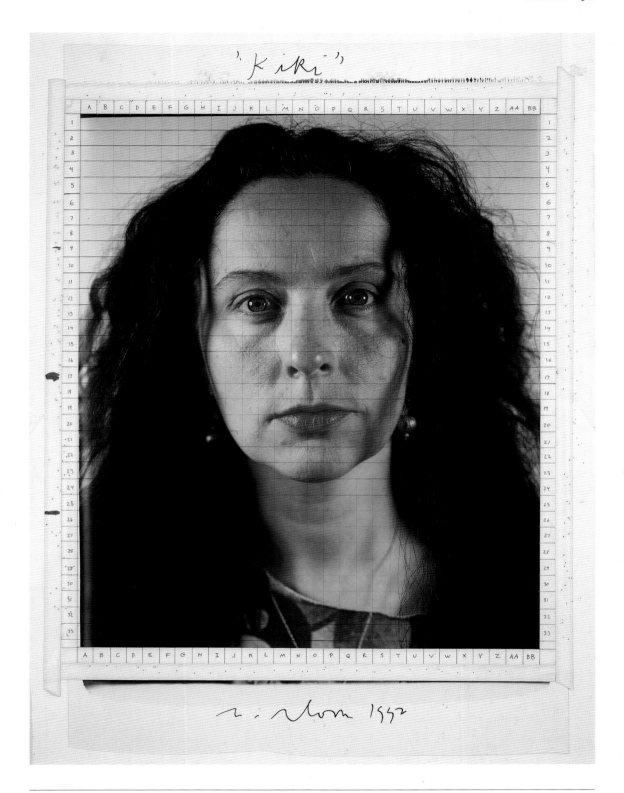

Maquette for *Kiki*, 1992. Polaroid mounted on foamcore, 24 x 20"

KIKI SMITH *Seer*, 2001. Iris print, 20 x 16". From an edition of 18 printed by Pamplemousse Press and published by Pace Editions, Inc., New York

"negative space," complete with impressions of the absent volumes, by the English sculptor Rachel Whiteread, and a ceiling-hung light fixture made of a cluster of thin fluorescent tubes and a few African figure carvings on a narrow table. The glass panels in the pair of tall doors opening to the room bore images of scraggly haired, disconsolate-looking female nudes by Smith. She explained that she had drawn them on pieces of glass that then underwent a firing process, similar to that used in making stained glass. The glass panels of another set of doors that opened to the small office space off the large room were adorned with a series of women's faces.

Well before Smith arrived at this state of relative equanimity in her life, she had worked at various jobs to support herself, from electrician's assistant to bartending in Times Square, where she also made and sold hand-painted scarves and T-shirts with overtly political messages. Once more or less centered in her career as a full-time artist, she began to pursue sociopolitical and gender-based themes that were far from those tie-dyed fantasies. These dealt, often in unflinchingly direct ways, with the human form, not only detailed aspects of its anatomy, but also its bodily processes, no matter how lowly and personal. In drawings and in the strange objects she made, she revealed her growing interest in life-force issues as they relate to birth and decay. Life's vulnerability was the theme to which she constantly alluded, both in her depictions of human forms and in her fanciful renditions of birds and insects, many of them realized in fragile materials such as paper, fabric, wax, and bits of glass. Through such images, her art began taking on a mythical dimension.

Smith was certainly correct in her musings about how Close represented her eyes in his portrait of her, but what she detected as "flowers" could just as well be four-leaf clovers, in a tip of the hat to her Irish ancestry. "By the time that I had finished painting her eyes," Close says, "I probably noticed that those marks looked a helluva lot like shamrocks, but I don't preconceive such things. They're not conceptualizations that I later illustrate. Everything comes out of the painting process." Still, he adds, "it's not a mindless one in which you are unaware of what you are doing, but you become aware of what's happening, and that awareness energizes the process even more. It can happen in the middle of what you are working on. You don't have to wait until the end. So I'm sure that by the time I got to the second eye, I was trying to take advantage of what happened in the first eye."

Yet for all such allusion to Smith's hippiedom, Close clearly envisaged her in far more classical terms in the 1993 *Kiki*. He presents her not as a mercurial 1960s

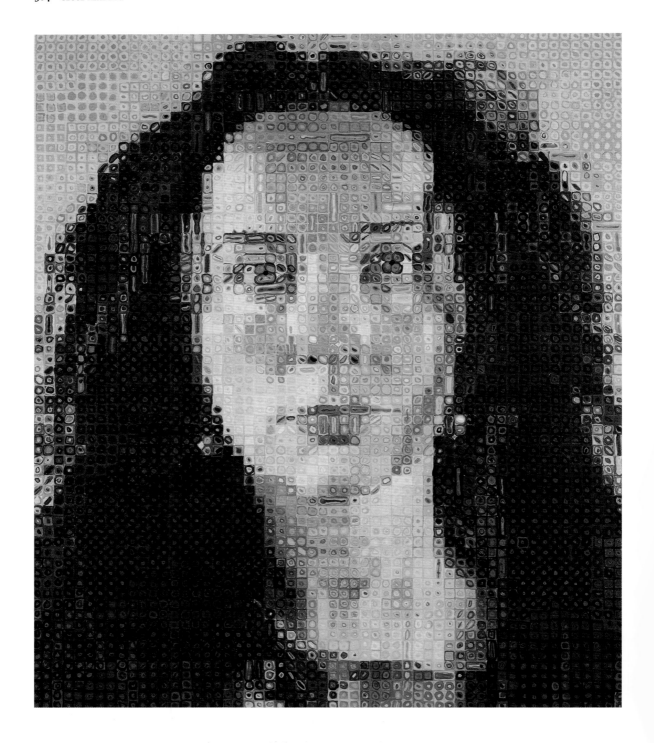

Kiki, 1993. Oil on canvas, 100 x 84". Collection of Walker Art Center, Minneapolis; gift of Judy and Kenneth Dayton, 1994

holdover, but as a dark-maned Minerva, with a far away look, as though transfixed. This was no instantaneous impression of a blithely unconventional sitter, but a richly layered representation of Smith, and like other Close portraits since the mid-1980s, a stately accretion of carefully measured brush strokes. Around the mouth and eyes, neatly fitted-together squares give way to rectangles and oblongs whose rounded nuclei mutate into vertical, horizontal, and diagonal lines. The pervasive tonality of *Kiki* is somewhere between deep carmine and a lively terra-cotta; light softly models the sides of the face and the bridge of the nose. In this vast enlargement of Smith's features, her mouth becomes an especially complex structure: the upper lip is a line of thin squares, the lower one, an aggregation of upright rectangles packed with wobbly dots and circles.

For all its specificity, however, *Kiki* verges on the edge of distortion. Everything seems just slightly abnormal: The large head is precariously balanced on a slender neck and the axis of head and neck tilts just enough to disrupt the symmetry of the composition. Smith's wide-open, gray eyes do not quite line up, the left being a bit higher than the right. The dark, indeterminate curling forms on both sides of her face could be strands of hair or their shadows, or both. The painting, in essence, is about agitation subtly undermining order—a concept resonant of Smith's own approach to making art. It's also about the mystery that can inhabit presumably logical structures.

In a conversation that Close had with Smith, which appears in *The Portraits Speak*, Close's 1997 book of interviews with artists who sat for him, and thus the immediate forerunner of this volume, he tells her about her mother coming to his studio on various occasions to see how the painting was progressing. He jokingly suggests to Kiki that Jane Smith might have come by so often because "maybe it's easier to get along with your painting than it is to get along with you." During that discussion, she confessed to Close that "as a kid, I never thought I could be an artist. I thought, 'Oh, I could be like the Mona Lisa, I can be someone who is the subject.'" So dominant was the influence of her famous father, the sculptor Tony Smith, that the probability that Kiki or her younger sisters, Seton and Beatrice, could do something as creative on their own may have seemed remote then. But as fate would have it, all three became artists. When Close asked if Kiki might have been impelled to make representational art because it was so different from her father's with its austere geometry, she agreed this could have been a reason, but claimed she was attracted to representational art "because it was popular. You didn't have to know

anything. . . . If you make things, especially bodies or faces, you don't have to know anything special about them. Everybody has equal experience with them, very different, but equal experience" (*The Portraits Speak: Chuck Close in conversation with 27 of his subjects.* New York: DAP, 1997, p. 590).

In 1991, during a visit to "Head-On/The Modern Portrait" at the Museum of Modern Art, Smith had a vivid introduction to Close's unique sensibility. For that installation, he had selected some sixty images—many of them self-portraits, not surprisingly—from the museum's holdings in painting, sculpture, drawing, and prints. The effect on her was strong, she recalls. This was the first exhibition she had seen that combined portraits from so many periods of modernism. "I was just totally fascinated by all that variety, and by how so many different artists approached portraiture." Furthermore, the timing of the exhibition was perfect, because, she continues, "it coincided with when I was starting to make self-portraits." One of the works on view in a corridor-like area off the main exhibition space was Close's 1989 painting of the artist Elizabeth Murray. "I hadn't paid much attention to Chuck's work until I saw that painting," Smith says. "I didn't know anything about him, whatsoever. I didn't even know that he had been ill. Then I saw that painting and was just totally knocked out by it. I couldn't believe how exciting it was. It was so alive. It had such vitality, and it flipped between abstraction and representation in such a concrete fashion." Once she got to know his work and learned about earlier pieces, she fixated on this one in particular.

When in the late 1980s Smith began using herself as a subject, she went about it tentatively, she says. "I started making charcoal drawings and pencil drawings of myself because my face was beginning to get wrinkles. Until I was about forty or so, there wasn't that much about it to hold on to in terms of line, but when I started getting wrinkles, I thought, 'Oh, this is fun, this is something I can look at and draw now.' So I would start at one point on my face and just draw all the details possible, like all the hairs and pores and everything else." Although Smith isn't sure that she would even categorize those first efforts at self-scrutiny as drawings, she was thoroughly caught up in the process of their making. It was an intuitive way of communing with herself, as well as studying her changing physiognomy. She would continue the process, even as her career as an artist made greater demands on her time. There were exhibitions, teaching jobs, and lectures to deal with—obligations for which she was often on the road. During those frequent times when she was away from New York,

she would often draw herself. "I wanted to get something more out of all that travel," she says, "so I brought along a cardboard tube with rolls of paper in it, and at night I'd sit and draw in the hotel room."

Smith approaches self-portraiture in an oddly objective way. Indeed, it is as though she were drawing someone else, so little are her depictions of her face and body ego-driven. Yet, when she is her own subject, there is often a disconcerting quality about the results, which are an unlikely synthesis of highly intimate and clinically dispassionate images. There is no separation in her mind between allowable and proscribed subject matter, especially in portraying the human body. In 1980 she and her sister Beatrice made a death mask of her father, after consulting George Segal, famed for his plaster figures, on how to proceed; they also made casts of Tony Smith's hands. Smith had talked with Close about the importance of death masks in her family. As he tells it, "She has a childhood recollection of her grandmother's death mask hung in the hallway. When her sister Beatrice died, she made one of her. She has all of them on a shelf at home. Her grandmother, whom she had never known, died about twenty to twenty-five years before Kiki was born. She was fascinated with how much her grandmother's death mask looked like the one of her dead sister. Some years later, she made a cast of her own face that she took to Germany in connection with a set design project there. She was shocked when she looked at it sideways, because it had the same profile as the masks of her sister and grandmother. She said, 'I started crying because it was like seeing a death mask of myself.'"

In 1985, in order to learn about the body's inner workings, Smith trained as an emergency medical technician at Brooklyn's Interfaith Hospital. She also took a course in anatomy at the New York Academy of Arts, characterized by Close as a "conservative school where they teach art as though it were the nineteenth century." Its students, he says, are taught to draw from cadavers used in medical schools. "I think it's after the medical students have pretty well ripped the body apart that they get a chance to come in and draw. But I love the idea that these art students were working side by side with Kiki Smith and didn't have any idea who she was." Smith's interest in the forms and workings of the body has taken her imagery in unconventional directions. Specific parts of the body—an arm, a hand, a stomach, kidney, or heart—and even the fluids that sustain and pass through it, from blood to urine to semen, soon became her subject matter. She rendered its skeletal structure and organs and allegorized its life-sustaining processes in hard and soft materials, from

latex and wax to painted plaster and bronze. These arresting images range from abject to oddly spiritual. She has never been squeamish around body parts or processes. In her art, there is no hierarchy of importance between the body's external and internal forms.

In 1986 Smith made two sets of large glass-jar sculptures, symbolically identifying each empty vessel in gothicized script as the container of some essential bodily fluid. In many ways, these were evocative of the ancient Egyptian canopic jars that contained the deceased's vital organs. She characterizes a 1994 intaglio of intestines as a self-portrait. Even though Smith says she prefers making drawings of other people to making them of herself, numerous images of her face and body dominate her ink, brush, and pencil renderings and are arrestingly pervasive in the many prints she has made since the late 1980s. Somehow, her immersion in the systematic, stage-by-stage methodologies of printmaking—whether lithography, etching, aquatint, or combinations of these—has led to a succession of moody, often disconcertingly direct self-images. Although Smith is primarily known as an artist who works with imaginative verve in materials such as bronze, wood, and glass, among the most evocative and confessional of her works are these self-portrayals on paper, specifically, those in black and white.

Since 1990 Smith has worked with Bill Goldston, the longtime director of Universal Limited Art Editions, where she has made many prints for which she was her own model. Her unorthodox, even dissident, approach to printmaking's rather staid conventions has involved manipulation of multiple-xeroxed and radically modified photographic images, frequently and improbably collaged together. When Goldston first saw an example of Smith's work, a startling eight-foot-high image of rows of embryos, in a 1989 Brooklyn Museum "Biennial" exhibition, he immediately contacted her to suggest she try her hand at printmaking, promising to back up her efforts with state-of-the-art equipment and the assistance of his master printers. To her question, "What shall I bring?" his reply was, "Nothing, just bring yourself and let's see what happens." She took him at his word.

Arriving at ULAE's Bay Shore, Long Island, headquarters with no drawings or even any specific ideas for what she might produce there, Smith immediately became her own subject. Her first lithograph, the 1990 *Untitled (Hair)*, was a back view of her head, a great dark mass, its contours tendril-like and languidly moving as though blown by the wind. The atmosphere of the print studio afforded Smith a kind of

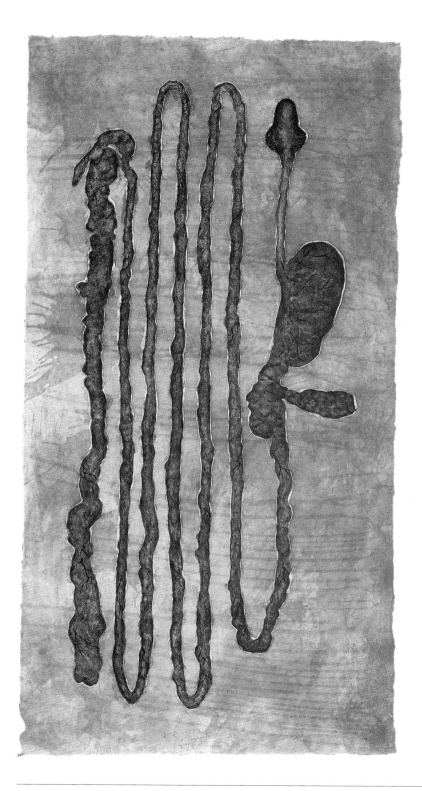

KIKI SMITH *Free Fall*, 1994. Intaglio with photogravure, etching, and drypoint, 33¼ x 42".
From an edition of 40 published by Universal Limited Art Editions, Bay Shore, New York

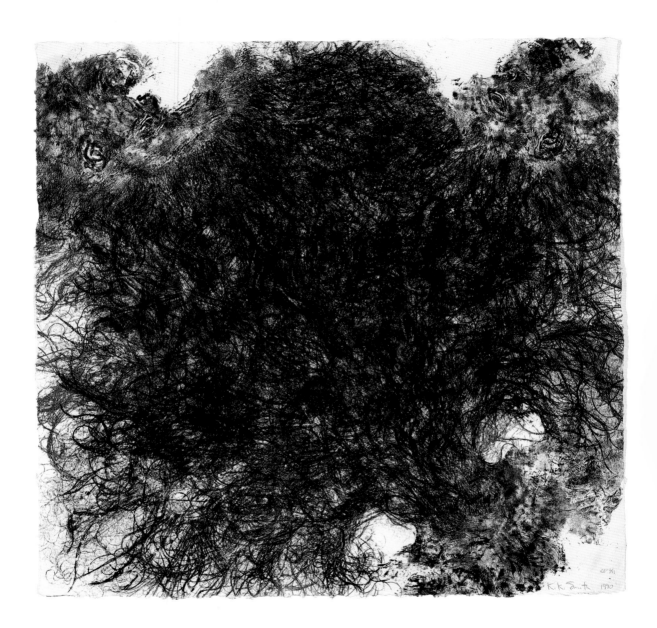

KIKI SMITH *Untitled (Hair)*, 1990. Lithograph (papier-mâché and Xerox transfer), 36 x 36". From an edition of 54 published by Universal Limited Art Editions, Bay Shore, New York

security, certainly enough to allow her to act out her fantasies in photographs in which she assumed various personas. Using her own image as a starting point, she often invested it with disturbing portent. In the large, wall-filling 1991 twelve-part print *Banshee Pearl,* she juxtaposed impressions of her face and parts of her body with those of a skull. Other episodes in this visual saga allude to internal organs and to bodily functions such as breathing, digestion, and reproduction.

In a series of photo-based works made in 2000 at Pace Prints in New York, Smith took a less visceral tack. Instead of focusing in quasi-clinical fashion on the workings of the body, hers or anyone else's, she pursued another favorite leitmotif: self-transformation into animals. In these prints, she represented herself variously as a butterfly, a bat, and a turtle. To make them, she recycled photographs of her younger self in the nude, which were then enlarged to Iris prints or ink-jet prints of sixteen-and-a-half by fifteen-and-a-half inches, in order that she could draw on or adhere other materials to their surfaces—materials such as bits of stiffened Japanese paper to make the bat's and butterfly's wings and the turtle's shell. Under one such winged image, in which legs, arms, and other parts of the body are scrawled over with dark brown lithograph crayon, is the crudely lettered word "butterfly." In a second, the word "butterfly" has been crossed out and replaced with "bat." The third print in this riveting trio, titled *Turtle,* reveals—but not too clearly—the long-haired artist on her knees, poking her head through a half-circle of fabric that represents the turtle's shell. In each instance, the artist is a performer, albeit a shy one who has taken considerable pains to obscure all overtly sexual areas of her body.

What becomes increasingly apparent in considering Smith's astonishing output is that her prints are about all manner of self-explorations. They document journeys into the uncharted realm where fantasy and reality are interchangeable. Consider the large 1992 *Worm,* in which her reclining nude form, based on an infrared photograph of her curled-up nude body, materializes in a reversal of light and shadow. Just below and to the left of this dream-state Eve is a gigantic worm form, its sharply tilted-back head eerily like that of Smith's. Its body is a chain of cylindrical segments that, on closer inspection, are revealed as her arms, legs, and other parts of her anatomy. While radical self-transformation characterizes most of her self-depictions, sometimes these are less body-oriented and take on a whimsical, if nevertheless still dark, cast. Some of the drawings and prints in which she has portrayed herself in various guises resemble greatly enlarged children's book illustrations. In them, she has

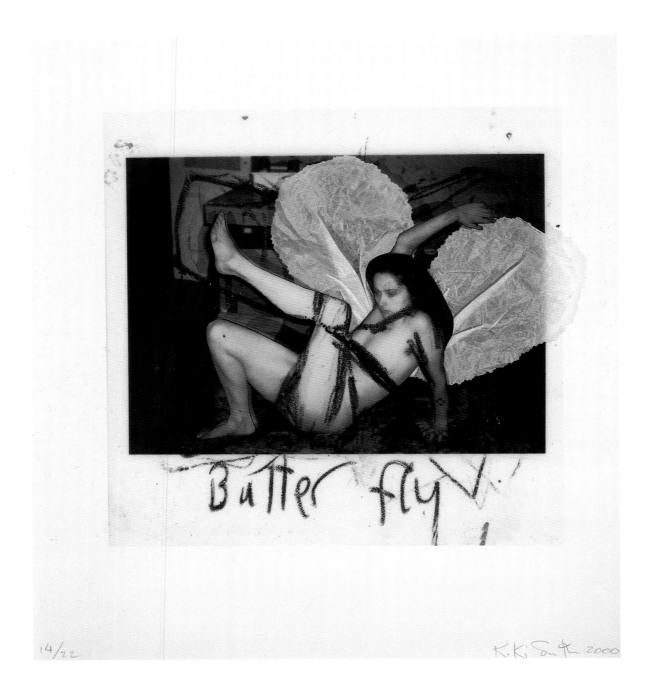

14/22

K.Ki Smith 2000

KIKI SMITH *Butterfly*, 2000. Dimensional Iris print with collage, 16½ x 15½ x 1¼". From an edition of 22 printed by Pace Editions Ink and published by Pace Editions, Inc., New York

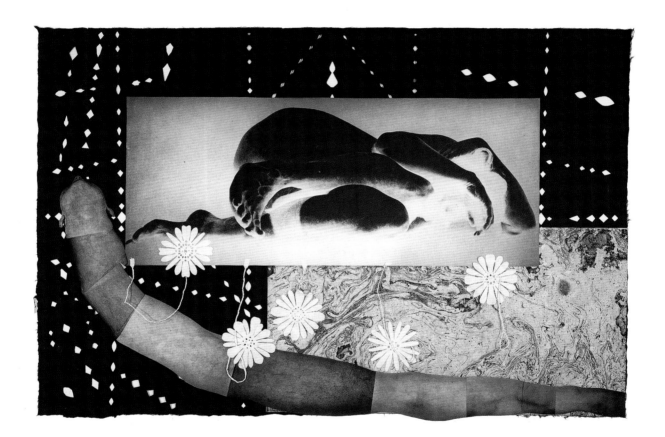

KIKI SMITH *Worm*, 1992. Intaglio and collage, 42 x 62". From an edition of 50 published by Universal Limited Art Editions, Bay Shore, New York

cast herself as Little Red Riding Hood embracing her grandmother who had been retrieved from the slain wolf's belly by the fearless woodsman's ax, and as Alice swimming alongside giant rats in a Wonderland pool of tears.

During our conversation, Smith described a sculpture she was working on. She had just made casts of her head, hands, and feet that, when translated into bronze, would be the only visible parts of a female figure on the ground. Her description instantly conjured up an Oz-like vision, the defining moment when the wicked witch is flattened under Dorothy's tornado-tossed house. Smith has made many sculptures of female figures but few, she says, are autobiographical. "Rarely do I ever use me as me. Mostly I just use one or two other people as models." Despite such ambivalence about being her own subject, she frequently assumes that role. One of the pleasures of doing so, she admits, is that she can take on an invented persona, even to the point where that persona "transgresses the self." By being one's own subject, she says, "You get to mutilate or deconstruct yourself, or to do something to yourself that doesn't have any lasting ramifications." In other words, hers is a fictional world she can enter and leave at will.

As unbridgeable as the gulf between their approaches would seem to be, Smith responds strongly to Close's vision of the world. She is fascinated both by his capacity to distill reality into abstract symbols and by the fact that a Close painting has a dual existence. "I like the idea that it's about representation, but when you get up close to it, it's really a concrete abstract painting." What also interests her about his work, she says, are the stylistic shifts, however incremental, that have taken place within the highly controlled forms of his paintings. "It's interesting how somebody can do the same thing for years and years, and then, all of a sudden, it looks absolutely different to everybody. I think that his work has changed a lot. It's much freer and more open." She thinks that his paintings of himself are more psychologically complex than those of his other subjects, a quality she first noticed in the self-portraits in his PaceWildenstein exhibition in 2000. In those, he seemed to be treating himself differently. "Most of his things are kind of straightforward, but the ones he painted of himself had a very different mood. They had a slightly depressed look—and I really liked that."

KIKI SMITH *Born*, 2002. Lithograph, 68 x 56". From an edition of 28 published by Universal Limited Art Editions, Bay Shore, New York

When I asked William Wegman what immediately came to mind when I showed him a color transparency of *Bill,* Close's six-foot-high 1990 portrait of him, his slightly hesitant answer was, "Well, the imagery of liquor bottles." Bottles? "Yes. Beside the usual color doughnut shapes that he put in most of his portraits of that era, he stuck liquor bottles in around my nose. There are a couple of them. I didn't know if they were a reference to my past, when I used to drink a lot, though I haven't in the last twenty-two years. For that matter, I did have a problem with doughnuts then. I used to eat quite a lot of them. When I asked Chuck, 'What made you think of using bottles in my portrait? Is it that I have a bloodshot nose or something like that?' he just laughed and said, 'I don't know. It just came to me.'"

Later, Wegman's musings about the significance of those forms prompted me to ask Close the same question: Why, indeed, were those shapes so disconcertingly like liquor bottles? His response was as oblique as his reply to Wegman. "Although I knew of Bill's early indulgence in alcohol, I never saw him falling-down drunk or anything. I'm sure that my use of those forms was totally unconscious." But the effects of such readings—seeing certain forms as indicting symbols—can work both ways, as Close himself ruefully once experienced. "I remember," he said, "when Tom Hess, who was a very perceptive critic of my work, did an article for *New York* magazine in which he said that he could detect the word 'cash' written in my beard. I could never find that word there, but he found it. It almost totally destroyed the painting for me. It was a seven-foot-high black-and-white watercolor that I painted of myself in the mid-1970s. So I can certainly empathize with Bill's reaction to seeing suspicious-looking objects embedded in his own image."

Did he really believe, I asked Wegman, that Close, consciously or otherwise, encodes his paintings with symbols? "Well, I wonder about that," he answered, "because I'm really interested in codes and in sneaking around and finding hidden treasures here and there." Aside from the possible significance of the bottles, what else might Close be saying about him in this large painting? For example, wasn't its somber face quite far from the perception that most people have of him as an artist celebrated for his inventive wit and light touch? Not necessarily, was his thoughtful response. In fact, he saw nothing in his much-magnified countenance that suggested an inaccurate reading of his persona. While conceding that his own imagery might

Maquette for *Bill*, 1990. Polaroid mounted on foamcore, 24 x 20"

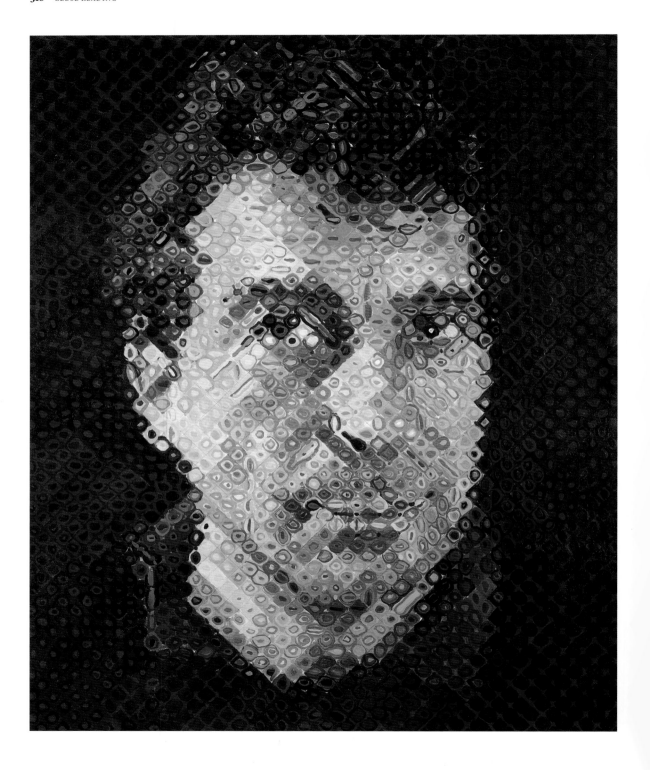

Bill, 1990. Oil on canvas, 72 x 60". Collection of Marsha and Jeffrey Perelman

come across to some as "light and airy, I don't think I'm so light and airy," he said emphatically.

Fair enough, but back to solemnity, not just Wegman's in this rendition, but as the mood projected by other Close subjects. Did he, as a photographer who knew the game so well, I asked Wegman, have any particular thoughts while seated before Close's lens? Was there something inhibiting about that experience that contributed to the somberness of a subject's expression? Maybe so, he replied, because "with that camera, you don't catch anyone by surprise. It's all carefully set up, the light is adjusted, and then this huge one-eyed box stares at you. So, just undergoing the experience of being one of Chuck's models takes time and makes you quiet. There's more than one person hovering around, and you realize you're being studied very carefully. It isn't like fashion photography or celebrity photography, where the model is encouraged to exude confidence." Quite the opposite, he recalls. Being photographed by Close was an absolutely passive experience. "He took three exposures. I didn't think he wanted me to do anything except sit there. I was pretty much a dutiful model."

Much as Wegman marvels at Close's ability to translate a photographic image of him into a six-foot-high field of oscillating, diamond-shaped cells, as he did in the first of the two portraits made from a 1990 photo-maquette, it was seeing *Bill II,* the second painting, a smaller canvas made a year later, that really surprised him. "I don't want to use the term 'impressionistic' to describe it, but I didn't expect it to be so shimmering, like it was in a state of flux. It had a stealthy smallness about it. From certain distances, it looked like my head was coming up from underwater to the surface." When I later mentioned Wegman's aqueous analogy to Close, he agreed. "One eye isn't even there. It's broken into so many squares that it totally dematerializes. The fact that it makes an eye from a hundred feet away is a miracle even to me, but I like that."

Holding a transparency of *Bill II* to the light, Wegman discoursed insightfully on the relationship between Close's posthospital paintings and the "high-color, open-form imagery" of Matisse's later works. "Matisse had to learn how to make a mark all over again because of his severely arthritic hands. He had to figure out new ways to do things, so his work just got bigger and brighter and bolder." Close, too, Wegman went on, had to come to terms with the effects of illness. Although he had used abstract color elements in paintings a few years prior to his illness, once he had recuperated enough to return to his studio, those grew even larger and more intense in hue.

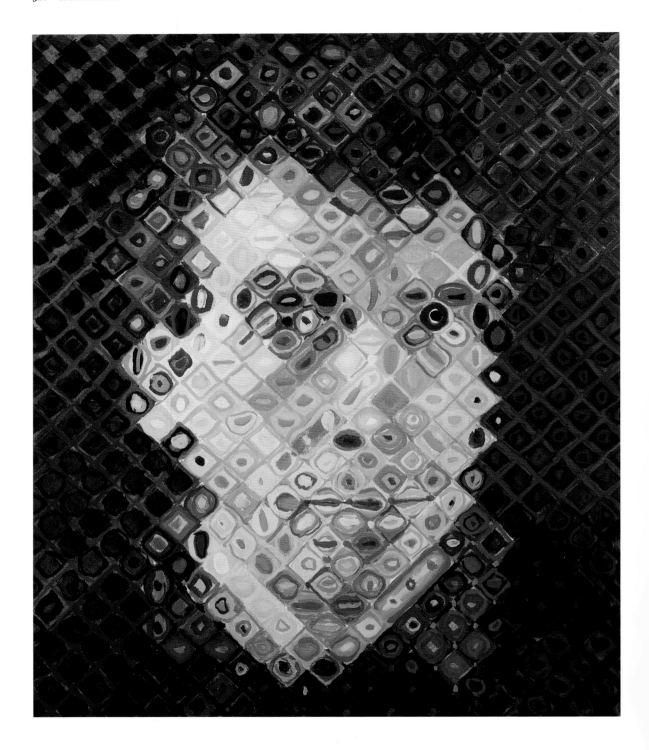

Bill II, 1991. Oil on canvas, 36 x 30". Private collection

Asked if he thought that Close's self-portraits differ much formally or psychologically from his paintings of other people, he countered with his own question, "Doesn't he always look at himself in a certain way? I haven't seen all the self-portraits, but they really are a straight-on kind of thing." He suggests that in making his self-portraits, Close instinctively falls into certain attitudes when he sits before the camera. Wegman says he can empathize with that because he does the same thing. "There's sort of a pose that I usually give myself whenever I look into the mirror." Evidently he makes similar adjustments when he looks into his own lens. "Most artists who are their own subjects do this. I know about those tendencies from my early performance-art background. You can always recognize the artist who conceived one of those pieces by the look that he or she gathers within him- or herself. You always know who they are, even when they're surrounded by helpers or assistants." But, possibly having second thoughts about Close's going through similar adjustments, he says, "Maybe Chuck's more courageous than I am and doesn't need to do all that when he sits for one of his own portraits." Whether he does or not, Wegman continues, guiding the discussion to Close's real-life appearance, as opposed to his camera's version of him, what is certain is that "Chuck has gotten more elegant as he's aged, certainly more handsome, especially over the last ten years. Before, he was sort of like a tall, ungainly teenager who grew too fast in too many directions."

Wegman is still not sure why Close asked him to sit for a photograph in 1990. "Long before I knew exactly what he was up to, I hoped that he would pick my dog Man Ray as a subject, but I never had the courage to ask him to." He and Close would frequently cross paths at Polaroid's studio, where Wegman has made photographs since 1980. His studio was across the street from Close's in the NoHo area, until he moved to Chelsea in 1996. As Close recalls, "Bill and I had seen each other at a thousand things, well before he posed for me. I knew his videos and some of his performance stuff and his early drawings. I also knew his sort of 'punning' photographs. The first photograph of his that I bought was one of those where he had sandwiched some negatives together so that the people in them were combined to make a composite image. It's an 'identical twin' photograph that includes a fake triplet he had added by combining the negatives of the two real ones. The interesting thing about that picture was that the characteristics of each twin's face softened the other's and that the fake triplet was far more attractive than either of the other two. I also bought a print of the *Ray-Bat,* the one with his first dog, Man Ray, hanging like a bat from

the ceiling, and have some other early ones, too. I just found Bill so amusing and open and unguarded, and I loved the wit in his work." That work was a welcome departure, he says, from most other 1970s Conceptualist-based imagery. The more he got to know Wegman, the more he thought so austere a movement was an unlikely milieu for an artist so aesthetically subversive. "Most of its people were pretty humorless, which Bill certainly wasn't. His imagery was so funny, especially at a time when the rest of them were taking themselves so seriously. The fact that he could make interesting, compelling work in that mode was such a breath of fresh air."

At least outwardly, about all that William Wegman and Chuck Close would seem to have in common is their extensive use of photography. In contrast to Close's determinedly static monohead camera images that lead to epic-size paintings, Wegman's photographs of faces, especially his own, defy easy categorization because they take so many forms and materialize in so many media. Though primarily known for portrayals of such canine superstars as Man Ray, his first Weimaraner model, and Fay Ray, "Man's" successor, he is also a prolific draftsman and painter. According to Wegman, he and Close share an aesthetic ancestry that he terms "Minimalist-Conceptualist cool." Musing about Close's emergence on the 1960s art scene, he observed that being a painter at that time was considered pretty suspect. "'Painter' was sort of a dirty word. To be able to get away with being one, you really had to be cool." In his view, Close, with his outsider stance, more than qualified.

Wegman's New York City studio and residence are in an anonymous, three-story gray structure and an adjacent, low red-brick building in Chelsea. Though their exteriors are nondescript, what goes on inside is another matter. Where else, for example, would a visitor to an artist's studio be greeted amiably by six large, tail-wagging gray Weimaraners at the top of a steep flight of stairs? Three, I learned, were regulars at this address, while the others were briefly in town from Wegman's summer place in Maine, where they are cared for by his sister. The New York dogs, models for many a Wegman photograph, reside upstairs, along with Wegman, his wife, Christine Burgin, and their two children, in a sprawling space whose second level incorporates a tree-shaded outdoor terrace. The large studio contains work spaces for photography and video projects, and other areas where young assistants work on various Wegman-related projects, among them preparation of exhibition material and publications. The walls of a small office space off the busy main area are lined with shelves of books, catalogues, and countless CDs, ranging from early English consort

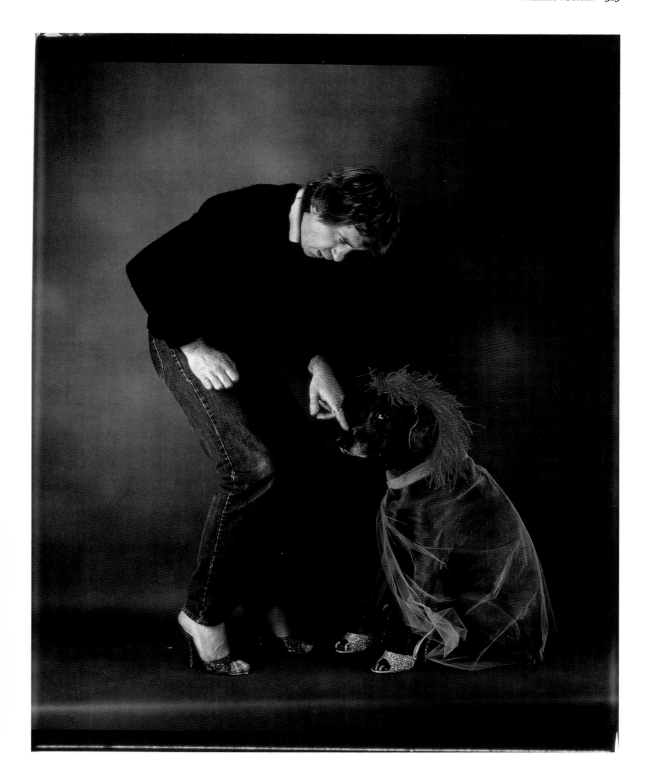

WILLIAM WEGMAN *Heels*, 1981. Color Polaroid, 24 x 20"

ensembles to Bach and Beethoven offerings, and on to twentieth- and twenty-first-century recordings. The atmosphere during my initial visit was of cheerful tumult—how could it have been otherwise, with so many dogs about, music on the stereo, and Wegman's young son, Atlas, bouncing a ball against a wall, perilously close to one of his father's large paintings, a landscape in gold-brown earth tones?

Wegman has been his own subject since the early 1970s, in still photography, in video pieces, and in drawings that vary from wispy pencil sketches to ink, gouache, and watercolor renditions. His drawings, generally small-scale and tentative in feeling, are somewhere between cartoons and intimate diary entries. As to matters of style, he says, "I'm really a chameleon—I mock myself—because I can draw or paint realistically or be a Minimalist." Many of his drawings are characterized by what at first seems to be a deliberately amateurish technique. In fact, Wegman says, he has always sought to keep technique to a minimum because "you can be sneakier if you don't have a known style." He hastens to say that he has never been involved with the "bad art" syndrome so cheerfully espoused by other feisty, aesthetically subversive young artists in the 1970s. He had a more sober view about his work then, describing it as much "darker emotionally" than his previous pieces. Riffling through a pile of those eight-and-a-half by eleven-inch sheets, he says, is like turning the pages of a book. "They can still get to me, though I may have forgotten many of their images."

What soon becomes apparent in looking over Wegman's self-portrayals, whether drawings or photographs, is the important role that family plays in them. In 1972, when his mother and father visited Southern California, where he had a studio in the then-scruffy, neobohemian beach town of Venice, he made a six-part photographic work, its top row composed of three benign faces—his father's, his mother's, and his. The row below consisted of another trio of faces that were various combinations of those above. For two of these countenances, he superimposed the image of himself on those of his father and mother; for the third, also a double printing, he combined the photographs of his mother and father. Titled *Family Combinations*, it is an edition of six, because of the number of images that composed it.

At that early stage of his career, he had little idea of what really went on in a darkroom; he had few technical skills, and printing overlapping images was an entirely new and difficult experience. "I was just learning about photography. My background was in painting, and I would never have thought about such things as overlapping

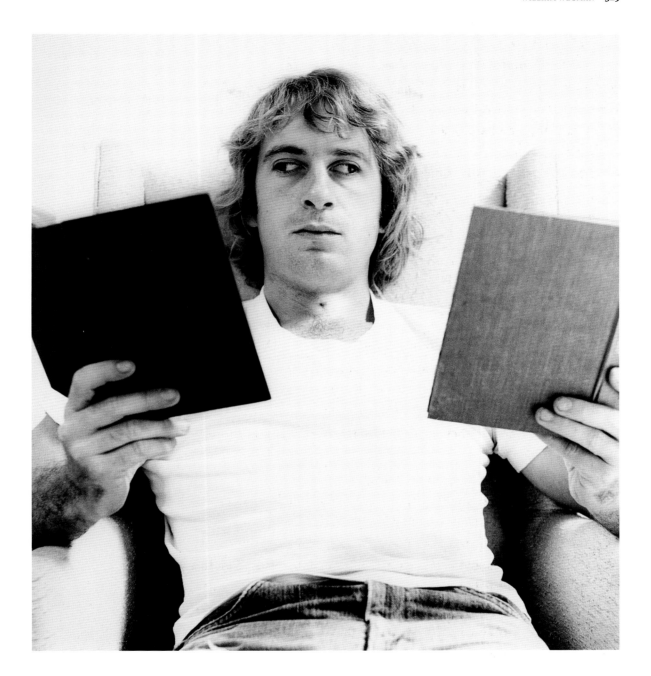

WILLIAM WEGMAN *Reading Two Books*, 1971. Gelatin-silver print, 11¾ x 10"

WILLIAM WEGMAN *Family Combinations*, 1972. Six black-and-white photographs, 12 ½ x 10 ⁵/₁₆" each

images when I was painting pictures." Even as he took this approach, he realized that his improbable nuclear family portrait might suggest some strange associations. "When I started to overlap the negatives, I got involved in the transsexual look. So the top row is of all of us straight, and the bottom one is the three of us in all of the permutations. I was using a twin-lens Mamiya C30 camera and the lens was not very flattering for portraiture. My mother never forgave me for that photograph, but of course being young then, I was oblivious to all that." As was true of so many of Wegman's photographs and his video pieces from the early 1970s, *Family Combinations* was about transformation, a persistent subtheme in all his work.

"I stopped using myself as a model in my photographs after I entered my thirties. I figured out why later. In your twenties, you're not so conscious of yourself as being young or old, or looking this way or that way, and I was able to just be a vehicle for the ideas. You're just timeless. Later on, though, I started to protect myself and worry about what I looked like. I got really crazy. So I stopped being interested in portraiture. When I got to the video camera, though, I was looking at myself all the time. You could point the camera behind you, to the side, or to the parts of yourself that you discover when you buy your first suit in seventh grade. In front of a three-way mirror, your butt looks funny, or you have a different nose. The video system allowed me to see myself other ways than straight-on. This triangle of subject, camera, and video monitor changed the relationship between what I was looking at and what was looking at me. In 1978, eight or nine years after making video pieces, I entered that room to start working again, but I ran out! I think something happened inside me. I didn't want to look at myself anymore. I wasn't seeing something I liked or could ignore. I was seeing something that troubled me, so I stopped doing it. I don't know what it was. Maybe it was just age, or the light, or whatever. Gone! The moment that I thought would be there whenever I wanted it wasn't there anymore.

"So fortunately, I was able to do something else. I got a dog, Man Ray, about the same time that I was working on the videos and starting to make photographs. He was really unhappy being tied up and kept out of my work so I began bringing him to my studio. He wanted to see what was happening, so he stuck his face right in front of the camera. When he died in 1982, I thought that was the end of that, and it was, for about seven years. Then I got Fay and tried to keep her out of the studio for a year, but she came around. I started to look at her more as a beautiful creature. I had never felt that way about Man Ray. I think he was more like the alter ego,

where Fay was more like the artist's model. Still, I didn't want to just make dog pictures so, even though I had stopped photographing myself earlier, I took about six Polaroid portraits of myself in between my shots of the dogs."

Often, when Wegman portrays himself in his drawings, he reaches back in time. A 1981 gouache self-portrait looks as though it might have been based on an old yearbook photograph. It's as though its then-thirty-eight-year-old creator, already a presence on the international art scene, had decided to evoke his younger self—shy, self-conscious smile, high pompadour. To the side of this James Dean look-alike are the identifying words "bill Wegman," neatly inscribed in slanting text. His face today—and probably then, too—bears only a passing resemblance to this wistful bit of recollection. Now, it's that of a wise, good-humored, aging boy, whose most prominent features are a large, broad-tipped nose, alert, dark, moody eyes under thick eyebrows, and permanent laugh lines alongside a mouth slightly turned up at the edges. It's a classically humorous but sad clown countenance. As he puts it, "I have the type of face that always looks sad because, for instance, the distance between my nose and my mouth is so long. So, even when I'm happy, I don't really look happy. Kind of like a dog's face, I suppose, if you want to think about it. There's something in a dog's face that's hard to read as happiness."

In the two-part 1982 "before and after" photograph, *Foamy After-Shave,* Wegman's normally mobile countenance takes on an uncomprehending, deadpan expression. Both images of his clueless-victim face in this piece are essentially the same, except for a few crucial differences. In the left one, the lower part is heavily lathered with shaving cream, while in the right, the unhappy results of a too-close shave are starkly revealed by razor cuts, slashes, and bits of randomly applied tissue to stanch the bloody flow. The spirit of Buster Keaton lives in this tragicomic duet. As his own subject, Wegman doesn't so much portray his face as employ it in off-kilter, existentialist everyman situations. Making use of it in these contexts is obviously more interesting to him than using it for intensive self-analysis. In a 1992 line drawing cryptically titled *Untitled,* he seems to have melded his countenance, consciously or not, with that of a dog. (Why not? After all, dogs have arguably been his stand-ins for quite some time.) The drawing is an arresting profile of an insouciant, long-snouted, floppy-eared (and at the same time, hairy-chested) figure in a plaid shirt, who subliminally just could be the artist himself. When I asked Wegman if this was indeed a self-portrait, his slightly wistful but qualified response was, "Well, it could be me. I do wear plaid a lot."

WILLIAM WEGMAN *bill Wegman*, 1981. Ink and gouache on paper, 15¼ x 11¾"

WILLIAM WEGMAN *Foamy After-Shave*, 1982. Color Polaroid, 24 x 20"

"When Bill talks about his looking like a dog," says an amused Close, "he's simply personalizing the old truism about people who, after a while, begin to look like their pets. But, I think it's really sort of true in his case. In fact, I always think of the two portraits I made of him as 'Big Bill,' that's the large one, and as 'Bill the Pup,' that's the smaller version. He also has that hangdog look—I hate to use that expression!—of a clown who doesn't have his makeup on. I thought the small painting looked a little like those clown paintings you find in thrift shops. But I think he's better-looking than that." As we talked about the quirky, off-center, narrative character of Wegman's work, so evident especially in his self-portrayals, I asked Close if his response to those qualities might have led him to invite Wegman to pose. Not necessarily, he answered. "While I love those aspects of his work, they're not something I can easily connect to. Besides, an artist doesn't have to work the way I do in order to be interesting to me. I asked Bill to sit for me because I responded so much to his work. He also doesn't fit readily into the canon. He's an island. He's outside the mainstream."

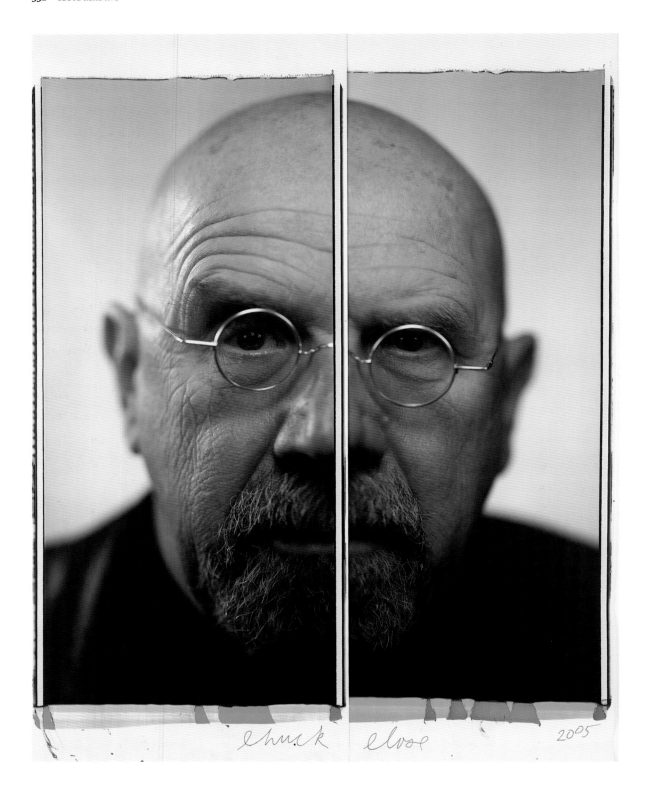

Self-Portrait Diptych, 2005. Two color 80 x 40" Polaroids

Coda

The last thing Close may have had in mind for his painting was that someday it would be part of the grand tradition of portraiture, but that is exactly what has happened. True, he has managed to skew, if not subvert, that tradition in singular ways: first, by politely dismissing his models immediately after capturing their trusting faces on film and then, by using their two-dimensional surrogates from which to paint. If his idiosyncratic approach psychologically insulates his painting from the vagaries of temporal reality, formally it represents an unceasing effort to find evidence of the universal in the particular.

There have been relatively few major changes in Close's work after its transition from the continuous-surface paintings of the late 1960s and early 1970s to those with exposed grids whose squares he loads with abstract color forms. The changes were more of degree than direction, each a step in probing the secret world behind realism's illusionistic facade. Three and a half decades after painting his first giant head, Close is unwaveringly steady in this quest.

In their origin and form, Close's heads have more to do with radical ideas posited by the Minimalists and Conceptualists than with the attitudes of the other descriptive artists of his generation. Still, his attachment to descriptive form is so ingrained that no matter how system-based his portraits are, the inescapable fact is that they are not abstractions but expertly realized representations of identifiable sitters.

What exactly did he mean, I asked Close, as we talked about his working methods, when he so dismissively said, "Inspiration is for amateurs"? "Waiting around to be hit on the head by a lightning bolt, you get nothing done," he explained, matter of factly. "Ideas flow out of the working process, out of what you have already done. You must know Woody Allen's great quote, 'Eighty percent of success is just showing up'? Well, that's pretty much how I feel about what I do." Nothing, in his ostensibly antiromantic view of making a painting—or a drawing, etching, or paper-pulp print—takes the place of working steadily at the job and pushing each process or technique to its limit.

Though Close has confined his explorations to single-theme, single-format territory, his patch of aesthetic real estate is considerably deeper than wide. So deep, in fact, that each time he excavates a little further he discovers something new. Consequently, stylistic changes from one Close painting to the next are often so

nuanced as to be imperceptible, being more about modulation and adjustment than directional shifts. When I asked if he sometimes wished that his thematic acreage were a bit larger, and whether he ever felt confined within its borders, his answer was, "Not at all, really." After all, he observed, quite a few artists, past and present, have constantly worked with the same subject and always found something new to say about it. And, when it comes to such matters, his "real hero," he says, is the mid-twentieth-century Italian painter Giorgio Morandi. "What a world he managed to create out of those same few still-life objects, a few bottles and whatever else he had around. And the emotional ride that you get from looking at them! Just a few of those bottles, close to each other but not touching." Close marvels at his strong reactions to Morandi's images: "How is it possible to feel such loneliness," he wonders, "when you're looking at a couple of bottles? But that's what really happens."

For an artist with so prominent a public persona, the wonder is that he has drawn a far different kind of circle around himself, one that seems to insulate him from other artistic approaches. There is little, if any, stylistic connection between his paintings and those of the many artists who have sat for him. His work has long been in a sphere of its own, and surprisingly self-sustaining. What he says about his ideas coming out of his working processes makes perfect sense in this regard. It's not that he isn't responsive or even enthusiastic about the approaches taken by other artists—however unlike his they might be—it's just that those approaches have little to do with how he goes about his own work. This lack of connection works both ways: it is hard, if not impossible, to identify influences on him more recent than those he was susceptible to during his early days as an artist. There was no shortage of heroes in the 1960s, with artists as disparate as de Kooning, Johns, Warhol, LeWitt, and Judd to look to for inspiration. For that matter, it is just as difficult to cite significant young artists whose styles have been shaped by his.

Close has never been an easy act to follow. The reasons are many. For one thing, the processes behind his paintings are far more complex than even their complex surfaces suggest. Further, those processes involve a juggling act: in one hand, a compulsion to deal with increasingly abstract forms; in the other, an unshakeable attachment to descriptive subject matter. It's the tension between these polarities that so energizes the surfaces of his paintings. Then, there's the fact that the realism he is so committed to is an artificial one, predicated as it is on photographic impressions of reality. That flattened reality—a frozen instant—is what Close so magically transmutes within the borders of his canvases. There's yet another reason why it's

unlikely there will ever be a Close "school," let alone a serious disciple. For the gregarious Close, the center of the social scene at openings, painting is decidedly a form of withdrawal. He has no real followers; a few imitators, perhaps, but who else could possibly stay the course of pursuing a single-head subject through every possible permutation? Who else would have the will, patience, or fortitude to operate within so strict a set of procedures, painting from the top down and obsessively filling squares with fragments of color from left to right?

So, Close is an original, a unique phenomenon. Compared with many of his peers, he remains obdurately fixed in his approach, yet for all his reliance on systems, he has no problem bending the rules. In fact he continues to find freedom in systematic processes, more than enough to infuse his presumably objective portraits with varying degrees of subjectivity. All this, by subtle adjustments of marks as Close's brush moves from one grid square to another.

Chuck Close is far from the first artist to ponder the nature of reality, but his speculations have taken a decidedly original form. The world he reveals in his paintings is an eerie limbo where nothing is truly real, or wholly abstract. Time is an important factor in his work, and he seemingly manages to slow it down as, almost cubistically, he deconstructs an image into multiple components. Accustomed as we are to relatively rapid stylistic changes in the work of other artists, we are all the more transfixed by the glacial rate of change in his production. Not only are changes in technique from one painting to the next often hard to detect, it also appears that none are made in the heat of passion. So restrictive and controlling is Close's square-by-square form-building that it would seem all spontaneity would be lost, but of course, that is not the case. The real action, it turns out, is in those mini solar furnaces, the grid squares that compose the painting. Put another way, the serene whole is the sum of its frenzied parts.

Asked if he foresaw any major changes in his visual language, an amused Close responded, "I've given up foreseeing anything. I'll tell you why. It's not that I wouldn't want to. It's that it never, ever corresponds to what I was imagining. The work that I complete in my mind's eye is always different from the material reality of the work that's made. So predicting what the vocabulary will be, or what it will feel like to be in front of, seems to be almost worthless as an activity."

He's right, of course, but where else can he go with his work? Given his self-imposed constraints, it's safe to say that the subject of his paintings, drawings, and

prints will continue to be the giant portrait. Why abandon the time-tested format of the single-image head in favor of, say, two or more heads or, even more dire an alternative, the complete figure? That could never happen. Close has so thoroughly internalized the solitary head that only the details of its rendering are mutable. His self-imposed conditions, beginning with the indispensable grid as the armature, contribute vastly to the formal resonance of his paintings. Though they have remained the same thematically and compositionally, they have gained immeasurably in another way, one made possible because of those very strictures. They have gained in emotional resonance.

Acknowledgments

What began as a series of casual conversations in Chuck Close's studio in the mid-1990s has evolved into this book about his self-portraits and his portraits of ten fellow artists. His interest and deep involvement in this ongoing enterprise was central to its realization. For his patient, good-humored assistance throughout this process, I am, of course, deeply grateful.

Warm thanks are due Chuck Close's wife, Leslie, for her astute, extremely thoughtful observations about her husband's successful efforts to make his work, despite the effects of his illness. Michael Volonakis, Chuck Close's knowledgeable assistant, a stalwart during many phases of the project, constantly offered valuable counsel. He and his colleague in Close's studio, Janie Samuels, generously made available archival photographs and other essential research materials.

The opportunity to converse with many of Chuck Close's subjects—themselves such distinguished art world figures—was a felicitous byproduct of working on this book. Their observations about his work and their own, and their highly individualistic ideas about the art of portraiture were thoroughly engrossing. Thus, my sincere thanks to Richard Artschwager, Francesco Clemente, Lyle Ashton Harris, Jasper Johns, Alex Katz, Robert Rauschenberg, Lucas Samaras, Cindy Sherman, Kiki Smith, and William Wegman for their generous participation in these informative discussions.

From the outset of this project, Arne Glimcher, President of PaceWildenstein and Chuck Close's long-time friend and dealer, made available to me his gallery's substantial research and photographic resources in support of this project. At PaceWildenstein, considerable thanks are due to Susan Dunne, Director; Emily-Jane Kirwin, Executive Assistant; and Beth Zopf, Director of Photography Archives, for invaluable assistance in obtaining images of works by Chuck Close, Alex Katz, Robert Rauschenberg, Lucas Samaras, and Kiki Smith. Peter MacGill, President of Pace MacGill Gallery, provided images of photographs by Close and Lucas Samaras. Images of works by Kiki Smith published by Pace Editions Inc. came from Pace/Prints.

I appreciate the efforts of Helene Winer, Director of Metro Pictures, in facilitating my meeting with Cindy Sherman, the assistance from Ealan Wingate, Director, Gagosian Gallery (Chelsea), in connection with my writing on Francesco Clemente, and Bob Monk, Director, Gagosian Gallery (Uptown), for his help with Richard Artschwager illustrations. Also for Richard Artschwager images, I thank Ann and Eva Artschwager.

Many individuals who have known Chuck Close at various times in his career kindly talked with me about him and his work. Prominent among them were three of his oldest friends, the composer Philip Glass, the painter Mark Greenwold, and the painter Alden Mason, his art teacher at the University of Washington. Especially helpful in their observations about Close's working methods, as well as his general accomplishments, were the artists Sol LeWitt, Robert Israel, and Jud Nelson. The art historian Jules Prown, whose student Close was at Yale University offered interesting insights about Close's academic achievements there. Klaus Kertess, the founder of the Bykert Gallery, where Close first showed his work in New York, eloquently described his fascinated initial reactions to the then-young artist's giant head images.

During various stages of my research, I had valuable help from many others. Early in this project, Peggy Penn offered observations about the psychology of the creative process that I kept in mind while writing about Close's self-portraiture. Rosemary Furtak, the Walker Art Center's resourceful librarian, was an unfailing source of important reference material related to the work of Chuck Close and other artists discussed in the book. I'm grateful to Jill Vetter, the Walker's archivist, and Stephanie Kays, its slide librarian, for their patient, positive responses to my many requests. Dodge Thompson, Chief of Exhibitions at the National Gallery of Art, talked with me about the Jasper Johns portrait he commissioned Close to make for the museum. John W. Coffey, Curator of American Art and Modern Art at the North Carolina Museum of Art, Raleigh, offered useful perspective on the self-portraits of Alex Katz, an exhibition of which he organized in 1990. The writer Raymond Foye provided intriguing views about the influences of Hindu art on paintings that Francesco Clemente made of himself. David White, the New York–based curator for Robert Rauschenberg, and the dancer Carolyn Brown, who took part in Rauschenberg-conceived performances, were extremely generous with their time and counsel. Sidney Felson, co-director of Gemini, G.E.L., informed me about the genesis of Rauschenberg's print *Boomer*, essentially a self-portrait composed of X-ray images. Bill Goldston, director of Universal Limited Art Editions, graciously showed me and discussed a wide range of self-portrait prints made by Kiki Smith in his Bay Shore, New York, workshop. While there I also saw a recent series of prints made at the ULAE workshop by Rauschenberg that abounded with autobiographical references.

Close's long identification with photography has involved many collaborative efforts. I learned a good deal about his early use of this medium as a prelude to his painting from conversations with the photographer Bevan Davies. John Reuter, in charge of Polaroid's SoHo studio, explained how he works with Close in making images that serve as his photo-maquettes. Close's essays into the realm of daguerreotype were greatly abetted by several specialists who knew his antiquarian medium well. Among those who recalled those experiences for me were Colin Westerbeck, Curator of Photography, The Art Institute of Chicago; Grant Romer, George Eastman House's photography historian and conservator; and the master daguerreotype photographer Jerry Spagnoli, whose expertise and studio Close uses to make these silvery images.

Throughout the preparation of the manuscript for this book, my wife, Mildred Friedman, offered many thoughtful suggestions, not only about its structure but also its content. Wendy Sherman, my literary agent, was always a dependable source of wise counsel. For her extraordinary abilities to assemble so much visual material for this publication, I am indebted to Céline Moulard. I am greatly appreciative of Brankica Kovrlija's design of this book as an admirable response to the directness and clarity of Chuck Close's imagery. Finally, it was a pleasure to work with so clear-eyed and objective an editor as Deborah Aaronson, who knew exactly when to cut to the chase in readying the text for publication.

Credits

Index
Page numbers in *italics* refer to illustrations.